D0205249

A DOCUMENTARY HISTORY OF ART

Volume I

Elizabeth Gilmore Holt was born in San Francisco and spent most of her childhood in Wisconsin. After receiving her B.A. from the University of Wisconsin and M.A. from Radcliffe College, she studied art history at the Kunsthistorisches Institute in Florence, Italy, and in Berlin and Munich, where she received her doctorate in 1934. Mrs. Holt has taught at Duke University, American University, and Talladega College.

A DOCUMENTARY
HISTORY OF ART

Volume I

The Middle Ages and

the Renaissance

Selected and Edited by
ELIZABETH GILMORE HOLT

PRINCETON UNIVERSITY PRESS
PRINCETON, NEW JERSEY

To my parents
Eugene Allen Gilmore
Blanche Basye Gilmore

LCC 81-47281
ISBN 0-691-03969-0
ISBN 0-691-00333-5 pbk.

*A Documentary History of Art, Volume I: The Middle Ages and
the Renaissance* is an expansion and revision of the first and
second sections of *The Literary Sources of Art History*, published
by Princeton University Press in 1947. Volume II is an expansion
and revision of the third and fourth sections.

Printed in the United States of America by Princeton University
Press, Princeton, New Jersey

Anchor Books edition, 1957
First PRINCETON PAPERBACK printing, 1981

FOREWORD

The present volume has been compiled in response to the ever increasing demand for the original documents on the arts. Its aim is to add freshness and solidity to the study of the history of art by making available the words of the artists themselves and of other persons concerned. The materials lifted here from the graves of old books in old libraries—the letters of Dürer; stories of fires and miracles from old chronicles; recipe books for apprentices; and treatises on painting and architecture from the days when it was permissible to spice theory with speculation—are fit to put new life and plastic quality into the familiar story of the evolution of styles.

Here, in a passage from the chronicle of the Cluniac monk Raul Glaber in about the year 1000, the student may read how, "when art was in the service of the church," the churches were built by wonders rather than by engineers. Or, in Theophilus' *Schedula,* he may follow step by step the production of gold leaf, and see within and through the shining gold the ground of red color burnt from sinoper polished with a beaver's tooth and beaten later with a brass mallet on a smooth anvil. Other processes too are outlined here: how to make a lovely violet color, how to acquire a good mountain style, and how to train a lion. In every case new planes seem to be introduced into the flat image and the flat story.

Many of the documents open windows on the personal qualities and conditions of the artists themselves, and how society dealt with them. It is not irrelevant to hear Dürer tell his ecstatic dream or to get firsthand news of Grüne-wald's melancholy. The facts given in their bareness may sometimes be trivial, but when clothed in the humor or

living verisimilitude of firsthand reports they bring genius and humanity together on the stage.

It is not the personalities of the artists alone that are brought to full life in these letters and journals. The social conditions within which they moved are here restored to them. The form of the work of art must acknowledge as part of its cause the state and temper of patronage and audience, the reigning ideal of beauty, the current esteem of mathematics or mythology. These accounts help to build up finally a realization of art as part of life.

Some of the sources in this book are indeed already comparatively easy of access; for example, Leonardo's Treatises. They were included here because of their importance in such an anthology. But much has never been rendered into English before, or is difficult to obtain because translated long ago and now out of print; and nowhere before has such a body of varied sources been collected into one volume for the enlightenment of the English-speaking student of the history of art.

KATHARINE GILBERT

Duke University

PREFACE TO THE FIRST EDITION

The material assembled here has long been known to serious students of European art and culture. It has been put in this form so that it may be more accessible to persons interested in the cultural development of Western civilization. Documents taken from their places in history vividly reveal the attitudes, needs and ideals of our spiritual ancestors. The lay person, familiar with the monuments of architecture, sculpture and painting, may find the material helpful in completing his impression of the personalities and circumstances which produced them, while the student of art history who has not yet acquired proficiency in medieval Latin, Italian, French and German can now catch something of the flavor of the originals which, in most instances heretofore, had been unavailable in English.

An awareness of the difficulties experienced by teachers, dependent on small departmental libraries, in making documents available to beginning students prompted this undertaking. The inclusion of comments and notes which the more advanced student might wish has been deliberately kept to a minimum. A compilation of this sort, viewed by scholars, has unpardonable omissions, for each will undoubtedly find a favorite document missing. It is hoped that they will bear in mind that this book was prepared not for those who know the original documents and the mass of commentary but for laymen, teachers and students in colleges and preparatory schools.

The reading, compiling and translating have been a pleasant if at times an arduous task, for it brought not only a greater knowledge of the material, but the acquaintance, friendship and assistance of scholars far more learned than the compiler. Without their unlimited generosity and

patience, it would have been impossible to attempt or complete this book. Dr. Erwin Panofsky worked out the general plan with me and through the years necessary for the completion of this work has never failed to help. The invaluable counsel, kindly criticism and friendly encouragement of Dr. Katharine Gilbert have made the fulfillment of the task possible. For valuable advice on the organization and selection of the material, I am indebted to Dr. Ulrich Middeldorf, Dr. Walter Friedländer, and Dr. Edgar Wind. To Dr. Wilhelm Koehler, Dr. Horst W. Janson, Dr. Rensselaer Lee, Father Ziegler, Dr. Georg Swarzenski, Dr. Elio Gianturco, Dr. Emanuel Winternitz, Dr. Helmut Hatzfield, Dr. Leo Spitzer, Prof. Ernest W. Nelson, Mrs. Vernon Lippard and Mrs. Pierre Lejins, I am glad to express my thanks for counsel and assistance.

The fifteenth-century Italian texts presented the greatest translation difficulties. It should be borne in mind that, as few of these texts have been revised or corrected since they were published in the nineteenth century, there is a need for a philological study of the different copies of the texts. It seemed wise, therefore, under such circumstances, to pursue in the interest of clarity and readability a middle course between a strictly literal but rather awkward translation and a freer one.

As this book has been compiled for the most part far from a library, I am happy to express my appreciation of the Inter-Library Loan and to acknowledge the kindness of Miss Alice Reynolds of Harvard College Library. The Iowa State University Library, Emory University Library, William and Mary College Library, Mrs. Lucille Haseman, Library of Congress, and Miss Elizabeth Fitton, Marquand Library, Princeton University, have all assisted me.

I am grateful to the Carnegie Corporation for the encouragement given by a grant-in-aid in 1939, and to the American Council of Learned Societies for their timely assistance, which enabled me to prepare the manuscript for publication. Acknowledgment for permission to quote from their publications is made to Cambridge University Press for the sections from G. C. Coulton, *Life in the Middle Ages;* to Houghton Mifflin and Co. for the section from

Henry Adams, *Mont Saint Michel and Chartres;* to Yale University Press for the sections from Daniel V. Thompson, *Cennini: The Craftsman's Handbook;* to the authors and to Oxford University Press for the sections from J. R. and I. A. Richter, *The Literary Works of Leonardo da Vinci.*

To such dear friends as Mrs. Henry R. Wadleigh, and to many others who have given me a helping hand, I express sincere thanks and appreciation.

I owe my deepest gratitude to my husband and family for their affectionate interest and support.

ELIZABETH GILMORE HOLT

July 5, 1945
Georgetown, Maine

PREFACE TO THE ANCHOR SECOND EDITION

My first thanks go to Mr. Jason Epstein, whose scholarly appreciation of the value of this source material to the interested lay person, the student and the teacher has permitted an addition of texts to the Middle Ages and the Renaissance sections of *Literary Sources of Art History*,[*] to be followed by the publication of Michelangelo and the Mannerists, the Baroque and eighteenth-century sections with similar additions.

In the selection of texts to be added, as in the preparation of the first edition, Dr. Erwin Panofsky generously gave his counsel. Dr. Glanville Downey, Dr. Creighton Gilbert, Dr. Ernest Gombrich, Dr. Wilhelm Heckscher, Dr. Richard Krautheimer, Dr. Ernest Kitzinger, Dr. Ulrich Middeldorf and Dr. Wylie Sypher gave valued suggestions. Prof. James Ackerman kindly permitted the inclusion of his translations of excerpts from the *Annali* of the Milan Cathedral published in his article "*Ars sine scientia est*, Gothic Theory of Architecture at the Cathedral of Milan," *Art Bulletin*, June 1949. I thank specially Miss E. Louise Lucas, Librarian, Fogg Art Museum, for constant and unfailing assistance in time of need, and Miss Margaret Rathbone, Librarian, Dumbarton Oaks. I am grateful to Prof. Bernard Peebles for his translations of the Latin texts, to Miss Emita Brady for assistance with the French texts, and to Mrs. Julia Wadleigh for the translation of the difficult Italian text of "A Report to Pope Leo X on Ancient Rome."

<div align="right">ELIZABETH GILMORE HOLT</div>

June 1956
Georgetown, Maine

[*] Cf. copyright page.

PREFACE TO THE
PRINCETON PAPERBACK EDITION

The *Literary Sources of Art History* offered for the first time in English under one cover, basic documents essential to an understanding of art history. Its influence in the intervening forty years resulted in many of the included single texts being made the subject of philological and scholarly monographs, for the student specializing in a particular field or time. Despite the publication of some texts in their entirety, the volume remains a valuable introduction to the use of primary sources and documents. The purpose of the volume remains to offer to interested persons easy access to materials and primary sources which will enable them to formulate opinions and make independent judgments.

The reprinting of the volume affirms the traditional policy of the Princeton University Press to serve not only the specialized scholar, but to make available scholarly material in a form that gives a greater public access to it. This reprinting permits me to express again my gratitude to Margot Cutter for her contribution as its first editor, and to P. J. Conkwright for the fitness of its original design.

This present edition includes a bibliography incorporating only a sampling of the literature that has appeared since the initial publication in 1947, of *Literary Sources of Art History*.

ELIZABETH GILMORE HOLT

March 1981
Georgetown, Maine

CONTENTS

Draw after as Few Masters as Possible; How, Be-
yond Masters, You Should Constantly Copy from
Nature with Steady Practice; How You Should
Regulate Your Life in the Interests of Decorum and
Condition of Your Hand; On the Character of a
Yellow Color Called Ocher; The Method and Sys-
tem for Working on a Wall, that is, in Fresco; and
on Painting and Doing Flesh for a Youthful Face;
The Way to Copy a Mountain from Nature; The
System by which You Should Prepare to Acquire
the Skill to Work on Panel; How to Paint on Panel.

II. THE RENAISSANCE
ITALY

LIST OF ILLUSTRATIONS
following page 180

BIBLIOGRAPHICAL ABBREVIATIONS

A few works have been cited throughout the volume in abbreviated form. These are:

BOTTARI-TICOZZI, *Raccolta*	Bottari-Ticozzi, *Raccolta di lettere sulla pittura, scultura, ed architettura,* 8 vols., Milan, 1922–1925.
OLSCHKI, *Geschichte*	L. Olschki, *Geschichte der neusprachlichen Wissenschriften Literatur,* I, Heidelberg, 1919.
SCHLOSSER, *Kunstlit.*	J. von Schlosser, *Kunstliteratur,* Vienna, 1924.
SCHLOSSER, *Lett. art.*	J. von Schlosser, *La letteratura artistica,* Florence, 1935.
VENTURI, *History*	L. Venturi, *History of Art Criticism,* New York, 1936.

SUGGESTED READING

WORKS OF A GENERAL NATURE

Hauser, Arnold. *The Social History of Art*. New York: Vintage, 1957.
Sources and Documents in the History of Art Series. General editor, Horst W. Janson. Englewood Cliffs, New Jersey: Prentice Hall, 1965.
Wittkower, Rudolf, and Wittkower, Margot. *Born Under Saturn*. New York: Norton, 1969.
The Pelican History of Art Series. Editor, Nicolas Pevsner. London, Baltimore: Penguin [1953-1978].

MIDDLE AGES

Abbot Suger. *Abbot Suger on the Abbey Church of St. Denis and its Treasures*. Translated by Erwin Panofsky. Princeton, New Jersey: Princeton University Press, 1946.
Baum, Julius. *German Cathedrals*. London: Thames and Hudson, 1956.
Block, Herbert. *Montecassino in the Middle Ages*. Cambridge, Mass.: Harvard University Press, 1980.
Branner, Robert, editor. *Chartres Cathedral*. New York: Norton, 1969.
Demus, Otto. *Byzantine Art and the West*. New York: New York University Press, 1970.
Fitchen, John. *The Construction of Gothic Cathedrals*. Oxford: Clarendon Press, 1961.
Focillon, Henri. *The Art of the West: Romanesque and Gothic*. Volumes 1 and 2. Edited by Jean Bony and translated by Donald King. New York: Phaidon, 1963.

Frankl, Paul. *The Gothic: Literary Sources and Interpretations Through Eight Centuries.* Princeton, New Jersey: Princeton University Press, 1960.

Grabar, André. *The Art of the Byzantine Empire: Byzantine Art in the Middle Ages.* Translated by Betty Forster. New York: Crown, 1966.

————, and Nordenfalk, Carl. *Romanesque Painting from the Eleventh to the Thirteenth Century.* Translated by S. Gilbert. New York: Skira, 1958.

Honnecourt, Vuillard de. *The Sketchbook of Vuillard de Honnecourt.* Edited by Theodore Bowe. Bloomington, Indiana, 1959.

Jantzen, Hans. *High Gothic: The Cathedral of Chartres, Reims and Amiens.* Translated by James Palmes. New York: Pantheon, 1974.

Katzenellenbogen, Adolf. *The Sculptural Programs of Chartres Cathedral.* Baltimore: Johns Hopkins University Press, 1959.

Kitzinger, Ernst. *Byzantine Art in the Making: Main Lines of Stylistic Development in Mediterranean Art.* Cambridge, Mass.: Harvard University Press, 1977.

Pope-Hennessey, John. *Italian Gothic Sculpture.* New York: Phaidon, 1970.

Sauerländer, Willabald, and Hirmer, M. *Gothic Sculpture in France 1140-1270.* Translated by J. Sondheimer. New York: Abrams, 1973.

Simson, Otto von. *The Gothic Cathedral: Origins of Gothic Architecture and the Medieval Concept of Order.* Second edition. Princeton, New Jersey: Princeton University Press, 1974.

Stoddard, Whitney. *Monastery and Cathedral in France.* Middletown: Wesleyan University Press, 1966. (Paperback title is *Art and Architecture in Medieval France.* New York: Harper and Row, 1972).

Watson, P. *Building the Medieval Cathedrals.* Cambridge: Cambridge University Press, 1976.

RENAISSANCE IN THE SOUTH

Alberti, Leon Battista. *On Painting and Sculpture.* Translated by C. Grayson. New York: Phaidon, 1972.

————. *Ten Books on Architecture.* Edited by Joseph Rykwert. London: Tiranti, 1955.

Avery, Charles. *Florentine Renaissance Sculpture*. New York: Harper and Row, 1970.

Baxandall, Michael. *Painting and Experience in Fifteenth Century Italy*. Oxford: Clarendon Press, 1972.

Cennini, Cennino. *The Craftsman's Handbook (Il Libro dell'Arte)*. Translated by Daniel V. Thompson, Jr. New York: Dover Publications (c. 1960).

Chambers, David, comp. *Patrons and Artists in the Italian Renaissance*. Columbia, South Carolina: University of South Carolina Press, 1971.

Edgerton, Samuel, Jr. *The Renaissance Rediscovery of Perspective*. First published in 1926. Revised edition. New York: Harper and Row, 1975.

Filarete (Antonio Averlino). *Treatise on Architecture*. Translated by John Spencer. Two volumes. New Haven: Yale University Press, 1965.

Fitchen, John. *The Construction of Gothic Cathedrals*. Oxford: Clarendon Press, 1961.

Frankl, Paul. *The Gothic: Literary Sources and Interpretations Through Eight Centuries*. Princeton, New Jersey: Princeton University Press, 1960.

Gilbert, Creighton. *History of Renaissance Art Throughout Europe: Painting, Sculpture, Architecture*. New York: Abrams, 1973.

Gombrich, Ernst. *Norm and Form in the Art of the Renaissance*. London: Phaidon, 1966.

Hartt, Frederick. *History of Italian Renaissance Art*. New York: Abrams, 1974.

Krautheimer, Richard, and Krautheimer, Trude. *Lorenzo Ghiberti*. Second edition. Princeton, New Jersey: Princeton University Press, 1970.

Leonardo da Vinci. *Treatise on Painting*. Translated by A. P. McMahon. Two volumes. Princeton, New Jersey: Princeton University Press, 1956.

Manetti, Antonio di Tucio. *The Life of Brunelleschi*. Edited by Howard Saalman and translated by Catherine Enggass. University Park, Pennsylvania: Pennsylvania University Press, 1970.

Panofsky, Erwin. *Studies in Iconology*. First published in 1939. New edition. New York: Harper and Row, 1962.

Piero della Francesca. *Libellus de Quinque corporibus regularibus. Piero della Francesca's mathematical treatises*. Ravenna: Longo, 1977.

Pope-Hennessey, John. *The Portrait in the Renaissance.* Princeton, New Jersey: Princeton University Press, 1966.

Sandstrom, Sven. *Levels of Unreality.* Uppsala, Sweden, 1963.

Thompson, Daniel. *The Materials and Techniques of Medieval Painting.* First published London: G. Allen and Unwin, Ltd. 1936. New edition. New York: Dover, 1956.

Turner, Almon. *The Vision of Landscape in Renaissance Italy.* Princeton, New Jersey: Princeton University Press, 1966.

White, John. *Birth and Rebirth of Pictorial Space.* London: Faber and Faber, 1957.

Wind, Edgar. *Pagan Mysteries in the Renaissance.* Revised edition. New York: Barnes and Noble, 1968.

Wittkower, Rudolf. *Architectural Principles in the Age of Humanism.* New York: Random House, 1965.

RENAISSANCE IN THE NORTH

Baldass, Ludwig. *Jan van Eyck.* London: Phaidon, 1952.

Benesch, Otto. *The Art of the Renaissance in Northern Europe.* Revised edition. London: Phaidon, 1965.

Bialostocki, Jan. "Albrecht Dürer." *Encyclopedia of World Art.* New York: McGraw-Hill [1959-1968], IV (1961), 512-31.

Cuttler, Charles. *Northern Painting: From Pucelle to Brueghel.* New York: Holt, Rinehart and Winston, 1968.

Dürer, Albrecht. *Writings.* Translated and edited by William Martin Conway, *The Writings of Albrecht Dürer.* (First published with the title *Literary Remains of Albrecht Dürer.*) New York: Philosophical Library, 1958.

Eichenberg, Fritz. *The Art of the Print: Masterpieces, History and Techniques.* New York: Abrams, 1976.

Friedländer, Max. *Early Netherlandish Painting.* Two volumes. (Part of *Die altniederlandische Malerei.* Fourteen volumes. Leiden, 1936). Translated by Heinz Norden. New York: Praeger, 1967, 1973.

Hind, A. M. *A History of Engraving and Etching.* First published London: Constable, 1927. Third edition. New York: Dover, 1963.

————. *An Introduction to the History of the Woodcut*. First published Boston and New York: Houghton Mifflin, 1935. Two volumes. New York: Dover, 1963.

Huizinga, Johan. *The Waning of the Middle Ages*. Translated by F. Hopman. London, 1927. New York: Doubleday Anchor edition, 1956.

Mander, Carel van. *Dutch and Flemish Painters. (Schilderboeck)*. Translated by C. van de Wall. New York, 1966.

Meiss, Millard. *French Painting in the Time of Jean de Berry: The Late Fourteenth Century and the Patronage of the Duke*. Two volumes. London: Phaidon, 1967.

————. *The Painter's Choice: Problems in the Interpretation of Renaissance Art*. New York: Harper and Row, 1976.

Panofsky, Erwin, *Early Netherlandish Painting*. Two volumes. Cambridge, Mass.: Harvard University Press, 1958.

————. *The Life and Art of Albrecht Dürer*. Fourth edition. Princeton, New Jersey: Princeton University Press, 1955.

Pevsner, Nikolaus, and Meier, Michael. *Grünewald*. New York: Abrams, 1958.

Sitzmann, K. and Battisti, E. "Grünewald," *Encyclopedia of World Art*, VII (1963), 182-91.

I. THE MIDDLE AGES

THEOPHILUS

[Very little is known of the writer of the *Diversarum Artium Schedula* but, to judge from the manuscripts in which his works are preserved, he probably lived in the tenth century and not in the eleventh or twelfth as was formerly believed. From his name and from what he himself says, it may be assumed that he was one of the many learned Greeks who at that time travelled throughout Europe observing its art works and finding employment at various secular and ecclesiastical courts. From his writings it is thought that he joined the Benedictine Order and on becoming a monk took the name of Rugerus. Monasteries like St. Emmerau at Regensburg, St. Gall, or St. Pantaleon at Cologne (where some of Theophilus' manuscripts were found) were centers of art as well as of learning. Although Theophilus himself was probably not a practicing artist, his *Schedula* is the most important art book in the early medieval period and describes the techniques and practices of the ecclesiastical arts of the time.]

AN ESSAY UPON VARIOUS ARTS[1]

Book I. *Preface.* All arts are taught by degrees. The first process in art of the painter is the composition of colours. Let your mind be afterwards applied to the study of the mixtures. Practise this labour, but restrain all things with

[1] The text is from *An Essay upon Various Arts, in Three Books, by Theophilus, called also Rugerus, Priest and Monk, Forming an Encyclopaedia of Christian Art of the Eleventh Century,* translated with notes by Robert Hendrie, London, 1847. Phrases in

precision, that your painting may be beautiful and natural. Your artistic skill will afterwards be increased by descriptions of many inventions, as this book will teach you.

I, Theophilus, an humble priest, servant of the servants of God, unworthy of the name and profession of a monk, to all wishing to overcome or avoid sloth of the mind or wandering of the soul, by useful manual occupation and delightful contemplation of novelties, send recompense of heavenly price. . . .

Wherefore, gentle son, whom God has rendered perfectly happy in this respect, that those things are offered to thee gratis which many, ploughing the sea-waves with the greatest danger to life, consumed by the hardship of hunger and cold, or subjected to the weary servitude of teachers, and altogether worn out by the desire of learning, yet acquire with intolerable labour, covet with greedy looks this "BOOK OF VARIOUS ARTS," read it through with a tenacious memory, embrace it with an ardent love.

Should you carefully peruse this, you will there find out whatever Greece possesses in kinds and mixtures of various colours; [whatever in artistically executed enameling and various types of niello Russia manufactures;] whatever Tuscany knows of in mosaic work, or in variety of enamel; whatever Arabia shows forth in work of fusion, ductility, or chasing; whatever Italy ornaments with gold, in diversity of vases and sculpture of gems or ivory; whatever France loves in a costly variety of windows; whatever industrious Germany approves in work of gold, silver, copper and iron, of wood and of stones.

When you shall have re-read this often, and have committed it to your tenacious memory, you shall thus recompense me for this care of instruction, that as often as you shall successfully have made use of my work, you pray for me for the pity of Omnipotent God, who knows

brackets are amendments and corrections of the Hendrie translation by Wilhelm Theobald in his *Technik des Kunsthandwerks im zehnten Jahrhundert des Theophilus Presbyter, Diversarum Artium Schedula,* Berlin, 1933.

See also: Schlosser, *Lett. art.,* p. 24, and *Kunstlit.,* p. 23; Venturi, *History,* p. 69.

that I have written these things, which are here arranged, neither through love of human approbation, nor through desire of temporal reward, nor have I stolen anything precious or rare through envious jealousy, nor have I kept back anything reserved for myself alone; but in augmentation of the honour and glory of His Name, I have consulted the progress and hastened to aid the necessities of many men.

BOOK I. CHAPTER XXIV. *Of Gold Leaf.* Take Greek parchment [that is, paper], which is made from linen cloth, and you will rub it on both sides with a red colour which is burned from sinoper, that is ochre, very finely ground and dry, and polish it with a beaver's tooth, or that of a bear or a wild boar, very carefully, until it becomes shining, and that the colour may adhere through friction. Then cut up this parchment with scissors, into square pieces, to the size of four fingers, equally broad and long. Afterwards make a kind of purse of vellum parchment, of the same dimension and strongly sewed, ample enough that you may fill into it many pieces of reddened parchment. Which being done, take pure gold and make it very thin with a hammer upon an even anvil, very carefully, so that there be no fracture in it, and cut it into four parts to the measure of two fingers. Then place in this purse one piece of reddened parchment, and upon it one piece of gold in the midst, and then parchment, and again gold; and do thus until you have filled up the purse, and so that the gold may always be placed inside. Then have a mallet cast from yellow brass, small towards the handle, and large in the flat part, with which you strike the purse upon a large and flat stone, not heavily, but moderately; and when you have frequently inspected it, you will consider whether you wish to make the gold very thin or moderately thick. If, however, the gold should be over-spread in the thinning and have exceeded the limits of the purse, cut it off with small and light scissors made altogether for this use. This is the fashioning of gold leaf. When you shall have thinned it to your mind, cut from it with the scissors what pieces you wish, and with it fashion golden crowns round the heads of rulers,

and round stoles, and borders of draperies and other things, as it may please you.

Book II. *Preface*. In the preceding book, dearest brother, through a disposition of sincere affection, I have not hesitated to convey to your virtuous disposition how much honour and perfection there is in avoiding indolence, and in contemning ignorance and sloth; and how sweet and agreeable it is to indulge in the exercise of divers usefulness after the word of a certain author, who says: "To know anything is praiseworthy; it is a fault to be unwilling to learn."

Nor let anyone be slow to understand him, concerning whom Solomon has said, "He that increaseth knowledge increaseth labour," because whoever carefully meditates may mark what perfection of mind and body may result from it.

For it is evident; clearer than the light; because whoever gives his mind to sloth and levity, also indulges in vain trifles, and slander, curiosity, drinking, orgies, quarrel, fight, homicide, excess, thefts, sacrileges, perjury, and other things of this kind, which are repugnant in the eyes of God, overlooking the humble and quiet man, working in silence in the manner of the Lord, and obedient to the precept of the holy Apostle Paul: *"But rather let him labour, working with his hands the thing which is good, that he may have to give to him that needeth."*

I, desiring to be the imitator of this man, have approached the porch of holy Sophia, and beheld the chancel filled with every variety of divers colours, and showing forth the nature and utility of each. From which, having forthwith entered with unwatched footstep, I filled up the storehouse of my heart fully, out of all; which I have set forth with clearness, having, by careful experiment, thoroughly examined one by one for your study, all these things sufficiently approved by the eye and hands, without jealousy. But since the practice of this kind of embellishment cannot be of quick apprehension, like a diligent inquirer I have greatly laboured to inform myself, by all methods, what invention of art and variety of colour may

beautify a structure and not repel [reflect] the light of day and the rays of the sun. Applying myself to this exercise, I comprise the nature of glass, and I consider that this can be effected by the use and variety of it alone. This art, as seen and reported I have learned, I have laboured, for your observance, to fathom.

Book II. Chapter XVII. *Of Composing Windows.* When you wish to compose glass windows, first make for yourself a flat wooden table, of such breadth and length that you can work upon it two portions of the same window [lay every window field double on it]; and taking chalk, and scraping it with a knife over all the table, sprinkle water everywhere, and rub it with a cloth over the whole. And when it is dry, take the dimensions of one portion of the window in length and breadth, marking it upon the table with rule and compass with the lead or tin; and if you wish to have a border in it, portray it with the breadth which may please you, and in the pattern you may wish. Which done, draw out whatever figures you will, first with the lead or tin, then with a red or black colour, making all the outlines with study, because it will be necessary, when you have painted the glass, that you join together the shadows and lights according to the [drawing on the] table. Then arranging the different tints of draperies, note down the colour of each one in its place; and of any other thing which you may wish to paint you will mark the colour with a letter. After this take a leaden cup, and put chalk, ground with water, into it: make two or three pencils for yourself from hair, either from the tail of the marten, or badger, or squirrel, or cat, or the mane of an ass, and take a piece of glass of whatever kind you like, which is in every way larger than the place upon which it is superposed, and fixing it in the ground of this place, so that you can perceive the drawing upon the table through the glass, so portray with the chalk the outlines upon the glass. And if the glass should be so thick [opaque] that you cannot perceive the lines which are upon the table, taking white glass, draw upon it, and when it is dry place the thick glass on the white, raising it against the light, and as you look through

it, so portray it. In the same manner you will mark out all kinds of glass, whether for the face, or in the draperies, in hands, in feet, in the border, or in whatever place you intend to place the colours.

BOOK III. *Preface.* The most renowned of the Prophets, David—of whom the Lord had prescience, and whom he predestined before mundane ages, and whom, on account of the simplicity and humility of his mind, He elected, after his own heart, and placed over the people of his choice, and established with his Holy Spirit, that he might nobly and wisely regulate the conduct appertaining to so great a name —concentrating within himself all the power of his soul in the love of his Maker, uttered these words amongst others: *"Lord, I have loved the beauty of thy house."* And although it was lawful that a man of so much authority and of such capacious intellect should call house the habitation of heavenly worship in which God presides in ineffable brightness over the hymns of choirs of angels, towards which he himself yearned with all his soul, saying, *"One thing have I desired of the Lord, that will I seek after; that I may dwell in the house of the Lord all the days of my life;"* or, as the refuge of a devoted breast and most pure heart, in which God truly dwelt, of which asylum an intense desire again prays forth, *"Renew a right spirit within me, O Lord"*—yet it is certain that he strongly desired the embellishment of the material house of God, which is the place of prayer.

For almost all the treasures in gold, silver, brass and iron of the house, whose founder he himself with such an ardent desire coveted to be made, yet of which he was not worthy, on account of the frequent effusion of human, although hostile, blood, he committed to his son Solomon. For he had read in Exodus that God had given command to Moses for the construction of the tabernacle, and had selected by name the masters of the works, and that he had filled them with the spirit of wisdom and intelligence and science, in every knowledge, for inventing and executing work in gold and silver, and brass, gems, wood, and in art of all kinds; and he had discerned by means of pious reflection, that God complacently beheld decoration of this kind, which

He was appointing to be constructed under the teaching and authority of his Holy Spirit; and he believed that without his inspiration no one could mould any work of this kind. Therefore, most beloved son, you will not doubt, but believe with an entire faith, that the Spirit of God has filled your heart when you have adorned his temple with so much beauty, and with such variety of work; and that you may not chance to fear, I can prove, with clear reasoning, that whatsoever you may be able to learn, understand, or invent in the arts, is ministered to you as a gift of the sevenfold Spirit.

Through the spirit of wisdom you know that all created things proceed from God, and that without Him nothing exists. Through the spirit of intelligence you have acquired the faculty of genius, in whatever order, in what variety, in what proportion, you may choose to apply to your varied work. Through the spirit of counsel you do not hide the talent conceded to you by God, but by working and teaching openly, with humility, you faithfully expound to those desirous to learn. Through the spirit of perseverance you shake off all lethargy of sloth, and whatever with quick diligence you commence, you carry through with full vigour to the completion. Through the spirit of science accorded to you, you rule with genius from an abounding heart, and from that with which you entirely overflow you bestow with the confidence of a well-stored mind for the common good. Through the spirit of piety you regulate the nature, the destination, the time, the measure and the means of the work; and, through a pious consideration, the price of the fee, that the vice of avarice or covetousness may not steal in. Through the spirit of the fear of God you meditate that you can do nothing from yourself, but you consider that you possess, or will, nothing unconceded by God; but by believing, confiding and giving thanks, you ascribe to divine compassion whatever you have learned, or what you are, or what you may be.

Animated, dearest son, by these covenants with the virtues, you have confidently approached the house of God, have decorated with the utmost beauty ceilings or walls with various work, and, showing forth with different colours

a likeness of the paradise of God, glowing with various flowers, and verdant with herbs and leaves, and cherishing the lives of the saints with crowns of various merit, you have, after a fashion, shown to beholders everything in creation praising God, its Creator, and have caused them to proclaim him admirable in all his works. Nor is the eye of man even able to decide upon which work it may first fix its glance; if it beholds the ceilings, they glow like draperies; if it regards the walls, there is the appearance of paradise; if it marks the abundance of light from the windows, it admires the inestimable beauty of the glass and the variety of the most costly work. But if perchance a faithful mind should behold a representation of our Lord's passion expressed in drawing, it is penetrated with compunction; if it beholds how many sufferings the saints have bodily supported, and how many rewards of eternal life they have received, it quickly induces the observance of a better life; if it regards how much rejoicing is in heaven, and how much suffering in the flames of hell, it is animated by hope for its good actions, and is struck with fear by the consideration of its sins.

Act therefore now, well-intentioned man, happy before God and men in this life, happier in a future, in whose labour and study so many sacrifices are offered up to God; henceforth warm yourself with a more ample invention, hasten to complete with all the study of your mind those things which are still wanting among the utensils of the house of the Lord, without which the divine mysteries and the services of ceremonies cannot continue. These are the chalices, candelabra, incense burners, vials, pitchers, caskets of sacred relics, crosses, missals and other things which useful necessity requires for the use of the ecclesiastical order. . . .

LEO OF OSTIA

[Leo of Ostia (1046?–1115), the son of a princely family, entered the celebrated Benedictine Monastery of

Monte Cassino as a boy of fourteen. The famous abbot
Desiderius had gathered there a group of important church-
men, scholars and artists until the monastery had become
the center of learning and art of the time, and in these
surroundings Leo received his education. Later, as librarian
and archivist for the convent's great library, which had
been increased by Desiderius, he was prepared for the
writing of his *Chronicle of Monte Cassino*. He was named
Cardinal Bishop of Ostia by Pope Paschal II, and played
an active and important part in the struggles between
Henry V and the Pope. These activities prevented his con-
tinuing the *Chronicle* beyond the year 1075.

The *Chronicle of Monte Cassino* differs from other
chronicles in its qualities of organization and reliability and
is, on that account, among the first documents which can
be classed as history. The third book is devoted to
Desiderius, especially to his building activity. The section
quoted below describes in detail the construction and dedi-
cation of the great abbey of St. Benedict, undertaken under
the abbot's direction. It records that he imported from
Constantinople craftsmen not only to carry out the decora-
tion of the church but to instruct the abbey monks in their
techniques and skills. The new wave of Byzantine influence
which was introduced into the arts of Italy at this time
may be traced, at least in part, to this conscious attempt
by Desiderius to make available the artistic achievements
of Byzantium. For this the present document remains the
principal source of our knowledge.]

THE CHRONICLE OF MONTE CASSINO[1]

Book III. §26. In all happiness and peacefulness, through
the merits of the Holy Father Benedict, God installed the
venerable abbot Desiderius. He was held in such great
honor by everyone around that not only all the people of

[1] The excerpts are translated from O. Lehman-Brockhaus,
*Schriftquellen zur Kunstgeschichte des 11. und 12. Jahrhunderts
für Deutschland, Lothringen, und Italien*, L., Berlin, 1938, pp.
476–480, 681–682, by Dr. Herbert Bloch. The footnotes are by
the translator.

modest origin, but even their princes and dukes eagerly rendered him the same obedience and ready response to his wishes that they rendered their sires or lords. Thus, not without divine inspiration, Desiderius planned the demolition of the old church and the construction of a new, more beautiful and august one. To most of our leading brethren this project seemed at that time entirely too difficult to attempt. They tried to dissuade him from this intention by prayers, by reasons, and by every other possible way, believing that his entire life would be insufficient to bring such a great work to an end. But trusting in God, he was confident of God's help in everything done for God. Therefore in the ninth year of his office, in March of A.D. 1066, after having built near the hospital the not sufficiently large church of St. Peter, in which the brethren of course should assemble for divine service in the interim, he proceeded to demolish to its foundations St. Benedict's church which, because of its smallness and ugliness, was entirely out of keeping with so great a treasure and so important a congregation.

And since the old church had been built on the very top of the mountain, and had been exposed in every direction to the violent buffeting of the winds, and as it had often been hit by lightning, Desiderius decided to destroy the ridge of stone with fire and steel, to level a space sufficient for the foundations of the basilica, and to make a deep excavation where the foundations should be laid. After having given orders to those who were to execute this work with the greatest dispatch, he went to Rome. After consulting each of his best friends and generously and wisely distributing a large sum of money, he bought huge quantities of [ancient] columns, bases, epistyles, and marble of

See also: U. Balzani, *Early Chroniclers of Europe: Italy*, London, 1883; E. Bertaux, *L'art dans l'Italie méridionale*, Paris, 1904; H. M. Willard, "A Project for the Graphic Reconstruction of the Romanesque Abbey at Monte Cassino," *Speculum*, April, 1935; E. A. Lowe, *The Beneventan Script*, Oxford, 1914; *idem.*, *Scriptura Beneventana*, Oxford, 1929; M. Avery, *The Exultet Rolls of South Italy*, II, Princeton, 1936; H. Bloch, "Monte Cassino, Byzantium and the West in the Earlier Middle Ages," *Dumbarton Oaks Papers*, No. 3, 1946, pp. 163–224.

different colors. All these he brought from Rome to the port, from the Portus Romanus thence by sea to the tower at the Garigliano River, and from there with great confidence on boats to Suium. But from Suium to this place he had them transported with great effort on wagons. In order that one may admire even more the fervor and loyalty of the faithful citizens, a great number of them carried up the first column on their arms and necks from the foot of the mountain. The labor was even greater [than it would be now] for the ascent then was very steep, narrow, and difficult. Desiderius had not yet thought of making the path smoother and wider, as he did later.

Then he levelled with great difficulty the space for the entire basilica, except for the sanctuary, procured all the necessary materials, hired highly experienced workmen, and laid the foundations in the name of Jesus Christ, and started the construction of the basilica [our *figs.* 1 and 2].

It was one hundred and five cubits long, forty-three cubits wide, and twenty-eight cubits high. On each side he erected on bases ten columns nine cubits high. In the upper part he opened rather large windows: twenty-one in the nave, six long ones and four round ones in the choir, and two in the central apse. He erected the walls of the two aisles to a height of fifteen cubits[2] and provided each aisle with ten windows. He then started to reduce the level of the sanctuary to that of the basilica—a difference of about six cubits—but at a depth of not even three ulnae,[3] he suddenly found the venerable tomb of St. Benedict. He expressed the opinion to his brethren and to other men of good judgment that he should not venture to change the tomb in the least, and in order that no one could snatch away anything from so great a treasure, he re-covered the tomb where it was with precious stones and above it, running north and south at right angles to the axis of the basilica, he built a sepulcher of Parian marble five cubits long—a wonderful work. By this device, the sanctuary remained in great eminence, so much so that one has to de-

[2] A cubit is eighteen inches. The basilica was 157 x 64 x 42 feet.
[3] An ulna is about forty-two inches. Cf. A. Pantoni, *Rivista di archeologia cristiana*, XVI, 1939, p. 275.

scend from its pavement to that of the basilica by eight
steps under the large arch which is, of course, above the
sanctuary. In the main apse, toward the east, he erected
an altar to St. John the Baptist, in the same place where
St. Benedict had built an oratory in honor of this saint.
In the south apse he erected an altar to the Mother of God
and in the north apse an altar to St. Gregory. Beside this
[north] apse, he built a house with two rooms for housing
the treasure of the church service. This house is usually
called the sacristy; and he connected this house with a
similar one in which the ministrants of the altar should
prepare themselves. As he had taken away not a small
part of his house to create space for the basilica, he made
the same house which connected with the sacristy wider
and more beautiful than the former one. On the side of it,
near the aisle of the main church, he built a short [narrow]
but very beautiful chapel with a curved wall to St.
Nicholas. Between this chapel and the very front of the
basilica he constructed in the same type of work, a venera-
ble oratory to St. Bartholomew. At the front, near the portal
of the main church, he erected an admirable campanile of
large square stones.

Before the church he also built the atrium, which we
call in the Roman fashion, "paradise." It was seventy-seven
and a half cubits long, fifty-seven and a half cubits wide,
and fifteen and a half cubits high, with four columns on
square bases at each end and eight columns at each side.
On its south side he installed below the pavement of the
atrium a large vaulted cistern of the same length. Before
the entrance to the basilica, he constructed five arches,
which we call "cross-vaults," and five before the entrance
to the atrium as well. At each of the two corners of the
west wing of the atrium he built a beautiful chapel in the
form of a tower: the right in honor of the Archangel
Michael, and the left one in honor of the prince of apostles,
St. Peter. Their interior is accessible by five steps from the
atrium. Since the ascent to the church was very difficult
and steep, he made an excavation sixty-six cubits square
and seven cubits deep in the mountain itself outside the
vestibule of the atrium and the two tower chapels, and

built there the twenty-four marble steps thirty-six cubits wide by which one ascends to the vestibule of the atrium.

§27. Meanwhile he sent envoys to Constantinople to hire artists who were experts in the art of laying mosaics and pavements. The [mosaicists] were to decorate the apse, the arch, and the vestibule of the main basilica; the others, to lay the pavement of the whole church with various kinds of stones. The degree of perfection which was attained in these arts by the masters whom Desiderius had hired can be seen in their works. One would believe that the figures in the mosaics were alive and that in the marble of the pavement flowers of every color bloomed in wonderful variety. And since *magistra Latinitas* had left uncultivated the practice of these arts for more than five hundred years and, through the efforts of this man, with the inspiration and help of God, promised to regain it in our time, the abbot in his wisdom decided that a great number of young monks in the monastery should be thoroughly initiated in these arts in order that their knowledge might not again be lost in Italy. And the most eager artists selected from his monks he trained not only in these arts but in all the arts which employ silver, bronze, iron, glass, ivory, wood, alabaster, and stone. But about that in another place; now we shall describe how he decorated and finally consecrated the basilica.

§28. He covered the whole basilica, the choir, and both aisles as well as the vestibule with roofs of lead. The apse and the major arch he faced with mosaic. He ordered the following verses to be written in large letters on the arch:

In order that under Thy Leadership the just may be able to
 reach and take possession of the heavenly home,
Father Desiderius founded here this hall for Thee.[4]

In the apse, under the feet of St. John the Baptist and St. John the Apostle, he ordered the following verses to be written:

This house is like Mount Sinai which brought forth sacred
 laws.

[4] These verses copy the inscription which Constantine the Great had set on the *arcus maior* of the Vatican basilica.

As the Law demonstrates what was once promulgated here.
The Law went out from here which leads the minds from
 the depths and having become known everywhere, it
 gave light through the times of the age.[5]

He filled all the windows of the nave and the choir with
plates made of lead and glass and connected with iron;
those in the sidewalls of both aisles he made of mica, but
of similar gracefulness. After having installed below the
timber work the ceiling admirably decorated with various
colors and designs, he had all the walls painted a beautiful
variety of colors. He laid the pavements of the entire church
including its annexes, the oratories of Sts. Nicholas and
Bartholomew, and his own house with an admirable num-
ber of cut stones hitherto quite unknown in these parts—
particularly the pavement near the altars and in the choir.
The steps leading to the altar were incrusted with precious
marbles. The front of the choir which he built in the center
of the basilica, he fenced with four marble plates, one was
red, one green, and the remaining plates around the choir
were white. He further decorated the arches above the en-
trance and the vestibule of the church with beautiful
mosaics. He had the whole façade of the basilica plastered
from the arches to the pavement. Also he had the outside
of the arches covered with mosaic and the verses of the
poet Marcus inscribed there in golden letters.[6] He ordered
the remaining three wings of the atrium painted outside
and inside with various scenes from the Old and New
Testaments,[7] and all the wings paved with marble. More-
over, he covered them with ceilings and brick roofs. The
vestibule of the atrium with its two towers was paved,
painted and covered in the same way.

[5] The first two verses are in imitation of the verses which
decorated the walls of the Lateran basilica. Desiderius' borrowing
is a particularly impressive testimony of his conscious attempt to
establish a relationship with the most venerable churches of
Christianity.

[6] The verses of Marcus, a pupil of St. Benedict, are found in
Migne, *Pat. Latina*, LXXX, p. 183.

[7] Desiderius decorated Sant' Angelo in Formis, near Capua,
in the same way.

§29. After all this had been completed, with God's help and through His grace, within five years, Desiderius resolved to dedicate the basilica with the greatest solemnity and with an immense festival for eternal memory. He petitioned and devoutedly invited Pope Alexander II to come to the dedication. When he found the Pope eager and willing, he also invited the latter's archdeacon, Hildebrand,[8] the other cardinals, and the Roman bishops. . . .[9] On the first day of October of A.D. 1071 . . . the basilica of St. Benedict with its five altars was dedicated by the most reverend and angelic Pope himself. The altar in honor of the Virgin in the southern part was dedicated by John, Bishop of Tusculum, the altar in honor of St. Gregory in the northern part was dedicated by Hubald, the Bishop of Sabina, and that in honor of St. Nicholas was dedicated by Eramus, Bishop of Segni. . . .[10]

§32. After the dedication of the church it may be fitting to report Desiderius' other contributions to its decoration. . . . He sent one of the brethren to the imperial city [Constantinople] with a letter to the emperor and thirty-six pounds of gold, and had made there a golden antependium[11] decorated with beautiful gems and enamels. In these enamels he had represented some stories from the New Testament and almost all the miracles of St. Benedict.

The Emperor Romanos IV Diogenes received our brother very honorably and treated him and all his companions

[8] Hildebrand, as Gregory VII, was Alexander's successor.

[9] The long list of guests and the description of the festivities is omitted.

[10] The basilica, with the exception of portions of the towers of the atrium, was destroyed by an earthquake in 1349. The fifteenth century church built on the site was destroyed by Allied aerial bombardment in 1944. The form of the basilica is to be seen in the church of Sant' Angelo in Formis, built near Capua by Desiderius. This church was partially destroyed by German shelling in 1944. For a brief description of Sant' Angelo in Formis, see T. F. Bumpus, *The Cathedrals and Churches of Rome and Southern Italy,* London, 1912.

[11] It was this Byzantine antependium which probably influenced the miniaturist, Leo of Monte Cassino, when he created the famous miniatures of the *Vita Sancti Benedicti* in the cod. Vat. lat. 1202. See Lowe, *Scriptura Beneventana,* Pl. 71.

honorably and reverently as long as they stayed, and he granted him all possible facilities for whatever he wished to have executed. He had made four barriers of bronze to be placed before the altar, between the choir and the sanctuary; also a beam of bronze with fifty candlesticks in which, on the principal holidays, as many candles were to be stuck; and thirty-six lamps which hung down on bronze hooks from the beam. This beam of bronze was supported by arms and handles of bronze. It was connected with [or: put in] a wooden beam which was beautifully made and decorated with gold and purple at Desiderius' order. It was placed upon six columns of silver—each four and a half cubits high and weighing eight pounds—in front of the choir. He had six round icons hung under the beam. Above it he had set thirteen square ones of equal size and weight, ten of which the above-mentioned brother had made of solid silver and gilded in Constantinople. Each of them weighed twelve or fourteen pounds. The round icons had only a silver frame and were painted by [one with] Greek experience in colors and figures. Three other square icons were made of the same metal, size, and way at the order of Desiderius by his own artists. Another round icon covered on both sides with embossed and gilded silver, and surrounded by silver buds on the outside was sent to St. Benedict from Constantinople at that time by a noble. Later on Desiderius had a similar one made and both were suspended in the ciborium of the altar. Moreover, Desiderius had made and gilded another beam of silver weighing about sixty pounds. This was placed under the major arch before the altar on four silver, partially gilded, columns, each five cubits high and weighing ten pounds. He also had made two large silver crosses, each weighing thirty pounds, on which the images were of beautiful embossed work. These he put on marble bases between the columns and below the above-mentioned beam. The three other sides of the major altar he faced with chased and gilded silver [plates] each weighing eighty-six pounds. The sides of the other three altars are decorated on three sides with old plates. For the ciborium of the altar he had made four beams with the outer sides likewise covered with embossed,

gilded silver, while he had the inner sides decorated with plates and colors. Two of the beams are six cubits long and weigh twenty pounds. The other two beams are four and a half cubits long and weigh twelve pounds. He also had made six large candlesticks of chased silver plates, three cubits high and each weighing five or six pounds. On the principal holidays they were to be placed in a straight line before the altar and lighted with great torches. He also had made a wooden pulpit for reading and singing, far more excellent and eminent than the former one. It has six steps. Out of a beautiful pulpit he made a most beautiful one [decorated] with various purple colors and gold plates. In front of it he set up on a base of porphyry a partially gilded silver column, six cubits high. Upon it is placed the huge candle, the blessing of which is solemnly celebrated on Easter Sunday. He had made in the form of a huge crown of silver a chandelier, twenty cubits in circumference and weighing about one hundred pounds, with twelve projecting towers and thirty-six lamps hanging from it. From a heavy chain of seven gilded balls, he suspended the chandelier outside the choir in front of the cross.

§18. While visiting Amalfi, Desiderius saw the bronze doors of the cathedral of Amalfi and as he liked them very much, he soon sent the measures of the doors of the old church of Monte Cassino to Constantinople with the order to make those now existing. As he had not yet resolved to renew the basilica, the doors are for this reason so short as they have remained until now.[12]

RAUL GLABER

[Raul Glaber, that is Rudolf the Bald (*ca.* 985–*ca.* 1046), was a Cluniac monk and chronicler of his own time whose life span included the long awaited end of the first millennium. While reading him one must bear in mind his pen-

[12] Maurus, a member of a most distinguished family of Amalfi, declared himself ready to bear the expense. These doors were intact until the Allied aerial bombardment in 1944. They may be

chant for dwelling upon the marvelous, the curious, and the calamitous. In 1002–1003, he wrote the following often-mentioned passage concerning contemporary church building.]

CONCERNING THE CONSTRUCTION OF CHURCHES THROUGHOUT THE WORLD[1]

Therefore, after the above-mentioned year of the millennium which is now about three years past, there occurred, throughout the world, especially in Italy and Gaul, a rebuilding of church basilicas. Notwithstanding the greater number were already well established and not in the least in need, nevertheless each Christian people strove against the others to erect nobler ones. It was as if the whole earth, having cast off the old by shaking itself, were clothing itself everywhere in the white robe of the church. Then, at last, all the faithful altered completely most of the episcopal seats for the better, and likewise, the monasteries of the various saints as well as the lesser places of prayer in the towns. . . .

ST. BERNARD OF CLAIRVAUX

[St. Bernard of Clairvaux (1091–1153), the most influential churchman of the twelfth century, was born near Dijon of a noble family. As a young man he entered the Monastery of Cîteaux, of the Benedictine Order. In 1115 he founded a religious colony, the Abbey of Clairvaux, which was recognized in 1119 by Pope Calixtus II. After devoting ten years to the organization of his order, which by 1153

recovered with the removal of the debris. See Th. Preston, *The Bronze Doors of the Abbey of Monte Cassino and of St. Paul's, Rome*, Diss. Princeton, 1915.

[1] The selection is translated from the Latin as given by V. Mortet, *Recueil de textes relatifs à l'histoire de l'architecture* . . . , I, Paris, 1911, p. 4, by Mr. Charles P. Parkhurst, Jr., who also wrote the above note.

consisted of 350 monasteries, he extended his influence to all fields of ecclesiastical life by his letters, tracts and sermons. He recognized the necessity for reforms within the church, and attacked laxness and corruption wherever he saw them. By the celebrated treatise *De laude novae militiae* he justified the war of the Christians against the infidels and preached the Second Crusade, 1146–1147, from the failure of which he never recovered. He died in 1153, having devoted his entire life to strengthening the church spiritually and politically.

The "Apologia" is part of a letter written by St. Bernard to the Abbot of St.-Thierry.]

"APOLOGIA" TO WILLIAM, ABBOT OF ST.-THIERRY[1]

. . . But these are small things; I will pass on to matters greater in themselves, yet seeming smaller because they are more usual. I say naught of the vast height of your churches, their immoderate length, their superfluous breadth, the costly polishings, the curious carvings and paintings which attract the worshipper's gaze and hinder his attention, and seem to me in some sort a revival of the ancient Jewish rites. Let this pass, however: say that this is done for God's honour. But I say, as a monk, ask of my brother monks as the pagan [poet Persius] asked of his fellow-pagans: "Tell me, O Pontiffs" (quoth he) "what doeth this gold in the sanctuary?" So say I, "Tell me, ye poor men" (for I break the verse to keep the sense) "tell me, ye poor (if, indeed, ye be poor), what doeth this gold in *your* sanctuary?" And indeed the bishops have an excuse which monks have not; for we know that they, being debtors both to the wise and the unwise, and unable to excite the devotion of carnal folk by spiritual things, do so by bodily adornments. But we [monks] who have now come forth from the people; we who have left all the precious and beautiful things of the world for Christ's sake;

[1] The letter from which the excerpt is taken is given in full in G. G. Coulton, *Life in the Middle Ages*, Cambridge, 1930, IV, pp. 72–76.

who have counted but dung, that we may win Christ, all things fair to see or soothing to hear, sweet to smell, delightful to taste, or pleasant to touch—in a word, all bodily delights—whose devotion, pray, do we monks intend to excite by these things? What profit, I say, do we expect therefrom? The admiration of fools, or the oblations of the simple? Or, since we are scattered among the nations, have we perchance learnt their works and do we yet serve their graven images? To speak plainly, doth the root of all this lie in covetousness, which is idolatry, and do we seek not profit, but a gift? If thou askest: "How?" I say: "In a strange fashion." For money is so artfully scattered that it may multiply; it is expended that it may give increase, and prodigality giveth birth to plenty: for at the very sight of these costly yet marvelous vanities men are more kindled to offer gifts than to pray. Thus wealth is drawn up by ropes of wealth, thus money bringeth money; for I know not how it is that, wheresoever more abundant wealth is seen, there do men offer more freely. Their eyes are feasted with relics cased in gold, and their purse-strings are loosed. They are shown a most comely image of some saint, whom they think all the more saintly that he is the more gaudily painted. Men run to kiss him, and are invited to give; there is more admiration for his comeliness than veneration for his sanctity. Hence the church is adorned with gemmed crowns of light—nay, with lustres like cart-wheels, girt all round with lamps, but no less brilliant with the precious stones that stud them. Moreover we see candelabra standing like trees of massive bronze, fashioned with marvellous subtlety of art, and glistening no less brightly with gems than with the lights they carry. What, think you, is the purpose of all this? The compunction of penitents, or the admiration of the beholders? O vanity of vanities, yet no more vain than insane! The church is resplendent in her walls, beggarly in her poor; she clothes her stones in gold, and leaves her sons naked; the rich man's eye is fed at the expense of the indigent. The curious find their delight here, yet the needy find no relief. Do we not revere at least the images of the Saints, which swarm even in the inlaid pavement whereon we tread? Men spit oftentimes in the Angel's

face; often, again, the countenance of some Saint is ground
under the heel of a passer-by. And if he spare not these
sacred images, why not even the fair colours? Why dost
thou make so fair which will soon be made so foul? Why
lavish bright hues upon that which must needs be trodden
under foot? What avail these comely forms in places where
they are defiled with customary dust? And, lastly, what are
such things as these to you poor men, you monks, you
spiritual folk? Unless perchance here also ye may answer
the poet's question in the words of the Psalmist: "Lord,
I have loved the habitation of Thy House, and the place
where Thine honour dwelleth." I grant it, then, let us suffer
even this to be done in the church; for, though it be harm-
ful to vain and covetous folk, yet not so to the simple and
devout. But in the cloister, under the eyes of the Brethren
who read there, what profit is there in those ridiculous
monsters, in that marvellous and deformed comeliness,
that comely deformity? To what purpose are those unclean
apes, those fierce lions, those monstrous centaurs, those
half-men, those striped tigers, those fighting knights, those
hunters winding their horns? Many bodies are there seen
under one head, or again, many heads to a single body.
Here is a four-footed beast with a serpent's tail; there, a
fish with a beast's head. Here again the forepart of a horse
trails half a goat behind it, or a horned beast bears the
hinder quarters of a horse. In short, so many and so marvel-
lous are the varieties of divers shapes on every hand, that
we are more tempted to read in the marble than in our
books, and to spend the whole day in wondering at these
things rather than in meditating the law of God. For God's
sake, if men are not ashamed of these follies, why at least
do they not shrink from the expense?

The abundance of my matter suggested much more for
me to add; but from this I am distracted both by my own
anxious business and by the too hasty departure of Brother
Oger [the bearer of this letter]. . . . This is my opinion of
your Order and mine; nor can any man testify more truly
than you, and those who know me as you do, that I am
wont to say these things not about you but to your faces.
What in your Order is laudable, that I praise and publish

abroad; what is reprehensible, I am wont to persuade you and my other friends to amend. This is no detraction, but rather attraction: wherefore I wholly pray and beseech you to do the same by me. Farewell.

ABBOT SUGER

[Suger (1081–1151), scion of an obscure family, was placed in the Abbey of St.-Denis as an oblate at the age of nine or ten, and was educated there. For additional learning he went to Burgundy, probably to the Abbey of St.-Benoît-sur-Loire. After his return (about 1107) he served his abbey as *praepositus* of two important possessions (up to about 1112) and was, in addition, entrusted with several missions to the Curia. On these he served the best interests of the abbey as well as of King Louis VI, his former schoolmate, who considered him, throughout life, as his "trusted adviser and friend." In 1122, Suger was ordained Abbot of St.-Denis and devoted himself to reforming the monastery, rebuilding the church, and enriching the treasury. Louis VII, the son of Louis VI, also employed Suger as his counsellor and named him regent during his absence on the Second Crusade in 1146.

Suger wrote the life of his patron, Louis VI, and began a life of Louis VII. But from the point of view of the art historian his most important literary works are a treatise on matters concerning the administration of the Abbey, including the remodeling and redecoration of the abbey church, and a more circumstantial description of the rebuilding and consecration of the latter. Suger died on January 13, 1151.]

THE BOOK OF SUGER, ABBOT OF ST.-DENIS[1]

ON WHAT WAS DONE UNDER HIS ADMINISTRATION

XXIV. *Of the Church's Decoration.* Having assigned the increase of the revenue in this manner, we turned our hand

[1] The excerpts are from *Abbot Suger, on the Abbey-Church of St.-Denis and its Art Treasures*, edited, translated and an-

to the memorable construction of buildings, so that by this thanks might be given to Almighty God by us as well as by our successors; and that by good example their ardor might be roused to the continuation and, if necessary, to the completion of this [work]. For neither any want nor any hindrance by any power will have to be feared if, for the love of the Holy Martyrs, one takes safely care of oneself by one's own resources. The first work on this church which we began under the inspiration of God [was this]: because of the age of the old walls and their impending ruin in some places, we summoned the best painters I could find from different regions, and reverently caused these [walls] to be repaired and becomingly painted with gold and precious colors. I completed this all the more gladly because I had wished to do it, if ever I should have an opportunity, even while I was a pupil in school.

XXV. *Of the First Addition to the Church.* However, even while this was being completed at great expense, I found myself, under the inspiration of the Divine Will and because of that inadequacy which we often saw and felt on feast days, namely the Feast of the blessed Denis, the Fair, and very many others (for the narrowness of the place forced the women to run toward the altar upon the heads of the men as upon a pavement with much anguish and noisy confusion), encouraged by the counsel of wise men and by the prayers of many monks (lest it displease God and the Holy Martyrs) to enlarge and amplify the noble church consecrated by the Hand Divine; and I set out at once to begin this very thing. In our chapter as well as in church I implored Divine mercy that He Who is the One, *the beginning and the ending, Alpha and Omega,* might join a good end to a good beginning by a safe middle; that He might not repel from the building of the temple a *bloody man* who desired this very thing, with his whole heart, more

notated by Erwin Panofsky, Princeton, 1946. Dr. Panofsky generously permitted these excerpts to be included. For commentary notes and identification of the objects mentioned in the text, the student is referred to Dr. Panofsky's scholarly work.

See also: Sumner Crosby, *The Abbey of St.-Denis,* 1, New Haven, 1942.

than to obtain the treasures of Constantinople. Thus we began work at the former entrance with the doors. We tore down a certain addition asserted to have been made by Charlemagne on a very honorable occasion (for his father, the Emperor Pepin, had commanded that he be buried, for the sins of his father Charles Martel, outside at the entrance with the doors, face downward and not recumbent); and we set our hand to this part. As is evident we exerted ourselves incessantly with the enlargement of the body of the church as well as with the trebling of the entrance and the doors, and with the erection of high and noble towers.

XXVII. *Of the Cast and Gilded Doors.* Bronze casters having been summoned and sculptors chosen, we set up the main doors on which are represented the Passion of the Saviour and His Resurrection, or rather Ascension, with great cost and much expenditure for their gilding as was fitting for the noble porch. Also [we set up] others, new ones on the right side and the old ones on the left beneath the mosaic which, though contrary to modern custom, we ordered to be executed there and to be affixed to the tympanum of the portal. We also committed ourselves richly to elaborate the tower[s] and the upper crenelations of the front, both for the beauty of the church and, should circumstances require it, for practical purposes. Further we ordered the year of the consecration, lest it be forgotten, to be inscribed in copper-gilt letters in the following manner:

"For the splendor of the church that has fostered and exalted him,
Suger has labored for the splendor of the church.
Giving thee a share of what is thine, O Martyr Denis,
He prays to thee to pray that he may obtain a share of Paradise.
The year was the One Thousand, One Hundred, and Fortieth
Year of the Word when [this structure] was consecrated."

The verses on the door, further are these:

"Whoever thou art, if thou seekest to extol the glory of
 these doors,
Marvel not at the gold and the expense but at the crafts-
 manship of the work.
Bright is the noble work; but, being nobly bright, the work
Should brighten the minds, so that they may travel, through
 the true lights,
To the True Light where Christ is the true door.
In what manner it be inherent in this world the golden
 door defines:
The dull mind rises to truth through that which is material
And, in seeing this light, is resurrected from its former sub-
 mersion."

And on the lintel:

"Receive, O stern Judge, the prayers of Thy Suger;
Grant that I be mercifully numbered among Thy own
 sheep."

 XXXI. *Of the Golden Altar Frontal in the Upper Choir.*
Into this panel, which stands in front of his most sacred
body, we have put, according to our estimate, about forty-
two marks of gold; [further] a multifarious wealth of pre-
cious gems, hyacinths, rubies, sapphires, emeralds and
topazes, and also an array of different large pearls—[a
wealth] as great as we had never anticipated to find. You
could see how kings, princes, and many outstanding men,
following our example, took the rings off the fingers of their
hands and ordered, out of love for the Holy Martyrs, that
the gold, stones, and precious pearls of the ring be put into
that panel. Similarly archbishops and bishops deposited
there the very rings of their investiture as though in a place
of safety, and offered them devoutly to God and His Saints.
And such a crowd of dealers in precious gems flocked in on
us from diverse dominions and regions that we did not wish
to buy any more than they hastened to sell, with everyone
contributing donations. And the verses on this panel are
these:

"Great Denis, open the door of Paradise
And protect Suger through thy pious guardianship.

Mayest thou, who hast built a new dwelling for thyself
 through us,
Cause us to be received in the dwelling of Heaven,
And to be sated at the heavenly table instead of at the pres-
 ent one.
That which is signified pleases more than he who signifies."

Since it seemed proper to place the most sacred bodies
of our Patron Saints in the upper apse as nobly as possible,
and since one of the side-tablets of their most sacred sar-
cophagus had been torn off on some unknown occasion, we
put back fifteen marks of gold and took pains to have gilded
its rear side and its superstructure throughout, both below
and above, with about forty ounces. Further we caused the
actual receptacles of the holy bodies to be enclosed with
gilded panels of cast copper and with polished stones,
fixed close to the inner stone vaults, and also with continu-
ous gates to hold off disturbances by crowds; in such a
manner, however, that reverend persons, as was fitting,
might be able to see them with great devotion and a flood
of tears. On these sacred tombs, however, there are the fol-
lowing verses:

"Where the Heavenly Host keeps watch, the ashes of the
 Saints
Are implored and bemoaned by the people, [and] the
 clergy sings in ten-voiced harmony.
To their spirits are submitted the prayers of the devout,
And if they please them their evil deeds are forgiven.
Here the bodies of the Saints are laid to rest in peace;
May they draw us after them, us who beseech them with
 fervent prayer.
This place exists as an outstanding asylum for those who
 come;
Here is safe refuge for the accused, here the avenger is
 powerless against them."

XXXII. *Of the Golden Crucifix.* We should have insisted
with all the devotion of our mind—had we but had the
power—that the adorable, life-giving cross, the health-
bringing banner of the eternal victory of Our Saviour (of

which the Apostle says: *But God forbid that I should glory, save in the cross of our Lord Jesus Christ*), should be adorned all the more gloriously as the sign of the Son of Man, appearing in the sky at the moment of utmost danger, is glorious not only to men but also to the very angels; and we should have perpetually greeted it with the Apostle Andrew: *Hail Cross, which are dedicated in the body of Christ and adorned with His members even as with pearls.* But since we could not do as we wished, we wished to do as best we could, and strove to bring it about by the grace of God. Therefore we searched around everywhere by ourselves and by our agents for an abundance of precious pearls and gems, preparing as precious a supply of gold and gems for so important an embellishment as we could find, and convoked the most experienced artists from diverse parts. They would with diligent and patient labor glorify the venerable cross on its reverse side by the admirable beauty of those gems; and on its front—that is to say in the sight of the sacrificing priest—they would show the adorable image of our Lord the Saviour, suffering, as it were, even now in remembrance of His Passion. In fact the blessed Denis had rested on this very spot for five hundred years or more, that is to say, from the time of Dagobert up to our own day. One merry but notable miracle which the Lord granted us in this connection we do not wish to pass over in silence. For when I was in difficulty for want of gems and could not sufficiently provide myself with more (for their scarcity makes them very expensive): then, lo and behold, [monks] from three abbeys of two Orders—that is from Cîteaux and another abbey of the same Order, and from Fontevrault—entered our little chamber adjacent to the church and offered us for sale an abundance of gems such as we had not hoped to find in ten years, hyacinths, sapphires, rubies, emeralds, topazes. Their owners had obtained them from Count Thibaut for alms; and he in turn had received them, through the hands of his brother Stephen, King of England, from the treasures of his uncle, the late King Henry, who had amassed them throughout his life in wonderful vessels. We, however, freed from the worry of searching for Gems, thanked God and gave four

hundred pounds for the lot though they were worth much more.

We applied to the perfection of so sacred an ornament not only these but also a great and expensive supply of other gems and large pearls. We remember, if memory serves, to have put in about eighty marks of refined gold. And barely within two years were we able to have completed, through several goldsmiths from Lorraine—at times five, at other times seven—the pedestal adorned with the Four Evangelists; and the pillar upon which the sacred image stands, enameled with exquisite workmanship, and [on it] the history of the Saviour, with the testimonies of the allegories from the Old Testament indicated, and the capital above looking up, with its images, to the Death of the Lord. Hastening to honor and extol even more highly the embellishment of so important and sacred a liturgical object, the mercy of our Saviour brought to us our Lord Pope Eugenius for the celebration of holy Easter (as is the custom of Roman Pontiffs, when sojourning in Gaul, in honor of the sacred apostolate of the blessed Denis, which we have also experienced with his predecessors, Calixtus and Innocent); and he solemnly consecrated the aforesaid crucifix on that day. Under the title of "The True Cross of the Lord Surpassing All and Every Pearl" he assigned to it a portion from his chapel; and publicly, in the presence of all, he anathematized, by the sword of the blessed Peter and by the sword of the Holy Ghost whosoever would steal anything therefrom and whosoever would raise his hand against it in reckless temerity; and we ordered this ban to be inscribed at the foot of the cross.

XXXIII. We hastened to adorn the Main Altar of the blessed Denis where there was only one beautiful and precious frontal panel from Charles the Bald,[2] the third Emperor; for at this [altar] we had been offered to the monastic life. We had it all encased, putting up golden panels on either side and adding a fourth, even more precious one; so that the whole altar would appear golden all the way round.

[2] The altar frontal given by Charles the Bald is lost but known to us through a Flemish picture of the fifteenth century. See Panofsky, *op. cit.*, p. 179 and fig. 9.

On either side, we installed there the two candlesticks of King Louis, son of Philip, of twenty marks of gold, lest they might be stolen on some occasion; we added hyacinths, emeralds, and sundry precious gems; and we gave orders carefully to look out for others to be added further. The verses on these [panels] are these.

On the right side:

"Abbot Suger has set up these altar panels
In addition to that which King Charles has given before.
Make worthy the unworthy through thy indulgence, O Virgin Mary.
May the fountain of mercy cleanse the sins both of the King and the Abbot."

On the left side:

"If any impious person should despoil this excellent altar
May he perish, deservedly damned, associated with Judas."

But the rear panel, of marvelous workmanship and lavish sumptuousness (for the barbarian artists were even more lavish than ours), we ennobled with chased relief work equally admirable for its form as for its material, so that certain people might be able to say: *The workmanship surpassed the material.* Much of what had been acquired and more of such ornaments of the church as we were afraid of losing—for instance a golden chalice the foot of which had come off, and several other things—we ordered to be fastened there. And because the diversity of the materials [such as] gold, gems and pearls is not easily understood by the mute perception of sight without a description, we have seen to it that this work, which is intelligible only to the literate, which shines with the radiance of delightful allegories, be set down in writing. Also we have affixed verses expounding the matter so that the [allegories] might be more clearly understood:

"Crying out with a loud voice, the mob acclaims Christ: 'Osanna.'
The true Victim offered at the Lord's Supper has carried all men.

He Who saves all men on the Cross hastens to carry the
cross.

The promise which Abraham obtains for his seed is sealed
by the flesh of Christ.

Melchizedek offers a libation because Abraham triumphs
over the enemy.

They who seek Christ with the Cross bear the cluster of
grapes upon a staff."

Often we contemplate, out of sheer affection for the
church our mother, these different ornaments both new and
old; and when we behold how that wonderful cross of St.
Eloy—together with the smaller ones—and that incompara-
ble ornament commonly called "the Crest" are placed upon
the golden altar, then I say, sighing deeply in my heart:
*Every precious stone was thy covering, the sardius, the
topaz, and the jasper, the chrysolite, and the onyx, and the
beryl, the sapphire, and the carbuncle, and the emerald.*
To those who know the properties of precious stones it be-
comes evident, to their utter astonishment, that none is ab-
sent from the number of these (with the only exception of
the carbuncle), but that they abound most copiously. Thus,
when—out of my delight in the beauty of the house of God
—the loveliness of the many-colored gems has called me
away from external cares, and worthy meditation has in-
duced me to reflect, transferring that which is material
to that which is immaterial, on the diversity of the sacred
virtues: then it seems to me that I see myself dwelling, as
it were, in some strange region of the universe which
neither exists entirely in the slime of the earth nor entirely
in the purity of Heaven; and that, by the grace of God, I
can be transported from this inferior to that higher world
in an anagogical manner. I used to converse with travelers
from Jerusalem and, to my great delight, to learn from those
to whom the treasures of Constantinople and the orna-
ments of Hagia Sophia had been accessible, whether the
things here could claim some value in comparison with
those there. When they acknowledged that these here were
the more important ones, it occurred to us that those mar-
vels of which we had heard before might have been put

away, as a matter of precaution, for fear of the Franks; lest through the rash rapacity of a stupid few the partisans of the Greeks and Latins, called upon the scene, might suddenly be moved to sedition and warlike hostilities; for wariness is preeminently characteristic of the Greeks. Thus it could happen that the treasures which are visible here, deposited in safety, amount to more than those which had been visible there, left [on view] under conditions unsafe on account of disorders. From very many truthful men, even from Bishop Hugues of Laon, we had heard wonderful and almost incredible reports about the superiority of Hagia Sophia's and other churches' ornaments for the celebration of Mass. If this is so—or rather because we believe it to be so, by their testimony—then such inestimable and incomparable treasures ought to be exposed to the judgment of the many. *Let every man abound in his own sense.* To me, I confess, one thing has always seemed preeminently fitting: that every costlier or costliest thing should serve, first and foremost, for the administration of the Holy Eucharist: *If* golden pouring vessels, golden vials, golden little mortars used to serve, by the word of God or the command of the Prophet, to collect the *blood of goats or calves or the red heifer: how much more* must golden vessels, precious stones, and whatever is most valued among all created things, be laid out, with continual reverence and full devotion, for the reception of the *blood of Christ!* Surely neither we nor our possessions suffice for this service. If, by a new creation, our substance were re-formed from that of the holy Cherubim and Seraphim, it would still offer an insufficient and unworthy service for so great and so ineffable a victim; and yet we have so great a propitiation for our sins. The detractors also object that a saintly mind, a pure heart, a faithful intention ought to suffice for this sacred function; and we, too, explicitly and especially affirm that it is these that principally matter. [But] we profess that we must do homage also through the outward ornaments of sacred vessels, and to nothing in the world in an equal degree as to the service of the Holy Sacrifice, with all inner purity and with all outward splendor. For it behooves us most becomingly to serve Our Saviour in all things in a universal way—

Him Who has not refused to provide for us in all things in a universal way and without any exception; Who has fused our nature with His into one admirable individuality; Who, *setting us on His right hand,* has promised us in truth *to possess His Kingdom;* our Lord Who *liveth and reigneth for ever and ever.*

XXXIV. We also changed to its present form, sympathizing with their discomfort, the choir of the brethren, which had been detrimental to health for a long time on account of the coldness of the marble and the copper and had caused great hardship to those who constantly attended service in church; and because of the increase in our community (with the help of God), we endeavored to enlarge it.

We also caused the ancient pulpit, which—admirable for the most delicate and nowadays irreplaceable sculpture of its ivory tablets—surpassed human evaluation also by the depiction of antique subjects, to be repaired after we had reassembled those tablets which were moldering all too long in, and even under, the repository of the money chests; on the right side we restored to their places the animals of copper lest so much and admirable material perish, and had [the whole] set up so that the reading of Holy Gospels might be performed in a more elevated place. In the beginning of our abbacy we had already put out of the way a certain obstruction which cut as a dark wall through the central nave of the church, lest the beauty of the church's magnitude be obscured by such barriers.

Further, we saw to it, both on account of its so exalted function and of the value of the work itself, that the famous throne of the glorious King Dagobert, worn with age and dilapidated, was restored. On it, as ancient tradition relates, the kings of the Franks, after having taken the reigns of government, used to sit in order to receive, for the first time, the homage of their nobles.

Also we had regilded the Eagle in the middle of the choir which had become rubbed bare through the frequent touch of admirers.

Moreover, we caused to be painted, by the exquisite hands of many masters from different regions, a splendid

variety of new windows, both below and above; from that
first one which begins [the series] with the *Tree of Jesse*
in the chevet of the church to that which is installed above
the principal door in the church's entrance. One of these,
urging us onward from the material to the immaterial, rep-
resents the Apostle Paul turning a mill, and the Prophets
carrying sacks to the mill. The verses of this subject are
these:

"By working the mill, thou, Paul, takest the flour out of the
 bran.
Thou makest known the inmost meaning of the Law of
 Moses.
From so many grains is made the true bread without bran,
Our and the angels' perpetual food."

Also in the same window, where the veil is taken off the
face of Moses:

"What Moses veils the doctrines of Christ unveils.
They who bare Moses despoil the Law."

In the same window, above the Ark of the Covenant:

"On the Ark of the Covenant is established the altar with
 the Cross of Christ;
Here life wishes to die under a greater covenant."

Also in the same [window], where the Lion and Lamb
unseal the Book:

"He Who is the great God, the Lion and the Lamb, unseals
 the Book.
The Lamb or Lion becomes the flesh joined to God."

In another window, where the daughter of Pharaoh finds
Moses in the ark:

"Moses in the ark is that Man-Child Whom the maiden
Royal, the Church, fosters with pious mind."

In the same window, where the Lord appeared to Moses
in the burning bush:

"Just as this bush is seen to burn yet is not burned,

So he who is full of this fire Divine burns with it yet is not
 burned."

Also in the same [window], where Pharaoh is submerged
in the sea with his horsemen:

"What Baptism does to the good, that does to the soldiery
 of Pharaoh
A like form but an unlike cause."

Also in the same [window], where Moses raises the
brazen serpent:

"Just as the brazen serpent slays all serpents,
So Christ, raised on the Cross, slays His enemies."

In the same window, where Moses receives the Law on
the mount:

"After the Law has been given to Moses the grace of Christ
 invigorates it.
Grace *giveth life, the letter killeth.*"

Now, because [these windows] are very valuable on ac-
count of their wonderful execution and the profuse expendi-
ture of painted glass and sapphire glass, we appointed an
official master craftsman for their protection and repair, and
also a goldsmith skilled in gold and silver ornament, who
would receive their allowances and what was adjudged to
them in addition, viz., coins from the altar and flour from
the common storehouse of the brethren, and who would
never neglect their duty to look after these [works of art].

XXXIV A. . . . We also offered to the blessed Denis,
together with some flowers from the crown of the Empress,
another most precious vessel of prase, carved into the form
of a boat, which King Louis, son of Philip, had left in pawn
for nearly ten years; we had purchased it with the King's
permission for sixty marks of silver when it had been offered
to us for inspection. It is an established fact that this vessel,
admirable for the quality of the precious stone as well
as for the latter's unimpaired quantity, is adorned with
"verroterie cloisonnée" work by St. Eloy which is held to
be most precious in the judgment of all goldsmiths.

Still another vase, looking like a pint bottle of beryl or

crystal, which the Queen of Aquitaine had presented to our
Lord King Louis as a newly wed bride on their first voyage,
and the King to us as a tribute of his great love, we offered
most affectionately to the Divine Table for libation. We
have recorded the sequence of these gifts on the vase itself,
after it had been adorned with gems and gold, in some lit-
tle verses:

"As a bride, Eleanor gave this vase to King Louis,
Mitadolus to her grandfather, the King to me, and Suger
 to the Saints."

We also procured for the services at the aforesaid altar
a precious chalice out of one solid sardonyx,[3] which [word]
derives from "sardius" and "onyx"; in which one [stone]
the sard's red hue, by varying its property, so strongly con-
trasts with the blackness of the onyx that one property
seems to be bent on trespassing upon the other.

Further we added another vase shaped like a ewer, very
similar to the former in material but not in form, whose lit-
tle verses are these:

"Since we must offer libations to God with gems and gold,
I, Suger, offer this vase to the Lord."

We also gladly added to the other vessels for the same
office an excellent gallon vase, which Count Thibaut of Blois
had conveyed to us in the same case in which the King of
Sicily had sent it to him.

Also we deposited in the same place the little crystal vases
which we had assigned to the daily service in our [private]
chapel.

And further we adapted for the service of the altar, with
the aid of gold and silver material, a porphyry vase, made
admirable by the hand of the sculptor and polisher, after
it had lain idly in a chest for many years, converting it
from a flagon into the shape of an eagle; and we had the
following verses inscribed on this vase:

[3] This chalice, long believed lost, was rediscovered in 1922,
acquired by Mr. Widener of Philadelphia and recently given to
the National Gallery of Art in Washington. See Panofsky, *op.
cit.*, p. 205 and fig. 24.

"This stone deserves to be enclosed in gems and gold.
It was marble, but in these [settings] it is more precious
 than marble."[4]

THE OTHER LITTLE BOOK ON THE CONSECRATION
OF THE CHURCH OF ST.-DENIS

II. When the glorious and famous King of the Franks,
Dagobert, notable for his royal magnanimity in the admin-
istration of his kingdom and yet no less devoted to the
Church of God, had fled to the village of Catulliacum in
order to evade the intolerable wrath of his father Clothaire,
and when he had learned that the venerable images of the
Holy Martyrs who rested there—appearing to him as very
beautiful men clad in snow-white garments—requested his
service and unhesitatingly promised him their aid with
words and deeds, he decreed with admirable affection that
a basilica of the Saints be built with regal magnificence.
When he had constructed this [basilica] with a marvelous
variety of marble columns he enriched it incalculably with
treasures of purest gold and silver and hung on its walls,
columns and arches tapestries woven of gold and richly
adorned with a variety of pearls, so that it might seem to
excel the ornaments of all other churches and, blooming
with incomparable luster and adorned with every terrestrial
beauty, might shine with inestimable splendor. Only one
thing was wanting in him: that he did not allow for the size
that was necessary. Not that anything was lacking in his
devotion or good will; but perhaps there existed thus far, at
that time of the Early Church, no [church] either greater
or [even] equal in size; or perhaps [he thought that] a
smallish one—reflecting the splendor of gleaming gold and
gems to the admiring eyes more keenly and delightfully be-
cause they were nearer—would glow with greater radiance
than if it were built larger.

Through a fortunate circumstance attending this singular
smallness—the number of the faithful growing and fre-
quently gathering to seek the intercession of the Saints—the
aforesaid basilica had come to suffer grave inconveniences.

[4] The "Aiguière de Suger" is in the Louvre, Paris.

Often on feast days, completely filled, it disgorged through all its doors the excess of the crowds as they moved in opposite directions, and the outward pressure of the foremost ones not only prevented those attempting to enter from entering but also expelled those who had already entered. At times you could see, a marvel to behold, that the crowded multitude offered so much resistance to those who strove to flock in to worship and kiss the holy relics, the Nail and Crown of the Lord, that no one among the countless thousands of people because of their very density could move a foot; that no one, because of their very congestion, could [do] anything but stand like a marble statue, stay benumbed or, as a last resort, scream. The distress of the women, however, was so great and so intolerable that [you could see] how they, squeezed in by the mass of strong men as in a winepress, exhibited bloodless faces as in imagined death; how they cried out horribly as though in labor; how several of them, miserably trodden underfoot [but then], lifted by the pious assistance of men above the heads of the crowd, marched forward as though clinging to a pavement; and how many others, gasping with their last breath, panted in the cloisters of the brethren to the despair of everyone. Moreover the brethren who were showing the tokens of the Passion of Our Lord to the visitors had to yield to their anger and rioting and many a time, having no place to turn, escaped with the relics through the windows. When I was instructed by the brethren as a schoolboy I used to hear of this; in my youth I deplored it from without; in my mature years I zealously strove to have it corrected. *But when it pleased Him who separated me from my mother's womb, and called me by His grace,* to place insignificant me, although my merits were against it, at the head of the so important administration of this sacred church; then, impelled to a correction of the aforesaid inconvenience only by the ineffable mercy of Almighty God and by the aid of the Holy Martyrs our Patron Saints, we resolved to hasten, with all our soul and all the affection of our mind, to the enlargement of the aforesaid place—we who would never have presumed to set our hand to it, nor even to think of it,

had not so great, so necessary, so useful and honorable an occasion demanded it.

Since in the front part, toward the north, at the main entrance with the main doors, the narrow hall was squeezed in on either side by twin towers neither high nor very sturdy but threatening ruin, we began, with the help of God, strenuously to work on this part, having laid very strong material foundations for a straight nave and twin towers, and most strong spiritual ones of which it is said: *For other foundation can no man lay than that is laid, which is Jesus Christ.* Leaning upon God's inestimable counsel and irrefragable aid, we proceeded with this so great and so sumptuous work to such an extent that, while at first, expending little, we lacked much, afterwards, accomplishing much, we lacked nothing at all and even confessed in our abundance: *Our sufficiency is of God.* Through a gift of God a new quarry, yielding very strong stone, was discovered such as in quality and quantity had never been found in these regions. There arrived a skillful crowd of masons, stonecutters, sculptors and other workmen, so that—thus and otherwise —Divinity relieved us of our fears and favored us with Its good will by comforting us and by providing us with unexpected [resources]. I used to compare the least to the greatest: Solomon's riches could not have sufficed for his Temple any more than did ours for this work had not the same Author of the same work abundantly supplied His attendants. The identity of the author and the work provides a sufficiency for the worker.

In carrying out such plans my first thought was for the concordance and harmony of the ancient and the new work. By reflection, by inquiry, and by investigation through different regions of remote districts, we endeavored to learn where we might obtain marble columns or columns the equivalent thereof. Since we found none, only one thing was left to us, distressed in mind and spirit: we might obtain them from Rome (for in Rome we had often seen wonderful ones in the Palace of Diocletian and other Baths) by safe ships through the Mediterranean, thence through the English Sea and the tortuous windings of the River Seine, at great expense to our friends and even under convoy of

our enemies, the near-by Saracens. For many years, for a long time, we were perplexed, thinking and making inquiries—when suddenly the generous munificence of the Almighty, condescending to our labors, revealed to the astonishment of all and through the merit of the Holy Martyrs, what one would never have thought or imagined: very fine and excellent [columns]. Therefore, the greater acts of grace, contrary to hope and human expectation, Divine mercy had deigned to bestow by [providing] a suitable place where it could not be more agreeable to us, the greater [acts of gratitude] we thought it worth our effort to offer in return for the remedy of so great an anguish. For near Pontoise, a town adjacent to the confines of our territory, there [was found] a wonderful quarry [which] from ancient times had offered a deep chasm (hollowed out, not by nature but by industry) to cutters of millstones for their livelihood. Having produced nothing remarkable thus far, it reserved, we thought, the beginning of so great a usefulness for so great and divine a building—as a first offering, as it were, to God and the Holy Martyrs. Whenever the columns were hauled from the bottom of the slope with knotted ropes, both our own people and the pious neighbors, nobles and common folk alike, would tie their arms, chests, and shoulders to the ropes and, acting as draft animals, drew the columns up; and on the declivity in the middle of the town the diverse craftsmen laid aside the tools of their trade and came out to meet them, offering their own strength against the difficulty of the road, doing homage as much as they could to God and the Holy Martyrs. There occurred a wonderful miracle worthy of telling which we, having heard it ourselves from those present, have decided to set down with pen and ink for the praise of the Almighty and His Saints.

III. On a certain day when, with a downpour of rain, a dark opacity had covered the turbid air, those accustomed to assist in the work while the carts were coming down to the quarry went off because of the violence of the rain. The ox-drivers complained and protested that they had nothing to do and that the laborers were standing around and losing time. Clamoring, they grew so insistent that some weak and

disabled persons together with a few boys—seventeen in number and, if I am not mistaken, with a priest present—hastened to the quarry, picked up one of the ropes, fastened it to a column and abandoned another shaft which was lying on the ground; for there was nobody who would undertake to haul this one. Thus, animated by pious zeal, the little group prayed: "O Saint Denis, if it pleaseth thee, help us by dealing for thyself with this abandoned shaft, for thou canst not blame us if we are unable to do it." Then, bearing on it heavily, they dragged out what a hundred and forty or at least one hundred men had been accustomed to haul from the bottom of the chasm with difficulty—not alone by themselves, for that would have been impossible, but through the will of God and the assistance of the Saints whom they invoked; and they conveyed this material for the church to the cart. Thus it was made known throughout the neighborhood that this work pleased Almighty God exceedingly, since for the praise and glory of His name He had chosen to give His help to those who performed it by this and similar signs.

As a second instance there is related another notable event worthy of remembrance, remarkable to tell and deserving to be set forth with authority. When the work had been finished in great part, when the stories of the old and the new building had been joined, and when we had laid aside the anxiety we had long felt because of those gaping cracks in the old walls, we undertook with new confidence to repair the damages in the great capitals and in the bases that supported the columns. But when we inquired both of our carpenters and those of Paris where we might find beams we were told, as was in their opinion true, that such could in no wise be found in these regions owing to the lack of woods; they would inevitably have to be brought hither from the district of Auxerre. All concurred with this view and we were much distressed by this because of the magnitude of the task and the long delay of the work; but on a certain night, when I had returned from celebrating Matins, I began to think in bed that I myself should go through all the forests of these parts, look around everywhere and alleviate those delays and troubles if [beams]

could be found here. Quickly disposing of other duties and hurrying up in the early morning, we hastened with our carpenters, and with the measurements of the beams, to the forest called Iveline. When we traversed our possession in the Valley of Chevreuse we summoned through our serv-ants the keepers of our own forests as well as men who knew about the other woods, and questioned them under oath whether we could find there, no matter with how much trouble, any timbers of that measure. At this they smiled, or rather would have laughed at us if they had dared; they wondered whether we were quite ignorant of the fact that nothing of the kind could be found in the entire region, especially since Milon, the Castellan of Chevreuse (our vassal, who holds of us one half of the forest in addition to another fief) had left nothing unimpaired or untouched that could be used for building palisades and bulwarks while he was long subjected to wars both by our Lord the King and Amaury de Montfort. We however—scorning whatever they might say—began, with the courage of our faith as it were, to search through the woods; and toward the first hour we found one timber adequate to the meas-ure. Why say more? By the ninth hour or sooner we had, through the thickets, the depths of the forests and the dense, thorny tangles, marked down twelve timbers (for so many were necessary) to the astonishment of all, especially those on the spot; and when they had been carried to the sacred basilica, we had them placed, with exultation, upon the ceiling of the new structure, to the praise and glory of our Lord Jesus, Who, protecting them from the hands of plunderers, had reserved them for Himself and the Holy Martyrs as He wished to do. Thus in this matter Divine generosity, which has chosen to temper and to grant all things *according to weight and measure,* manifested itself as neither excessive nor defective; for not one more [timber] than was needed could be found.

IV. Thus continually encouraged in so great enterprises by so great and manifest signs, we immediately hastened to the completion of the aforesaid building. Having delib-erated in what manner, by what persons, and how truly solemnly the church should be consecrated to Almighty

God, and having summoned the excellent man, Hugues, Archbishop of Rouen, and the other venerable Bishops, Eudes of Beauvais [and] Peter of Senlis, we chanted in celebration of this ceremony a polyphonic praise amidst a great throng of diverse ecclesiastical personages and an enormous one of clergy and laity. . . . Concerning the date of completion, however, this is the established truth as it can be read—oh may it not be obscured!—in the golden inscription above the gilded doors which we have caused to be made in honor of God and the Saints:

"The year was the One Thousand, One Hundred, and
 Fortieth
Year of the Word when [this structure] was consecrated."

After the consecration of the Chapel of St. Romanus and others which, with the help of the Highest Majesty, had been celebrated in the front part [of the church], our devotion—so much invigorated by its own success, and so long and intolerably distressed by that congestion around the Holy of Holies—directed our intentions toward another goal: free from the aforesaid work, and through postponing the completion of the towers in their upper portions, we would strive with all our might to devote labor and expense, as fittingly and nobly as it could reasonably be done, to the enlargement of the church our mother—as an act of gratitude because Divine condescension had reserved so great a work to so small a man who was the successor to the nobility of such great kings and abbots. We communicated this plan to our very devoted brethren, *whose hearts burned for Jesus while He talked with them by the way.* Deliberating under God's inspiration, we choose—in view of that blessing which, by the testimony of venerable writings, Divine action had bestowed upon the ancient consecration of the church by the extension of [Christ's] own hand—to respect the very stones, sacred as they are, as though they were relics; [and] to endeavor to ennoble the new addition, which was to be begun under the pressure of so great a need, with the beauty of length and width. Upon consideration, then, it was decided to remove that vault, unequal to the higher one, which, overhead, closed the apse containing the bodies

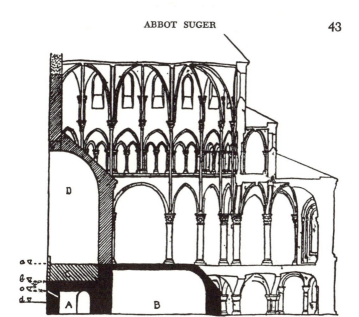

St.-Denis, Chevet. Comparative Longitudinal Section
(chiefly based on S. McK. Crosby, *The Abbey of St.-Denis,*
I, New Haven, 1942, Figs. 36, 68, 86, 87).

■ Carolingian Masonry Preserved by Suger.
▨ Carolingian Masonry Torn Down by Suger.
▧ Masonry Filled in by Suger.
☐ Suger's New Upper Choir (Tentative Approxima-
 tion).

A. Carolingian "Confessio" (Original Resting Place
 of the Patron Saints).
B. Carolingian Sunken Chapel (*crypta cui [volta
 altiori inæqualis] adhærebat*).
C. Masonry Filled in by Suger.
D. Carolingian Apse (*volta altiori inæqualis*), "re-
 moved" by Suger.

a. Floor Level of Suger's Upper Choir.
b. Floor Level of Carolingian Apse.
c. Floor Level of Present Nave.
d. Floor Level of Carolingian Nave.

of our Patron Saints, all the way down to the upper surface of the crypt to which it adhered;[5] so that this crypt might offer its top as a pavement to those approaching by either of the two stairs, and might present the chasses of the Saints, adorned with gold and precious gems, to the visitors' glances in a more elevated place. Moreover, it was cunningly provided that—through the upper columns and central arches which were to be placed upon the lower ones built in the crypt—the central nave of the old nave should be equalized, by means of geometrical and arithmetical instruments, with the central nave of the new addition; and, likewise, that the dimensions of the old side-aisles should be equalized with the dimensions of the new side-aisles, except for that elegant and praiseworthy addition, in [the form of] a circular string of chapels, by virtue of which the whole [church] would shine with the wonderful and uninterrupted light of most sacred windows, pervading the interior beauty.

V. For three years we pressed the completion of the work at great expense, with a numerous crowd of workmen, summer and winter lest God have just cause to complain of us: *Thine eyes did see my substance yet being unperfect;* we made good progress with His own cooperation and, in the likeness of the things Divine, there was established to *the joy of the whole earth mount Zion, on the sides of the north, the city of the Great King,* in the *midst* of which *God will not be moved,* but will not disdain, *moved* by the entreaties of the sinners, to be placated and propitiated by the sweet-smelling burnt offerings of the penitent. The *midst* of the edifice, however, was suddenly raised aloft by columns representing the number of the Twelve Apostles and, secondarily, by as many columns in the side-aisles signifying the number of the [minor] Prophets, according to the

[5] See illustration, p. 43, reproduced from Panofsky, *op. cit.,* p. 221; and *ibid.,* p. 220: "Freely paraphrased, the sentence means: 'It was decided to remove the apse (D) which formed the upper part of the sanctuary wherein were kept (A) the relics of our Patron Saints. This apse, lower than the present one, was removed all the way down to the top surface of the crypt (B) to which it was attached. . . .'"

Apostle who buildeth spiritually. *Now therefore ye are no more strangers and foreigners,* says he, *but fellow citizens with the saints and of the household of God; and are built upon the foundation of the apostles and prophets, Jesus Christ Himself being the chief cornerstone* which joins one wall to the other; *in Whom all the building*—whether spiritual or material—*groweth unto one holy temple in the Lord. In Whom we, too,* are taught *to be builded together for an habitation of God through the* Holy *Spirit* by ourselves in a spiritual way, the more loftily and fitly we strive to build in a material way.

Meanwhile—chiefly solicitous for the translation of our Patron Saints the most Holy Martyrs and also of the other saints who, scattered about the church, were worshiped in the different chapels—we felt devoutly moved to embellish their most sacred chasses, especially those of the Patrons; and selecting [a place] to which they might be transferred [so as to present themselves] to the visitors' glances in more glorious and conspicuous manner, we endeavored, with the help of God, to build [a tomb] very illustrious both by the exquisite industry of the goldsmiths' art and by a wealth of gold and precious stones. We made preparations to fortify them all round, outwardly noble for ornament by virtue of these and similar [precious materials], yet inwardly not ignoble for safety by virtue of a masonry of very strong stones; and on the exterior—lest the place be disfigured by the substance of unconcealed stones—to adorn it (yet not [so handsomely] as would be proper) with gilded panels of cast copper. For the generosity of so great Fathers, experienced by ourselves and all, demands that we, most miserable men who feel as well as need their tutelage, should deem it worth our effort to cover the most sacred ashes of those whose venerable spirits, radiant as the sun, attend upon Almighty God with the most precious material we possibly can: with refined gold and a profusion of hyacinths, emeralds and other precious stones. One thing, however, we did choose to have done resplendently: we would erect in front of the most honored bodies of the Saints what had never been there before—an altar for the sacrificial worship of God, where popes and persons of high rank

might worthily offer the propitiatory Hosts, acceptable to God, with the intercession of those who offered themselves to God as a fragrant burnt offering. While we, overcome by timidity, had planned to set up in front of this [altar] a panel golden but modest, the Holy Martyrs themselves handed to us such a wealth of gold and most precious gems —unexpected and hardly to be found among kings—as though they were telling us with their own lips: "Whether thou wantst it or not, we want it of the best"; so that we would neither have dared, nor have been able to, make it other than admirable and very precious in workmanship as well as material. For not only did the very pontiffs—who wear them especially on account of the dignity of their office—consent, if they were present, to assign their pontifical rings, set with a wonderful variety of precious stones, to this panel; they even, if they were absent in lands overseas, sent them of their own accord, incited by the love of the Holy Martyrs. Also the illustrious King himself, offering of his own accord emeralds, pellucid and distinguished by markings—Count Thibaut, hyacinths and rubies—peers and princes, precious pearls of diverse colors and properties: [all these] invited us to complete the work in glorious fashion. In addition, so many [gems and pearls] were brought to us for sale from nearly all the parts of the world (and, by the grace of God, we were also offered wherewith to buy them) that we should have been unable to let them go without great shame and offense to the Saints. Here and elsewhere we could find by experience: let there be a good work in the will—then, with the aid of God, will it be in perfection. Thus, should anyone presume to take away with rash temerity, or knowingly to diminish, this ornament presented by the devotion of such great men to such great Protectors: may he deserve the wrath of our Lord Denis and to be pierced by the sword of the Holy Ghost.

Nor do we think it proper to be silent in regard to the following fact: when the work on the new addition with its capitals and upper arches was being carried forward to the peak of its height, but the main arches—standing by themselves—were not yet held together, as it were, by the bulk of the vaults, there suddenly arose a terrible and almost un-

bearable storm with an obfuscation of clouds, an inunda-
tion of rain, and a most violent rush of wind. So mighty
did this [storm] become that it blew down, not only well-
built houses but even stone towers and wooden bulwarks.
At this time, on a certain day (the anniversary of the glori-
ous King Dagobert), when the venerable Bishop of Char-
tres, Geoffroy, was solemnly celebrating at the main altar a
conventual Mass for the former's soul, such a force of con-
trary gales hurled itself against the aforesaid arches, not
supported by any scaffolding nor resting on any props, that
they threatened baneful ruin at any moment, miserably
trembling and, as it were, swaying hither and thither. The
Bishop, alarmed by the strong vibration of these [arches]
and the roofing, frequently extended his blessing hand in
the direction of that part and urgently held out toward it,
while making the sign of the cross, the arm of the aged St.
Simeon; so that he escaped disaster, manifestly not through
his own strength of mind but by the grace of God and the
merit of the Saints. Thus [the tempest], while it brought
calamitous ruin in many places to buildings thought to be
firm, was unable to damage these isolated and newly made
arches, tottering in mid-air, because it was repulsed by the
power of God.

There followed another memorable event which hap-
pened, not by accident (as is believed of such matters by
those agreeing with that doctrine according to which

Chance wanders aimlessly,
Brings and brings back events; and Accident
rules all that is mortal),

but by Divine Generosity Which abundantly provides for
those who place their hope in It in all things great and small,
and administers what It knows to be beneficial. On a cer-
tain day we conferred with our friends, servants and stew-
ards about the provisions for the court [to be held on the
occasion] of the imminent consecration, because we antici-
pated it would be very great; and, considering the difficulty
of the times (for in June almost all victuals were scarce),
we had fairly well provided for all other things. Only one
thing worried us grievously: because of a plague among the

sheep born in that year we would have to search for mutton in the district of Orléans and toward Burgundy. I had reluctantly ordered to give 1,000 shillings, or whatever was necessary, to those who would go there for this purpose, lest they should take too long in returning inasmuch as they had started so late. But on the following morning, when I, according to custom, hurried from our little chamber to the celebration of Holy Mass, a Premonstratensian monk suddenly drew me back to my room in spite of my protests. When I—a little irritated because he detained me from so great a task—had answered him without too much civility, he said: "We have heard, Lord Father, that you need mutton for the impending celebration of your consecration; therefore, sent by our brethren, I bring to your Paternal Grace a very great flock of rams so that you may keep what you like and send us back what you do not like." When we heard this we requested him to wait for us until after Mass, and after Mass we informed our brethren in his presence of what he had offered to us. They ascribed this to Divine Generosity because I had unexpectedly furnished, through the pious brethren's bringing it hither, the only thing which we were lacking and should have found tiresome to search for.

VI. Now the laborious consummation of the work and our suspended devotion, which had been panting for this a long time, demanded the consecration of the new church. And since we fervently wished this consecration as well as the translation cf our Patron Saints to be a most solemn event—as an act of gratitude, as it were, and as a most welcome fruit of our labors—we fixed, upon deliberation and with the gracious consent of his Royal Majesty Louis the Most Serene King of the Franks (for he ardently wished to see the Holy Martyrs, his protectors), the date of the ceremony for the second Sunday in June, that is, the third day before the Ides, the day of the Apostle Barnabas. . . .

LETTERS ON HOW CHARTRES WAS BUILT

[In 1145, Haimon, abbot of Saint-Pierre-sur-Dives in Normandy, wrote to the monks of Tutbury Abbey in England, describing the miracle of the building of churches throughout France. He told of people banded together in honor of the Virgin, and with prayers and sweat bringing together the materials for the fabric of a great church. This practice began, he said, at Chartres, and afterwards gained momentum throughout Normandy.

A second letter, from Archbishop Hugh of Rouen to Bishop Thierry of Amiens, describes in particular the zealous labors of the people of Chartres.

These letters, it must be remembered, were written by ecclesiastics having the state of men's souls uppermost in their minds, and while the great popular support to church building of which they speak reveals the spiritual color of the times, we must not forget that architects and masons, glaziers and carvers, among them some of the greatest the world has known, directed these vast works.]

ABBOT HAIMON TO HIS BROTHERS
AT TUTBURY[1]

Brother Haimon of the Company of Saint-Pierre-sur-Dives, humble servant of servants of the Blessed Mother of God, to his most dear brothers and fellow servants of Tutbury. . . . Who has ever seen!—Who has ever heard tell, in times past, that powerful princes of the world, that men brought up in honor and in wealth, that nobles, men and women, have bent their proud and haughty necks to the harness of carts, and that, like beasts of burden, they have dragged to the abode of Christ these waggons, loaded with

[1] The letters are translated in large part by Henry Adams, *Mont Saint-Michel and Chartres*, Boston, 1904 (fifteenth impression, 1925), and the remainder, from the Latin given by V. Mortet, *Recueil de textes relatifs à l'histoire de l'architecture*, Paris, 1911, ii, pp. 64 ff., was translated by Charles P. Parkhurst, Jr.

wines, grains, oil, stone, wood, and all that is necessary for the wants of life, or for the construction of the church? But while they draw these burdens, there is one thing admirable to observe; it is that often when a thousand persons and more are attached to the chariots—so great is the difficulty —yet they march in such silence that not a murmur is heard, and truly if one did not see the thing with one's eyes, one might believe that among such a multitude there was hardly a person present. When they halt on the road, nothing is heard but the confession of sins, and pure and suppliant prayer to God to obtain pardon. At the voice of the priests who exhort their hearts to peace, they forget all hatred, discord is thrown far aside, debts are remitted, the unity of hearts is established.

But if any one is so far advanced in evil as to be unwilling to pardon an offender, or if he rejects the counsel of the priest who has piously advised him, his offering is instantly thrown from the waggon as impure, and he himself ignominiously and shamefully excluded from the society of the holy. There one sees the priests who preside over each chariot exhort every one to penitence, to confession of faults, to the resolution of better life! There one sees old people, young people, little children, calling on the Lord with a suppliant voice, and uttering to Him, from the depth of the heart, sobs and sighs with words of glory and praise! After the people, warned by the sound of trumpets and the sight of banners, have resumed their road, the march is made with such ease that no obstacle can retard it. . . . When they have reached the church they arrange the waggons about it like a spiritual camp, and during the whole night they celebrate the watch by hymns and canticles. On each waggon they light tapers and lamps; they place there the infirm and sick, and bring them the precious relics of the Saints for their relief. Afterwards the priests and clerics close the ceremony by processions which the people follow with devout heart, imploring the clemency of the Lord and of his Blessed Mother for the recovery of the sick. . . .

ARCHBISHOP HUGO OF ROUEN TO BISHOP
THIERRY OF AMIENS

Hugo, priest of Rouen, to the Reverend Father Thierry, Bishop of Amiens, may he prosper always in Christ. Great is the work of the Lord, excellent in all of His will. The inhabitants of Chartres have combined to aid in the construction of their church by transporting the material; our Lord has rewarded their humble zeal by miracles which have roused the Normans to imitate the piety of their neighbors. People of our land, therefore, having received blessing from us, set out continuously for that place and fulfill their vows. Since then, the faithful of our diocese and of other neighboring regions have formed associations for the same object; they admit no one into their company unless he has been to confession, has renounced enmities and revenges, and has reconciled himself with his enemies. That done, they elect a chief, under whose direction they conduct their waggons in silence and with humility, and present their oblations not without discipline and tears. These three things which we set forth, confession with penitence, concord in place of all malevolence, and humility with obedience—we require from those who are about to come to us; if they defer to these three, we receive them piously, absolve and bless them. While thus instructed they travel on their way, and whenever they bring their sick with them great miracles are very frequently wrought in our church, and they lead away as well those who came with them as invalids. And we allow our own people to go outside our regions, but we prohibit them from entering among the excommunicated or the interdicted. Given in this year of the Incarnate Word, 1145. Farewell.

GERVASE OF CANTERBURY

[Gervase of Canterbury (1141–1210) lived all of his adult life in the convent of Christ Church, Canterbury,

which he entered as a monk in 1163. He witnessed the dramatic conflict of Henry II and Archbishop Thomas à Becket, and played a minor role in the continual struggle of his monastery with the Archbishop. These events, as well as the description of the burning of the cathedral in 1174 and its rebuilding, he set down in his *Chronica,* a record of the Archbishopric from 1100 to 1199.

In 1193 he was made Sacristan of the monastery. No other details of the life of this monk are known.]

HISTORY OF THE BURNING AND REPAIR OF THE CHURCH OF CANTERBURY[1]

1. *The Conflagration.* In the year of grace one thousand one hundred and seventy-four, by the just but occult judgment of God, the church of Christ at Canterbury was consumed by fire, in the forty-fourth year of its dedication [1130], that glorious choir, to wit, which had been so magnificently completed by the care and industry of Prior Conrad.

Now the manner of the burning and repair was as follows. In the aforesaid year, on the nones of September, at about the ninth hour [Sept. 5, 1174, between 3 and 4 p.m.] and during an extraordinarily violent south wind, a fire broke out before the gate of the church, and outside the walls of the monastery, by which three cottages were half destroyed. From thence, while the citizens were assembling and subduing the fire, cinders and sparks carried aloft by the high wind, were deposited upon the church, and being driven by the fury of the wind between the joints of the lead, remained there amongst the half rotten planks, and shortly glowing with increasing heat, set fire to the rotten rafters; from these the fire was communicated to the larger beams and their braces, no one yet perceiving or helping.

[1] The excerpts and footnotes are from R. Willis, *The Architectural History of Canterbury Cathedral,* London, 1845. The Latin text is given in *The Historical Works of Gervase of Canterbury,* edited by William Stubbs, London, 1879. (See our fig. 3.)

See also: S. A. Warren, *Canterbury Cathedral,* London, 1923.

For the well-painted ceiling below, and the sheet-lead covering above, concealed between them the fire that had arisen within.

Meantime the three cottages, whence the mischief had arisen, being destroyed, and the popular excitement having subsided, everybody went home again, while the neglected church was consuming with internal fire unknown to all. But beams and braces burning, the flames arose to the slopes of the roof; and the sheets of lead yielded to the increasing heat and began to melt. Thus the raging wind, finding a freer entrance, increased the fury of the fire; and the flames beginning to shew themselves, a cry arose in the churchyard; "See! see! the church is on fire."

The people and the monks assemble in haste, they draw water, they brandish their hatchets, they run up the stairs, full of eagerness to save the church already, alas! beyond their help. But when they reach the roof and perceive the black smoke and scorching flames that pervade it throughout, they abandon the attempt in despair, and thinking only of their own safety, make all haste to descend.

And now that the fire had loosened the beams from the pegs that bound them together, the half-burnt timbers fell into the choir below upon the seats of the monks; the seats, consisting of a great mass of woodwork, caught fire, and thus the mischief grew worse and worse. And it was marvellous, though sad, to behold how that glorious choir itself fed and assisted the fire that was destroying it. For the flames multiplied by this mass of timber, and extending upwards full fifteen cubits,[2] scorched and burnt the walls, and more especially injured the columns of the church.

And now the people ran to the ornaments of the church, and began to tear down the pallia and curtains, some that they might save, but some to steal them. The reliquary chests were thrown down from the high beam and thus broken, and their contents scattered; but the monks collected them and carefully preserved them from the fire. Some there were who, inflamed with a wicked and diabolical cupidity, feared not to appropriate to themselves the things of the church, which they had saved from the fire.

[2] Ca. 25 ft.

In this manner the house of God, hitherto delightful as a paradise of pleasures, was now made a despicable heap of ashes, reduced to a dreary wilderness, and laid open to all the injuries of weather.

The people were astonished that the Almighty should suffer such things, and maddened with excess of grief and perplexity, they tore their hair and beat the walls and pavement of the church with their heads and hands, blaspheming the Lord and His saints, the patrons of the church; and many, both of laity and monks, would rather have laid down their lives than that the church should have so miserably perished.

For not only was the choir consumed in the fire, but also the infirmary, with the chapel of St. Mary, and several other offices in the court; moreover many ornaments and goods of the church were reduced to ashes.

2. *The Operations of the First Year.* Bethink thee now what mighty grief oppressed the hearts of the sons of the Church under this great tribulation; I verily believe the afflictions of Canterbury were no less than those of Jerusalem of old, and their wailings were as the lamentations of Jeremiah; neither can mind conceive, or words express, or writing teach, their grief and anguish. Truly that they might alleviate their miseries with a little consolation, they put together as well as they could, an altar and station in the nave of the church, where they might wail and howl, rather than sing, the diurnal and nocturnal services. Meanwhile the patron saints of the church, St. Dunstan and St. Elfege, had their resting-place in that wilderness. Lest, therefore, they should suffer even the slightest injury from the rains and storms, the monks, weeping and lamenting with incredible grief and anguish, opened the tombs of the saints and extricated them in their coffins from the choir, but with the greatest difficulty and labour, as if the saints themselves resisted the change.

They disposed them as decently as they could at the altar of the Holy Cross in the nave. Thus, like as the children of Israel were ejected from the land of promise, yea, even from a paradise of delight, that it might be like people, like priest, and that the stones of the sanctuary might be poured out

at the corners of the streets; so the brethren remained in grief and sorrow for five years in the nave of the church, separated from the people only by a low wall.

Meantime the brotherhood sought counsel as to how and in what manner the burnt church might be repaired, but without success; for the columns of the church, commonly termed the *pillars*, were exceedingly weakened by the heat of the fire, and were scaling in pieces and hardly able to stand, so that they frightened even the wisest out of their wits.

French and English artificers were therefore summoned, but even these differed in opinion. On the one hand, some undertook to repair the aforesaid columns without mischief to the walls above. On the other hand, there were some who asserted that the whole church must be pulled down if the monks wished to exist in safety. This opinion, true as it was, excruciated the monks with grief, and no wonder, for how could they hope that so great a work should be completed in their days by any human ingenuity.

However, amongst the other workmen there had come a certain William of Sens,[3] a man active and ready, and as a workman most skillful both in wood and stone. Him, therefore, they retained, on account of his lively genius and good reputation, and dismissed the others. And to him, and to the providence of God was the execution of the work committed.

And he, residing many days with the monks and carefully surveying the burnt walls in their upper and lower parts, within and without, did yet for some time conceal what he found necessary to be done, lest the truth should kill them in their present state of pusillanimity.

But he went on preparing all things that were needful for the work, either of himself or by the agency of others. And when he found that the monks began to be somewhat comforted, he ventured to confess that the pillars rent with the fire and all that they supported must be destroyed if

[3] Sens is a considerable town of France, eighty-four miles southeast of Paris, in the ancient province of Champagne. The nave of its cathedral, which was completed about 1168, has several peculiarities in common with the work of Canterbury.

the monks wished to have a safe and excellent building. At
length they agreed, being convinced by reason and wishing
to have the work as good as he promised, and above all
things to live in security; thus they consented patiently, if
not willingly, to the destruction of the choir.

And now he addressed himself to the procuring of stone
from beyond the sea. He constructed ingenious machines
for loading and unloading ships, and for drawing cement
and stone. He delivered molds for shaping the stones to the
sculptors who were assembled, and diligently prepared
other things of the same kind. The choir thus condemned
to destruction was pulled down, and nothing else was done
in this year.

As the new work is of a different fashion from the old, it
may be well to describe the old work first and then the new.
Edmer, the venerable singer, in his Opuscula, describes the
ancient church built in the Roman manner, which Arch-
bishop Lanfranc, when he came to the See, utterly de-
stroyed, finding it in ashes. For Christ Church is recorded
to have suffered thrice from fire; first, when the blessed
martyr Elfege was captured by the Danes and received the
crown of martyrdom; secondly, when Lanfranc, abbot of
Caen, took the rule of the church of Canterbury; thirdly,
in the days of Archbishop Richard and Prior Odo. Of this
last conflagration, unhappily, we have not read, but have
seen it with our own eyes.[4] . . . Leaving out, therefore, all
that is not absolutely necessary, let us boldly prepare for
the destruction of this old work and the marvellous build-
ing of the new, and let us see what our master William has
been doing in the meanwhile.

5. *Operations of the First Five Years.* The master began,
as I stated long ago, to prepare all things necessary for the
new work, and to destroy the old. In this way the first year
was taken up. In the following year, that is after the feast
of St. Bertin (Sept. 5, 1175) before the winter, he erected

[4] Here Gervase inserts the description by Edmer of the old
church, which may be found in translation in Willis, *op. cit.*, pp.
9–16 (chap. 1, art. 15). Gervase's description of the Church of
Lanfranc and the Choir of Conrad (chaps. 3 and 4 respectively),
translated in *ibid.*, pp. 37 ff., have also been omitted here.

four pillars, that is, two on each side, and after the winter (1176) two more were placed, so that on each side were three in order, upon which and upon the exterior wall of the aisles he framed seemly arches and a vault, that is three *claves*[5] on each side. I put clavis for the whole *ciborium* because the clavis placed in the middle locks up and binds together the parts that converge to it from every side. With these works the second year was occupied.

In the third year (1176/7) he placed two pillars on each side, the two extreme ones of which he decorated with marble columns placed around them, and because at that place the choir and crosses were to meet, he constituted these principal pillars. To which, having added the keystones and the vault, he intermingled the lower triforium[6] from the great tower to the aforesaid pillars, that is, as far as the cross, with many marble columns. Over which he adjusted another triforium of the other materials, and also the upper windows. And in the next place, three *claves* of the great vault, from the tower, namely, as far as the crosses. All which things appeared to us and to all who saw them, incomparable and most worthy of praise. And at so glorious a beginning we rejoiced and conceived good hopes to the end, and provided for the acceleration of the work with diligence and spirit. Thus was the third year occupied and the beginning of the fourth.

In the summer (1178), commencing from the cross, he erected ten pillars, that is, on each side five. Of which the first two were ornamented with marble columns to correspond with the other two principal ones. Upon these ten he placed the arches and vaults. And having, in the next place, completed on both sides the triforia and upper windows, he was, at the beginning of the fifth year, in the act of pre-

[5] Each compartment of a vault was frequently termed in later times a "severy." G. uses "ciborium" in this sense and not in the usual meaning of the canopy of the high alter. *Clavis* and *Key* are in medieval architecture the bosses of a ribbed vault. See R. Willis, *Architectural Nomenclature of the Middle Ages* (Cambridge Antiquary Society, No. ix), Cambridge, 1844.

[6] The triforium is the clerestory gallery.

paring with machines for the turning of the great vault, when suddenly the beams broke under his feet, and he fell to the ground, stones and timbers accompanying his fall, from the height of the capitals of the upper vault, that is to say, of fifty feet. Thus sorely bruised by the blows from the beams and stones, he was rendered helpless alike to himself and for the work, but no other than himself was in the least injured. Against the master only was this vengeance of God or spite of the devil directed.

The master, thus hurt, remained in his bed for some time under medical care in expectation of recovering, but was deceived in this hope, for his health amended not. Nevertheless, as the winter approached, and it was necessary to finish the upper vault, he gave the charge of the work to a certain ingenious and industrious monk, who was the overseer of the masons; an appointment whence much envy and malice arose, because it made this young man appear more skillful than richer and more powerful ones. But the master reclining in bed commanded all things that should be done in order. And thus was completed the ciborium between the four principal pillars. In the keystone of this ciborium the choir and crosses seem as it were to meet. Two ciboria[7] on each side were formed before the winter; when the heavy rains beginning stopped the work. In these operations the fourth year was occupied and the beginning of the fifth. But on the eighth day from the said fourth year, on the ides of September, there happened an eclipse of the sun at about the sixth hour, and before the master's accident.

And the master, perceiving that he derived no benefit from the physicians, gave up the work, and crossing the sea returned to his home in France. And another succeeded him in charge of the works; William by name, English by nation, small in body, but in workmanship of many kinds acute and honest. In the summer of the fifth year (1179) he finished the cross on each side, that is, the south and the north, and turned the ciborium which is above the great Altar, which the rains of the previous year had hindered, although all was prepared. Moreover he laid the foundation

[7] Namely, the vaults of the eastern transepts.

for the enlargement of the church at the eastern part, because a chapel of St. Thomas was to be built there.

For this was the place assigned to him; namely the chapel of the Holy Trinity, where he celebrated his first mass, where he was wont to prostrate himself with tears and prayers, under whose crypt for so many years he was buried, where God for his merits had performed so many miracles, where poor and rich, kings and princes, had worshipped him, and whence the sound of his praises had gone forth into all lands.

The master William began, on account of these foundations, to dig in the cemetery of the monks, from whence he was compelled to disturb the bones of many holy monks. These were carefully collected and deposited in a large trench, in that corner which is between the chapel and the south side of the infirmary house. Having, therefore, formed a most substantial foundation for the exterior wall with stone and cement, he erected the wall of the crypt as high as the bases of the windows.

Thus was the fifth year employed and the beginning of the sixth. . . .

7. *Remaining Operations of the Sixth Year.* Our craftsman had erected outside the choir four altars, where the bodies of the holy archbishops were deposited as they were of old. . . .

Moreover, in the same summer, that is of the sixth year (1180), the outer wall round the chapel of St. Thomas, begun before the winter, was elevated as far as the turning of the vault. But the master had begun a tower at the eastern part outside the circuit of the wall as it were, the lower vault of which was completed before the winter.

The chapel of the Holy Trinity above mentioned was then levelled to the ground; this had hitherto remained untouched out of reverence to St. Thomas, who was buried in the crypt. But the saints who reposed in the upper part of the chapel were translated elsewhere, and lest the memory of what was then done should be lost, I will record somewhat thereof. On the eighth idus of July the altar of the Holy Trinity was broken up, and from its materials the

altar of St. John the Apostle was made; I mention this lest the history of the holy stone should be lost. . . .

8. *Explanations.* It has been above stated, that after the fire nearly all the old portions of the choir were destroyed and changed into somewhat new and of a more noble fashion. The differences between the two works may now be enumerated. The pillars of the old and new work are alike in form and thickness but different in length. For the new pillars were elongated by almost twelve feet. In the old capitals the work was plain, in the new ones exquisite in sculpture. There the circuit of the choir had twenty-two pillars, here are twenty-eight. There the arches and everything else was plain, or sculptured with an axe and not with a chisel. But here almost throughout is appropriate sculpture. No marble columns were there, but here are innumerable ones. There, in the circuit around the choir, the vaults were plain, but here they are arch-ribbed and have keystones. There a wall set upon the pillars divided the crosses from the choir, but here the crosses are separated from the choir by no such partition, and converge together in one keystone, which is placed in the middle of the great vault which rests on the four principal pillars. There, there was a ceiling of wood decorated with excellent painting, but here is a vault beautifully constructed of stone and light tufa. There, was a single triforium, but here are two in the choir and a third in the aisle of the church. All which will be better understood from inspection than by any description.

This must be known, however, that the new work is higher than the old by so much as the upper windows of the body of the choir, as well as of its aisles, are raised above the marble tabling.

And as in future ages it may be doubtful why the breadth which was given to the choir next the tower should be so much contracted at the head of the church, it may not be useless to explain the causes thereof. One reason is, that the two towers of St. Anselm and of St. Andrew, placed in the circuit on each side of the old church, would not allow the breadth of the choir to proceed in the direct line. Another reason is, that it was agreed upon and necessary that the

chapel of St. Thomas should be erected at the head of the church, where the chapel of the Holy Trinity stood, and this was much narrower than the choir.

The master, therefore, not choosing to pull down the said towers, and being unable to move them entire, set out the breadth of the choir in a straight line, as far as the beginning of the towers (i . . . ix). Then, receding slightly on either side from the towers, and preserving as much as he could the breadth of the passage outside the choir on account of the processions which were there frequently passing, he gradually and obliquely drew in his work, so that from the opposite the altar (ix), it might begin to contract, and from thence, at the third pillar (xi), might be so narrowed as to coincide with the breadth of the chapel, which was named of the Holy Trinity. Beyond these, four pillars (xii, xiii) were set on the sides at the same distance as the last, but of a different form; and beyond these other four (xiv, xv) were arranged in a circle, and upon these the superposed work (of each side) was brought together and terminated. This is the arrangement of the pillars.

The outer wall, which extends from the aforesaid towers, first proceeds in a straight line, is then bent into a curve, and thus in the round tower the wall on each side comes together in one, and is there ended. All which may be more clearly and pleasantly seen by the eyes than taught in writing. But this much was said that the differences between the old and new work might be made manifest.

9. *Operations of the Seventh, Eighth, and Tenth Years.* Now let us carefully examine what were the works of our mason in this seventh year (1181) from the fire, which, in short, included the completion of the new and handsome crypt,[8] and above the crypt the exterior walls of the aisles up to their marble capitals. The windows, however, the master was neither willing nor able to turn, on account of the approaching rains. Neither did he erect the interior pillars. Thus was the seventh year finished, and the eighth begun.

[8] Namely, the crypt of St. Thomas' chapel, now called by its old name of Trinity chapel.

In this eighth year (1182) the master erected eight interior pillars (XII . . . XV) and turned the arches and the vault with the windows in the circuit. He also raised the tower up to the bases of the highest windows under the vault. In the ninth year (1183) no work was done for want of funds. In the tenth year (1184) the upper windows of the tower, together with the vault, were finished. Upon the pillars was placed a lower and an upper triforium, with windows and the great vault. Also was made the upper roof where the cross stands aloft, and the roof of the aisles as far as the laying of the lead. The tower was covered in and many other things done this year. In which year Baldwin, bishop of Worcester, was elected to the rule of the church of Canterbury on the eighteenth kalend of January, and was enthroned there on the feast of St. Dunstan next after. . . .

THE MARVELS OF ROME

[The Marvels of Rome, known as the *Miribilia*, served as the guide book for the more scholarly visitors to Rome and as a reference book for scholars who, like Petrarch, used it for descriptions of the Eternal City. Benedictus Canonicus, the probable author, wrote it shortly before the establishment of the Commune of Rome in 1143. By the end of that century it was among the books of the Roman Curia as a quasi-official document. It was revised and reorganized in the fourteenth and fifteenth centuries. It consists of three parts, a descriptive list of the principal objects, a collection of the legends associated with the monuments, and a tour of the ancient city beginning with the Vatican and ending in Trastevere. As the earliest attempt at scholarly topography, it is a reflection of the curiosity and interest in ancient architecture and art linked with the increasing political independence of Rome that emerged in the twelfth century.]

THE MARVELS OF ROME[1]

1. *Of the Foundations of the City of Rome.*[2] After the
sons of Noah built the Tower of Confusion, Noah with his
sons entered into a ship, as Hescodius writeth, and came
unto Italy. And not far from the place where now is Rome,
he founded a city of his own name;[3] wherein he brought
his travail and his life to an end. Then his son Janus, with
Janus his son, Japhet his grandson, and Camese a man of
the country, building a city, Janiculum, in the Palatine
mountain, succeeded to the kingdom; and when Camese
had gone the way of all flesh, the kingdom passed to Janus
alone. The same with the aforesaid Camese, did build him
a place in *Transtiberium,* that he called Janiculum, to wit,
in that place where the church of Saint John at Janiculum
now standeth. But he had the seat of his kingdom in the
palace that he had builded in the mountain Palatine;
wherein all the Emperors and Caesars of after times did
gloriously dwell. Moreover at that time Nembroth, which
is the same as Saturnus that was shamefully entreated of
his son Jupiter, came to the said realm of Janus, and up-
holden by his aid founded a city in the Capitol, which he
called Saturnia after his own name. And in those days king
Italus with the Syracusans, coming to Janus and Saturnus,
built a city by the river Albula, and called it after his name;
and the river of Albula they did name Tiber, after the like-
ness of the dyke of Syracuse that was so called. After this,
Hercules coming unto the realm of Janus with the Argives,

[1] The text and footnotes are from F. M. Nichols, *Mirabilia
Urbis Romae*, The Marvels of Rome, London, 1889; pp. 1–26,
35–78.

[2] This chapter, added to the *Mirabilia* in the thirteenth century,
shows the nascent archaeology of the period. [For other additions
and their dates, see Nichols, *op. cit.*]

[3] *Arca Noe,* Noah's Arch, was the popular name of a monument
adjoining the Forum of Nerva.

as Varro telleth, made a city called Valentia under the Capitol. And afterwards, Tibris, king of the Aborigines, coming with his nation, did build him a city by the Tiber, nigh whereunto he was slain by Italus in a fight that he had with him. At last Evander, king of Arcady, with his men made a city in the Palatine mountain. In like wise Coribas, coming with an host of Sicanians, built a city fast by, in the valley. And Glaucus also, younger son of the son of Jupiter, coming thither with his men, raised a city and built walls. After whom, Roma, Aeneas' daughter, coming with a multitude of Trojans, built a city in the palace of the town. Moreover Aventinus Silvius, king of the Albans, did rear him a palace and mausoleum in the mountain Aventius.

Now when the four hundred and thirty-third year was fulfilled after the destruction of the town of Troy, Romulus was born of the blood of Priam, king of the Trojans. And in the twenty-second year of his age, in the fifteenth day of the Calends of May, he encompassed all the said cities with a wall, and called the same Rome after his own name. And in her Etrurians, Sabines, Albans, Tusculans, Politanes, Telenes, Ficanians, Janiculans, Camerians, Capenates, Faliscans, Lucanians, Italians, and, as one may say, all the noble folk of the whole earth, with their wives and children, come together for to dwell.

2. *Of the Town Wall.* The wall of the city of Rome hath towers three hundred threescore and one, castles forty and nine, chief arches seven, battlements six thousand and nine hundred, gates twelve, posterns five; and in the compass thereof there are twenty and two miles,[4] without reckoning the *Transtiberium,* and the Leonine city, that is the same as Saint Peter's Porch.

3. *Of the Gates.* The gates[5] of the famous city be these. *Porta Capena,* that is called Saint Paul's Gate, by the Tem-

[4] The exaggeration of the circuit of wall, common to other mediaeval descriptions, is thought to have originated in a misapprehension of the measurements given in Pliny.

[5] The gates are named in the order of their position beginning with Porta di San Paolo.

ple of Remus;[6] *porta Appia* where is the church, that is named *Domine quo vadis,* that is to say, Lord whither goest thou, where are seen the footsteps of Jesus Christ; *porta Latina,* because there the Latins and Apulians were wont to go into the city; there is the vessel that was filled with boiling oil and in which the blessed John the Evangelist was set; *porta Metrovia; porta Asinaria,* that is called Lateran Gate; *porta Lavicana,* that is called the Greater; *porta Taurina,* that is called Saint Laurence's Gate, or the gate of Tivoli, and it is called *Taurina,* or the Bull Gate, because there be carved thereon two head of bulls, the one lean and the other fat; the lean head, that is without, signifieth them that come with slender substance into the city, the fat and full head within signifieth them that go forth rich; *porta Numentana* that leadth to the city of Nomentum; *porta Salaria,* that which hath two Ways, to wit, the old Salarian Way that leadth to the Milvian Bridge, and the new way that goeth forth to the Salarian Bridge; *porta Pinciana,* because king Pincius his palace is there; *porta Flaminia,* that is called Saint Valentine's; *porta Collina,* at the castle that is by Saint Peter's bridge, the which is called the emperor Hadrian's castle, who made Saint Peter's bridge.

Beyond Tiber be three gates: *porta Septimiana,* seven Naiads joined with Janus; *porta Aurelia* or *aurea,* that is to say, Golden, the which is now called Saint Pancras his gate; and *porta Portuensis.*

In Saint Peter's Porch be two gates, whereof the one is called the gate of the Castle of the holy Angel, and the other *porta Viridaria,*[7] that is to say, the gate of the Garden.

4. *Of Triumphal Arches.* Arches Triumphal be these that follow which were made for an Emperor returning from a triumph, and whereunder they were led with worship by the senator, and his victory was graven thereon for a remembrance to posterity; Alexander's Golden Arch at Saint Celsus, the arch of the emperors Theodosius and

[6] The pyramid of Cestius bore the name of Sepulchre (or Temple) of Remus.

[7] The *porta Viridaria* is now the porta Angelica.

Valentinian and Gratian at Saint Ursus; the triumphal arch of marble that the Senate decreed to be adorned with trophies in honour of Drusus, father of Claudius Caesar, on account of the Rhaetic and German wars by him nobly achieved; whereof the vestiges do barely appear without the Appian Gate at the temple of Mars; in the Circus the arch of Titus and Vespasian; the arch of Constantine by the Amphitheatre; at the New Saint Mary's, between the Greater Palace and the temple of Romulus, the arch of the Seven Lamps of Titus and Vespasian, where is Moses his candlestick having seven branches, with the Ark, at the foot of the Cartulary Tower; the arch of Julius Caesar[8] and the Senators between the *Aedes Concordiae* and the Fatal Temple, before Saint Martina, where be now the Breeches Towers;[9] nigh unto Saint Laurence *in Lucina,* the triumphal arch of Octavian; Antoninus his arch, nigh to his pillar, where is now the tower of the Tosetti. Then there is an arch at Saint Mark's, that is called Hand of Flesh, for at the time when in this city of Rome, Lucy, an holy matron, was tormented for the faith of Christ by the emperor Diocletian, he commanded that she should be laid down and be beaten to death; and behold, he that smote her was made of stone, but his hand remained flesh, unto the seventh day; wherefore the name of that place is called Hand of Flesh to this day. In the Capitol is the arch of Gold Bread; and in the Aventine the arch of Faustinus nigh to Santa Sabina.

There are moreover other arches, which are not triumphal but memorial arches, as is the arch of Piety before Round Saint Mary's. In this place upon a time when an emperor was ready in his chariot to go forth to war, a poor widow fell at his feet, weeping and crying: Oh my lord, before thou goest, let me have justice. And he promised her that on his return he would do her full right; but she said: Peradventure thou shalt die first. This considered, the emperor leapt from his chariot, and held his consistory on

[8] It was probably given this name instead of that of Severus due to a careless reading of the inscription IMP.CAES.

[9] It was crowned in the Middle Ages with two towers, hence this name.

the spot. And the woman said, I had one only son, and a young man hath slain him. Upon this saying the emperor gave sentence. The murderer, said he, shall die, he shall not live. Thy son then, she said, shall die, for it is he that playing with my son hath slain him. But when he was led to death, the woman sighed aloud, and said, Let the young man that is to die be given unto me in the stead of my son; so shall I be recompensed, else shall I never confess that I have had full right. This therefore was done, and the woman departed with rich gifts from the emperor.[10]

5. *Of the Hills.* Hills within the city be these: *Janiculus* that is commonly Janarian, where is the church of Saint Sabba; Aventine, that is also called Quirinal because the Quirites were there, where is the church of Saint Alexius; Caelian where is the church of Saint Stephen *in monte Caelio;* Capitol or Tarpeian Hill, where is the Senator's Palace; *Pallanteum* where is the Greater Palace; Exquiline that is called above the others, where is the basilica of Saint Mary the Greater; Viminal where is Saint Agatha's church, and where Virgil,[11] being taken by the Romans, escaped invisibly and went to Naples, whence it is said, *vado ad Napulim.*

6. *Of Thermae.* There be called *thermae* great palaces, having full great crypts under ground, wherein in the winter-time a fire was kindled throughout, and in the summer they were filled with fresh waters, so that the court dwelt in the upper chambers in much delight; as may be seen in the *thermae* of Diocletian, before Saint Susana. Now there are the Antonian *Thermae;* the Domitian *Thermae;* the Maximian; those of Licinius; the Diocletian; the Tiberian behind Saint Susana; the Novatian; those of Olympias at Saint Laurence *in panisperna;* those of

[10] The legend of the Justice of Trajan is as old as the eighth century. It is conjectured that the widow of the legend was in the original sculpture, a suppliant nation at the feet of an emperor. Dante found the same subject carved in Purgatory; *Purgatorio,* x. 73.

[11] Virgil had fame as a wizard in the Middle Ages.

Agrippa behind Round Saint Mary's; and the Alexandrine where is the hospital of the *Thermae*.

7. *Of Palaces.* Palaces[12] in the city be these: the Greater Palace of the Monarchy of the Earth, wherein is the capital seat of the whole world, and the Caesarean palace, in the Pallantean hill; the palace of Romulus nigh unto the hut of Faustulus; the palace of Severus by Saint Sixtus; the palace of Claudius between the Colosseum and Saint Peter *in vincula;* the palace of Constantine in the Lateran, where my lord Pope dwelleth: this Lateran palace was Nero's, and named from the side of the northern region wherein it standth, or from the frog which Nero secretly produced; in the which palace there is now a great church; the Susurrian palace where is now the church of Saint Cross; the Volusian palace; the palace of Romulus between New Saint Mary and Saint Cosmas, where are the two temples of Piety and Concord, and where Romulus set his golden image, saying, It shall not fall till that a virgin bear a child; and as soon as the Virgin bore a son, the image fell down; the palace of Trajan and Hadrian, where is the pillar twenty paces of height; Constantine's palace; Sallust his palace; Camillus his palace; Antonine's palace, where is his pillar twenty-seven paces high; Nero's palace where is Saint Peter's needle and wherein rest the bodies of the Apostles Peter and Paul, Simon and Jude; Julius Caesar's palace, where is the sepulchre of Julius Caesar; Chromatius his palace; Eusimianus his palace; the palace of Titus and Vespasian without Rome at the catacombs; Domitian's palace beyond Tiber at the Golden Morsel;[13] Octavian's palace at Saint Laurence *in Lucina.*

8. *Of Theatres.* The theatres[14] be these: the theatre of Titus and Vespasian at the catacombs; the theatre of Tar-

[12] This term is evidently applied, not only to the genuine palaces of popular and ecclesiastical tradition, but to other important ruins.

[13] Perhaps the same as Montorio, a name said to be derived from the yellow sand found there.

[14] The first six monuments appear to be; 1, circus of Maxentius, 2, circus Maximus, 3, theatre of Pompey, 4, theatre of Balbus,

quin and the Emperors at the Seven Floors; Pompey's theatre at Saint Laurence *in Damaso;* Antonius his theatre by Antoninus his bridge; Alexander's theatre nigh unto Round Saint Mary's; Nero's theatre nigh to Crescentius his castle; and the Flaminian theatre.

9. *Of Bridges.* Bridges[15] be these: the Milvian bridge; the Hadrian bridge; the Neronian bridge at Sassia;[16] the Antonine bridge *in arenula,* the Fabrician bridge, which is called the Jews' bridge, because the Jews dwell there; Gratian's bridge between the island and the *Transtiberium;* the Senators' bridge of Saint Mary; the marble bridge of Theodosius at Riparmea, and the Valentinian bridge.

10. *Of the Pillars of Antonine and of Trajan; and of the Images that were of old time in Rome.* The winding pillar of Antonine hath one hundred threescore and fifteen feet of height, steps in number two hundred and three, windows forty and five. The winding pillar of Trajan hath in height one hundred thirty and eight feet, steps in number one hundred fourscore and five, windows forty and five.

The colosean Amphitheatre hath one hundred and eight submissal feet of height.

In Rome were twenty and two great horses of gilded brass, horses of gold fourscore, horses of ivory fourscore and four, common jakes an hundred and fourscore and four, great sewers fifty, bulls, griffons, peacocks, and a multitude of other images, the costliness whereof seemed beyond measure, insomuch that men coming to the city had good cause to marvel at her beauty.

PART II: THE SECOND PART CONTAINETH DIVERS HISTORIES
TOUCHING CERTAIN FAMOUS PLACES AND IMAGES IN ROME

8. *Of the Foundation of the three great Churches of Rome by the Emperor Constantine, and of his Parting from*

5, stadium of Severus Alexander (Piazza Navona), 6, circus Hadrian.

[15] The bridges are arranged in order going down stream.

[16] The locality now called Borgo di San Spirito in Sassia was in the early Middle Ages known as the *Vicus Saxonum* or *Saxonia,* owing to the foundation there of a *schola saxonum* by Ini, King

Pope Silvester.[17] In the days of Pope Silvester, Constantine Augustus made the Lateran Basilica, the which he comely adorned. And he put there the Ark of the Covenant, that Titus had carried away from Jerusalem with many thousands of Jews; and the golden candlestick having seven lamps with vessels for oil. In the which ark be these things, to wit, the golden emerods, mice of gold,[18] the Tables of the Covenant, the rod of Aaron, manna, the barley loaves, the golden urn, the coat without seam, the reed and garment of Saint John Baptist, and the tongs that Saint John the Evangelist was shorn withal. Moreover he did put in the same basilica a civory[19] with pillars of porphyry. And he set there four pillars of gilded brass,[20] which the consuls of old had brought into the Capitol from the Mars' Field and set in the temple of Jupiter.

He made also, in the time of the said pope and after his prayer, a basilica for the Apostle Peter before Apollo's temple in the Vatican. Whereof the said emperor did himself first dig the foundation, and in reverence of the twelve Apostles did carry thereout twelve baskets full of earth. The said Apostle's body is thus bestowed. He made a chest closed on all sides with brass and copper, the which may not be moved, five feet of length at the head, five at the foot, on the right side five feet, and on the left side five feet, five feet above, and five feet below; and so he inclosed the body of the blessed Peter, and the altar above in the fashion of an arch he did adorn with bright gold. And he made a civory with pillars of porphyry and purest gold. And he set there before the altar twelve pillars of glass that he had brought out of Grecia, and which were of Apollo's temple at Troy. Moreover he did set above the blessed Apostle Peter's body a cross of pure gold, having an hundred and fifty

of the West Saxons, in 727, and of a hospital for pilgrims by Offa, King of Mercia, in 794. [See M. Paris, our text, p. 91.]

[17] This chapter is from a thirteenth century manuscript.

[18] I Samuel, VI, 4.

[19] Ciborium; a canopy of stone or marble over the altar.

[20] The bronze columns are believed to be those which now are at the altar of the Sacrament.

pounds of weight; whereupon was written: *Constantinus Augustus et Helena Augusta.*

He made also a basilica for the blessed Apostle Paul in the Ostian Way, and did bestow his body in brass and copper, in like fashion as the body of the blessed Peter.

The same emperor, after he was become a Christian, and had made these churches, did also give to the blessed Silvester a Phrygium,[21] and white horses, and all the *imperialia* that pertained to the dignity of the Roman Empire; and he went away to Byzantium; with whom the pope, decked in the same did go so far forth as the Roman Arch, where they embraced and kissed the one the other, and so departed.

PART III: THE THIRD PART CONTAINETH A PERAMBULATION
OF THE CITY

1. *Of the Vatican and the Needle.* Within the Palace of Nero[22] is the temple of Apollo, that is called Saint Parnel;[23] before which is the basilica that is called Vatican, adorned with marvellous mosaic and ceiled with gold and glass. It is therefore called Vatican because in that place the *Vates,* that is to say the priests, sang their offices before Apollo's temple, and therefore all that part of St. Peter's church is called Vatican. There is also another temple, that was Nero's Wardrobe, which is now called Saint Andrew;[24] nigh whereunto is the memorial of Caesar, that is the Needle, where his ashes nobly rest in his sarcophagus, to the intent that as in his lifetime the whole world lay subdued before him, even so in his death the same may lie beneath him for ever. The memorial[25] was adorned in the lower part with tables of gilded brass, and fairly limned with Latin letters; and above at the ball, where he rests,

[21] Frigium; what is now commonly called the Tiara.
[22] The remains of the circus of Caligula at the Vatican were called the palace of Nero; near this, according to ecclesiastical tradition, was the temple of Apollo.
[23] The church was a round building where is now the apse on the south side of St. Peter's.
[24] The church of St. Andrew became the Sacristy of St. Peter's.
[25] The obelisk was popularly called St. Peter's needle.

it is decked with gold and precious stones, and there it is written:

> Caesar who once wast great as is the world,
> Now in how small a cavern art thou closed.

And this memorial was consecrated after their fashion, as still appeareth, and may be read thereon. And below in Greek letters these verses be written:

> If one, tell how this stone was set on high;
> If many stones, show where their joints do lie.

2. *Of the Basin, and the Golden Pine-cone, in Saint Peter's Parvise.* In Saint Peter's Parvise[26] is a Basin, that was made by Pope Symmachus, and dight [decked] with pillars of porphyry, that are joined together by marble tables with griffons, and covered with a costly sky of brass, with flowers, and dolphins of brass gilt, pouring forth water. In the midst of the basin is a brazen Pine-cone,[27] the which, with a roof of gilded brass, was the covering over the statue of Cybele, mother of the gods, in the opening of the Pantheon. Into this Pine-cone water out of the Sabbatine Aqueduct was supplied under ground by a pipe of lead; the which being always full, gave water through holes in the nuts to all that wanted it; and by the pipe under ground some thereof flowed to the emperor's bath near the Needle.

3. *Of the Sepulchre of Romulus, and the Terebinth of Nero.* In the *Naumachia* is the sepulchre of Romulus, that is called Meta,[28] or the Goal; which aforetime was incased with marvellous stone, wherewith was made the pavement of the Parvise and the steps of St. Peter. It had about it an open court of twenty feet, paved with the stone that cometh from the Tibur, with its drain and border of flowers. About it was the Terebinth[29] of Nero, of no less

[26] Parvise, or Paradise, was the atrium in front of the basilica.
[27] The Pine-cone is now in the Giardino della Pigna at the Vatican. [See E. Quarton, our text, p. 299.]
[28] The Meta was destroyed by Pope Alexander VI.
[29] It was destroyed in the twelfth century.

height than the Castle of Hadrian, that is called the Angel's Castle,[30] incased with marvellous stone, from which the work of the steps and the Paradise was finished. This building was round like a castle, with two circles, whereof the lips were covered with tables of stone for dripping. Nigh thereunto was Saint Peter the Apostle crucified.

4. *Of the Castle of Crescentius.*[31] Moreover, there is a castle, that was the temple of Hadrian, as we read in the Sermon of the festival of Saint Peter, where it saith: The memorial of the emperor Hadrian, a temple built up, of marvellous greatness and beauty; the which was all covered with stones and adorned with divers histories, and fenced with brazen railings round about, with golden peacocks and a bull, of the which peacocks[32] two were those that are at the Basin of the Parvise. At the four sides of the temple were four horses of gilded brass, and in every face were brazen gates. In the midst of the circle was the porphyry sepulchre of Hadrian, that is now at the Lateran before the Fullery, and is the sepulchre of Pope Innocent;[33] and the cover is in Saint Peter's Parvise upon the Perfect's[34] tomb. Below were gates of brass as they now appear. And in the porphyry monument of the blessed Helen is buried pope Anastatius[35] the Fourth.

The monuments whereof we have spoke were dedicated for temples, and the Roman maidens flocked to them with vows, as Ovid saith in the book of *Fasti.*

[30] Before the end of the twelfth century it was called the Castle of the Holy Angel.

[31] This name was given it after Crescentius' obstinate defence of it against emperor Otho III in 998.

[32] The two bronze peacocks are now in the Giardino della Pigna.

[33] Innocent II died 24 September 1143.

[34] The prefect was Cencius, who died in 1079.

[35] He died in 1154 and had the sarcophagus of Helen, in which he was buried, brought from her church on the via Labicana. It is now in the Vatican Museum.

THEODERICH

[One of the European pilgrims to the Holy Land between 1171–1173 was a German priest named Theoderich. Although nothing is known of him except what may be deduced from his *Description of the Holy Places*, he is thought to be the same Theoderich who became the Bishop of Würzburg in 1223. Theoderich landed at Acre in the spring of the year, journeyed to Jerusalem, Jericho and Jordan, and started homeward on the Wednesday of Easter week of the same year. His descriptions are based in part on what he himself saw and in part on the reports of others.]

DESCRIPTION OF THE HOLY PLACES[1]

CHAPTER V. *The Church of the Holy Sepulchre; First the Chapel Thereof.* It only remains, then, that we should tell of the holy places, on account of which the city itself is called holy. We have thought, therefore, that it would be right to begin with the Holy of Holies; that is, from the sepulchre of our Lord. The Church of the Holy Sepulchre, of marvelous workmanship, is known to have been founded by the Empress Helena;[2] and its outer wall being carried, as it were, round the circumference of a circle, makes the

[1] The text is from *Theoderich's Description of the Holy Places*, translated by Aubrey Steward, Palestine Pilgrims' Text Society, London, 1891, vol. v, pp. 7–12.

[2] The mother of Constantine. The plan of the church like that of Santa Costanza erected in Rome by the imperial family as a mausoleum for two of the princesses, was derived from the architectural form of the Roman mausoleum. See R. Krautheimer, "Santo Stefano Rotanda a Roma e la Chiesa del Santo Sepolcro a Gerusalemme," *Revista di archeologia christiana*, 1935, pp. 51–102. The original church, torn down on orders of Caliph al-Hakim in 1009, was rebuilt in 1048 by the Byzantine Emperor Constantine Monomach in the form the Crusaders saw it after their capture of Jerusalem in 1099. In 1808, the complicated building, the result of eight centuries of embellishment and additions, was devastated by fire. Rebuilt in 1810, the present church reflects dimly its former glory. See H. T. F. Duckworth, *The Church of the Holy Sepulchre*, London, 1922.

church itself round. The place of our Lord's sepulchre occupies the central point in the church, and its form is that of a chapel built above the sepulchre itself, and beautifully ornamented with a casing of marble. It is not in the form of a complete circle, but two low walls proceed from the circumference towards the east, and meet a third wall. These walls contain three doors, 3 feet wide and 7 feet high, one of which opens on the north, another on the east, and another on the south side. The entrance is by the northern door and the exit by the southern door. The eastern door is set apart for the use of the guardians of the sepulchre.

Between these three small doors and the fourth door— that by which one goes into the sepulchre itself—is an altar which, though small, is of great sanctity, whereon our Lord's body is said to have been laid by Joseph and Nicodemus before it was placed in the sepulchre. Moreover, above the actual mouth of the sepulchre, which stands behind the altar, these same men are shown in a picture of mosaic-work placing our Lord's body in the tomb, with our Lady, His Mother, standing by, and the three Maries, whom we know well from the Gospel, with pots of perfumes, and with the angel also sitting above the sepulchre, and rolling away the stone, saying, 'Behold the place where they have laid Him.' Between the opening and the sepulchre itself a line is drawn in a semicircular form, which contains these verses:

'The place and guardian testify Christ's resurrection, also the linen clothes, the angel, and Redemption.'

All these things are portrayed in most precious mosaic-work, with which work the whole of this little chapel is adorned. Each of these doors has very strict porters, who will not allow fewer than six, or more than twelve, people to enter at one time, for, indeed, the place is so narrow that it will not hold more. After they have worshipped, they are obliged to go out by another door. No one can enter the mouth of the sepulchre itself except by crawling upon his knee, and having crossed it, he finds that most-wished-for treasure—I mean the sepulchre wherein our most gracious Lord Jesus Christ lay for three days—which

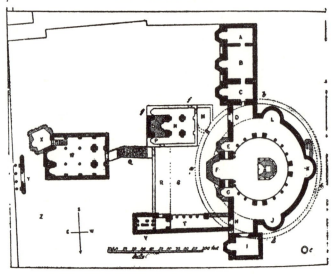

Plan of the churches as rebuilt by the Emperors of Constantinople after their destruction by Caliph al-Hakim, 1009, according to the description of Saewulf, 1103.[3]

A. Chapel of St. James
B. Chapel of the Holy Trinity
C. Chapel of St. John
D. Southeast door of the Rotunda
E, F, G. Apses conjecturally supplied
H. Northeast door
I. The Chapel of St. Mary
J, K, L. The three western apses
M. Chapel of St. Mary over the Unction Stone
N. Golgothan Church
P. *Exedra* in which relics were kept

Q. Steps leading to Chapel of St. Helena
W. Chapel of St. Helena, also called Basilica of Constantine
S. The *Paradise*
T. Corridor
V. Prison
Y. The Portal of Constantine's Basilica
Z. Treasury of Helena, or Cistern
a. The *Compas* or center of the world
b, c, d. Outer walls of church prior to its destruction in 1009

[3] Plan and explanation by Robt. Willis, given in George Williams, *The Holy City*, London, 1849, vol. II, p. 289.

is wondrously adorned with white marble, gold and pre-
cious stones. In the side it has three holes, through which
the pilgrims give their long-wished-for kisses to the very
stone whereon their Lord lay, which measures 2½ feet in
width, and the length of a man's arm from the elbow and
one foot also. The floor between the sepulchre itself and
the wall is large enough to allow five men to pray on their
knees with their heads turned towards the sepulchre.
Round about this building outside are ranged ten pillars,
which, with the arches which they support, make a circular
enclosure, beneath which is a base, having this text of Scrip-
ture carved upon it in letters of gold: 'Christ having risen
from the dead dieth no more. Death hath no more dominion
over Him: for in that He liveth, He liveth unto God.'[4] At
His head, which was turned towards the west, there is an
altar surrounded by partition walls, doors, and locks of iron,
with lattice-work of cypress-wood decorated with various
paintings, and with a roof of the same kind and similarly
decorated, resting upon the walls. The roof of the work it-
self is formed of slabs of gilt copper, with a round opening
in the middle, round which stand small pillars in a circle,
carrying small arches above them, which support a cup-
shaped roof. Above the roof itself is a gilded cross, and
above the cross is a dove, likewise gilded.[5] Between every
two columns throughout the circle, from each arch hangs
a lamp. In like manner, also, two lamps hang between each
of the lower columns all round the circle. Round the lower
arches, on every arch, verses are written, which upon some
of them we were not able to read because of the fading of
the colours. We were able to read six plainly, which were
written on three of the arches:

> 'Within this tomb was laid
> He who the world hath made:
> Ye who His tomb do see
> Haste ye to be
> A temple meet for me.

[4] Rom., VI, 9, 10.
[5] Probably a gift of the Byzantine Emperor Manuel Commenus.

Lamb of God blest!
Patriarches old,
Longed, ere their rest,
Him to behold.

Brought forth at Ephrata,
Suffered at Golgotha.
He from his rocky bed,
Adam our father led,
 Bore him on high;
Conquered the devil's arts,
And saith to sinking hearts,
 "Rise, it is I." '

Also round the iron enclosure which, as we have said be-
fore, is placed at the head of the sepulchre, above which
is the lattice-work, there runs a scroll containing these
verses:

'Twas here the victory o'er Death was won
 And life for us begun;
To God the pleasing sacrifice was given,
The victim fell;
Our sins are all forgiven;
There is joy in heaven,
And grief in hell;
Ends the Old Testament,
God hath a New one sent:
We learn from this, O Christ, who here hast bled,
That holy is the ground whereon we tread.'

CHAPTER VI. *The Church or the Rotunda Itself.* Now,
the pavement of this church is most beautifully laid with
Parian and various coloured marble. The church itself is
supported below by eight square pillars, which are called
piers, and sixteen monolithic columns; but above, since it
is vaulted both above and below, like the church at Aix-la-
Chapelle,[6] it is supported in the same fashion on eight
piers and sixteen pillars. The lower string-course, which
runs round the whole church, is covered with inscriptions

[6] Built by Charlemagne in 796–805, it was derived in plan
from San Vitale, Ravenna. See note 2.

in Greek letters. The surface of the wall which lies between the middle and the upper string-courses glows with mosaic work of incomparable beauty. There, in front of the choir, that is, above the arch of the sanctuary, may be seen the boy Jesus wrought in the same mosaic but of ancient workmanship, depicted in glowing colours as far as the navel, with a most beauteous face; on His left hand His Mother, and on His right the Archangel Gabriel pronouncing the well-known salutation, 'Hail, Mary, full of grace; the Lord is with thee, blessed among women, and blessed the fruit of thy womb.' This salutation is written both in Latin and in Greek round the Lord Christ Himself. Further on, on the right-hand side, the twelve apostles are depicted in a row in the same mosaic, each of them holding in his hand praises of Christ in words alluding to the holy mysteries. In the midst of them, in a recess slightly sunken into the wall, sits in royal splendour, wearing the trabea,[7] the Emperor Constantine, because he, together with his mother Helena, was the founder of the church. Also, beyond the apostles, the blessed Michael follows a row of thirteen prophets, all of whom have their faces turned towards the beauteous boy, and reverently address Him, holding in their hands the prophecies with which He inspired them of old. In the midst of them, opposite to her son, sits the blessed Empress Helena, magnificently arrayed. Upon the wall itself rests a leaden roof supported by rafters of cypresswood, having a large round opening in the midst, through which the light comes from above and lights the whole church, for it has no other window whatever.

ROBERT OF CLARI

[Robert of Clari, as a vassal of Pierre of Amiens, took part in the Fourth Crusade (1201–1204). This crusade, led by Baldwin of Flanders, Boniface of Montferrat, Geoffroy de Villehardouin and others, was diverted from going

[7] The ancient Roman robe of state.

to the Holy Land and united with the Venetians to capture
Zara in Dalmatia and to restore the Byzantine Emperor,
Isaac Angelus, to his throne. The eleven thousand cru-
saders, accompanied by the Doge, Enrico Dandolo, and
brought to Constantinople by two hundred Venetian ships,
attacked, captured and sacked the great Christian Greek
city in 1204. As a result of the pillaging, many art treasures
and holy relics were brought back to Europe, but Con-
stantinople never recovered either from the fires that de-
stroyed much of it, including the great library, or from the
loss of its wealth.

Robert, an ordinary unlettered knight, fought outside the
land walls in July 1203 and took part in the final great
attack in April 1204. He witnessed the despoiling of the
palaces and the distribution of the loot among the great
princes and marveled at the monuments of the city. By
1205, Robert had returned to France and dictated in 1216
his prose tale (*estoire*) of the historical events he had par-
ticipated in. It shows him to have been an observant sight-
seer, for besides his account of the episodes of the crusade,
no other European before him had described with such ac-
curate detail the marvels of Constantinople.]

THE CONQUEST OF CONSTANTINOPLE[1]

. . . When the city was captured and the pilgrims were
quartered, as I have told you, and the palaces were taken
over, then they found in the palaces riches more than a
great deal. And the palace of Boukoleon was very rich and
was made in such a way as I shall tell you. Within this
palace,[2] which was held by the marquis,[3] there were fully

[1] Text and footnotes, somewhat abbreviated, are from *Robert
of Clari, The Conquest of Constantinople,* translated by Edgar
H. McNeal, New York, Columbia University Press, 1936; pp.
102–113.

[2] A complex of buildings lying between the Hippodrome and
the sea walls, known as the Great Palace.

[3] Boniface, marquis of Montferrat, king of Salonika, was a
member of the powerful family of Lombardy, connected by
marriage both with the Capetians and with the Hohenstaufen.
Its members had played important roles in the kingdom of
Jerusalem and in the Byzantine empire.

five hundred halls, all connected with one another and all made with gold mosaic. And in it there were fully thirty chapels, great and small, and there was one of them which was called the Holy Chapel,[4] which was so rich and noble that there was not a hinge nor band nor any other part such as is usually made of iron that was not all of silver, and there was no column that was not of jasper or porphyry or some other rich precious stone. And the pavement of this chapel was of a white marble so smooth and clear that it seemed to be of crystal, and this chapel was so rich and so noble that no one could ever tell you its great beauty and nobility. Within this chapel were found many rich relics. One found there two pieces of the True Cross as large as the leg of a man and as long as half a *toise*,[5] and one found there also the iron of the lance with which Our Lord had His side pierced and two of the nails which were driven through His hands and feet, and one found there in a crystal phial quite a little of His blood, and one found there the tunic which He wore and which was taken from Him when they led Him to the Mount of Calvary, and one found there the blessed crown with which He was crowned, which was made of reeds with thorns as sharp as the points of daggers. And one found there a part of the robe of Our Lady and the head of my lord St. John the Baptist and so many other rich relics that I could not recount them to you or tell you all the truth.

Now there was still another relic in this chapel which we had forgotten to tell you about. For there were two rich vessels of gold hanging in the midst of the chapel by two heavy silver chains. In one of these vessels there was a tile and in the other a cloth. And we shall tell you where these relics came from. There was once a holy man in Constantinople. It happened that this holy man was covering the house of a widow with tile for the love of God.

[4] The church of the Blessed Virgin of the Pharos.

[5] *Toise:* The medieval *toise* was about equivalent to the fathom, or six feet. If Robert is using the term in this sense, his figures are very inaccurate here as well as elsewhere. Later he estimates the two columns of Constantinople as 50 toises or 300 feet high which is about twice the actual height. [See p. 87.]

And as he was covering it, Our Lord appeared to him and said to him (now this good man had a cloth wrapped about him): "Give me that cloth," said Our Lord. And the good man gave it to Him, and Our Lord enveloped His face with it so that His features were imprinted on it. And then He handed it back to him, and He told him to carry it with him and touch the sick with it, and whoever had faith in it would be healed of his sickness. And the good man took it and carried it away; but before he carried it away, after God had given him back his cloth, the good man took it and hid it under a tile until vespers. At vespers, when he went away, he took the cloth, and as he lifted up the tile, he saw the image imprinted on the tile just as it was on the cloth, and he carried the tile and the cloth away, and afterwards he cured many sick with them.[6] And these relics were hanging in the midst of the chapel,[7] as I have told you. Now there was in this chapel still another relic, for there was an image of St. Demetrius which was painted on a panel. This image gave off so much oil that it could not be removed as fast as it flowed from the picture. [And there was another palace in the city, called the palace of Blachernae.] And there were fully twenty chapels there and at least two hundred chambers, or three hundred, all connected with one another and all made of gold mosaic. And this palace was so rich and noble that no one could describe it to you or recount its great nobility and richness. In this palace of Blachernae there was found a very great treasure, for one found there the rich crowns which had belonged to former emperors and the rich ornaments of gold and the rich cloth of silk and gold and the rich imperial robes and the rich precious stones and so many other riches that no one could number the great treasure of gold and silver that was found in the palaces and in many other places in the city.

Then the pilgrims regarded the great size of the city, and the palaces and fine abbeys and churches and the great

[6] This is a variant of the legend of the "Image of Edessa," or the "Portrait not made by the hand of man."

[7] The church of the great martyr St. Demetrius was founded by Basil I (867–886). It is just north of the church of the Virgin

wonders which were in the city, and they marveled at it greatly. And they marveled greatly at the church of Saint Sophia and at the riches which were in it.

Now I will tell you about the church of Saint Sophia, how it was made. Saint Sophia in Greek means Sainte Trinité in French. The church of Saint Sophia was entirely round, and within the church there were domes, round all about, which were borne by great and very rich columns, and there was no column which was not of jasper or porphyry or some other precious stone, nor was there one of these columns that did not work cures. There was one that cured sickness of the reins when it was rubbed against, and another that cured sickness of the side, and others that cured other ills. And there was no door in this church and no hinges or bands or other parts such as are usually made of iron that were not all of silver. The master altar of the church was so rich that it was beyond price, for the table of the altar was made of gold and precious stones broken up and crushed all together, which a rich emperor had had made. This table was fully fourteen feet long. Around the altar were columns of silver supporting a canopy over the altar which was made just like a church spire and it was all of solid silver and was so rich that no one could tell the money it was worth. The place where they read the gospel was so fair and noble that we could not describe it to you how it was made. Then down through the church there hung fully a hundred chandeliers, and there was not one that did not hang by a great silver chain as thick as a man's arm. And there were in each chandelier full five and twenty lamps or more. And there was not a chandelier that was not worth at least two hundred marks of silver. On the ring of the great door of the church, which was all of silver, there hung a tube, of what material no one knew; it was the size of a pipe such as shepherds play on. This tube had such virtue as I shall tell you. When an infirm man who had some sickness in his body like the bloat, so that he was bloated in his belly, put it in his mouth, how-

("Holy Chapel") and is connected with it by a vestibule, so that Robert speaks of it as part of the same building. The portrait was brought from Thessalonica by Emperor Manuel.

ever little he put it in, when this tube took hold it sucked out all the sickness and it made the poison run out of his mouth and it held him so fast that it made his eyes roll and turn in his head, and he could not get away until the tube had sucked all of this sickness out of him. And the sicker a man was the longer it held him, and if a man who was not sick put it in his mouth, it would not hold him at all, much or little.

Then in front of this church of Saint Sophia there was a great column which was fully three times the reach of a man's arms in thickness and was fully fifty *toises* in height. It was made of marble and of copper over the marble and was bound about with strong bands of iron. And on top of this column there lay a flat slab of stone which was fully fifteen feet in length and as much in width. On this stone there was an emperor[8] made of copper on a great copper horse, and he was holding out his hand toward heathendom, and there were letters written on the statue which said that he swore that the Saracens should never have truce from him. And in the other hand he held a golden globe with a cross on it. The Greeks said that this was Heraclius the emperor. And on the croup of the horse and on the head and round about there were fully ten nests of herons, who nested there every year.

Then elsewhere in the city there was another church which was called the church of the Seven Apostles.[9] And it was said to be even richer and nobler than the church of Saint Sophia. There was so much richness and nobility there that no one could recount to you the richness and nobility of this church. And there lay in this church the bodies of seven apostles. There was also the marble column to which Our Lord was bound, before He was put on the cross. And it was said that Constantine the emperor lay there and Helena, and many other emperors.

[8] The equestrian statue of Emperor Justinian in the Forum of the Augusteion, which lies between Saint Sophia and the entrance to the Great Palace. It survived through the fifteenth century.

[9] This is the church of the Holy Apostles. It was built by Justinian on the site of an older church of the Apostles built by Constantine; it was the model for St. Mark's of Venice.

Now there was elsewhere in the city a gate which was called the Golden Mantle.[10] On this gate there was a golden globe which was made by such enchantment that the Greeks said as long as it was there no thunderbolt would fall in the city. On this globe there was an image cast of copper, with a golden mantle clasped about it, which it held out in its arm, and it had letters written on it which said: "Anyone," said the image, "who lives in Constantinople a year can have a golden mantle just as I have."

Elsewhere in the city there is another gate which is called the Golden Gate.[11] On this gate there were two elephants made of copper which were so large that it was a fair marvel. This gate was never opened except when an emperor was returning from battle after conquering territory. And when an emperor returned from battle after conquering territory, then the clergy of the city would come out in procession to meet him, and the gate would be opened, and they would bring out a chariot of gold, which was made like a cart with four wheels, such as we call a *curre*. Now in the middle of this chariot there was a high seat and on the seat there was a throne and around the throne there were four columns which bore a canopy to shade the throne, which seemed as if it were all of gold. Then the emperor, wearing his crown, would take his seat on the throne, and he would enter through this gate and be borne in this chariot, with great joy and rejoicing, to his palace.

Now in another part of the city there was another marvel. There was an open place near the palace of Boukoleon which was called the Games of the Emperor.[12] This place was a good bowshot and a half long and nearly a bowshot wide. Around this place there were fully thirty rows of seats or forty, on which the Greeks used to mount to watch the

[10] The identification of this gate is doubtful.

[11] The most famous gate of the city, located near the southern end of the land walls.

[12] *Jus l'empereur:* the Hippodrome. The eleventh century Arabian geographer Edrisi said of the Hippodrome that one walks between two rows of bronze statues representing men and bears and lions, larger than life size.

games, and above these rows there was a loge, very dainty and noble, where the emperor and the empress sat when the games were held, and the other high men and ladies. And if there were two sides playing at the same time, the emperor and the empress would wager with each other that one side would play better than the other, and so would all the others who watched the games. Along this open place there was a wall which was a good fifteen feet high and ten feet wide. Upon this wall there were figures of men and women, and of horses and oxen and camels and bears and lions and many other kinds of animals, all made of copper, and all so well made and formed so naturally that there is no master workman in heathendom or in Christendom so skillful as to be able to make figures as good as these. And formerly they used to play by enchantment, but they do not play any longer. And the French looked at the Games of the Emperor in wonder when they saw it.

Now there was elsewhere in the city another marvel. There were two statues made of copper in the form of women, well and naturally made, and more beautiful than a good deal. And neither of them less than a good twenty feet in height. One of these figures held its hand out toward the West, and it had letters written on it which said: "From the West will come those who will capture Constantinople," and the other figure held its hand out toward a vile place and said: "Here," said the figure, "here is where they will throw them."[13] These two figures were sitting in front of the Change, which used to be very rich there, for the rich money changers used to be there with great heaps of besants and of precious stones in front of them, before the city was taken, but there were not so many of them afterwards.

There was elsewhere in the city still another marvel.

[13] The chronicler, Nicetas, describes a magnificent bronze statue of Athena which the mob overturned and destroyed during the siege. The left hand held back the draperies while the right supported the head which was slightly inclined toward the south. Those who did not know the directions declared that the statue was looking toward the West and inviting with its hand the army of the West to attack the city.

There were two columns, each of them at least three times the reach of a man's arms in thickness and at least fifty *toises* in height. And hermits used to live on the tops of these columns in little shelters that were there, and there were doors in the columns by which one could ascend. On the outside of these columns there were pictured and written by prophecy all the events and all the conquests which have happened in Constantinople or which were going to happen. But no one could understand the event until it had happened, and when it had happened, the people would go there and ponder over it, and then for the first time they would see and understand the event. And even this conquest of the French was written and pictured there and the ships in which they made the assault when the city was taken, and the Greeks were not able to understand it before it had happened, but when it had happened they went to look at these columns[14] and ponder over it, and they found that the letters which were written on the pictured ships said that a people, short haired and with iron swords, would come from the West to conquer Constantinople. All these marvels which I have recounted to you here and still a great many more we could recount, the French found in Constantinople after they had captured it, nor do I think, for my part, that any man on earth could number all the abbeys of the city, so many there were, both of monks and of nuns, aside from the other churches outside of the city. And it was reckoned that there were in the city a good thirty thousand priests, both monks and others. Now about the rest of the Greeks, high and low, rich and poor, about the size of the city, about the palaces and the other marvels that are there, we shall leave off telling you. For no man on earth, however long he might have lived in the city, could number them or recount them to you. And if anyone should recount to you the hundredth part of the richness

[14] According to J. Ebersolt, *Constantinople byzantine et les voyageurs du Levant,* Paris, 1918, these were the columns of Theodosius the Great in the Forum of Theodosius (the Tauros), erected in 386, and of Arcadius in the Forum of Xerolophos, erected in 403. They were modeled on the column of Trajan in Rome.

and the beauty and the nobility that was found in the abbeys and in the churches and in the palaces and in the city, it would seem like a lie and you would not believe it. And among the rest, there was another of the churches which they called My Lady Saint Mary of Blachernae, where was kept the *sydoine* in which Our Lord had been wrapped, which stood up straight every Friday so that the features of Our Lord could be plainly seen there. And no one, either Greek or French, ever knew what became of this *sydoine*[15] after the city was taken. And there was another of the abbeys[16] where the good emperor Manuel lay, and never was anyone born on this earth, sainted man or sainted woman, who was so richly and so nobly sepulchred as was this emperor. In this abbey there was the marble slab on which Our Lord was laid when He was taken down from the Cross, and there could still be seen there the tears which Our Lady had let fall upon it. . . .

VILLARD DE HONNECOURT

[Villard de Honnecourt (thirteenth century), a native of northeastern Picardy, was a master-mason who travelled extensively, going wherever there was an opportunity for employment, as was the custom of men in his profession. In his sketch book is evidence that he knew most of the great churches that were being built during his lifetime. Vaucelles and Cambrai were in his native province. The latter is often ascribed to him, though there are no correspondences between the building and his notebook to warrant this. It is more probable that he was active in the building of St. Quentin. He knew Rheims, Chartres, Laon, Meaux and

[15] Robert seems to have confused the sudarium (the sweat cloth or napkin, the True Image of St. Veronica) with the *sindon* (the grave cloth in which the body of Jesus was wrapped for entombment). Both relics were in the church of the Blessed Virgin in the Great Palace, and not in the church in the palace of Blachernae.

[16] This was the church of Christ Pantocrator ("Almighty"), founded by Empress Irene, wife of John II Commenus.

Lausanne. He speaks of a trip to Hungary which probably took place between 1220 and 1235. What he built there is not known.

Villard's book was begun as a sketch book, but after years of compilation developed into a manual giving for the first time detailed instructions for the execution of certain objects with accompanying explanatory drawings. His material is derived from the geometry of antiquity and current knowledge. His rule for lion training is based on the belief of his day, but the emphasis he places on the fact that he drew the lion from life is important. Although the figures of the lion and trainer are highly stylized, in them are found traces of a hurried sketch of an actual scene. In spite of the conventionalized character of his representation, the medieval artist attempted to approximate nature. Even though no more than half of the book is preserved, it is of great value not only as a technical manual, but as a reflection of the universality of interest and the variety of work required of the master-mason in the thirteenth century.]

THE SKETCH BOOK[1]

PLATE II [our *fig.* 4]. Here you can find the figures of the Twelve Apostles seated.

Villard de Honnecourt salutes you, and implores all who will work with the aid of this book to pray for his soul, and remember him. For in this book one may find good advice for the great art of masonry, and the construction of carpentry; and you will find therein the art of drawing, the elements being such as the discipline of geometry[2] requires and teaches.

[1] The selections have been taken from the *Facsimile of the Sketch-book of Wilars de Honecort*, translated and edited by R. Willis, London, 1859. The translation of the text was facilitated by the German translation by Hans R. Hahnloser, *Villard de Honnecourt; Kritische Gesamtausgabe des Bauhüttenbuches Ms. fr. 19093 der Pariser Nationalbibliothek*, Vienna, 1935.

[2] Geometry is the third discipline of the Quadrivium (Hahnloser, *op. cit.*, p. 13).

PLATE XII [our *fig.* 5]. This is a clock-house.

He who wishes to make a clock-house may see here one that I once saw. The first and lowest story is square with gablets; the story above has eight sides, then comes a roof, and then [come] four gablets [and] between [every] two gablets [is] an empty space; the highest story is square, with four gablets and the roof is eight sided. Here is the drawing.

PLATE XIII [our *fig.* 6]. Who desires to make a lectern from which the Gospel can be read, see here the best kind that I made. First, three serpents rest on the ground, and then over that a plate with three arches, and over that, three serpents of another kind, and columns the same height of the serpents, and over that a triangle. Afterwards, look well to see in what way the pulpit is made. See here an image of it. In the middle of the three columns there must be a staff with a knob on it on which the eagle sits.

PLATE XXIX [our *fig.* 7]. This choir Villard de Honnecourt and Peter de Corbie have contrived in collaboration.

This is the choir of St. Faron, Meaux.[3]

See here the plan of the church of St. Stephen at Meaux.

Above is a church with a double aisle which Villard de Honnecourt and Peter Corbie have designed.

PLATE XXXV [our *fig.* 8]. Here begins the instruction in the art of drawing.[4]

PLATE XXXVI [our *fig.* 9]. Here begins the art of the elements of drawing as the discipline of geometry teaches it, so explained as to make the work easy.

On the other leaf are those of masonry.

[3] This was written by a later hand and is incorrect (Hahnloser, *op. cit.*, p. 72).

[4] See Panofsky, "The History of the Theory of Human as a Reflection of the History of Styles," *Meaning in the Visual Arts,* Doubleday Anchor, New York, 1955, p. 83. "Here the figure is no longer 'measured' at all, not even according to head- or face-lengths; the schema almost completely renounced, so to speak, the object. The system of lines—often conceived from a purely ornamental point of view and at times quite comparable to the shapes of Gothic tracery—is superimposed upon the human form like an independent wire framework. The straight lines are 'guiding lines' rather than measuring lines: not always coextensive

PLATE XLVII [our *fig.* 10]. I will tell you of the training of the lion. He who trains the lion has two dogs. When he wants to make the lion do anything, he commands him to do it. If the lion growls, the man beats the dogs. When the lion sees how the dogs are beaten he becomes afraid. His courage disappears and he does what he is commanded. I will not speak of when he is in a rage, for then he would not obey anyone's wish either good or bad. You should know that this lion was also drawn from life.

MATTHEW PARIS

[Matthew Paris (†1259) became a monk in 1217 in St. Alban's Abbey, the leading Benedictine monastery in England. The monastery was founded in 793 by Offa (†796), King of Mercia, to receive the relics of St. Alban he had discovered there, at the scene of the saint's martyrdom. It became a center of scholarly and artistic activity from the twelfth to the fourteenth century. Matthew Paris headed the Abbey's scriptorium in 1236, directing the scribes and artists in the production of manuscripts. In this office he is shown to have been a man of affairs with universal ability. He was sent on a mission for Louis IX to Haakon IV of Norway in 1248. He worked as a painter, miniaturist, goldsmith and sculptor. Among English chroniclers he is unsurpassed for his fresh vigor in the writing of contemporary events in his *Chronica Minora, Chronica Maiora,* and an abridgment of the latter, *Historia Anglorum.* He also versified in French the legends of Saints Alban and Amphibalus, and Thomas and Edmund, archbishops of Canterbury, and the story of Edward the Confessor. His writings are illustrated in part by himself and in part by competent assistants. Matthew Paris composed his versified

with the natural dimensions of the body, they determine the appearance of the figure only in so far as their position indicates the direction in which the limbs are supposed to move, and as their points of intersection coincide with single, characteristic loci of the figure."

story of Edward the Confessor at the request of Abbot Laurence of Westminster for presentation to Queen Eleanor in connection with the ceremonies of the transfer of the saint's relics to a splendid new shrine prepared by Henry III in Westminster Abbey which he had begun to rebuild in 1245. This manuscript was written by another scribe, but some of the illustrations are by Matthew; this is also true of the illustrations in his *Lives of Saints Alban and Amphibalus.*]

THE STORY OF SAINT EDWARD, THE KING[1]

DESCRIPTION OF THE ILLUSTRATIONS

XXXII King Edward calls this holy place
 The Gate of Heaven, improves and loves it;
 But the church was old and in disorder;
 Wherefore he causes to come there a great band
 Of masons and carpenters,
 That the monastery[2] may well be restored, . . .

 . . . By this account I have recalled the memory,
 Just as the history testifies,
 Of the love and devotion
 Of King Edward, the reason for which

[1] The translation is from H. R. Luard, *The Lives of Edward the Confessor,* Chronicles and Memorials of Great Britain and Ireland, London, 1858, vol. I, pp. 168, 243–244. The illustrations are from M. R. James, *L'Estoire de Seint Aedward le Rei* (a French verse Life of Edward the Confessor), Oxford, 1920. See also Margaret Rickert, *Painting in Britain, The Middle Ages,* Baltimore, 1954; M. R. James, *Illustrations to the Life of St. Alban,* Oxford, 1924.

[2] The Abbey of St. Peter, a Benedictine monastery. In 1050, Edward began the construction of the new church, Westminster Abbey, which was consecrated just before his death in 1065. (See our *fig.* 11.) The figures, clad in the garb of Matthew Paris' time, standing forward to hear the king, are a master-mason wearing the master's cap, the gloves usually provided him as part of his pay and a badge of office, and holding a long ruler;

This church, which was almost entirely
Fallen down and long ago destroyed,
Since the time of which I relate to you
Because age destroys mighty things,
To restore, to put in to a proper condition
Under a prelate he had often wished,[3]
And to enrich with rich gifts
Of treasure and possession;
His body he grants to it and intends
That he be buried in this church,
And in order well to confirm his gifts,
He now sends to Rome,
Where is the mother throne[4] of the world,
That the privilege may be ratified:
But the one who was so intimate a friend[5]
Was dead, and another put into his seat,
And he wishes that he for him renew,
And reconfirm and reseal,
And cause to be put in the register
All the grants of his ancestor.

 Now he laid the foundations of the church
With large square blocks of grey stone;
Its foundations deep,[6]
The front toward the east he makes round,
The stones are very strong and hard,
In the center rises a tower,
And two at the western front,
And fine and large bells he hangs there,

behind him are a mason and a group of workmen. A carpenter wearing a coif and holding an axe kneels in front of him. See also: P. du Colombier, *Les Chantiers des Cathédrales*, Paris, 1953, pp. 53–55.

[3] Robert Atkinson in "Strictures on Mr. Luard's Edition of a French Poem on the Life of Edward the Confessor," *Hermathena*, Dublin, 1873, no. 1, pp. 1–81, translates this line "As a convent under a prelate he wishes."

[4] R. Atkinson, *op. cit.*, gives "master-seat."

[5] Reference is probably to the reforming Pope, Leo X (1049–1054).

[6] R. Atkinson, *op. cit.*, gives "With foundations broad and deep."

The pillars and entablature
Are rich without and within,
At the bases and capitals.
 The work rises grand and royal,
Sculptured are the stones
And storied the windows;
All are made with skill
Of a good and loyal workmanship;
And when he finished the work,
With lead the church completely he covers,
He makes there a cloister, a chapter house in front,
Towards the east, vaulted and round,
Where his ordained ministers
May hold their secret chapter:
Refectory and dormitory
And the offices in the tower.[7]
Splendid manors, lands and woods
He gives, confirms [the gift] at once,
And according to his grant he intends
For his monastery royal freedom:
Monks he causes there to assemble,
Who have a good heart there to serve God,
And puts the order in good condition
Under a holy and ordained prelate;
And receives the number of the convent
According to the order of Saint Benedict . . .

THE LIFE OF SAINT ALBAN[8]

The King has founded a church,
Which is set in the same place,
Where the martyr Saint Auban
For God has suffered and died.

[7] R. Atkinson, *op. cit.*, gives "and workshops around."

[8] The translation of the rubrics is from the text given in *Vie de Seint Auban, A poem in Norman French ascribed to Matthew Paris,* edited by Robert Atkinson, London, 1876, p. 60. The illustrations of this MS. are reproduced from the facsimiles added to *L'Estoire de Seint Aedward le Rei* (a French verse Life of Edward the Confessor), Oxford, 1920. They are also to be found in *Illustrations to the Life of St. Alban.* Reproduced in Collotype

Masons were sent for and engineers,
Who made the foundations of the walls,
Voussoirs and pavements,
Pillars, bases and tablements.
The King put great trouble and care,
That each on his work labors,
Carpenter, mason, glazier,
Each according to his craft.
There one sets, another cuts,
This one hits, this one bats,[9] this one strikes;
He of the axe, he of the hammer.
He of the mallet and of the chisel.
The gentle king of good life,
Offa, perfects his abbey. . . .

MATHIAS RORICZER

[Mathias Roriczer (†1492) represented the third gen-
eration of a family of master-masons that served as the
cathedral architect of Regensburg, and as such was the
head of the lodge (*Bauhuette*) where the building work
was executed. Designs, sketches of moldings and scaffold-
ing, and other useful professional information such as was
assembled by Villard de Honnecourt in his sketch book were

Facsimile by the care of W. R. L. Lowe and E. F. Jacob. With
a Description of the Illustrations by M. R. James, Oxford, 1924.
The Life of St. Alban (Trin. Coll. Dublin. MSE. i. 40), versified
by Matthew Paris, is composed of three parts; The Story of St.
Alban and St. Amphibalus; The Visit of St. Germanus and St.
Lupus to Britain; The Invention and translation of Alban's relics
and the Foundation of the Abbey by King Offa. The text is illus-
trated by fifty-four pictures, the last of which depict the foun-
dation of St. Alban's Abbey, showing contemporary building
operations with which Matthew Paris was familiar. In the story,
The Lives of the Two Offas (Br. Mus. Nero D.I.), also written
by Matthew Paris, the two illustrations reproduced here (see
our *figs.* 12 and 13) are combined into a single drawing.
[9] *Bat:* This may mean to use a batter rule, formed by a plumb
line and a rule which was used to regulate the slope or the "bat-
ter" of a wall. A figure standing on the wall appears to do that
(our *fig.* 13).

essential to the master-masons. Such manuals probably re-
mained at the lodge of the building operations, to be used
and added to by succeeding master-masons. In keeping
with this practice of the Middle Ages, Roriczer wrote and
published a small pamphlet giving the solution to the prob-
lem of erecting from a ground plan a pinnacle in correct
proportions.]

ON THE ORDINATION
OF PINNACLES[1]

To the Reverend Prince and Lord, the Lord Wilhelm,[2]
Bishop of Eystedt, of the family of Reichenau, my very
good lord; do I, Mathes Roriczer, at present cathedral ar-
chitect, at Regensburg, signify my obedient humble service
to the fore ready and willing:

My very good Lord,—As your princely grace not only
hitherto was, and now is, an amateur and patron of the free
art of geometry, but also heretofore, even from the begin-
ning in idea, wish, and resolution, has been a desirer that
all those, who must make use, and obtain their support, of
the said art, may advance in understanding thereof, so that
the deficiencies and weaknesses (through which they do so
assume a place to themselves in it, yet are not thoroughly
well based) may become obviated, and that such an art of
general utility should be thrown open and clearly exposed,
so your grace at many times with me thereof has held dis-
course.

To fulfil your grace's good pleasure, and to promote the
common good (such indeed the materials of every art,

[1] The translation of the dedication is by John W. Papworth,
Roriczer on Pinnacles, Architectural Publications Society, De-
tached Essays issued during years 1848–1853; T. Richards,
London, 1853, vol. I, p. 9. The footnotes are abbreviations of the
explanations from the above.

The translation is from the text as given in C. Heideloff, *Die
Bauhuette des Mittelalters in Deutschland*, Nuremberg, 1844.
See also: P. Frankl, "The Secret of the Mediaeval Masons," *Art
Bulletin*, March 1945.

[2] Wilhelm, Bishop of Eichstadt from 1464–1496, was active in
the building council of the churches of Regensburg, Ulm and
Ingolstadt.

shape, and size!), I have undertaken, with the help of God, to expound somewhat of the before-named art of geometry, and, from the very commencement of the drawn-out stone-work, to explain how, and in what proportions, out of the very grounds of geometry with division by compasses, it ought to be deduced and brought into right sizes, and in the hereafter expressed manner, with a few illustrations, I have given it (and not altogether from myself is it eluci-dated, but, before all, especially from the old connoisseurs of the art, and particularly from the 'younkers of Prague'[3]); begging your princely grace, and those versed in this art, to consider of this my performance, that I have undertaken it not for private glory, but altogether for general benefit, and where it is to be bettered, to better it, if any one will bring thereunto fruit, he will brighten up and give light to the art.

ON THE ORDINATION
OF PINNACLES

Would you draw a plan for a pinnacle after the mason's art, by regular geometry? Then heave to and make a square as is here designated with the letters, A:B:C:D: [Draw] A to B, and B to D, and from D to C, and from C to A, so it may be as in the given figure.[4]

[3] The fourteenth century family of master-mason-architects and sculptors, Peter Parler, his son Peter, and Heinrich and Wenzel, around which was formed the Parler School or 'Par-lerhuette' of Schwaebisch-Gmuend, Germany.

[4] The square is the net size of the plinth of the shaft.

Then you make a[nother] square . . . : divide A to B in two equal parts, and place E; likewise, divide BD and there make H; and from D to C and there make an F; similarly from C to A, and there make a G. After that draw a line from E to H, and from H to F, F to G, G to E. An example is in the following figure.[5]

After that you make like the one made above a[nother] square . . . : divide FH into two equal parts and there put a K. Similarly on HF place M; also on FG make L, similarly on GE place I. After that draw a line from K to M, from M to L, from L to I, from I to K, as in the following figure.[6]

[5] This square will be equal to the size of the shaft when worked.

[6] With this third square is given the faces of the panels of the shaft.

After that you make the three squares equal to the size of ABCD and IKLM and the square EHGF; [place] these . . . as [shown] in the given figure.[7]

Then you . . . draw the line IL to the line EH, and place N; do this on the four corners as in the example in the next figure.

[7] This results in three squares in a specific relationship to each other. The diagonal of the second square is equal to the side of the first, and likewise, the diagonal of the third is equal to the side of the second. Thus by an extremely simple method results are obtained without apparently the use of any theoretical knowledge of geometry. The arrangement of the square, or the octagon that proceeds from two super-imposed squares, was a construction principle used by master-masons in Gothic buildings, as well as the construction principle of the equilateral triangle. The octagon is referred to as the "eight-pointed," in German the "acht-ort" and "acht-uhr." [See Hahnloser, *op. cit.*, pp. 105–108, 115–116.]

. . . . Then take . . . [IN as a radius] and with a compass draw a circle having the center in N and make O on the line EH . . . ; do this at the four corners. Then set the compass . . . at O and with the compass draw [a line] from N . . . to the line IK . . . as in the example given in the figure.[8]

After that make [and letter a] square . . . as you did before; lay a perpendicular or ruler at N near E on the line EH, and at N near F on the line FH, and draw a line from N toward A, there make P. Likewise from the other N toward D, there put a Q. After that make a line from the N near E [on line EG] toward A, there set R. Likewise from the N [near F on line FG] toward D, there set S; [duplicate this process] at B and C. After that put the compass on the line P to R [take that as the radius]. Then put the compass on P or the line NP and make two parts, and there put T. Likewise on RN, there set V. After that draw a line TV; then cut TV in two equal parts and there put X. After that with the same radius [of TX] put the compass on T and make a point on the line going toward N, there put Y. Then where V goes toward N, there put Z. Then draw a line from X to Y, and from X to Z. Do the same at the other corners.[9] Thus is the ground plan ready. Then divide AB in two equal parts and there put D¹. Likewise do the same below between CD, and there also place such a D¹ and draw a line between these D¹'s. By this line one marks the center line of the plan and

[8] Thence results the hollow molding of the panel and the completed plan of the shaft.

[9] Thence results the plan of the crockets.

that is how a half section is made. Thus is the ground plan of a pinnacle made. An example is in the following figure.[10]

ARTICLES AND POINTS OF MASONRY

[The "Articles and Points of Masonry" were general rules of conduct drawn up by masons to be observed while engaged on a building project. For the erection of a large church, a building council or committee was responsible for the administration of funds and the selection and supervision of the master-mason serving as architect. He was in charge of the actual building operations, the architectural design, planning the construction, setting out the stone, and supervising the master carpenter, stone-cutters, setters, and all the other workmen brought haphazardly together, often by impressment in England, when the building was underway. The work was carried on in sheds or lodges erected at the building site. There the relationships of the master-mason and the masons were regulated by a mutually agreed to code. Articles such as these were rela-

[10] When the letters and the construction-helpers are omitted from these lines the diagram is thus:

tively uniform throughout England and on the Continent from the thirteenth to the fifteenth century. While these articles were probably written about 1430, it is generally agreed that they are a copy of a document dating from a century earlier.]

THE ARTICLES AND POINTS OF MASONRY[1]

The first article is this, that every master of this art should be wise and true to the lord he serves, dispensing his goods truly as he would his own were dispensed; and not giving more pay to any mason than what he may deserve in accordance with the scarcity of corn and victuals in the country, so that, without favor, every man be rewarded according to his work.

The second article is this, that every master of this art should be warned beforehand to come to his congregation[2] so that they [the masons] come duly, unless they be excused for some good reason. If, nevertheless, they be found rebellious in such congregations or faulty in any manner harmful to their lords and proven guilty of this, they should not be excused in any manner except for being in peril of death. Though they be in peril of death, they shall warn the master who is the principal one of the gathering of his trouble.

The [third] article is this, that no master take any apprentice for less time than seven years at the least, because he who has been in for less time may not come perfectly to his art nor be able to serve truly his lord as a mason should.

The fourth article is this, that no master take for profit

[1] The text from D. Knoop and G. Jones, *The Mediaeval Mason,* London, 1933, pp. 270–271, is modernized. See also P. du Colombier, *Les Chantiers des Cathédrales,* Paris, 1953; L. F. Salzman, *Building in England down to 1540,* Oxford, 1952. (See our *figs.* 14 and 15.)

[2] An assembly of masons that met, usually with the town officials, especially the sheriff, the officer in England, responsible for building repairs, as well as procuring workmen from the county. A master-mason entering a community to direct a building operation was obliged to arrange with the local assembly for labor and observe its customs.

any apprentice for teaching who is born from bondage blood because his lord to whom he is bound, will take him as he well may from his art and lead him out of his lodge or of the place where he works. His fellows, perchance, would help him and debate for him; therefore, manslaughter might arise [and] it is forbidden. And also for another reason that this art took its beginning from great lords' children freely begotten as it is said before.

The fifth article is this, that no master give more to his apprentice at the time of his apprenticeship than he can give without disservice to the lord that he serves nor so much but the lord of the place [where] he is taught in may have some profit in his being taught.

The sixth article is this, that no master for neither covetness nor profit take any apprentice to teach who is imperfect, that is to say, is maimed in any way, for which reason he may not work as truly as he ought to do.

The seventh article is this, that no master be found knowingly either to help or procure or maintain or allow any common night worker to rob by such night work they who may not fulfill their day's work, and work in a manner that their fellows might be made wroth.

The eighth article is this, that if it happen that any mason that be perfect and skillful come for such work and find any imperfect and unskillful working, the master of the place shall receive the perfect and do away with the imperfect to the profit of his lord.

The ninth article is this, that no master shall supplant another, for it is said in the art of masonry that no man can bring to an end so well the work begun by another to the profit of his lord as he that began it, unless it be by his designs or by him to whom he shows his designs.

This council is made of various lords and masters of various provinces and various congregations of masonry and it is, to wit, that he who desires to come to the state of the aforesaid art [of masonry], it behooves him first to acknowledge God and the Holy Church and all the Saints, and his master and his fellows as his own brethren.

The second point, he must fulfill his day's work truly for which he takes his pay.

The third, that he heed the council of his fellows in the lodge, and in the chamber, and in every place where they are as masons.

The fourth point, that he do no disservice to the aforesaid art, neither prejudice nor give support to any articles against the skill nor against any of the art, but he shall support it with all honor as much as he may.

The fifth point, when he shall take his pay, he shall take it meekly at the time ordered by the master for it and that he fulfill the stipulations of work and of his rest [periods] as ordered and fixed by the master.

The sixth point, if any discord shall arise between him and his fellows, he shall obey him [the master] meekly and be still at the bidding of his master or of the warden of his master, in his master's absence, until the holy day following and that he agree then to the disposition of his fellows and not upon the work days [which would] hinder their work and the profit of his lord.

The seventh point, that he covet not the wife or the daughter of his master, or of another of his fellows unless it be for the marriage [of the daughter], nor keep concubines because of the discord that might befall among the fellows.

The eighth point, if it befall him to be warden under his master that he be true between his master and his fellows and that he be busy in absence of his master to the honor of his master and to the profit of the lord he serves.

The ninth point, if he be wiser and more subtile [in his skill] than his fellows working with him in his lodge or in any other place and he perceives that this fellow should leave the stone that he is working on for want of cunning, and if he can teach him and improve the stone, he shall tell him and help him [so] that more love may increase among them and that the work of the lord be not lost.

EDWARD III OF ENGLAND

[Edward III (1312–1377), the eldest son of Edward II and Isabella of France, was born at Windsor, and crowned in 1327. His claim to the French crown commenced a strug-

gle which was prolonged into the Hundred Years' War. Despite being constantly preoccupied in holding his French provinces, he devoted much time and money to rebuilding Windsor Castle. Henry II had built a round tower there in 1272 to replace the walls of William the Conqueror. Edward III reconstructed it on a more massive scale as the meeting place for the Order of the Garter, which he established to fulfill a vow he had taken to restore the Round Table of the Knights of King Arthur. In order to secure the large number of masons required for the building, the right of purveyance was used to impress them. It was an ancient right of the English sovereign to receive lodging and food for himself and his suite when traveling through the country. It was later interpreted to mean provision in the widest sense, including compulsory labor, and was used to secure the labor necessary to erect Westminster Abbey, Westminster Palace, and other royal buildings.]

CONCERNING THE TAKING OF MASONS[1]

The King to the same [sheriffs, mayors, bailiffs and other ministers] greeting. Know that we, trusting in the discretion and loyalty of Master Robert of Gloucester,[2] our mason, have assigned and deputed him to take and arrest as many masons, [cementarios][3] as may be necessary for the erection of our works in our castle of Wyndesore, wherever he can find them, within liberties or without, and to place them in our works aforesaid at our wages, and to take and arrest all masons[4] whom he shall find contrary or rebellious in this matter and bring them to the aforesaid

[1] The text is from D. Knoop and G. Jones, *The Mediaeval Mason*, London, 1933; pp. 244-245.

[2] Robert of Gloucester: the warden of the royal masons at Windsor and at London.

[3] *Cementarios, latomos:* Latin words used almost universally in the twelfth and thirteenth centuries, and synonymous with the Norman French word *masoun* used to designate the ordinary mason. See also P. du Colombier, *Les Chantiers des Cathédrales,* Paris, 1953, p. 36.

[4] In England, even prior to the Black Death of 1361, there was a scarcity of masons.

castle there to be held in prison until they shall find security to remain at those works according to the instruction of the said Robert on our behalf. And therefore we command you that to the same Robert in these matters &c you be of assistance. In witness whereof &c. At Redyng, January 6th, 1359/1360.

The King to the sheriff of Norfolk and Suffolk greeting. We command you as strictly as we can that immediately on sight of these present letters you cause to be chosen and attached within the said counties, whether within liberties or without, of the better and more skilled masons [*latomos*] forty masons [*latomos*] for hewing freestone and forty masons [*latomos*] for laying stone and cause them to be brought or sent, with the tools belonging to their trade, to our castle of Windsor so that you have them there by the first of May next at the latest, to be delivered to our beloved clerk William of Wykeham,[5] clerk of our works there, to remain at our works for as long as may be necessary at our wages. And you shall take from all the same masons such sufficient security as you would be willing to answer for to us that they will remain continuously in our aforesaid works and will not depart therefrom without our special licence. And all masons whom the aforesaid William shall certify to you as having left our said works without leave and returned to the aforesaid counties you shall cause to be bodily taken and arrested wherever they may be found in your bailiwick, whether within or without, and kept securely in our prison, so that without our special mandate they shall in no wise be released from the same. And you shall inform us clearly and without concealment by the first of May of the names of masons aforesaid and of the security you take from each of them to remain at our works

[5] William of Wykeham (1323–1404) entered Edward III's service in 1356 and was appointed supervisor of the king's works in the castle of Windsor in that year. He was never an architect, but as clerk of the works paid and supervised the master-mason, William of Wynford. Wykeham took orders in 1362 and was elected Bishop of Winchester in 1366. Richard II appointed him chancellor in 1389.

for as long as may be necessary at our wages.[6] And you shall take from all the same masons such sufficient security as you would be willing to answer for to us that they will remain continuously in our aforesaid works and will not depart therefrom without our special licence. And all those masons whom the aforesaid William shall certify to you as having left our said works without leave and returned to the aforesaid counties you shall cause to be bodily taken and arrested wherever they may be found in your bailiwick, whether within liberties or without, and kept securely in our prison, so that without our special mandate they shall in no wise be released from the same. And you shall inform us clearly and without concealment by the first of May of the names of masons aforesaid and of the security you take from each of them to remain at our works aforesaid. And this you shall in no wise omit on pain of forfeiting everything you can forfeit us. Witness the King at Westminster April 12th 1361.

ANNUAL REPORTS ON THE BUILDING OPERATIONS OF MILAN CATHEDRAL

[The Milan Cathedral was founded in 1386 by Gian Galeazzo Visconti, who, by the murder of his uncle in 1385, became the sole ruler of the enlarged Milanese territories. He was ambitious to erect a church to rival the largest Gothic cathedrals and succeeded in that it was the largest church in Europe until surpassed by St. Peter's in Rome and the Cathedral of Sevilla.

It is not known who produced the original designs on

[6] Compare Geoffrey Chaucer, *The Knight's Tale*, The Canterbury Tales, edited by F. N. Robinson, Boston, 1944, p. 41.

> "And shortly to concluden, swich a place
> Was noon in erthe, as in so litel space;
> For in the lond ther was no crafty man
> That geometrie or ars-metrike kan,
> Ne portreyour, ne kervere of ymages,
> That Theseus ne yaf him mete and wages,
> The theatre for to maken and devise."

Chaucer succeeded William of Wykeham as Clerk of the King's Work at the time Windsor Castle was being completed.

which the foundations were established, but soon the local
Lombard Gothic builders had difficulty in solving the con-
struction problems that arose and the building council con-
sulted French and German master-masons more experi-
enced in Gothic principles of architectural construction.
The annual records of the building operations of the cathe-
dral provide a documentary account of the negotiations
with the numerous French and German architects brought
at various times to Milan, appointed "chief engineer" of the
cathedral, and then released when their solutions did not
meet the approval of the building council. Among them
were Nicolas de Bonaventure, Heinrich Parler of Gmuend,
a member of the famous mason-architect family, Ulrich von
Ensingen, the master-mason of Ulm Münster, and Annas
de Firimburg.]

ANNUAL REPORTS ON THE BUILDING
OPERATIONS OF MILAN CATHEDRAL[1]

1400 Sunday, 25 January. Master Jean Mignot has stated
to the council here present that he has given in writing to
the said council a note computing to date all the reasons
and every motive which lead him to say that the aforesaid
work lacks strength, and he does not wish to give other
reasons.

Final statements were given by aforesaid Master Jean on
the 25th day of January.

Master Jean Mignot points out to you excellent lords of
the workshop council of the Milanese church with respect

[1] The translated excerpts are from *Annali della fabbrica del
Duomo di Milano dall'origine fino al presente,* edited by C.
Gaetano, Milan, 1877; Vol. I, pp. 209 ff., and the footnotes are
taken with Prof. James Ackerman's kind permission from "*Ars
sine scientia nihil est,* Gothic Theory of Architecture at the Ca-
thedral of Milan," *Art Bulletin,* June 1949. See also Dr. P. Frankl,
"The Secret of the Mediaeval Masons," *Art Bulletin,* March 1945.
In 1399, Jacob Cova of Bruges, referred to as a painter, came
with two assistants, Jean Campanios, a Norman, and Jean Mignot,
a Parisian, and was appointed chief engineer. Nine months later
the first two named left. Jean Mignot remained and presented to
the building council his criticism of the construction and sug-
gestions for proceeding. He was dismissed in December 1400.

and pure truth that as he had demonstrated in writing else-
where and among other matters, the defects of said church,
he reiterates and affirms that all the buttresses around the
church are neither strong nor able to sustain the weight
which rests upon them, since they ought in every case to
be three times the thickness of one pier in the interior of
the church. The Masters reply:

Concerning the first statement, they say that all the but-
tresses of said church, are strong and capable of sustaining
their weight and many times more, for many reasons, since
one braccio of our marble and *saritium*,[2] whatever its width,
is as strong as two braccia of French stone or of the French
church[3] which he gives to the aforesaid masters as an ex-
ample. Therefore they say that if aforesaid buttresses are
one-and-a-half times [the size]—and they are—of the piers
in the interior of the church, that they are strong and cor-
rectly conceived, and if they were larger they would darken
said church because of their projection, as at the church
in Paris, which has buttresses of Master Jean's type, and
since they can be an obstruction [there are] other reasons.

Moreover, he [Mignot] says that four towers were begun
to support the crossing-tower of said church, and there are
no piers nor any foundation capable of sustaining said tow-
ers, and if the church were to be made with said towers
in this position it would infallibly fall. Concerning the
claims, however, which were made by certain ignorant peo-
ple, surely through passion, that pointed vaults are stronger
and exert less thrust than round, and moreover concerning
other matters, proposals were made in a fashion more will-
ful than sound; and what is worse, it was objected that
the science of geometry should not have a place in these
matters, since science is one thing and art another. Said
Master Jean says that art without science is nothing [*ars
sine scientia nihil est*[4]], and that whether the vaults are
pointed or round, they are worthless unless they have a

[2] A local building stone employed in the foundations and under
marble facing.

[3] Notre Dame in Paris.

[4] Art is used in the sense of "technique" and science in the
sense of (geometrical) "theory."

good foundation, and nevertheless, no matter how pointed they are, they have a very great thrust and weight.

Whereupon they [the Masters] say that the towers which they wanted to make are for many reasons and causes [desirable]. Namely, in the first place, to integrate aforesaid church and transept so that they correspond to a rectangle according to the demands of geometry, but beyond this, for the strength and beauty of the crossing-tower. To be sure, as if as a model for this, the Lord God is seated in Paradise in the center of the throne, and around the throne are the four Evangelists according to the Apocalypse, and these are the reasons why they were begun. And although two piers of each sacristy are not founded, but begin at ground level, the church is truly strong nevertheless for these reasons, that there are projections upon which the said piers stand, and the said projections are of large stones and joined with iron dowels as was said above with other statements, and that the weight on these three [sic] towers falls evenly on their square, and they will be built properly and strong, and what is vertical cannot fall;[5] therefore they say that they are strong in themselves, and for that reason will give strength to the crossing-tower, which is enclosed in the center of those towers. Therefore said church is truly strong.

Moreover he [Mignot] recognizes that their premises are willfully conceived, nor do those who disagree wish to give in to the right and the betterment of said church and workshop, but want to win their case either for their own profit or from fear, or else from obstinacy, since they would like to continue in spite of defects. For this reason said Master Jean requests that four or six or twelve of the better engineers who are expert in these matters might be brought together, either from Germany, England, or France, otherwise said work will certainly fall, which would be a great loss in every way. Further, to make the truth clear and to conserve his honor, he wishes to be allowed an audience with the illustrious lord, the Duke, to explain to him in general the aforesaid things and other matters. Moreover he

[5] This statement is contrary to the laws of statics.

indicates that it would be for the good of the church to work elsewhere in said church than over defective places, at least until such time as provisions and decisions might be clearly made concerning these defects.

Whereupon they [the Masters] say and reply in the same statement, that where it says that the science of geometry should not have a place in these [matters], the above-mentioned say: if he [Mignot] invokes, as it were, the rules of geometry, Aristotle says that the movement of man in space which we call locomotion is either straight or circular or a mixture of the two.[6] Likewise the same [writer] says elsewhere that every body is perfected in three [ways], and the movement of this very church rises *ad triangulum*[7] as has been determined by other engineers. So they say that all [the measurements] are in a straight line, or an arch, therefore it is concluded that what has been done, has been done according to geometry and to practice, and even he [Mignot] has said that science without art is nothing;[8] concerning art, however, replies have been made already in other statements.

1400—21 February. On 21 February 1400, in his palace there came before the most reverend Archbishop of Milan numerous deputies and members of the council of the Cathedral, and Simonetus Negrus, Johannes Sanomerius, and Mermetus de Sabandia [Savoy], all three French engineers and [they] were queried on the questions set forth in writing below as to what they would say and decide under oath since they are in transit to Rome.

First it was asked on this question by the above-mentioned lords if it seemed to them that this church was adequately founded to sustain and carry the weight belonging to said church.

[6] The argument is entirely irrelevant, since it applies a law of dynamics to statics.

[7] This refers to the process of "triangulation," a Gothic method of designing the cross section of a building by inscribing it within a triangle, usually equilateral.

[8] Note that Mignot's statement has been twisted to fit the argument. See also R. Wittkower, *Architectural Principles in the Life of Humanism*, London, 1949.

We the aforesaid engineers and masons say that we have seen and reviewed all of said church, and especially we have seen the foundations of two piers exposed, which two piers should sustain and abut the apse of said church, and are inadequately and poorly founded. And one of these is more than a foot at fault inside the work, and of poor material. All the piers of said church both inside and outside are to be reviewed down to the lowest base and all those which were badly founded as are the aforementioned, are to be refounded of large blocks of well-laid stone, and their bedding should be well leveled and planed and joined, and buttressed by dovetailing into the other foundations well inside, and built in with a mortar bath. These foundations should be made two braccia or more beyond the plumb line of the bases of the piers, coming to one braccio at the surface by a setback.

Furthermore, it was asked and the question was put if the aforementioned two piers outside the apse of said church are strong enough to sustain and buttress against all its weight.

We state that if one founded two piers for carrying two flying buttresses, that the church would be made stronger, but to avoid impediment, we state that it should be refounded of one weight of large blocks of good stone, and mortared [? goger] and joined [? gont], that is, well squared and set in a bath of mortar of four braccia abutting along the whole length up to the level of the earth. And said stones should be buttressed by dovetailing below the other foundation, and from ground level up, by lengthening or widening said two piers by two braccia all the way up. And the new stones should be doweled with the old ones, and in this fashion we think they can carry their weight.

Furthermore, it was asked and the question was put if all the other piers of said church seemed to us to be good.

We state that if they were to be made now they could be made better.

Furthermore it was asked if all the aforesaid piers could carry and transmit their loads as they are (now).

We reply that it seems so to us providing a good mason

were available to change the mouldings and load-bearing members above the capitals, and to make this moulding proper and lighter, as it should be, since some of these piers are not well aligned. The purpose of this would be to arrange them correctly so that there should not appear to be bad workmanship in them, and also to load them less.

Furthermore we note that there are cracks and holes cut through from the circular openings [probably stairwells] of the corner pier of the sacristies of this cathedral to carry off the rain water that is shed from the roofs of the sacristies and chapels, and this is unsound. It is necessary that they be closed and cemented up and that additional, new gargoyles be made which should have their gutters [? *pancas*] and channels [? *noves*] and crockets [? *brodes*] to receive said water. Also a new dado should be made for the choir, outdoors.

(Signed) Symonetus Nigrus, Johannes Sanomerius, and Mermetus de Sabaudia.

1400—8 May. In the name of God and the Virgin Our Lady Saint Mary, in the year 1400 on the 8th of May. I, Bertholino of Novara, who have been sent by the illustrious and most high prince, my lord, the Duke, for certain views and disagreements brought up by some of the masters in the construction and commission of the church of our lady, St. Mary, which disagreements and opinions the overseers of the said construction have given me in writing, and I have seen and examined, and besides, I have been with the masters and engineers who are at present on this said construction, to see the disagreements with my own eyes from every angle. And besides this looking, I had the foundations of the said church dug into at certain points to see the said foundations, so as to be clearer about the doubts brought up about the construction. Briefly answering, I said that the church should have had a truer proportion around the foundations, and in certain other places above ground. But it is not to be scorned on that account, in fact it is to be praised for a most beautiful big building, but in my opinion it would have to have an addition made for permanent strengthening as follows:

First, because the buttresses of the body of the church are not as large as is needed, considering the breadth and height of the said church, the first nave should be reduced to the form of chapels with partitions between one chapel and another, with some openings through which one could see the Host from either side of the church. By doing this the greatest strength would result in the other three naves, on account of these thrown arches, it would have a sounder base, and the body of the church would be beautiful and more wisely rational because it would match the size of the crossing.

Further, there would be need to make a chapel at the apse of the church toward the cemetery, which chapel would be attached to those two buttresses on the right side, making it as small as possible and not damaging anything already built, and this chapel would result in more strength, and in this area could be placed that tomb which it is said my lord, the Duke, wishes to make, and with the tomb installed in this place it could be located straighter, because the choir would turn out larger.

Further, I say that this addition would not cause the main part to be worked over or removed, and the method begun and approved would be followed.

Master Bernardo of Venice, Master Bertolino of Novara.[9]

CONTRACT FOR BUILDING THE NAVE OF FOTHERINGHAY CHURCH

[The Fotheringhay Church was begun by Edmund Langley, the fifth son of Edward III, to serve the college he founded. He erected a choir at the eastern end of the parish church. His son, Edward, Duke of York, wished to continue the project by rebuilding the nave in agreement with the

[9] The above opinion on the matter was given at the command of the Duke Gian Galeazzo Visconti by Bertolino of Novara and the court architect, Bernardo of Venice. Their advice was not followed. The building committee in spite of the contentions and criticisms of the northerners and their own countrymen continued

choir, and appointed trustees to carry his intentions into execution. He was killed at Agincourt in 1415 before the building could be begun. Richard, Duke of York, (1411–1460), his nephew and successor, signed through commissioners the deed of agreement with William Horwood to fulfill the desire of his uncle. The nave was probably completed in time to receive for burial the body of Richard. He had laid claim to the English crown and after having been acknowledged Henry VI's heir was slain by the Lancastrians.

William Horwood, given in the contract as living in Fotheringhay, may be the same William Horwood mentioned as a citizen of London to whom Roger Mapilton, mason, owed forty shillings in 1459. Roger was related to Thomas Mapilton, the King's chief mason from 1421 until his death in 1438. Thomas Mapilton and Stephen Lote (active 1390–1418) collaborated in the execution of the tomb of Edward, Duke of York, in the Fotheringhay Church choir. The design of the choir, now destroyed, but from which the nave was copied, was to be traced back to these two master-masons. Thomas Mapilton's principal work was the great southwest tower of Canterbury Cathedral.]

CONTRACT FOR BUILDING
THE NAVE OF FOTHERINGHAY CHURCH, 22ND SEPTEMBER, 1434[1]

This contract made between William Wolston, squire, Thomas Pecham, clerk, commissioners for the high and

to follow their own methods in the cathedral's construction and despite "the poor foundations, weak piers, inadequate buttresses (the present buttresses were added in the late eighteenth and early nineteenth centuries), undivided chapels, the *falso ordino* of triangulation, and vaults 'which do not exert a thrust on the buttresses,' the church has survived for five and a half centuries." Ackerman, *op. cit.*, p. 104.

[1] The text from D. Knoop and G. Jones, *The Mediaeval Mason*, London, 1933, pp. 245–248, has been modernized. See also: H. F. Bonney, *Historical Notes in reference to Fotheringhay*, London, 1821; John H. Harvey, *Gothic England*, London, 1948,

mighty prince, and my right dread lord, the Duke of York, on the first part, and William Horwood, free-mason, dwelling in Fotheringhay, on the other part, witnesses that the same William Horwood has granted and undertaken, and by this same has contracted, granted and undertaken to make up a new nave of a church joining to the choir, of the college of Fotheringhay, of the same height and breadth that the said choir is; and in length eighty feet from the said choir downward, within walls a meter-yard [thick] a meter-yard of England, counted always as three feet. And in this covenant, the said William Horwood shall also make well all the ground work of the said nave, and take it and excavate it at his own cost, and as slowly and as adequately as it ought to be, overseen by masters of the same craft. The material that belongs to such a work is sufficiently provided for him at my said lord's cost. And to the said nave he shall make two aisles, and do the ground work and excavation of them in the aforesaid manner, both the aisles to be in accordance with the height and breadth of the aisles of said choir, and the height of the aforesaid nave; the ground of the same nave and aisles to be made within the end with rough stone under the ground table-stones; and for the ground stones b..ments [sic]; and all the remainder of the said nave and aisles to the full height of said choir all made with clean-hewn ashlar in the outer side to the full height of the said choir. And all the inner side to be of rough-stone,[2] except that the bench-table-stones,[3] the sills of the windows, the pillars and capitals that the arches and pendants rest upon, shall all be of free-stone wrought truly and duly as it ought to be.

And in each aisle shall be windows of free-stone, agreeing in all points to the windows of the said choir, but they

and *idem, English Mediaeval Architects,* London, 1954; L. F. Salzman, *Building in England down to 1540,* Oxford, 1952, pp. 505–508.

[2] The rough stone was plastered over to give it a smooth surface.

[3] "Bench-table-stone": a projecting course at the base of a building or around a pillar.

shall have no bowtels[4] at all. And in the west end of either of the said aisles, he shall make a window of four lights, agreeing with the windows of the said aisles. And to either aisle shall be as square embattaillment of free-stone through out, and both the ends embattailled[5] butting upon the steeple. And either of the said aisles shall have six mighty buttresses of free-stone, clean-hewn; and every buttress finished with a pinnacle, agreeing in all points to the pinnacles of the said choir, save only that the buttress of the nave shall be larger, stronger and mightier than the buttress of the said choir.

And the clerestory, both within and without, shall be made of clean ashlar grounded upon ten mighty pillars, with four responds;[6] that is to say two above joining the choir, and two beneath joining to the end of the said nave. And to the two responds of the said choir shall be two perpeyn-walls[7] joining of free-stone, clean wrought: that is to say, one on either side of the middle choir door. And in either wall, three lights, and piscinas on either side of the wall, which shall serve for four altars, that is to say one on either side of the middle door of the said choir and one on either side of the said aisles.

And in each of the said aisles shall be five arches above [sic] the steeple, and above every arch a window and every window to be of four lights, agreeing in all points to the windows of the clerestory of the said choir. And either of the said aisles shall have six mighty arches butting on either side to the clerestory, and two mighty arches butting on either side to the said steeple, agreeing with the arches of the said choir, both in table-stones and crestis, with a square embattaillment thereupon.

And in the north side of the church the said William Horwood shall make a porch; the outer side of clean ashlar, the inner side of rough stone, containing in length twelve

[4] "Bowtels": three-quarter round convex moulding.
[5] Battlements were an important feature of the perpendicular style.
[6] "Responds": half piers.
[7] "Perpeyn-walls": built of prebend-stone, reaching through a wall so as to appear on both sides of it and act as a binder.

feet, and in breadth as the buttress of the said nave will permit; and in height agreeing to the aisle of the same side, with reasonable lights in either side; and with a square embattaillment above.

And in the south side toward the cloister, another porch joining the door of said cloister, being as wide as the buttress will permit, and in height between the church and the [cloister] door, with a door in the west side of the porch toward the town; and in either side as many lights as will suffice; and a square embattaillment above, and in height agreeing with the place where it is set.

And to the west end of the said nave shall be a steeple standing [high above] the church upon three strong and mighty arches vaulted with stone. The said steeple shall have in length eighty feet after the meter-yard of three feet to the yard, above the ground from the table-stones, and [measure] twenty feet square within the walls, the walls being six foot thick above the said ground table-stones. And to the height of the said nave [of the church], it shall be square, with a large door, which shall be in the west end of the same steeple.

And when the said steeple comes to the height of the said battlement, then it shall be changed and turned[8] in eight panes and at every angle, a buttress finished with a pinnacle agreeing to the pinnacles of the said choir and nave; the said chapell [to be] embattailled with a large square embattaillment. And above the door of the said steeple, a window rising in height as high as the great arch of the steeple and in breadth as wide as the nave will come out to be. And in the said steeple will be two floors, and above each floor eight clerestory set in the middle of the wall, each window of three lights, and all the outer side of the steeple of clean wrought free-stone; and the inner side of rough stone. And in said steeple shall be a stair-way [? *ulce towrnyng*], serving up to the said nave, aisles and choir, both beneath and above. Included is all manner of work necessary that belongs to such a nave, aisles, steeple and

[8] See Roriczer, p. 99, note 7.

porches, also as is comprehended and expressed, [even] that not comprehended in this agreement.

And for all the work that is devised and rehearsed in this same agreement, my said Lord of York shall find the carriage and materials, that is to say, stone, lime, sand, ropes, bolts, ladders, timber, scaffolds, machines, and all kinds of materials that belong to the said work, by which the work will be well, truly, and duly made and finished in the manner as it is above devised and declared. The said William Horwood shall have of my said lord, three hundred pounds Sterling; of which sum he shall be paid in the manner as it shall be declared hereafter; that is to say, when he has excavated the ground of said church, aisles, buttresses, porches, and steeple, hewn and set his ground table-stones, and his string-courses and the wall thereto within and without as it ought to be well and duly made, then he shall have six pounds, thirteen shillings, four pence. And when the said William Horwood has set one foot above the ground table-stone, also the outer side as well as the inner side throughout all the said work, then he shall have payment of a hundred pounds Sterling. And so for every foot of the said work, after it be fully wrought and set as it ought to be and as it is above devised, until it comes to the full height of the highest pinnacles and battlement of the said nave, hewing, setting, raising [the tower] of the steeple after it has passed the highest embattaillment of the said nave, he shall have but thirty shilling Sterling, until it be fully ended and completed in the manner as it is above directed.

And when all the work above rehearsed and devised is fully finished, as it ought to be and as it is above agreed to and devised between the said commissioners and the said William, then the said William Horwood shall have full payment of the three hundred pounds Sterling if any be due or left unpaid thereof to him. And during all the said work, the said William Horwood shall neither set more nor fewer masons, nor less rough setters thereupon, but as shall be ordained by the governance and supervision of the said work as my Lord of York will ordain and assign him to have.

And if it be that the said William Horwood not make full

payment to all or any of his workmen, then the clerk of the work shall pay him [the workman] in his presence and stop as much from the said William Horwood's hand as the payment amounts to that shall be due to the workmen.

And during all the said work, the setters shall be chosen and taken by those that shall have the control and supervision of the said work for my said lord. They are to be paid by the hand of the said William Horwood, in the form and manner above written and devised. And if it should be that the said William Horwood will complain and say at any time that two setters or any of them, be not profitable nor adequate workmen for my lord's profit, then with the oversight of the master-masons of the country they shall be judged. And if they be found faulty or unable, then they shall be changed and others taken and chosen by such as shall have control of the said work by my said lord's order and command.

And if it be that the said William Horwood makes not end of the said work within reasonable time, which shall be set clearly by my said lord, or by his counsel in form and manner as is above written and devised in these same agreements, then he shall yield his body to prison at my lord's will, and all his movable goods and heritances at my said lord's disposition and order.

In witness, & the said commissioners, as [well as] the said William Horwood have set their seals interchangeably to these present contracts, the XXIVth day of September, the XIIIth year of the reign of our sovereign lord King Henry the Sixth, after the conquest of England.

WILLIAM DURAND

[William Durand, called "The Speculator" (*ca.* 1220–1296), a nobleman of Languedoc whose clerical life led him through a professorship in canon law at Modena, several military campaigns for the Papacy, a provincial governorship and a Bishopric, wrote about 1286 on the origin and

symbolism of the Christian ritual, including one book on the meaning of a church and its parts.

His work presents a picture of the thirteenth century penchant for symbolism, for the Gothic mind accepted every artistic detail of a church as a token of some aspect of Catholic dogma; at the same time it affords a contemporary explanation, however brief or prejudiced, of the principal religious images of the Gothic period.]

RATIONALE OF THE DIVINE OFFICES[1]

CHAPTER III. *Of Pictures and Images, and Curtains, and the Ornaments of Churches.* 1. Pictures and ornaments in churches are the lessons and the scriptures of the laity. Whence Gregory: It is one thing to adore a picture, and another by means of a picture historically to learn what should be adored. For what writing supplieth to him which can read, that doth a picture supply to him which is unlearned, and can only look. Because they who are uninstructed thus see what they ought to follow: and *things* are read, though letters be unknown. True is it that the Chaldeans, which worship fire, compel others to do the same, and burn other idols. But Paynim adore images, as icons, and idols; which Saracens do not, who neither will possess nor look on images, grounding themselves on that saying, "Thou shalt not make to thyself any graven image, nor the likeness of any thing that is in heaven above, nor in the earth beneath, nor in the waters under the earth," and on other the like authorities: these they follow incontinently, casting the same in our teeth. But we worship not images, nor account them to be gods, nor put any hope of salvation in them; for that were idolatry. Yet we adore them for the memory and remembrance of things done long ago. . . .

2. The Greeks, moreover, employ painted representa-

[1] The selection is from William Durandus, *Rationale Divinorum Officiorum, Book I*, translated by J. M. Neale and B. Webb as *The Symbolism of Churches and Church Ornaments*, 1st ed., Leeds, 1843, pp. 53–69. Mr. Charles P. Parkhurst, Jr., contributed the biographical note and selected the material.

tions, painting, it is said, only from the navel upwards, that all occasion of vain thoughts may be removed. But they make no carved image, as it is written, "Thou shalt not make a graven image." And again: "Thou shalt not make an idol, nor a graven image." And again: "Lest ye be deceived, and make a graven image." And again: "Ye shall not make unto you gods of silver: neither shall ye make with Me gods of gold." So also the Prophet, "Their idols are silver and gold, the work of man's hand. They that make them are like unto them: and so are all they that put their trust in them." And again: "Confounded be all they that worship graven images: and that put their glory in their idols."

3. Also, Moses saith to the children of Israel, "Lest perchance thou shouldest be deceived, and shouldest worship that which the Lord thy God hath created." Hence also was it that Hezekiah King of Judah brake in pieces the brazen serpent which Moses set up: because the people, contrary to the precepts of the Law, burnt incense to it.

4. From these forementioned and other authorities, the excessive use of images is forbidden. The Apostle saith also to the Corinthians, "We know that an idol is nothing in the world: and there is no god but One." For they who are simple and infirm may easily by an excessive and indiscreet use of images, be perverted to idolatry. Whence he saith in Wisdom, "There shall be no respect of the idols of the nations, which have made the creatures of God hateful, and temptations for the souls of men, and snares for the feet of the unwise." But blame there is none in a moderate use of pictures, to teach how ill is to be avoided, and good followed. Whence saith the Lord to Ezekiel, "Go in, and behold the abominations which these do. And he went in, and saw the likeness of reptiles and beasts, and the abominations, and all the idols of the house of Israel portrayed on the wall." Whence saith Pope Gregory in his Pastorale, "When the forms of external objects are drawn into the heart, they are as it were painted there, because the thoughts of them are their images." Again, He saith to the same Ezekiel, "Take a tile, and lay it before thee, and describe in it the city Jerusalem." But that which is said above, that pictures are the letters of the laity ex-

plaineth that saying in the Gospel, "He saith, They have Moses and the prophets: let them hear them." Of this, more hereafter. The Agathensian Council forbids pictures in churches: and also that that which is worshipped and adored should be painted on the walls. But Gregory saith, that pictures are not to be put away because they are not to be worshipped: for paintings appear to move the mind more than descriptions: for deeds are placed before the eyes in paintings, and so appear to be actually carrying on. But in description, the deed is done as it were by hearsay: which affecteth the mind less when recalled to memory. Hence, also, is it that in churches we pay less reverence to books than to images and pictures.

5. Of pictures and images some are above the church, as the cock and the eagle: some without the church, namely, in the air in front of the church, as the ox and the cow: others within, as images, and statues, and various kinds of painting and sculpture: and these be represented either in garments, or on walls, or in stained glass. Concerning some of which we have spoken in treating of the church: and how they are taken from the tabernacle of Moses and the temple of Solomon. For Moses made carved work, and Solomon made carved work, and pictures, and adorned the walls with paintings and frescoes.

6. The image of the Saviour is more commonly represented in churches three ways: as sitting on His throne, or hanging on His cross, or lying on the bosom of His Mother. And because John Baptist pointed to Him, saying, "Behold the Lamb of God," therefore some represented Christ under the form of a lamb. But because the light passeth away, and because Christ is very man, therefore, saith Adrian, Pope, He must be represented in the form of a man. A holy lamb must not be depicted on the cross, as a principal object: but there is no let when Christ hath been represented as a man, to paint a lamb in a lower or less prominent part of the picture: since He is the true Lamb which "taketh away the sins of the world." In these and divers other manners is the image of the Saviour painted, on account of diversity of significations.

7. Represented in the cradle, the artist commemorateth

His nativity: on the bosom of His Mother, His childhood: the painting or carving His cross signifieth His Passion (and sometimes the sun and moon are represented on the cross itself, as suffering an eclipse): when depicted on a flight of steps, His Ascension is signified: when on a state or lofty throne, we be taught His present power: as if He said: "All things are given to Me in heaven and in earth": according to that saying, "I saw the Lord sitting upon His Throne": that is, reigning over the angels: as the text, "Which sitteth upon the Cherubin." Sometimes He is represented as He was seen of Moses and Aaron, Nadab and Abihu, on the mountain: when "under His Feet was as it were a paved work of sapphire stones, and as the body of heaven in His clearness": and as "they shall see," as saith St. Luke, "the Son of Man coming in the clouds with power and great glory." Wherefore sometimes He is represented surrounded by the seven angels that serve Him and stand by His throne, each being portrayed with six wings, according to the vision of Isaiah, "And by it stood the seraphim: each one had six wings: with twain he covered his face, and with twain he covered his feet, and with twain he did fly."

8. The angels are also represented as in the flower of youthful age: for they never grow old. Sometimes St. Michael is represented trampling the dragon, according to that of John, "There was war in heaven: Michael fought with the dragon." Which was to represent the dissentions of the angels: the confirmation of them that were good, and the ruin of them that were bad: or the persecution of the faithful in the Church Militant. Sometimes the twenty-four Elders are painted around the Saviour, according to the vision of the said John, with "white garments, and they have on their heads crowns of gold." By which are signified the doctors of the Old and New Testaments; which are twelve, on account of faith in the Holy Trinity preached through the *four* quarters of the world: or twenty-four, on account of good works, and the keeping of the Gospels. If the seven lamps be added, the gifts of the Holy Spirit are represented: if the sea of glass, Baptism.

9. Sometimes also representation is made of the four liv-

ing creatures spoken of in the visions of Ezekiel and the aforesaid John: the face of a man and the face of a lion on the right,—the face of an ox on the left, and the face of an eagle above the four. These be the Four Evangelists. Whence they be painted with books by their feet, because by their words and writings they have instructed the minds of the faithful, and accomplished their own works. Matthew hath the figure of a man, Mark of a lion. These be painted on the right hand: because the Nativity and the Resurrection of Christ were the general joy of all: whence in the Psalms: "And gladness at the morning." But Luke is the ox: because he beginneth from Zachary the priest, and treateth more specially of the Passion and Sacrifice of Christ: now the ox is an animal fitted for sacrifice. He is also compared to the ox, because of the two horns,—as containing the two testaments; and the four hoofs, as having the sentences of the four Evangelists. By this also Christ is figured, who was the sacrifice for us: and therefore the ox is painted on the left side, because the death of Christ was the trouble of the Apostles. Concerning this, and how Blessed Mark is depicted, in the seventh part. But John hath the figure of the Eagle: because, soaring to the utmost height, he saith, "In the beginning was the word." This also representeth Christ, "Whose youth is renewed like the eagle's": because, rising from the dead, He ascendeth into Heaven. Here, however, it is not portrayed as by the side, but as above, since it denoteth the Ascension, and the word pronounced of God. But how, since each of the living creatures hath four faces and four wings, they can be depicted, shall be said hereafter.

10. Sometimes there are painted around, or rather beneath, the Apostles; who were His witnesses by deed and word to the ends of the earth: and they are portrayed with long hair, as Nazarenes, that is, holy persons. For the law of the Nazarenes was this: from the time of their separation from the ordinary life of man, no razor passed upon their heads. They are also sometimes painted under the form of twelve sheep: because they were slain like sheep for the Lord's sake: and sometimes the twelve tribes of Israel are so represented. When, however, more or less sheep than

twelve are painted, then another thing is signified, according to that saying of Matthew, "When the Son of Man shall come in His glory—then shall He sit on the throne of His glory: and before Him shall be gathered all nations and He shall separate them one from the other, as a shepherd divideth the sheep from the goats." How the Apostles Bartholomew and Andrew are to be painted, shall be said hereafter.

11. And note that the Patriarchs and Prophets are painted with wheels[2] in their hands. Some of the Apostles with books and some with wheels: namely, because before the advent of Christ the faith was set forth under figures, and many things were not yet made clear, to represent this, the Patriarchs and Prophets are painted with wheels, to signify that imperfect knowledge. But because the Apostles were perfectly taught of Christ, therefore the books, which are the emblems of this perfect knowledge, are open. But because some of them reduced their knowledge in writing, to the instruction of others, therefore fittingly they are presented with books in their hands like doctors. So Paul, and the Evangelists, Peter, James and Jude. But others, who wrote nothing which has lasted or been received into the canon by the Church, are not portrayed with books, but with wheels, as a type of their preaching. Whence the Apostle to the Ephesians, "And he gave some apostles, and some prophets, and some evangelists, and some pastors and teachers for the work of the ministry."

12. But the Divine Majesty is also portrayed with a closed book in the hands: "which no man was found worthy to open but the Lion of the tribe of Juda." And sometimes with an open book: that in it every one may read that "He is the Light of the world": "and the Way, the Truth, and the Life": and the Book of life [is also portrayed]. But why Paul is represented at the right, and Peter at the left of the Saviour, we shall show hereafter.

13. John Baptist is painted as a hermit.

[2] This should read "scrolls." See Meyer Schapiro, in *Studies in Art and Literature for Belle da Costa Greene*, 1954, p. 334, note 13.

14. Martyrs with the instruments of their torture: as St. Laurence with the gridiron: St. Stephen with stones: and sometimes with palms, which signify victory, according to that saying, "The righteous shall flourish like a palm-tree": as a palm-tree flourishes, so his memory is preserved. Hence is it that palmers, they who come from Jerusalem, bear palms in their hands in token that they have been the soldiers of that King Who was gloriously received in the earthly Jerusalem with palms: and Who afterwards, having in the same city subdued the devil in battle, entered the palace of Heaven in triumph with His Angels, where the just shall flourish like a palm-tree, and shall shine like stars.

15. Confessors are painted with their insignia, as Bishops with their mitres, Abbots with their hoods: and some with lilies, which denote chastity. Doctors with books in their hands: Virgins, according to the Gospel, with lamps.

16. Paul with a book and a sword: with a book, as a doctor, or with reference to his conversion: with a sword as a soldier. Whence the verse:

> The sword denotes the ire of Saul,
> The book, the power converting Paul.

17. Generally the effigies of the Holy Fathers are portrayed on the walls of the church, or on the back panels of the altar, or on vestments, or in other various places, so that we may meditate perpetually, not indiscreetly or uselessly, on their holiness. Whence in Exodus it is commanded by the divine law, that in the breast of Aaron, the breastplate of judgment should be bound with strings: because fleeting thoughts should not occupy the mind of a priest, which should be girt by reason alone. In this breastplate also, according to Gregory, the names of the twelve Patriarchs are commanded to be carefully inscribed.

18. To bear the fathers thus imprinted on the breast, is to meditate on the lives of ancient Saints without intermission. But then doth the priest walk blamelessly when he gazeth continually on the example of the Fathers which have gone before, when he considereth without ceasing the footsteps of the Saints, and represseth unholy thoughts, lest he wander beyond the limits of right reason.

19. It is to be noted that the Saviour is always represented as crowned, as if He said, "Come forth, children of Jerusalem, and behold King Solomon in the diadem with which his mother crowned him." But Christ was triply crowned. First by His mother on the day of His Conception, with crown of pity: which was a double crown: on account of what He had by nature, and what was given Him: therefore also it is called a diadem, which is a double crown. Secondly, by His stepmother[3] in the day of His Passion, with the crown of misery. Thirdly, by His Father in the day of His Resurrection, with the crown of glory: whence it is written, "O Lord, Thou hast crowned Him with glory and honour." Lastly, He shall be crowned by His whole family, in the last day of Revelation, with the crown of power. For He shall come with the judges of the earth to judge the world in righteousness. So also all Saints are portrayed as crowned, as if they said: Ye children of Jerusalem, behold the Martyrs with the golden crowns wherewith the Lord hath crowned them. And in the book of Wisdom: "The just shall receive a kingdom of glory, and a beautiful diadem from the hand of their God."

20. But their crown is made in the fashion of a round shield: because the saints enjoy the divine protection. Whence they sing with joy: "Lord, Thou hast crowned us with the shield of Thy favour." But the Crown of Christ is represented under the figure of a cross: and is thereby distinguished from that of the Saints: because, by the banner of His cross He gained for Himself the glorification of His humanity, and for us freedom from our

[3] For the meaning of this passage, Dr. Panofsky generously supplied the following note and reference: (1) The idea of the first crown, bestowed upon Christ in the Incarnation by His Mother, is derived from the Song of Sol. 3:11 and symbolizes Christ's humanity; (2) the second crown is not symbolic but real: it is the crown of thorns (therefore: "crown of misery") placed on His head by "the Jews"; (3) the "stepmother" of Christ is therefore, very simply, the Synagogue (ecclesia Judaeorum) in contrast to His real mother, viz., the Church as personified both in the Virgin Mary and the Bride of the Song of Solomon. See Petrus Berchorius, Dictionarium seu Repertorium morale (composed about 1340), Venice edition, 1583, vol. I, p. 380, s.v. corona.

captivity, and the enjoyment of everlasting life. But when any living prelate, or Saint is portrayed, the glory is not fashioned in the shape of a shield, but four-square: that he may be shown to flourish in the four cardinal virtues: as it is contained in the legend of blessed Gregory.

21. Again, sometimes Paradise is painted in churches, that it may attract the beholders to a following after its rewards: sometimes hell, that it may terrify them by the fear of punishment. Sometimes flowers are portrayed, and trees: to represent the fruits of good works springing from the roots of virtues.

22. Now the variety of pictures denoteth the diversity of virtues. For, "to one is given by the Spirit the word of wisdom: to another the word of knowledge," etc. But virtues are represented under the forms of women: because they soothe and nourish. Again, by the ceilings or vaultings, which are for the beauty of the house, the more unlearned servants of Christ are set forth, who adorn the Church, not by their learning, but by their virtues alone.

The carved images which project from the walls, appear as it were to be coming out of it: because when by reiterated custom virtues so pertain to the faithful, that they seem naturally implanted in them, they are exercised in all their various operations. How a synagogue is depicted, shall be said hereafter: as also how the pall of the Roman Pontiff: and the year and the zodiacal signs and its months. But the diverse histories of the Old and New Testaments may be represented after the fancy of the painter. For

Pictoribus atque poetis
Quod libet addendi semper fuit aequa potestas.

JEAN PUCELLE

[Jean Pucelle was active in Paris from 1319 as a lay book illuminator and the head of a great workshop engaged in book illumination at the time French illumination was the finest in Europe. To him are assigned three magnificent

manuscripts of the first half of the fourteenth century, "The book of Hours of Jeanne II of Navarre," "The Billyng Bible," and "The Breviary of Belleville." The last manuscript, a Dominican breviary in two volumes, received its name from the first owner, Jeanne de Belleville, whose husband, Olivier de Clisson, was executed in the market place of Paris in 1343. As the couple's possessions were confiscated, the breviary probably entered the royal possession shortly after. At the beginning of the first volume is given an explanation of the psalter illustrations written by the same hand as the text. The illustrations portray the relationship of the seven sacraments to the three theological and four cardinal virtues established by St. Thomas Aquinas (1282) in *De Sacramentis* and the prophetic relationship of the Old Testament to the New Testament. The importance of the designs is attested by their being found with certain variations in seven copies and in both the large and small "Hours" of Jean, Duke of Berry, at the end of the fourteenth century. Written in the manuscript is the name of the artist, Pucelle, his assistants and the price paid for a piece.]

THE BELLEVILLE BREVIARY

THE EXPOSITION OF THE IMAGES OF THE FIGURES THAT ARE ON THE CALENDAR AND ON THE PSALTER, AND IS REALLY THE CONCORDANCE OF THE OLD AND NEW TESTAMENTS[1]

St. Gringoire says that he who sees and does not understand profits no more than he who hunts and catches nothing, and Solomon, the sage, agrees with him, when he says that one becomes wise by hearing and understanding, and when one sees anything obscurely shown, one should seek and ask for the meaning and explanation, and in all that follows to the end of the psalter, if there be any obscure figures, I wish to explain them so that each can understand and profit from them.

[1] The translation is from the text as given in *Fifty Manuscripts: A descriptive catalogue in the collection of Henry Y. Thompson*, 2nd series, London, 1902. See also: F. G. Godwin, *Speculum*, 1951, pp 609 ff.

The Scripture says that God is not a man, fallible or
subject to change; for however much man and all crea-
tures may be changed as concerns himself, his works and his
thoughts, nevertheless the Creator, the Supreme Artisan,
cannot undergo change. And as it is He who ordained and
established the Old and the New Testaments, it is proper
that the two should be brought into agreement and unified.
And the Saints agree with this in several places in the Holy
Scripture, when they say that the New Testament is all
present in symbols within the Old Testament. This accord
is the meaning of the pictures hereafter.

First come the Apostles who are the authors of the New
Testament, who gather clauses that are shown obscurely
in the Old Testament, and uncover and clarify them and
the articles of faith; so that for each of the twelve months
there is one of the twelve apostles and one of the twelve
Prophets, in such a way that the prophet gives a veiled
prophecy to the Apostle and the Apostle uncovers it and
makes it an article of faith. And since we speak of the
Synagogue in the time of the Old Testament and the
Church in the time of the New Testament in two different
ways, in the broad and material sense and in the subtle and
spiritual sense, I am putting both ways since at the back
of each is a material synagogue from which the prophet
draws a stone that he gives to the apostle with the prophecy
and the synagogue crumbles away as the days move for-
ward and the articles of faith increase as you can see in the
pictures.

And since the articles of faith are the way and the gates
to enter into Paradise, I am putting the twelve gates of the
heavenly Jerusalem above the twelve apostles, and the
Virgin Mary,[2] through whom the door was opened to us,
holding a panel over each of the gates on which is painted
in a picture the article of faith which the apostle has made
below in words. And each panel corresponds to each article
as is fitting.

And since St. Paul was not yet among the apostles when
they made the Credo and assembled the articles of faith,

[2] Virgin Mary: embodiment of Church.

I put his illumination, how he was illuminated and called, under the first article that the Virgin Mary holds on the panel; and then afterwards for the other months how he preached and demonstrated the articles of faith that the Virgin is holding over the gates to the eleven kinds of people to whom he wrote eleven epistles.

Then, after all this view, comes a page where the apostles gather together and erect a church from the stones that they have drawn and carried from the synagogue, and this church is made in the form that St. Paul devised in one of his epistles that reads thus: "Now therefore ye are no longer strangers and foreigners, but fellow-citizens with the saints, and members of the household of God; built upon the foundation of the apostles and prophets, Jesus Christ Himself being the chief cornerstone."[3]

So is the stone cross above the steeple and the weather vane is Angel Gabriel who announced to the Virgin Mary that she was the beginning of all this good. And at the right arm of the cross of this steeple is St. Paul who affirms the authority that I have put in French and that this church exposes.

And since the scriptures can be set forth in several ways, I am showing the crucifixion differently; I am putting it in the earthly Paradise, in the garden of delight, symbolized by the river that was in the Paradise of delights and that came forth and divided itself into four parts to water the garden of Paradise. It is Jesus Christ who came forth from Paradise and who was extended in four directions on the cross to water the garden of Paradise; because it was so dry that no fruit could grow, no soul could be planted there; therefore, he watered it with His Precious Blood that spread out through the garden in seven streams; and at the end of these streams are the seven sacraments of the Holy Church, from which she is entirely nourished, that issued from and found their strength in the side of Jesus Christ according to the clerics.

Again I show this crucifixion another way, and all that I say here is painted for whoever looks at it. By the cross,

[3] Ephes. II, 19–20.

that is in the garden of Delight, I mean the tree of Life and by Jesus Christ, the fruit. And, below, outside the garden is Eve, the first woman, who plucked the fruit against the will and command of our Lord. And before her is the evil angel who told her that she would take it. And beneath the cross is the good angel who foretold to the second woman, that is to the Virgin Mary, that she would take this fruit, Jesus Christ, through the command of the Lord. And she is there who hears the news quietly and holds out her hand to the fruit and says: "Behold the fruit of life that I give."

Thus we have [shown] how the apostles, executors of the New Testament, gathered the phrases of the Old Testament and brought them to Jesus Christ on the Cross; thus the New Testament was confirmed and sealed and the church was ordained and confirmed; and St. Peter, the founder and first bishop of the Holy Church, who puts out his hand to receive the keys of Paradise that Jesus Christ holds out to him. Then follows another page on which are the four tables of this Testament; there are the four Evangelists and the four beasts appropriate to them who are holding for them the four instruments of the Passion of Jesus Christ.

First, the eagle holds out to St. John the three nails that signify divinity, to the number of three persons, and which, like the divine, is charity, that draws and joins together hearts, therefore the nails are made to attract and join together; and St. John speaks especially of divinity.

Next, the angel extends to St. Matthew the cross that signifies the humanity of Jesus Christ who was a man stretched upon the Cross; and St. Matthew speaks especially of the humanity of Jesus Christ.

Next, the ox holds to St. Luke the spear that signifies the torment and passion; and St. Luke speaks especially of the Passion.

Thus we have the tablets of the New Testament and their figures through which this Testament is formed to endure forever without change.

In the center of these four tables, in a green field, is the treasure of the Holy Church, the Precious Blood of

Jesus Christ, from which this Testament is made. And the Virgin Mary who helped Him conquer, holds Him from one side and calls all to come and ask whether they have any part in this Testament. And St. Peter, on the other side, the first guardian of the treasure, who holds the key, is ready to give to each his part of the Testament. And so that each may readily see what there is, the mirror is in the middle of the treasure where it can readily be seen. Jesus Christ leaves nothing in His Testament except to those who do His will; therefore look at your life and see Jesus Christ in front of you, and the instruments of His passion, and see whether you do well His will.

And there is the shore of the streams issuing from his side; these are the seven sacraments which you see under the seven large letters of the Psalter which the Holy Ghost leads through the seven qualities to the seven virtues, for that is the way which the life of man and woman should follow in this world. And therefore I put the seven virtues under the seven Matins of the Psalter, for by Matins we mean life and by vespers, its end, according to the Scripture. And therefore I put the end of the world, the judgement day, at vespers. "Dixit Dominus." And do not take the path on the left where are the seven vices opposed to the seven virtues. And so you will come to the general reckoning on the day of judgement which you see painted above: "Dixit Dominus." And you will have the gracious gift given by God to his friends when He will say: "Come here my friends who have done my will; take the Kingdom of Paradise which is given over to you for ever without end."

To this kingdom may the Holy Spirit lead us and may Jesus Christ, who is blest throughout all generations receive us. Amen, Amen, Amen.

PROCESSION AT THE COMPLETION OF DUCCIO'S *MAJESTY*

[Duccio di Buoninsegna, founder of the Sienese school of painting, is known principally for his famous altarpiece, the

Majesty, painted for the cathedral of Siena between 1309 and 1311. To celebrate the removal of this great work from the artist's workshop to the high altar for which it was painted, fellow townsmen and clerics formed a solemn procession, of which contemporary chroniclers wrote extravagantly.]

THE PROCESSION[1]

At this time the altarpiece for the high altar was finished, and the picture which was called the "Madonna with the large eyes," or Our Lady of Grace, that now hangs over the altar of St. Boniface, was taken down. Now this Our Lady was she who had hearkened to the people of Siena when the Florentines were routed at Monte Aperto, and her place was changed because the new one was made, which is far more beautiful and devout and larger, and is painted on the back with the stories of the Old and New Testaments. And on the day that it was carried to the Duomo the shops were shut, and the bishop conducted a great and devout company of priests and friars in solemn procession, accompanied by the nine signiors, and all the officers of the commune, and all the people, and one after another the worthiest with lighted candles in their hands took places near the picture, and behind came the women and children with great devotion. And they accompanied the said picture up to the Duomo, making the procession around the Campo, as is the custom, all the bells ringing joyously, out of reverence for so noble a picture as is this. And this picture Duccio di Niccolò the painter made, and it was made in the house of the Muciatti outside the gate *a Stalloreggi*. And all that day they stood in prayer with great almsgiving for poor persons, praying God and His Mother, who is our advocate, to defend us by their infinite mercy from every adversity

[1] The account is translated in Charles Eliot Norton, *Historical Studies of Church-Building in the Middle Ages*, New York, 1880, pp. 144–145. The Italian text is found in G. Milanesi, *Documenti per la storia dell' arte senese*, Siena, 1854, I, p. 169.

See also: Helene Wieruszowski, "Art and the Commune in the Time of Dante," *Speculum*, January 1944, p. 14.

and all evil, and keep us from the hands of traitors and of the enemies of Siena.

CENNINO CENNINI

[Cennino Cennini was born about 1370 near Florence. A record of 1398 shows that as a young man he went to Padua, where he found work in the service of Francesco da Carrara, married, and probably lived the rest of his life. He was a pupil of Agnolo Gaddi, who had been a pupil of Taddeo Gaddi, who in turn was a pupil of Giotto. Thus Cennino is a direct artistic descendant of Giotto and the inheritor of the traditional practices of the fourteenth century Italian art workshop. There are no known works by Cennino in existence today.

Cennino's importance is due to his *Libro dell' arte* (*The Craftsman's Handbook*), which stands between the medieval and modern periods and contains elements of both. While considering nature to be the best master, Cennino provides the student of painting with medieval precepts and examples similar to those found in Theophilus' writings. The proportions of man are discussed here for the first time in a treatise on art, but Cennino's knowledge of anatomy is biblical and medieval. For the first time since antiquity, artistic fantasy is recognized; this, Cennino says, when it accompanies technical skill, enables an artist to represent as reality that which is an imitation of nature. The concept establishes the distinction between the "mechanical" and the "fine" arts that will, however, be fully realized only much later, for in Cennino's book there is as yet no separation between the two.]

THE CRAFTSMAN'S HANDBOOK[1]

Here begins the craftsman's handbook, made and com-

[1] The excerpts and footnotes are from *Cennino Cennini, Il libro, dell' arte* (*Volume Two*). *The Craftsman's Handbook,* translated by Daniel V. Thompson, Jr., New Haven, 1933.

posed by Cennino of Colle, in the reverence of God, and of the Virgin Mary, and of Saint Eustace, and of Saint Francis, and of Saint John Baptist, and of Saint Anthony of Padua, and, in general, of all the Saints of God; and in the reverence of Giotto, of Taddeo and of Agnolo, Cennino's master; and for the use and good and profit of anyone who wants to enter this profession.

THE FIRST CHAPTER OF THE FIRST SECTION OF THIS BOOK. In the beginning, when Almighty God created heaven and earth, above all animals and foods he created man and woman in his own image, endowing them with every virtue. Then, because of the misfortune which fell upon Adam, through envy, from Lucifer, who by his malice and cunning beguiled him—or rather, Eve, and then Eve, Adam —into sin against the Lord's command: because of this, therefore, God became angry with Adam, and had him driven, him and his companion, forth out of Paradise, saying to them: "Inasmuch as you have disobeyed the command which God gave you, by your struggles and exertions you shall carry on your lives." And so Adam, recognizing the error which he had committed, after being so royally endowed by God as the source, beginning, and father of us all, realized theoretically that some means of living by labor had to be found. And so he started with the spade, and Eve, with spinning. Man afterward pursued many useful occupations, differing from each other; and some were, and are, more theoretical than others; they could not all be alike, since theory is the most worthy. Close to that, man pursued some related to the one which calls for a basis of that, coupled with skill of hand: and this is an occupation known as painting, which calls for imagination, and skill of hand, in order to discover things not seen, hiding themselves under the shadow of natural objects, and to fix them with the hand, presenting to plain sight what does not actually exist. And it justly deserves to be enthroned next to theory, and to be crowned with poetry. The justice lies

See also: Schlosser, *Lett. art.*, p. 77, and *Kunstlit.*, p. 77; Venturi, *History*, p. 180; D. V. Thompson, *The Materials of Medieval Painting*, London, 1936.

in this: that the poet, with his theory, though he have but one, it makes him worthy, is free to compose and bind together, or not, as he pleases, according to his inclination. In the same way, the painter is given freedom to compose a figure, standing, seated, half-man, half-horse, as he pleases, according to his imagination. So then, either as a labor of love for all those who feel within them a desire to understand; or as a means of embellishing these fundamental theories with some jewel, that they may be set forth royally, without reserve; offering to these theories whatever little understanding God has granted me, as an unimportant practicing member of the profession of painting: I, Cennino, the son of Andrea Cennini of Colle di Val d'Elsa,—(I was trained in this profession for twelve years by my master, Agnolo di Taddeo of Florence; he learned this profession from Taddeo, his father; and his father was christened under Giotto, and was his follower for four-and-twenty years; and that Giotto changed the profession of painting from Greek back into Latin, and brought it up to date; and he had more finished craftsmanship than anyone has had since),—to minister to all those who wish to enter the profession, I will make note of what was taught me by the aforesaid Agnolo, my master, and of what I have tried out with my own hand; first invoking [the aid of] High Almighty God, the Father, Son, and Holy Ghost; then [of] that most delightful advocate of all sinners, Virgin Mary; and of Saint Luke, the Evangelist, the first Christian painter; and of my advocate, Saint Eustace; and, in general, of all the Saints of Paradise, AMEN.

CHAPTER II. *How Some Enter the Profession through Loftiness of Spirit, and Some for Profit.* It is not without the impulse of a lofty spirit that some are moved to enter this profession, attractive to them through natural enthusiasm. Their intellect will take delight in drawing, provided their nature attracts them to it of themselves, without any master's guidance, out of loftiness of spirit. And then, through this delight, they come to want to find a master; and they bind themselves to him with respect for authority, undergoing an apprenticeship in order to achieve perfec-

tion in all this. There are those who pursue it, because of poverty and domestic need, for profit and enthusiasm for the profession too; but above all these are to be extolled the ones who enter the profession through a sense of enthusiasm and exaltation.

CHAPTER III. *Fundamental Provisions for Anyone Who Enters this Profession.* You, therefore, who with lofty spirit are fired with this ambition, and are about to enter the profession, begin by decking yourselves with this attire: Enthusiasm, Reverence, Obedience, and Constancy. And begin to submit yourself to the direction of a master of instruction as early as you can; and do not leave the master until you have to.

CHAPTER IV. *How the Schedule Shows You into how Many Sections and Branches the Occupations are Divided.* The basis of the profession, the very beginning of all these manual operations, is drawing and painting. These two sections call for a knowledge of the following: how to work up or grind, how to apply size, to put on cloth, to gesso, to scrape the gessos and smooth them down, to model with gesso, to lay bole, to gild, to burnish; to temper, to lay in; to pounce, to scrape through, to stamp or punch; to mark out, to paint, to embellish, and to varnish, on panel or ancona.[2] To work on a wall you have to wet down, to plaster, to true up, to smooth off, to draw, to paint in fresco. To carry to completion in *secco:*[3] to temper, to embellish, to finish on the wall. And let this be the schedule of the aforesaid stages which I, with what little knowledge I have acquired, will expound, section by section.

CHAPTER XXVII. *How You Should Endeavor to Copy and Draw after as Few Masters as Possible.* Now you must forge ahead again, so that you may pursue the course of this theory. You have made your tinted papers; the next

[2] By *ancona* is to be understood a compound panel, one with its moldings integrally attached. It may be large or small; complex, as a polyptych, or merely a "self-framed" panel. The *tavola,* the simple "panel," has no moldings.

[3] *I.e.,* dry.

thing is to draw. You should adopt this method. Having first practiced drawing for a while as I have taught you above, that is, on a little panel, take pains and pleasure in constantly copying the best things which you can find done by the hand of great masters. And if you are in a place where many good masters have been, so much the better for you. But I give you this advice: take care to select the best one every time, and the one who has the greatest reputation. And, as you go on from day to day, it will be against nature if you do not get some grasp of his style and of his spirit. For if you undertake to copy after one master today and after another one tomorrow, you will not acquire the style of either one or the other, and you will inevitably, through enthusiasm, become capricious, because each style will be distracting your mind. You will try to work in this man's way today, and the other's tomorrow, and so you will not get either of them right. If you follow the course of one man through constant practice, your intelligence would have to be crude indeed for you not to get some nourishment from it. Then you will find, if nature has granted you any imagination at all, that you will eventually acquire a style individual to yourself, and it cannot help being good; because your hand and your mind, being always accustomed to gather flowers, would ill know how to pluck thorns.

CHAPTER XXVIII. *How, Beyond Masters, You Should Constantly Copy from Nature with Steady Practice.* Mind you, the most perfect steersman that you can have, and the best helm, lie in the triumphal gateway[4] of copying from nature. And this outdoes all other models; and always rely on this with a stout heart, especially as you begin to gain some judgment in draftsmanship. Do not fail, as you go on, to draw something every day, for no matter how little it is it will be well worth while, and will do you a world of good.

[4] This unconventional figure of speech is fairly typical of Cennino when he abandons exposition for rhetoric. He seems to have had some half-formed conception of his course of study as an architectural layout, with steps rising and gates opening; but this is confused with ideas of journeys, by land and, as here, by sea.

CHAPTER XXIX. *How You Should Regulate Your Life in the Interests of Decorum and Condition of Your Hand; and in What Company; and What Method You Should First Adopt for Copying a Figure from High Up.* Your life should always be arranged just as if you were studying theology, or philosophy, or other theories, that is to say, eating and drinking moderately, at least twice a day, electing digestible and wholesome dishes, and light wines; saving and sparing your hand, preserving it from such strains as heaving stones, crowbar, and many other things which are bad for your hand, from giving them a chance to weary it. There is another cause which, if you indulge it, can make your hand so unsteady that it will waver more, and flutter far more, than leaves do in the wind, and this is indulging too much in the company of woman. Let us get back to our subject. Have a sort of pouch made of pasteboard, or just thin wood, made large enough in every dimension for you to put in a royal folio, that is, a half; and this is good for you to keep your drawings in, and likewise to hold the paper on for drawing. Then always go out alone, or in such company as will be inclined to do as you do, and not apt to disturb you. And the more understanding this company displays, the better it is for you. When you are in churches or chapels, and beginning to draw, consider, in the first place, from what section you think you wish to copy a scene or figure; and notice where its darks and half tones and high lights come; and this means that you have to apply your shadow with washes of ink; to leave the natural ground in the half tones; and to apply the high lights with white lead.

CHAPTER XLV. *On the Character of a Yellow Color Called Ocher.* A natural color known as ocher is yellow. This color is found in the earth in the mountains, where there are found certain seams resembling sulphur; and where these seams are, there is found sinoper, and terre-verte and other kinds of color. I found this when I was guided one day by Andrea Cennini, my father, who led me through the territory of Colle di Val d'Elsa, close to the borders of Casole, at the beginning of the forest of the commune of Colle, above a township called Dometaria. And upon reach-

ing a little valley, a very wild steep place, scraping the steep with a spade, I beheld seams of many kinds of color: ocher, dark and light sinoper, blue, and white; and this I held the greatest wonder in the world—that white could exist in a seam of earth; advising you that I made a trial of this white, and found it fat, unfit for flesh color. In this place there was also a seam of black color. And these colors showed up in this earth just the way a wrinkle shows in the face of a man or woman.

To go back to the ocher color, I picked out the "wrinkle" of this color with a penknife; and I do assure you that I never tried a handsomer, more perfect ocher color. It did not come out so light as giallolino; a little bit darker, but for hair, and for costumes, as I shall teach you later, I never found a better color than this. Ocher color is of two sorts, light and dark. Each color calls for the same method of working up with clear water; and work it up thoroughly, for it goes on getting better. And know that this ocher is an all-round color, especially for work in fresco; for it is used, with other mixture, as I shall explain to you, for flesh colors, for draperies, for painted mountains, and buildings and horses and in general for many purposes. And this color is coarse by nature.

CHAPTER LXVII. *The Method and System for Working on a Wall, that is, in Fresco; and on Painting and Doing Flesh for a Youthful Face.* In the name of the Most Holy Trinity I wish to start you on painting. Begin, in the first place, with working on a wall; and for that I will teach you step by step, the method which you should follow.

When you want to work on a wall, which is the most agreeable and impressive kind of work, first of all get some lime and some sand, each of them well sifted. And if the lime is very fat and fresh it calls for two parts sand, the third part lime. And wet them up well with water; and wet up enough to last you for two or three weeks. And let it stand for a day or so, until the heat goes out of it: for when it is so hot, the plaster which you put on cracks afterward. When you are ready to plaster, first sweep the wall well, and wet it down thoroughly, for you cannot get it too wet. And

take your lime mortar, well worked over, a trowelful at a time; and plaster once or twice, to begin with, to get the plaster flat on the wall. Then, when you want to work, remember first to make this plaster quite uneven and fairly rough. Then when the plaster is dry, take the charcoal, and draw and compose according to the scene or figures which you have to do; and take all your measurements carefully, snapping lines first, getting the centers of the spaces.[5] Then snap some, and take the levels from them. And this line which you snap through the center to get the level must have a plumb bob at the foot. And then put one point of the big compasses on this line,[6] and give the compasses a half turn on the under side. Then put the point of the compasses on the middle intersection of one line with the other,[7] and swing the other semicircle on the upper side. And you will find that you make a little slanted cross on the right side, formed by the intersection of the lines. From the left side apply the line to be snapped in such a way that it lies right over both the little crosses; and you will find that your line is horizontal by a level.[8] Then compose the scenes or figures

[5] Diagonal lines from corner to corner would, of course, intersect at the center of the whole area. If the composition were a large one, plumb lines might be dropped, other sets of diagonals snapped, and the "centers of the spaces" determined *ad lib*. See next note.

[6] The construction which follows is perfectly general. The arcs may be swung from any center on any plumb line, according to where the horizontal is wanted: near the edges, for borders, or well up in the composition for a horizon. Short horizontals might be required across a subdivision of the total area, as for an architectural subject, and these would be constructed on the vertical axis of that subdivision. It should be remembered that very large areas might be involved, and that the size of compasses is somewhat limited in practice. Even with a two-foot radius, which would be cumbersome, the points on the horizontal would be only about three and a half feet apart; so for a horizontal border thirty or forty feet long, it would be wise to repeat the construction on lines snapped plumb through several sections.
The space to be decorated may readily be "squared up" in this way, for enlarging a drawing; but Cennino does not seem to have had this in mind.

[7] That is, the intersection of the arc with the vertical axis.

[8] Modern practice would probably rely on a long spirit level

with charcoal, as I have described. And always keep your areas in scale, and regular.[9] Then take a small, pointed bristle brush, and a little ocher without tempera, as thin as water; and proceed to copy and draw in your figures, shading as you did with washes when you were learning to draw. Then take a bunch of feathers, and sweep the drawing free of the charcoal.

Then take a little sinoper without tempera, and with a fine pointed brush proceed to mark out noses, eyes, the hair, and all the accents and outlines of the figures; and see to it that these figures are properly adjusted in all their dimensions, for these[10] give you a chance to know and allow for the figures which you have to paint. Then start making your ornaments, or whatever you want to do, around the outside; and when you are ready, take some of the aforesaid lime mortar, well worked over with spade and trowel, successively, so that it seems like an ointment. Then consider in your own mind how much work you can do in a day; for whatever you plaster you ought to finish up. It is true that sometimes in winter, in damp weather, working on a stone wall, the plaster will occasionally keep fresh until the next day; but do not delay if you can help it, because working on the fresh plaster, that is, that day's, is the strongest tempera and the best and most delightful kind of work. So then, plaster a section with plaster, fairly thin, but not excessively, and quite even; first wetting down the old plaster. Then take your large bristle brush in your hand; dip it in clear water; beat it, and sprinkle over your plaster. And with a little block the size of the palm of your hand, proceed to rub with a circular motion over the surface of the well-moistened plaster, so that the little block may succeed in removing mortar whenever there is too much, and supplying it wherever there is not enough, and in evening up your plaster nicely. Then wet the plaster with that

to determine points on the horizontal to be snapped; but failing that instrument, Cennino's geometry might be trusted safely.

[9] Literally: "And arrange your areas always even and equal."

[10] That is, the preliminary layout on the rough plaster, over which the finish plaster and final painting are applied.

brush, if you need to; and rub over the plaster with the point of your trowel, very straight and clean. Then snap your lines in the same system and dimensions which you adopted previously on the plaster underneath.

And let us suppose that in a day you have just one head to do, a youthful saint's, like our Most Holy Lady's. When you have got the mortar of your plaster all smoothed down, take a little dish, a glazed one, for all your dishes should be glazed and tapered like a goblet or drinking glass, and they should have a good heavy base at the foot, to keep them steady so as not to spill the colors; take as much as a bean of well-ground ocher, the dark kind, for there are two kinds of ocher, light and dark: and if you have none of the dark, take some of the light. Put it into your little dish; take a little black, the size of a lentil; mix it with this ocher; take a little lime white, as much as a third of a bean; take as much light cinabrese as the tip of a penknife will hold; mix it up with the aforesaid colors all together in order, and get this color dripping wet with clear water, without any tempera. Make a fine pointed brush out of flexible, thin bristles, to fit into the quill of a goose feather; and with this brush indicate the face which you wish to do, remembering to divide the face into three parts, that is, the forehead, the nose, and the chin counting the mouth. And with your brush almost dry, gradually apply this color, known in Florence as verdaccio, and in Siena, as bazzèo. When you have got the shape of the face drawn in, and if it seems not to have come out the way you want it, in its proportions or in any other respect, you can undo it and repair it by rubbing over the plaster with the big bristle brush dipped in water.

Then take a little terre-verte in another dish, well thinned out; and with a bristle brush, half squeezed out between the thumb and forefinger of your left hand, start shading under the chin, and mostly on the side where the face is to be darkest; and go on by shaping up the under side of the mouth; and the sides of the mouth; under the nose, and on the side under the eyebrows, especially in toward the nose; a little in the end of the eye toward the ear; and

in this way you pick out the whole of the face and the hands, wherever flesh color is to come.

Then take a pointed minever brush, and crisp up neatly all the outlines, nose, eyes, lips, and ears, with this verdaccio.

There are some masters who, at this point, when the face is in this stage, take a little lime white, thinned with water; and very systematically, pick out the prominences and reliefs of the countenance; then they put a little pink on the lips, and some "little apples" on the cheeks. Next they go over it with a little wash of thin flesh color; and it is all painted, except for touching in the reliefs afterward with a little white. It is a good system.

Some begin by laying in the face with flesh color; then they shape it up with a little verdaccio and flesh color, touching it in with some high lights: and it is finished. This is a method of those who know little about the profession.

But you follow this method in everything which I shall teach you about painting: for Giotto, the great master, followed it. He had Taddeo Gaddi of Florence as his pupil for twenty-four years; and he was his godson. Taddeo had Agnolo, his son. Agnolo had me for twelve years: and so he started me on this method, by means of which Agnolo painted much more handsomely and freshly than Taddeo, his father, did.

First take a little dish; put a little lime white into it, a little bit will do, and a little light cinabrese, about equal parts. Temper them quite thin with clear water. With the aforesaid bristle brush, soft, and well squeezed with your fingers, go over the face, when you have got it indicated with terre-verte; and with this pink touch in the lips, and the "apples" of the cheeks. My master used to put these "apples" more toward the ear than toward the nose, because they help to give relief to the face. And soften these "apples" at the edges. Then take three little dishes, which you divide into three sections of flesh color; have the darkest half again as light as the pink color, and the other two, each one degree lighter. Now take the little dish of the lightest one; and with a very soft, rather blunt, bristle brush take some of this flesh color, squeezing the brush with your

fingers; and shape up all the reliefs of this face. Then take the little dish of the intermediate flesh color, and proceed to pick out all the half tones of the face, and of the hands and feet, and of the body when you are doing a nude. Then take the dish of the third flesh color, and start into the accents of the shadows, always contriving that, in the accents, the terre-verte may not fail to tell. And go on blending one flesh color into another in this way many times, until it is well laid in, as nature promises. And take great care, if you want your work to come out very fresh: contrive not to let your brush leave its course with any given flesh color, except to blend one delicately with another, with skillful handling. But if you attend to working and getting your hand in practice, it will be clearer to you than seeing it in writing. When you have applied your flesh colors, make another much lighter one, almost white; and go over the eyebrows with it, over the relief of the nose, over the top of the chin and of the eyelid. Then take a sharp minever brush; and do the whites of the eyes with pure white, and the tip of the nose, and a tiny bit on the side of the mouth; and touch in all such slight reliefs. Then take a little black in another little dish, and with the same brush mark out the outline of the eyes over the pupils of the eyes; and do the nostrils in the nose, and the openings in the ears. Then take a little dark sinoper in a little dish; mark out under the eyes, and around the nose, the eyebrows, the mouth; and do a little shading under the upper lip, for that wants to come out a little bit darker than the under lip. Before you mark out the outlines in this way, take this brush; touch up the hair with verdaccio; then with this brush shape up this hair with white. Then take a wash of light ocher; and with a blunt-bristle brush work back over this hair as if you were doing flesh. Then with the same brush shape up the accents with some dark ocher. Then with a sharp little minever brush and light ocher and lime white shape up the reliefs of the hair. Then, by marking out with sinoper, shape up the outlines and the accents of the hair as you did the face as a whole. And let this suffice you for a youthful face.

CHAPTER LXXXVIII. *The Way to Copy a Mountain*

from Nature. If you want to acquire a good style for mountains, and to have them look natural, get some large stones, rugged, and not cleaned up; and copy them from nature, applying the lights and the dark as your system requires.

CHAPTER CIV. *The System by which You Should Prepare to Acquire the Skill to Work on Panel.* Know that there ought not to be less time spent in learning than this: to begin as a shopboy studying for one year, to get practice in drawing on the little panel; next, to serve in a shop under some master to learn how to work at all the branches which pertain to our profession; and to stay and begin the working up of colors; and to learn to boil the sizes, and grind the gessos; and to get experience in gessoing anconas, and modeling and scraping them; gilding and stamping; for the space of a good six years. Then to get experience in painting, embellishing with mordants, making cloths of gold, getting practice in working on the wall, for six more years; drawing all the time, never leaving off, either on holidays or on workdays. And in this way your talent, through much practice, will develop into real ability. Otherwise, if you follow other systems, you need never hope that they will reach any high degree of perfection. For there are many who say that they have mastered the profession without having served under masters. Do not believe it, for I give you the example of this book: even if you study it by day and by night, if you do not see some practice under some master you will never amount to anything, nor will you ever be able to hold your head up in the company of masters.

Beginning to work on panel, in the name of the Most Holy Trinity: always invoking that name and that of the Glorious Virgin Mary.

CHAPTER CIV. *How to Paint on Panel.* I believe that by yourself you will have enough understanding, with your experience, to train yourself, by following this method, to understand working neatly with various kinds of cloth. And by the grace of God it is time for us to come to painting on panel. And let me tell you that doing a panel is really a gentleman's job, for you may do anything you want to with

velvets on your back.[11] And it is true that the painting of
the panel is carried out just as I taught you to work in
fresco, except that you vary it in three respects. The first,
that you always want to work on draperies and buildings
before faces. The second is that you must always temper
your colors with yoke of egg, and get them tempered
thoroughly—always as much yoke as the color which you
are tempering. The third is that the colors want to be more
choice, and well worked up, like water. And for your great
pleasure, always start by doing draperies with lac[12] by the
same system which I showed you for fresco; that is, leave
the first value in its own color; and take the two parts of lac
color, the third of white lead; and when this is tempered,
step up three values from it, which vary slightly from each
other: tempered well, as I have told you, and always made
lighter with white lead well worked up. Then set your
ancona up in front of you; and mind you always keep it
covered with a sheet, for the sake of the gold and the
gessos, so that they may not be injured by dust, and that
your jobs may quit your hands very clean. Then take a
rather blunt minever brush, and start to apply the dark
color, shaping up the folds where the dark part of the figure
is to come. And in the usual way take the middle color and
lay in the backs and the reliefs of the dark folds, and begin
with this color to shape up the folds of the relief, and around
toward the light part of the figure. And shape it up once
more in this way. Then take the light color, and lay in the
reliefs and the backs of the light part of the figure. And
in this way go back once again to the first dark folds of the
figure with the dark color. And carry on as you began, with
these colors, over and over again, first one and then the
other, laying them in afresh and blending them skillfully,

[11] The height of elegance! Velvets were something of a rarity
in fourteenth century Italy.

[12] [Elsewhere in the Handbook (Thompson, Cennino Cennini,
p. 26) Cennini says of lac: "A color known as lac is red, and I
have various receipts for it; . . . Get the lac which is made from
gum." See also: New English Dictionary, s.v. lac; Thompson, op.
cit., p. 26, note 1; and idem, Materials of Medieval Painting, pp.
108–110.]

softening delicately. And with this[13] you have enough time so that you can get up from your work and rest yourself for a while, and reflect upon this work of yours. Work on panel wants to be done with much enjoyment.

When you have got it well laid in and these three colors blended, make another lighter one out of the lightest, always washing the brush between one color and the next; and out of this lighter one make another lighter still; and have the variations among them very slight. Then touch in with pure white lead, tempered as has been said; and touch in with it over the strongest reliefs. And make the darks, gradually, in the same way, until you finally touch in the strongest darks with pure lac. And bear this in mind: just as you prepared your colors value by value, so you put them into your little dishes value by value, so as not to take one of them for another by mistake.

And use this same system, likewise, for any color which you want to paint, whether reds, or whites, or yellows, or greens. But if you want to make a lovely violet color, take good choice lac, and good choice fine ultra-marine blue; and with this mixture and white lead make up your colors, value by value, always tempering them. If you wish to do a drapery with blue with lights on it, make it lighter in this way with white lead; and execute it in the way described above.

[13] *I.e.,* "as opposed to fresco."

II. THE RENAISSANCE

ITALY

LORENZO GHIBERTI

[Lorenzo Ghiberti (1378–1455) was born in Florence
and spent his life there. He began his career as a painter
and, although he was also trained as a goldsmith by his
stepfather, Bartoluccio, he did not become a member of
that guild until 1409. In 1402 he won the commission,
awarded on the basis of a competition, to execute the north
door of the Baptistry in Florence. This task occupied him
until 1424. During this period he also executed the statues
of St. John the Baptist and St. Matthew for Or San Michele,
two bronze reliefs, the *Baptism of Christ* and *St. John be-
fore Herod,* for the baptismal font at Siena, and the design
for the center stained-glass window in the façade of the
Duomo in Florence. He was also associated with Brunelle-
sco in building the dome of the Duomo.

In 1424 an outbreak of the plague in Florence caused
him to go to Venice. While there he undoubtedly went to
Padua, where he saw the *Venus* described in the third
Commentary. He received the commission for the east door
of the Baptistry January 2, 1424; this task occupied him
until 1452. His bronze foundry became a veritable academy
and among his assistants were his son, Vittorio, Donatello,
Michelozzo, Paolo Uccello, Benozzo Gozzoli, and others.
During this period, he also designed cartoons for five more
windows for the Duomo (1424–1441) and executed the *St.
Stephen* on Or San Michele and two reliquary shrines.

Toward the end of his life, Ghiberti wrote his three *Com-
mentarii* or "reminiscences." The material for the first,
which gives an account of ancient art, is derived from Vi-
truvius and Pliny. The lives of the *trecento* artists and their

work is treated in the second Commentary, and, having no authorities to draw on, Ghiberti wrote what he himself had learned and described what he had seen during his long life. These lives of the artists are the first such lives. In spite of his admiration for the ancient art, he considers the art of the *trecento* and Giotto to be equal to that of the ancient masters. Included in the second Commentary is Ghiberti's autobiography, the first written in a literary form by an artist. With the third Commentary, he returns to the authorities for a discussion of the theoretical basis of art. Much of his material is taken not only from the Roman writers but also from the Arabian scholars, Alhazen (Ibn-al-Hartam, died 1038) and Avicenna (Ibn-Sina, died 1037), whose writings were the basis for the scientific and anatomical knowledge of the Middle Ages. In this Commentary, Ghiberti attempts a scientific study of optics, written in Italian in a scientific prose. Here is also the first literary description by an artist of an antique art work. Stimulated by Vitruvius' chapter on proportion, Ghiberti established a system for the human form and set the maxim that beauty depends on proportion.

Ghiberti was not a scholar such as Alberti and Piero della Francesca. He was, however, a learned artist as is shown by his knowledge of the classical writers, his collection of antiques, and his *Commentaries* which present his recollections of his life as a practicing artist. He died in Florence in 1455 and was buried in Santa Croce.]

THE COMMENTARIES[1]

THE SECOND COMMENTARY. The Christian faith was victorious in the time of Emperor Constantine and Pope Sylvester. Idolatry was persecuted in such a way that all the

[1] The text and footnotes are translated from J. von Schlosser, *Lorenzo Ghibertis Denkwürdigkeiten* (*I Commentarii*), 2 vols., Berlin, 1912. Footnotes within brackets are by the translator.

See also: J. von Schlosser, *Leben und Meinungen des florentinischen Bildners, Lorenzo Ghiberti*, Basel, 1941; *idem, Lett. art.*, p. 87, and *Kunstlit.*, p. 87; R. Krautheimer and T. Krautheimer-Hess, *Lorenzo Ghiberti*, Princeton, 1956.

statues and pictures of such nobility, antiquity and perfection were destroyed and broken to pieces. And with the statues and pictures, the theoretical writings, the commentaries, the drawing and the rules for teaching such eminent and noble arts were destroyed. In order to abolish every ancient custom of idolatry it was decreed that all the temples should be white. At this time the most severe penalty was ordered for anyone who made any statue or picture. Thus ended the art of sculpture and painting and all the teaching that had been done about it. Art was ended and the temples remained white for about six hundred years. The Greeks feebly began the art of painting, and with great crudity produced [works] in it, for the people of that age were as rough and crude as the ancients were skillful. This was 382 olympiads[2] after Rome was built.

The art of painting began to arise in Etruria in a village called Vespignano, near the city of Florence. There was born a boy of wonderful talent, who was drawing a sheep from life [when] the painter Cimabue,[3] passing by on the road to Bologna, saw the lad seated on the ground, drawing on a slab of rock. Struck with great admiration for the boy, who, though so young, did so well, and perceiving his skill came from nature, Cimabue asked him what he was named. The lad answered, "I am called by the name Giotto. My father is named Bondoni and he lives in this house that is near." Cimabue, who had a distinguished appearance, went with Giotto to his father. He asked the father, who was very poor, for the boy. He gave the lad to Cimabue, who took him with him. Giotto was a disciple of Cimabue, who held to the Greek manner [of painting] and had acquired very great fame in Etruria for this style. Giotto made himself great in the art of painting.

He introduced the new art [of painting]. He abandoned the crudeness of the Greeks and rose to be the most excellent [painter] in Etruria. Wonderful works were executed [by

[2] Ghiberti's extraordinary system of dating which he took from Pliny. It is very difficult to determine the date he began with. See Krautheimer, *op. cit.*, pp. 353–58.

[3] Cimabue was merely a name to Ghiberti, as he mentions no works by him.

him] especially in the city of Florence and in many other places. Many of his disciples were as gifted as the ancient Greeks. Giotto saw in art what others had not attained. He brought the natural art and refinement with it, not departing from the proportions.[4] He was extremely skillful in all the arts and was the inventor and discoverer of many methods which had been buried for about six hundred years. When nature wishes to grant anything she does so without avarice. He was prolific in all methods, [working] in [fresco] on walls, in oil, and on panels. . . .

Now let us speak of the sculptors who were in these times. There was Giovanni,[5] the son of Maestro Nichola. Maestro Giovanni made the pulpit of Pisa,[6] the pulpit of Siena[7] was by his hand, and that of Pistoia.[8] These works are seen to be by Maestro Giovanni as is also the fountain of Perugia.[9] Maestro Andrea da Pisa[10] was a very good sculptor. He made many things at Santa Maria a Ponte[11] in Pisa. On the Campanile in Florence he made [the panels representing] the seven acts of mercy,[12] the seven virtues,

[4] [This is a literal translation of an often translated passage. Cf. e.g. "Giotto saw that in art whereto others had not attained; he brought nature into art and grace therewith, not overpassing just limits" (Charles Eliot Norton, *Historical Studies of Church-Building in the Middle Ages,* New York, 1880, p. 221); "Giotto voyait dans l'art ce que les autres n'atteignirent jamais; il rendit l'art naturel et en même temps gracieux, sans sortir des limites du goût" (C. C. Perkins, *Ghiberti et son école,* Paris, 1886, pp. 114–115); "Brachte die natürliche Kunst herbei (l'arte naturale) und mit ihr die Artigkeit (la gentilezza); trat nicht aus dem Regeln" (W. Hausenstein, *Giotto,* Berlin, 1923, p. 103); "He introduced natural art and refinement with it, never departing from correct proportions" (Goldwater and Treves, *Artists on Art,* New York, 1945, p. 29). For a discussion of Ghiberti's meaning, see Schlosser, *Leben und Meinungen,* p. 197.]

[5] Giovanni Pisano (1250–1328?) the son of Niccolò.

[6] 1310. [It is now in the Cathedral.]

[7] 1265–1268. [It is still in the cathedral of Siena. It is by Niccolò, not Giovanni.]

[8] 1301. It is in S. Andrea at Pistoia.

[9] 1278–1280. The famous city fountain of Perugia.

[10] Andrea Pisano (1273–1348).

[11] This church is no longer extant.

[12] They are the seven sacraments.

the seven sciences, and the seven planets.[13] Maestro Andrea also carved four figures, each four *braccia*[14] high. Also he carved a great part of those [panels] which depict the innovators of the arts.[15] It is said that Giotto sculptured the first two stories—he was skillful in one art as well as in the other. Maestro Andrea made for the church of St. John the Baptist a bronze door[16] on which are carved the stories of St. John, and [he made] a figure of St. Stephen[17] which was placed on the front of S. Reparata on the side toward the Campanile. These are the works found by this master. He was a very great sculptor and lived in olympiad 410.

In Germany in the city of Cologne was a master named Gusmin[18] who was most talented and highly skilled in the art of sculpture. He was [employed] by the Duke of Anjou, for whom he executed a great many objects in gold. Among other things he made with wonderful ingenuity and mastery a table of gold which he executed excellently. He achieved perfection in his works and was the equal of the ancient Greek sculptors. He did heads and every part of the nude marvelously well. He had no fault except that his statues were a little short. He was most celebrated, gifted, and excellent in this art. I saw many works from his hand.[19] He had a very delicate quality in his work, for he was most gifted. He saw the work which he had made with so much love and skill destroyed to alleviate the official needs of the Duke. He saw that his labor had been in vain and, throw-

[13] These are wrongly attributed by Ghiberti.

[14] A *braccio* equals about 28 inches. As a unit of measurement it varied in different Italian cities.

[15] The liberal and mechanical arts.

[16] The door was cast in 1332 by a Venetian bronze-caster. It was a tremendous achievement for the *trecento*.

[17] It was on the old façade which was demolished in 1586.

[18] It is not known just who he was. [Dr. Swarzenski relates him on stylistic grounds to the master of the alabaster crucifixion from Rimini, now in the Städelsches Kunstinstitut, Frankfurt a.M., and the Borromeo alabaster altar, formerly in Milan, now in the Pal. Borromeo, Isola Bella. See G. Swarzenski, "Der Kölner Meister bei Ghiberti," *Vorträge der Bibliothek Warburg, 1926/27*, Berlin, 1930.] See R. Krautheimer, "Ghiberti and Master Gusmin," *Art Bulletin*, xxix (1947), pp. 25 ff.

[19] [He may mean: variations, replicas, copies.]

ing himself on his knees, he raised his eyes and hands to heaven, saying, "O Lord, who governs the heavens and the earth and determines all things, may I not be so ignorant as to follow any other than Thee. Have mercy upon me." At once, for the love of the Creator of all things, he sought to give away what he possessed. He went up on a mountain where there was a large hermitage, entered, and there did penance while he lived. He was old and died in the time of Pope Martin.[20] Certain young men and those who sought to become skillful in the art of sculpture told me how gifted he was in both painting and sculpture and how he painted where he was living. He was a learned man and died in the olympiad 438. He was a very great draughtsman and very docile. Young men who wished to learn went to visit him and he received them most humbly, giving them expert instruction, showing them many rules of proportion, and making for them many models. He was perfect, and died in great humility in that hermitage. Thus he was most excellent both in art and in his holy life. . . .

I, O most excellent reader, did not have to obey [a desire for] money, but gave myself to the study of art, which since my childhood I have always pursued with great zeal and devotion. In order to master the basic principles [of art] I have sought to investigate the way nature functions in art; and in order that I might be able to approach her, how images come to the eye, how the power of vision functions, how visual [images] come, and in what way the theory of sculpture and painting should be established.

In my youth in the year of Christ 1400, because of the corrupt air in Florence and the bad state of the country,[21] I left that city with an excellent painter whom Signor Malatesta of Pesaro had summoned. He had had a room made which was painted by us with great care. My mind

[20] Pope Martin V, 1417–1431.

[21] He refers to the plague and the political situation in Florence when the Ghibelline families, the Alberti, Medici, Strozzi, and Ricci, were struggling with the Albizzi. The Alberti were in exile at this time, 1387–1428.

was in a large part turned to painting[22] because of the work the prince promised us, and also the companion with whom I was continually showed me the honor and benefit we would acquire. However, at this time my friends wrote me that the governors of the church of S. Giovanni Battista were sending for skilled masters whom they wished to see compete. From all countries of Italy a great many skilled masters came in order to take part in this trial and contest. I asked permission of the prince and my companion to leave. The prince, hearing the reason, immediately gave me permission [to go]. Together with the other sculptors I appeared before the *Operai*[23] of that church [Baptistry of S. Giovanni]. To each was given four tables of bronze. As the trial piece the *Operai* and the governors of the church wanted each [artist] to make one scene for the door. The story they chose was the Sacrifice of Isaac and each contestant was to make the same story [our *figs.* 16 and 17]. The trial pieces were to be executed in one year, and he who won had to be given the victory. These were the contestants: Filippo di Ser Brunellesco, Symone da Colle,[24] Nicholò d'Areço,[25] Jacopo della Quercia da Siena, Francesco di Valdombrina,[26] Nicholò Lamberti.[27] We six were to take part in the contest, which was to be a demonstration of the art of sculpture. To me was conceded the palm of the victory by all the experts and by all those who had competed with me. To me the honor was conceded universally and with no exception. To all it seemed that I had at that time

[22] Ghiberti began as a painter. He was not admitted to the goldsmiths' guild until 1409.

[23] [The *Operai* are the committee in charge of a building. The term is also used to designate the chairman of the committee. The responsibility for the maintenance of certain public buildings was assigned to different guilds, in this case, the *Arte di Calimala* (the foreign wool merchants' guild). The church of the patron saint of a guild was usually maintained by the guild.]

[24] Nothing more is known of Simone da Colle.

[25] Niccolò d'Arezzo was the brother of the painter Spinelli.

[26] [Francesco di Valdambrino, an excellent Sienese sculptor and a collaborator of Jacopo della Quercia. See P. Bacci, *Francesco di Valdambrino*, Siena, 1936.]

[27] Niccolò di Piero Lamberti had been active on the Duomo since 1388.

surpassed the others without exception, as was recognized
by a great council and an investigation of learned men. The
Operai of the governing [board] wanted the judgment of
these men written by their own hands. They were men
highly skilled from the painters and sculptors of gold, silver,
and marble. There were thirty-four judges from the city
and the other surrounding countries. The testimonial of the
victory was given in my favor by all, the consuls, the *Operai*,
and the entire merchants' guild which has charge of the
church of S. Giovanni. It was granted to me and deter-
mined that I should make the bronze door for this church.
This I executed with great care. This is my first work: the
door with the frame around it cost about twenty-two thou-
sand florins. Also in the door are twenty-eight compart-
ments; in twenty are stories from the New Testament, and
at the bottom are the four Evangelists and the four
[church] Doctors, and around the work are a great number
of human heads. With great love the door was diligently
made, together with frames of ivy leaves, and the door
jambs with a very magnificent frame of many kinds of
leaves. The work weighed thirty-four thousand pounds. It
was executed with the greatest skill and care. At the same
time was made of fine bronze the statue of St. John the
Baptist,[28] four and a third *braccia* high. It was erected in
1414.

The commune of Siena ordered from me two panels[29]
that are in the Baptistry, one of St. John baptizing Christ,
the other of St. John being led before Herod. Also produced
by my hand is the bronze statue of St. Matthew,[30] four and
a half *braccia* high. I also made in bronze the tomb of
Messer Leonardo Dati,[31] the general of the Dominicans. He
was a most learned man whose portrait I took from life.
The tomb is in low relief and has an epitaph at the feet. I
also had made in marble the tombs of Ludovico degli

[28] Ordered by the *Arte di Calimala* for Or San Michele (1414).
[29] 1417–1427. The font was begun by Jacopo della Quercia.
Donatello also did two panels for it.
[30] Ordered by the *Arte della Zecca* for Or San Michele (1419–
1422).
[31] 1423. This tomb is still in S. Maria Novella.

Obizzi and Bartolomeo Valori,[32] who are buried in the church of the Franciscans. Also to be seen is a chest of bronze[33] in S. Maria degli Angeli where the Brothers of St. Benedict live. In the chest are the bones of three martyrs, Prothiius, Hyacinthus, and Nemesis. On the front are sculptured two little angels holding in their hands a wreath of olive leaves in which are written the martyrs' names. At the same time, I set in gold a cornelian as large as a nut with the shell on, on which three figures had been expertly carved by the hands of an excellent ancient master.[34] As a clasp I made a dragon with its wings a little open, its head low, and its neck arched and the wings formed the handle of the seal. The dragon, or serpent, as we call it, was placed among ivy leaves. Around the figures were antique letters giving the name of Nero which I carved with great care. The figures in the cornelian were an old man, seated on a rock on which was a lion skin, who was tied with his hands behind him to a dry tree. At his feet, there was a child who knelt on one knee watching a young man who held a paper in his right hand and a zither in his left. It seemed that the child was asking the youth for instruction. These three figures represented our three ages. They were certainly from the hand of Pyrgoteles or Polycletes. They were as perfect as anything I have ever seen in intaglio.

[When] Pope Martin came to Florence he commissioned me to make a gold miter and a morse for a cope.[35] On the miter I made eight half-length figures in gold and on the morse I made a figure of Our Lord giving the benediction.

[32] G. did only the sketches for these. He never worked in marble. The tombs are in Santa Croce.

[33] This was ordered by Cosimo de' Medici (1427–1428). It is in the Museo Nazionale, Florence.

[34] Ghiberti probably made the setting for Cosimo de' Medici in 1428. It is listed in an inventory of Lorenzo de' Medici in 1492. The ascription to Polycletes or Pyrgoteles, a famous gemcutter of Alexander's time, is legendary. The scene represents the Flaying of Marsyas. The stone is preserved only in a bronze casting in the Kaiser Friedrich Museum, Berlin.

[35] In 1419. Ghiberti was an excellent goldsmith. Cellini praised him highly. These works were probably melted down for war funds in 1527 by Pope Clement VII.

When Pope Eugene came to live in the city of Florence, he had me make a miter of gold, the gold of which weighed fifteen pounds while the weight of the stones was five and a half pounds. The stones, rubies, sapphires, emeralds and pearls, were valued by the jewelers of our country at thirty-eight thousand florins. In this miter were six pearls the size of hazel nuts. It was ornamented with many figures and rich adornments. In the front, on a throne, with many little angels around it, was Our Lord. Similarly placed at the back was Our Lady with similar little angels around the throne. There were the four evangelists in gold compartments and a great many little angels in a frieze around the base. It was made with great magnificence. I was commissioned by the governors of the *Arte della Lana* to make a bronze statue four and a half *braccia* high [which] they placed in the oratorio of Or San Michele. It was a statue of St. Stephen the Martyr which according to my custom I made with great care.[36] The *Operai* of S. Maria del Fiore commissioned me to make for the body of St. Zenobius a bronze casket three and a half *braccia* long on which are reliefs of the stories of the saint.[37] On the front is shown how he resuscitated the boy who was confided to him by the mother until she should return from a pilgrimage; how the boy died while she was on her journey and on her return she asked St. Zenobius for the boy, and how the saint revived him. [Also is shown] how he revived another person who was killed by a cart. There is [represented] also how he revived one of the two servants St. Ambrose sent him, who had died in the Alps and when his companion sorrowed over his death, St. Zenobius said, "Go, he sleeps. You will find him alive." The servant went and found him alive. On the back are six little angels holding a wreath of elm leaves; and carved in antique letters within it is an epitaph in honor of the saint.

I was commissioned to do the other door, that is, the third door, of S. Giovanni.[38] The commission gave me per-

[36] *St. Stephen* (1427–1428).
[37] The casket is still in the Duomo in Florence (1432–1442).
[38] Andrea Pisano's doors were moved to the south entrance of the Baptistry to make room for Ghiberti's second doors.

mission to execute it in whatever way I believed would result in the greatest perfection, the most ornamentation, and the greatest richness. I began the work in frames one and a third *braccia* in size. The stories, which had numerous figures in them, were from the Old Testament. With every proportion observed in them, I strove to imitate nature as closely as I could, and with all the perspective I could produce [to have] excellent compositions rich with many figures. In some scenes I placed about a hundred figures, in some less, and in some more. I executed that work with the greatest diligence and the greatest love. There were ten stories all [sunk] in frames because the eye from a distance measures and interprets the scenes in such a way that they appear round [plastic]. The scenes are in the lowest relief and the figures are seen in the planes; those that are near appear large, those in the distance small, as they do in reality. I executed this entire work with these principles.

There are ten scenes. The first is the creation of man and woman and how they disobeyed the Creator of all things. Also in this same scene is shown how they were driven from paradise for the sin they committed; thus in that panel four stories—that is scenes—are given. In the second panel, Adam and Eve beget Cain and Abel, who appear as small children. Then there is [shown] how Cain and Abel offered [their] sacrifices. Cain sacrificed the worst and vilest thing he had. Abel sacrificed the best and noblest. Abel's sacrifice was very acceptable to God, and that of Cain was entirely the opposite. There was [shown] how Cain slew Abel in envy. In that scene Abel was watching the animals and Cain was tilling the soil. Also there was [shown] how God appeared to Cain and demanded of him the brother he had slain. Thus in each panel are scenes of four stories. In the third panel is [shown] how Noah came out of the ark with his sons, his daughters-in-law, his wife, and all the birds and animals; and how with all his company he offered sacrifice. There is [shown] how Noah planted the vine and became drunk and Ham, his son, mocked him; and how his other two sons covered him. In the fourth panel is [shown] how three angels appear to Abraham and how he worshipped one of them; and how the servants and the ass remain at

the foot of the mountain and how he stripped Isaac and wanted to sacrifice him, and the angel seized the hand with the knife and showed Abraham the ram. In the fifth frame is [shown] how Esau and Jacob were born to Isaac; how Esau was sent to hunt; how the mother instructed Jacob, gave him the kid, and fastened the skin at his neck and told him to ask the blessing of Isaac; and how Isaac searched for his neck, found it hairy, and gave him his benediction. In the sixth panel is [shown] how Joseph is placed in the cistern by his brothers; how they sold him and how he is given to Pharaoh, the king of Egypt, and it was revealed through a dream that there would be a great famine in Egypt, and the remedy Joseph gave, and all the country and the provinces were spared, for their needs were met; and how he was greatly honored by Pharaoh. [Also is depicted] how Jacob sent his sons, and Joseph recognized them; and how he told them to return with Benjamin, their brother, otherwise they would receive no grain. They returned with Benjamin and Joseph gave them a feast and had a cup placed in Benjamin's sack. [There is shown] how the cup was found and Benjamin was led before Joseph and how he made himself known to his brothers. In the seventh panel is [shown] how Moses received the tables on the mountain top, and how Joshua remained half way up the mountain, and how the people wondered at the earthquake, lightning and thunder, and how the people at the foot of the mountain were amazed. In the eighth panel is [shown] how Joshua went to Jericho, came and crossed the Jordan, and placed [there] twelve tents; how he went around Jericho sounding the trumpets, and how at the end of seven days the walls fell and Jericho was taken. In the ninth panel is [shown] how David slew Goliath and how the people of God destroyed the Philistines, and how David returned with the head of Goliath in his hand and how the people came to meet him making music and singing and saying, "Saul destroyed one thousand, David ten thousand." In the tenth panel is [shown] how the Queen of Sheba came with a large company to visit Solomon. The scene is rich and contains many people.

There are twenty-four figures in the frieze that surrounds

the stories. Between one frieze and the other is placed a head. There are twenty-four heads. Executed with the greatest study and perseverance, of all my work it is the most remarkable I have done and it was finished with skill, correct proportions, and understanding. In the outer frieze on the doorjambs and the lintel is a decoration of leaves, birds, and little animals as is suitable to such ornamentation. There is also an architrave of bronze. On the inside of the doorjambs is a decoration in low relief made with the greatest skill. And likewise the threshold, at the base, that decoration is of fine bronze.

But not to tire my readers, I shall omit a great many works I have produced. I know that one can find no pleasure in such material. Nevertheless I ask pardon of all readers and all to have patience. Also by making sketches in wax and clay for painters, sculptors, and stone carvers and by making designs of many things for painters, I have helped many of them to achieve the greatest honors for their works. Also for him who had to make figures larger than life-size, I gave the rules for executing them with perfect proportion. I designed the *Assumption of the Virgin* for the round window in the middle of the façade of S. Maria del Fiore, and I designed the other windows on the sides. I designed many glass windows in that church. In the choir are three round windows designed by my hand. In one is [depicted] how Christ ascends to heaven, in the other, when He prays in the Garden, and in the third when He is carried to the Temple. Few things of importance were made in our country that were not designed and planned by me. Especially in the building of the cupola [of the Duomo]; Filippo and I worked together at the same salary for eighteen years while we were building it. I shall write a treatise on architecture and discuss this material. The second commentary is finished. We come to the third.

THE THIRD COMMENTARY. . . . Also I have seen in a diffused light the most perfect sculptures which were executed with the greatest skill and care. Among these I saw in Rome in olympiad 440[39] the statue of an hermaphrodite, the size

[39] Olympiad 440 is 1447. Of the seven known hermaphrodite

of a thirteen-year-old girl, which had been made with admirable skill. It was found at that time in a drain about eight *braccia* underground. The top of the drain was level with the statue. The statue was covered with earth to the level of the street. The drain, which was being cleaned, was near S. Celso, and a sculptor who lived there had the statue brought out and taken to S. Cecelia in Trastevere, where he was working on the tomb of a cardinal. There he had removed some of the marble from it in order to send the statue more easily to our country [Florence]. It is impossible for the tongue to tell the perfection and the knowledge, art and skill of that statue. The figure was on spaded earth over which a linen cloth was thrown. The figure was on the linen cloth and was turned in a way to show both the masculine and the feminine characteristics. The arms rested on the ground and the hands were crossed one over the other. One of the legs was stretched out and the large toe had caught the cloth, and the pulling of the cloth was shown with wonderful skill.[40] The statue was without a head but nothing else was missing. In this statue were the greatest refinements. The eye perceived nothing if the hand had not found it by touch.

Also I saw in Padua a statue[41] that had been taken there by Lombardo della Seta. It was found in the city of Florence, buried in the ground under the houses of the Brunelleschi family. When the Christian faith arose this statue was hidden in that place by some gentle spirit who, seeing such a perfect thing made with such wonderful skill and such genius, was moved to pity and had a sepulcher made of bricks and entombed the statue in it. It was covered with a large slab of stone so that it might not be entirely broken to pieces. It was found with the head and arms broken and was placed in the sepulcher so that the rest might not be

statues none corresponds closely enough to this description to be identified with it.

[40] [Dr. Ulrich Middeldorf suggested this reading of the text.]

[41] Ghiberti saw the statue in 1424. Lombardi della Seta, a friend of Petrarch, died in 1390. The Capitoline *Venus* and the Costanzi *Hermaphrodite* were found in such tombs. This statue cannot be identified with any known today.

broken; and thus entombed in that condition it was pre-
served in our city for a very long time. This statue is a
marvel among the other sculptures. Posed on the right foot
and a piece of drapery around the thighs, it is most per-
fectly made. It has very many refinements the eye cannot
see in either a strong or a moderate light; only the hand
touching it finds them. It was executed with great care.
The statue was taken to Ferrara when a son of Lombardo
della Seta, to whom it had been left by his father, sent it
as a gift to the Marchese of Ferrara, who took great de-
light in painting and sculpture.

Also one [statue] was found, similar to these two; it was
found in the city of Siena, for which a great festival was
held. The experts considered it a marvelous work, and on
the base was written the name of the master, who was a
most excellent artist, whose name was Lysippus. It had one
leg raised and that on which it rested was a dolphin.[42] This
statue I have seen only in a drawing by Ambrogio Loren-
zetti, one of the greatest painters of the city of Siena, which
[drawing] was kept with the greatest care by a very old
friar of the order of the Carthusians. The friar was a gold-
smith—as his father had been—and was called Fra Jacopo.[43]
He was a draughtsman and took great pleasure in the art of
sculpture. He undertook to tell me how the statue was
found during the digging of a foundation where the houses
of the Malavolti stand, and how all the experts, and those
learned in the art of sculpture, the goldsmiths, and the
painters ran to see this statue of such wonder and art. Ev-
eryone admiring praised it; to each of the great painters
that were in Siena at that time it appeared to be of the
greatest perfection. With much honor they set it on their
fountain as a thing of great eminence. All flocked to place it
with great festivities and honors and they set it magnifi-
cently above the fountain. In that place it reigned for a

[42] [Dr. Ulrich Middeldorf suggested this reading of the text.]
[43] Fra Jacopino del Torchio, who was very old when G. saw
him in 1416, could have seen the statue before 1357 when it was
destroyed. It must have been found before 1348 because Am-
brogio Lorenzetti died then. The story is true. The statue stood
on the Fonte Gaia.

short time. As the country had met with much adversity in a war with the Florentines, the flower of their [Sienese] citizenry assembled in council. One citizen arose and spoke in this vein of the statue: "Signori, citizens, consider that since we found this statue we have always been overtaken by misfortune. Consider how idolatry is forbidden by our faith. We must believe that God sent us all our adversities because of our errors. And see the result, since we have honored this statue, always have we gone from bad to worse. I am sure that as long as we have it in our territory we shall always come out badly. I am one of those who would advise taking it down, destroying it entirely, and smashing it and sending [the pieces] to be buried in the land of the Florentines." All in accord affirmed the opinion of their citizen, and so they put into action [the plan] and it was buried in our land.

Among the other admirable things I ever saw is a wonderful chalcedony intaglio which was in the hands of one of our citizens; his name was Nicholaio Nicholi.[44] He was a very learned man and in our times was an investigator and collector of many excellent antique things and of Greek and Latin inscriptions and manuscripts, and among the other antique things he had this chalcedony, which is the most perfect thing I ever saw. Oval in form, it had on it the figure of a youth with a knife in his hand.[45] He was almost kneeling with one foot on an altar; the right leg was resting on the altar and the foot placed on the ground was foreshortened with such art and mastery that it was a wonderful thing to see it. In his left hand he had a cloth with which he held a small idol. It seemed that the youth was threatening the idol with his knife. By all those skilled and expert in sculpture or painting, without the disagreement of a single person, this carving was said to be a marvelous

[44] Niccolò Niccoli (1363–1427) was one of the most learned men of his time. He owned a fine library which later formed the nucleus of the Medicean library.

[45] The scene represents the theft of the Palladium by Diomedes. For information on Renaissance gems, see Ernst Kris, *Meister und Meisterwerke der Steinschneidekunst in der italienischen Renaissance*, Vienna, 1929.

work, having all the measurements and proportions any carving or sculpture should have. It was highly praised by all the able persons. One could not see it well in a strong light. The reason is this: that when fine polished stones are carved, the strong light and the reflections conceal the carving. This carving could best be seen by turning the carved part against a strong light; then one may see it perfectly. . . .

ANTONIO MANETTI

[Antonio Manetti (1423–1491), like other Florentines of his time, was a student of mathematics and astronomy and was well informed in art and architecture. For this reason he was chosen one of the judges of the competition of 1491 for the façade of the church of S. Maria del Fiore. To him is ascribed on quite good evidence the *Life of Filippo di Ser Brunellesco*, the first biography of the great architect, which supplied the basis for all subsequent biographies. It is significant because, even though written only a few years after Brunellesco's death, it makes him the innovator of "true architecture" in the sense of the ancient architects and Alberti. Although the *Life* is entirely partial to Brunellesco, unnecessarily prejudiced against Ghiberti, and intentionally inaccurate at times, it is a remarkable document because of its vividness and personal quality.]

THE LIFE OF FILIPPO DI SER BRUNELLESCO[1]

Filippo di Ser Brunellesco [called Filippo or Brunellesco], the architect, was of our city [Florence], he lived in my time, and I knew him and talked with him. He was

[1] The excerpts are translated from Antonio Manetti, *Vita di Filippo di Ser Brunellesco*, ed. E. Toesca, Florence, 1927, by the editor and Creighton Gilbert. As the text is exceedingly difficult because of the fifteenth century Tuscan colloquialisms, a middle course between accuracy and clarity has been sought. The footnotes are by the editor. Dr. Clarence Kennedy, Smith College,

born there of good and honorable family in the year of the Lord 1377. Here he lived most of the time and died, as all flesh. His paternal grandfather, for whom he was named, was called Lippo. His great-grandfather was Cambio and his great-great-grandfather was a physician, Maestro Ventura Bacherini. The wife of Ser Brunellesco [Filippo's father] belonged to the famous and liberal family of the Spini. Besides Filippo, she had two other sons, one named Maso, who was a plain enough person, and another who became a priest. Ser Brunellesco was an active man, a prudent and honest person. All his life he managed the affairs of soldiers, and, in particular, those of all our commanders and *condottieri*[2] in his time, and especially those of the most important ones. A truthful and loyal person in whom they had great confidence, he was their lawyer and business agent, solicited and drew their appropriations and pay. Every day, wherever he was, he had the task of helping them with their business, receiving arms, clothing, silverware, horses, and whatever else they needed. He was often employed by the *Dieci della Balìa*, which has long had the responsibility of wars, and was sent to recruit soldiers in Germany, France, Britain, Flanders, and other countries. In those times, and especially in Italy, usually soldiers from beyond the Alps were employed, and for the most part they were noblemen in their own countries. . . .

At a tender age, Filippo learned to read, write and calculate, as most boys of good families are expected to do in Florence, and also [received] some book learning, since his father was a notary and perhaps planned that he should be the same. At that time few persons among those who did not expect to become doctors, lawyers or priests were given literary training. He was very obedient to his instruc-

kindly clarified many difficult passages. Dr. Ulrich Middeldorf checked the entire translation. The text is also found in the following: *Filippo Brunelleschi di Antonio di Tuccio Manetti*, ed. H. Holtzinger, Stuttgart, 1887; G. Milanesi, *Operette istoriche di Antonio Manetti*, Florence, 1887.

See also: Schlosser, *Lett. art.*, p. 100, and *Kunstlit.*, p. 100.

[2] A leader of a small professional army selling its services to any state.

tions. He was easy to teach and fearful of censure. This was more helpful to him than threats, and he was eager to win praise whenever he could. As a small boy, he took a natural delight in drawing and painting, and was much attracted to those subjects. So when his father, as is usual, wanted him to learn some profession, Filippo chose to be a gold-smith.[3] His father consented, as he was a man of discernment and saw that Filippo had the necessary talent. He soon became proficient in all parts of his craft, particularly in the basic elements of design, for which he seemed to have remarkable gifts. In a little while he became a perfect master of niello, enamel, and colored or gilded ornaments in relief, as well as of the cutting, splitting, and setting of precious stones. Thus in any work to which he applied himself and both in this craft and in any other related to it, he always had wonderful success, more than his age would have led one to expect.

Therefore, when in his youth, certain important figures of silver were to be added to the elaborate altar in S. Jacopo in Pistoia, Filippo was commissioned to execute them. He wrought them with his own hand; for, even though he was young, he was already a master. He carved in wood and painted a very beautiful almost life-size statue of St. Mary Magdalen. It was burned in 1471 when the church of S. Spirito was burned. He made a life-size crucifix of wood [carved] in the round which he colored himself. It may be seen in the transept of the S. Maria Novella on the side toward the old piazza, fastened to a pilaster between two small chapels at the left of the choir chapel. In the opinion of connoisseurs, there is among statues and particularly among crucifixes not another in the world of such quality. As for his mastery of sculpture, according to the report of his contemporaries, he executed other very beautiful works in bronze and other materials. But those I have mentioned, I myself have seen.

Since there appeared in him what is called a marvelous understanding he often was asked for advice on building

[3] He was matriculated in the Silk Guild in 1398 at the age of twenty-four. This guild included the jewellers. He became a master in 1404.

matters. When Appollonio Lapo, his relative, planned to build the house which today belongs to his son, Bartolomeo, near the Canto de' Ricci toward the Mercato Vecchio, he used the services of Filippo. Inside one may see much that is good, comfortable and pleasing. Nevertheless, in those times the method of building was crude, as may be seen in the building of that time and before.

It is said that when Villa Petraia[4] was to be built, the architect consulted Filippo and that the tower was erected with his counsel. I have heard this tower praised by others, but I have never seen it except at a distance. The building of Petraia was discontinued because of changing fortunes.

When Filippo was a youth, it happened that, in the Palace of the Priori, the offices and residence of the officials of the Monte[5] and the room of their directors had to be built. This is in the place where formerly there were mostly loggias with columns made for the adornment and beauty of the building, which were highly regarded in their own time and are still to be seen there. Filippo was invited to be the planning and supervising architect and executed the work. Here one may see that the way of dressing the stones used in those days displeased him, and, unwilling to adopt it, he used a different manner. At that time he did not yet know about the style which he later developed after he had seen ancient Roman buildings.

At this same period, Filippo expounded and practiced what painters today call perspective, because it is part of that science which aims at setting down well and rationally the differences of size that men see in far and near objects, such as buildings, plains, mountains, and landscapes of all kinds and which assigns to figures and other things the right size that corresponds to the distance at which they are shown. From Filippo comes the rule which is the basis of all that has been done with this from that time on. It is the more remarkable, since it is not known whether the ancient

[4] Villa Petraia was an hereditary possession of the Brunelleschi. Filippo probably had nothing to do with the tower. His name was confused with the owners. See L. Scott, *Brunellesco,* London, 1901, p. 119.

[5] The *Monte* is a type of savings bank.

painters of centuries ago, who are believed to have been good artists in the time when sculpture was at such a high level, knew perspective and whether they applied it consciously. Even if they [ancient painters] practiced it by rules (for not without reason do I speak of it just above as science) as Filippo later did, still those who could teach him had been dead for centuries and if any written record is to be found, it is not intelligible. But his hard work and acuteness either rediscovered or invented it. Although the superior of many contemporaries in many things so that he was able to make his own period more cultivated, as well as those that followed, nevertheless he was never seen to boast or to extoll himself or to display arrogance or conceit whatever or say a single word in his own praise, but, as opportunity offered, he demonstrated his ability by deeds alone. Unless greatly provoked he never was angry at petty or spiteful things done to him; he was loving to his friends and he found it worth his while to praise those who seemed to him to deserve it. He willingly taught those who desired and were able to respond [to his instruction]. In this, as in other things, he was keen and discerning.

As for perspective, the first work in which he showed it was a small panel about half a *braccio*[6] square on which he made a picture of the church of S. Giovanni of Florence. He painted the outside of the church and as much as can be seen at one glance. It seems that to draw this picture he went some three *braccia* inside the central door of S. Maria del Fiore. The panel was made with much care and delicacy and so precisely, in the colors of the black and white marble, that there is not a miniaturist who could have done better. He pictured in the center the part of the piazza directly in front of him, and thus, on one side, that which extends toward the Misericordia as far as the arch and the Canto de' Pecori; and on the other that from the column commemorating the miracle of St. Zenobius all the way to the Canto alla Paglia. For the distance, and the part representing the sky, [i.e.] where the boundaries of the painting merge into the air, Filippo placed burnished

[6] See p. 155, note 14. Cf. Alberti, p. 208, note 10.

silver so that the actual air and the sky might be reflected in it, and so the clouds, that one sees reflected in the silver, are moved by the wind when it blows.

The painter of such a picture assumes that it has to be seen from a single point, which is fixed in reference to the height and the width of the picture, and that it has to be seen from the right distance. Seen from any other point, the effect of the perspective would be distorted. Thus, to prevent the spectator from falling into error in choosing his view point, Filippo made a hole in the picture at that point in the view of the church of S. Giovanni which is directly opposite to the eye of the spectator, who might be standing in the central portal of S. Maria del Fiore in order to paint the scene. This hole was small as a lentil on the painted side, and on the back of the panel it opened out in a conical form to the size of a ducat or a little more, like the crown of a woman's straw hat. Filippo had the beholder put his eye against the reverse side where the hole was large, and while he shaded his eye with his one hand, with the other he was told to hold a flat mirror on the far side in such a way that the painting was reflected in it. The distance from the mirror to the hand near the eye had to be in a given proportion to the distance between the point where Filippo stood in painting his picture and the church of S. Giovanni. When one looked at it thus, the burnished silver already mentioned, the perspective of the piazza, and the fixing of the point of vision made the scene absolutely real. I have had the painting in my hand and have seen it many times in those days, so I can testify to it.

Filippo also painted in perspective a view of the Palazzo dei Signori of Florence, including everything in front of the palace and around it that the eye can see when one stands outside of the piazza; that is, in line with the façade of S. Romolo and slightly inside the street which enters the piazza a few yards further toward [the church] Or San Michele just past the corner of the Calimala Francesca.[7] From that position one has such a view of the Piazza dei

[7] Instead of Calimala Francesca the text should read Calimala Francese, which was one of the old names of the present via della

Signori that two fronts, the west and the north, are seen in their entirety. It is wonderful to see the palace together with all the other things that the eye embraces from this point. Some time later Paolo Uccello and other painters tried to do the same thing and imitated Brunellesco. I have seen more than one of these attempts and none were as good as that of Filippo.

Here one might ask: Why in this painting which was also a perspective view did not Brunellesco make a hole to look through as in the little panel toward S. Giovanni from the Duomo? The reason is that the view of such a big square had to be fairly large in order to include so many different things. With a painting of such size it would not have been possible, as with that of S. Giovanni, to hold it up to the eye with one hand and hold a mirror with the other; for the arm of a man is not long enough, no matter how far he might reach out, to hold the mirror at the required distance and in the correct position; nor would anyone be strong enough to hold the mirror at arm's length. Filippo left the proper point of view to the discretion of the spectator, as is done with all other pictures by other painters, although the observer often does not pay enough attention to such a rule. In the part where, in the picture of S. Giovanni, he placed the burnished silver, here he cut away the panel, following the outlines of the buildings. Then he took the picture to some place where he could look at it against the sky, which showed above the silhouette of the architecture.

It happened in his youth, in the year of Christ 1401, that is, in his twenty-fourth year, while he was working at the goldsmith trade, that the *Operai*[8] of S. Giovanni in charge of its restoration, had to contract for the making of the second pair of bronze doors of this church, which to-day are on the north side. The *Operai* first informed themselves as to which were the most renowned masters of bronze casting, including those in Florence itself, in order to give the commission to the best one. After many debates

Calimazza, at the southwest corner of the Piazza della Signoria. The church of S. Romolo on the west side of the piazza was demolished in the eighteenth century.

[8] See p. 157, note 23.

among themselves and consultations with citizens and craftsmen, it was decided that the two best were both Florentine and that neither in Florence nor elsewhere were they able to get any report of better masters. One of these two was Filippo and the other Lorenzo di Bartolo, whose name is inscribed on the doors as Lorenzo di Cione Ghiberti, for he was the son of Ciono. At the time, when the work on the doors was taken into consideration, Lorenzo was still young. He was at Rimini, employed by the Lord Malatesta, and was called by this event to Florence. To choose the best of the contestants, this method was adopted: the *Operai* took as a model the shape of one of the compartments of the bronze doors, representing the story of St. John, which were already there and which were executed in the past century by foreign sculptors,[9] though the design of the figures, which were modelled in wax, was by the painter, Giotto. They asked each of the masters to make in bronze a scene in this same shape, intending to award the commission to whichever of them produced the best trial piece. The works made have been preserved to our day.[10] The one from the hand of Lorenzo is in the reception room of the Arte de' Mercatanti. The other by Filippo is built into the back of the altar of the sacristy of S. Lorenzo in Florence. In each panel is the scene of Abraham sacrificing his son. Filippo made his panel in the form which is still to be seen today. He did it quickly because he mastered his art boldly. When he had made it, chased it, and polished it completely, he felt no impulse to talk about it to anyone, because, as I have said, he was no braggart, but he waited confidently until the time of the judging. Lorenzo, it was said, was more afraid than not of Filippo's talent which was obvious enough to him, and not sure of his mastery of the art, he proceeded slowly. When it was rumored about what a beautiful thing was Filippo's he be-

[9] Andrea Pisano (1274–1348) is referred to as foreign in the sense of being non-Florentine. He came from Pisa. The bronze founder who did the casting was a Venetian.

[10] The two successful panels are in the Bargello, Florence (our *figs.* 16 and 17). The others, which were kept for awhile, have disappeared.

thought himself, being a man of parts, of making up for it by industry and by humbly asking for advice and criticism from all those whose opinion he esteemed and who, since they were goldsmiths, painters, and sculptors, would eventually judge his work. Thus he meant to prevent the failure of his work at the competition. And while he was working on the wax model, continually consulting and asking advice, deferring to people of this sort, he endeavored to find out as much as possible about Filippo's model. Conferring with these experts, Lorenzo undid and remade the whole and parts of his model as many times as it seemed necessary to the best of them, not shirking any amount of labor while it was still under his hand in the wax stage, and after a long time he finally finished it completely. Then came the contest and the judging. The *Operai* and the officials of the building consulted precisely those experts whom Lorenzo had picked out as the most learned since they were in fact the most competent and perhaps there were no others; they were the very ones who had had a share in Lorenzo's work many times in the course of its progress. Since not one of them had seen Filippo's model, they did not believe that Filippo, or even Polycletus himself, would have been able to do better than Lorenzo. The fame of Filippo was not yet widespread, for he was still a young man and had his mind more on doing than on talking. But when the experts saw his model all were astonished and amazed at the problems he had set himself, such as the movement of Abraham, the position of his finger under Isaac's chin, his animation, the draperies and the style, the design of the boy's whole body, the style and draperies of the angel, his gestures, how he seizes the hand of Abraham; at the pose, style and design of the boy drawing the thorn from his foot, and likewise of the man drinking bent over. They were amazed at the many difficulties in those figures he had overcome and how well the figures performed their functions, for there was not a limb that did not have life. They admired the design of the animals that are there and every other detail as well as the composition as a whole. But since they had strongly praised Ghiberti's work to every one who would listen, it seemed awkward to them now to have to contradict themselves,

though they were aware of the truth. Thus, consulting to-
gether, they fixed on this solution and made this report to
the *Operai*: both models were very beautiful and for their
part, when all things were balanced, they could not discover
any superiority. Since the task was great, demanding much
time and expense, let them allot an equal share in the com-
mission to each of them so that they would work in it to-
gether as partners. When Filippo and Lorenzo were called
and told the decision, Lorenzo was silent, but Filippo would
not agree unless the work was entirely his, and in this he
persisted. The officials kept to their decision, fully believing
that in the end they would agree. Filippo would not budge,
like one whom God, without his knowledge, had destined
for greater things. The officials threatened to commission
it from Lorenzo if he did not change his mind. He replied
that he did not want to take part if he did not have entire
charge and if they did not wish to do this, as far as he was
concerned, he would be perfectly happy if they should give
the commission to Ghiberti. They asked for opinions and as
a result the city was sharply divided. Those siding with
Filippo were resentful that the entire work had not been
given to him. However, the matter was settled in that way.
And we can see that considering what the future held in
store for Filippo it was better so.

Having been rejected in this manner, it is almost as
though Filippo said, "I did not know how to do well enough
to have them put their confidence entirely in me; it would
be a good thing to go and study where sculpture is really
good." And so he went to Rome, for at that time there were
plenty of good things that could be seen in public places.
Some of the things are still there, though few. Many have
since been stolen and carried and sent away by various
pontiffs and cardinals, Romans and men of other nations.
While looking at the sculpture, as he had a good eye and
an alert mind, he saw the way the ancients built and their
proportions. As if he were enlightened concerning great
things by God, he seemed to recognize quite clearly a cer-
tain order in their members and structural parts. This he
noticed especially, for it looked very different from what
was usual in those times. He proposed, while he was look-

ing at the statues of the ancients, to devote no less attention
to the order and method of building. And so he observed
closely the supports and thrusts of the buildings, their
forms, arches and inventions, according to the function they
had to serve, as also their ornamental detail. In these he
saw many wonders and beauties, for the buildings were
made at various times and for the most part by good mas-
ters who became great because of their experience in build-
ing and because the rewards of the princes made it possible
for them to study, and also because they were not unedu-
cated men. Brunellesco proposed to rediscover the excellent
and highly ingenious building methods of the ancients and
their harmonious proportions and where such proportions
could be used with ease and economy without detriment
to the building. Having perceived the great and difficult
problems that had been solved in the Roman buildings, he
was filled with no small desire to understand the methods
they had adopted and with what tools [they had worked].
In the past he had made, for his pleasure, clocks and alarm
clocks with various different types of springs put together
from a variety of different contrivances. All or most of these
springs and contrivances he had seen; which was a great
help to him in imagining the various machines used for
carrying, lifting, pulling, according to the occasions where
he saw they had been necessary. He took notes or not, ac-
cording to what he thought necessary. He saw some ruins,
some still standing upright, and others which had been
overthrown for various reasons. He studied the methods of
centering the vaults and of other scaffolding, and also where
one could do without them to save money and effort, and
what method one would have to follow. Likewise, [he con-
sidered] cases where scaffolding cannot be used because
the vault is too big and for various other reasons. He saw
and considered many beautiful things which from those
antique times, when good masters lived, until now had not
been utilized by any others, as far as we know. Because of
his genius, by experimenting and familiarizing himself with
those methods, he secretly and with much effort, time and
diligent thought, under the pretense of doing other than he
did, achieved complete mastery of them, as he afterwards

proved in our city and elsewhere, as will be shown in due time in the present narrative.

During this period in Rome he was almost continually with the sculptor Donatello. From the beginning they were in agreement concerning matters of sculpture more particularly, and to these they applied themselves continually. Donatello never opened his eyes to architecture. Filippo never told him of his interest, either because he did not see any aptitude in Donatello or perhaps because he was himself not sure of his grasp, seeing his difficulties more clearly every moment. Nevertheless, together they made rough drawings of almost all the buildings in Rome and in many places in the environs, with the measurements of the width, length and height, so far as they were able to ascertain them by judgment. In many places they had excavations done in order to see the joinings of the parts of the buildings and their nature, and whether those parts were square, polygonal or perfectly round, circular or oval, or of some other shape. And thus where they were able to estimate the height from the bases and foundations to the cornices and the roofs of the buildings, they noted the measurements on strips of parchment like those used for squaring pages, with arithmetical numbers and characters which Filippo only understood. Since both were good goldsmiths they earned their livelihood by that trade; for at the workshops of the goldsmiths they were given more work than they could do. Filippo dressed many precious stones which he had been given to cut, set and polish. Neither was bothered by family cares and worries because neither had a wife nor children there or elsewhere. Neither was much concerned with how he ate, drank, lived or dressed himself, provided he could satisfy himself with these things to see and measure. Because they had to dig in many places in order to investigate structures or to find buildings where some indication was discernible that some buried edifice existed, it was necessary for them to hire porters and other laborers, and this at great expense, since no one else did the thing or understood why they did it. The reason why none understood why they did this was that at that time no one gave any thought to the ancient method of building, nor had for hundreds of years.

In the time of the pagans some authors gave rules, as Battista Alberti did in our own time, but these were little more than generalities. Constructive ideas which are peculiar to a master of their craft are necessarily the gift in large measure of nature or obtained through the master's own industry.

To return to the excavations of Filippo and Donato, they were generally called the treasure-men, in the belief that they were spending treasures and seeking them. It was said, those treasure-men are searching today in this place and another time in another place, etc. It is true that sometimes, although seldom, one finds in such excavations medals of silver and even of gold, and also carved gems, calcedons, cameos, and similar stones. This was the source of the belief that they were digging for treasure. At such work Filippo spent many years. He found in the decoration and adornment of the various buildings many differences in the finish of the building blocks as well as in the columns, bases, capitals, architraves, friezes, cornices and pediments, in the shapes and styles of temples and in the thickness of the columns. From these observations, with his keen vision, he began to distinguish the characteristics of each style, such as Ionic, Doric, Tuscan, Corinthian and Attic, and he used those styles at the times and places he thought best, as one may still see in his buildings.

VESPASIANO DA BISTICCI

[Vespasiano da Bisticci (1421–1498) was the principal bookseller of Florence. Although he himself was not a scholar, he had a professional knowledge of the Greek and Latin texts he bought and sold, and was concerned for their translation and transcription for his clients. His shop was a meeting place for manuscript-searching scholars from all Europe. He supplied books to Cosimo de' Medici, Pope Nicolas V, Federigo da Urbino, William Gray, the Bishop of Ely, John Tiptoft, the Earl of Worcester, and other famous book collectors of the day. Toward the end of his

life, he wrote the lives of the people he had known. These hundred and five biographies, divided into five different categories, show him to have been a man with considerable common sense, little personal conceit, who was a shrewd observer and judge of people.

His collection of biographies was found among others in the Vatican Library manuscript, *Spicilegium Romanum,* and was first published in part in 1839 and completely in 1859 under the title "Vite di uomini illustri del Secolo XV."]

LIVES OF ILLUSTRIOUS MEN OF THE XVTH CENTURY[1]

I. A DISCOURSE BY THE AUTHOR

I have often considered how great is the value of the light which learned writers, in times both ancient and modern, have thrown upon the actions of illustrious men; how that the fame of many worthies has come to naught because there was no one to preserve in writing the memory of their deeds, and that, if Livy and Sallust and other writers of excellence had not lived in the time of Scipio Africanus, the renown of that great man would have perished with his life. Neither would there have been any record of Metellus, or of Lycurgus, or of Cato, or of Epaminondas the Theban, or of the infinite number of men of mark who lived in Greece and Rome. But because many illustrious writers flourished amongst these people, the lives and actions of their great men have been displayed and published abroad so that they are as real to us as if they had lived today, whereas they happened a thousand years and more ago. For this reason great men may well lament that, in their lifetime, there should be living no writers to record their deeds.

As to the origin of Florence, it is the opinion of Messer Lionardo[2] and of many other learned men that the Floren-

[1] The excerpts are from *The Vespasiano Memoirs by Vespasiano da Bisticci, Bookseller,* translated by William George and Emily Waters, London, 1926, pp. 31–52.

[2] Lionardo d'Areszo, the author of a history of Florence.

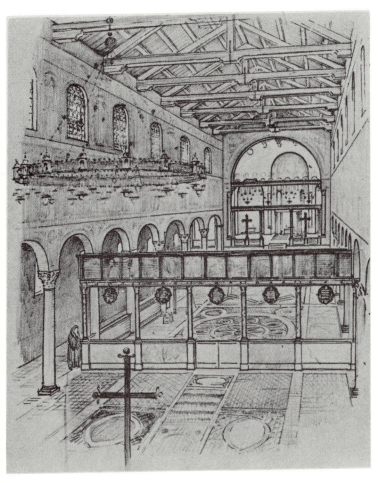

FIG. 1. Monte Cassino, the Desiderian Monastery, interior
(Conjectural restoration by K. J. Conant with the
collaboration of H. M. Willard)

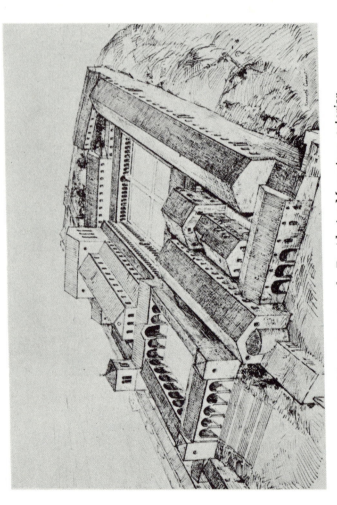

FIG. 2. Monte Cassino, the Desiderian Monastery, exterior (Conjectural restoration by K. J. Conant with the collaboration of H. M. Willard)

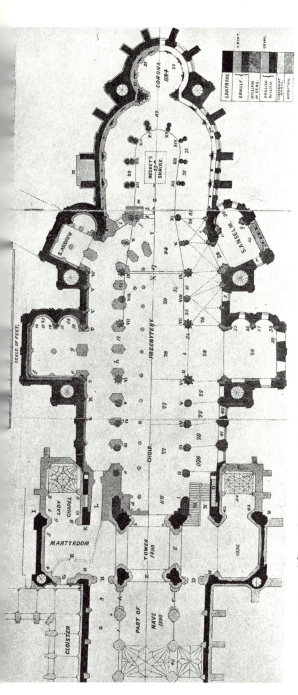

FIG. 3. Plan of Canterbury Cathedral (Reproduced from R. Willis, *The Architectural History of Canterbury Cathedral*, London, 1845. Various tints of shading indicate the works of different periods. Roman numerals are used to distinguish the piers. Nos. 1–50 refer to monuments and shrines. Nos. 75 and up refer to the dates of the vaults where there was insufficient space to write the date in full, as 76 for 1176, etc.)

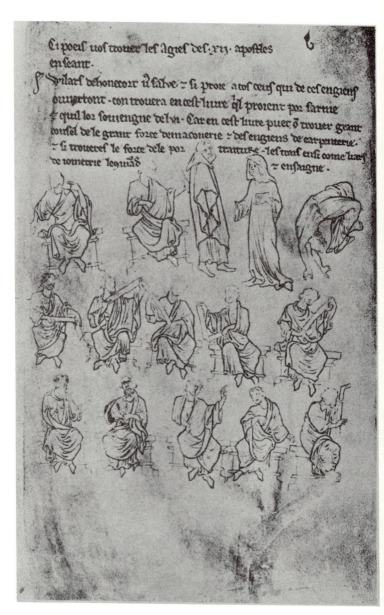

FIG. 4. Villard de Honnecourt, Sketch Book, Plate II
"Here you can find the figures of the Twelve Apostles seated."

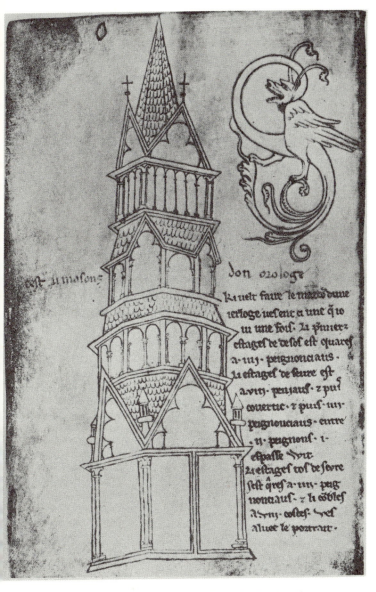

FIG. 5. Villard de Honnecourt, Sketch Book, Plate XII
"This is a clock house."

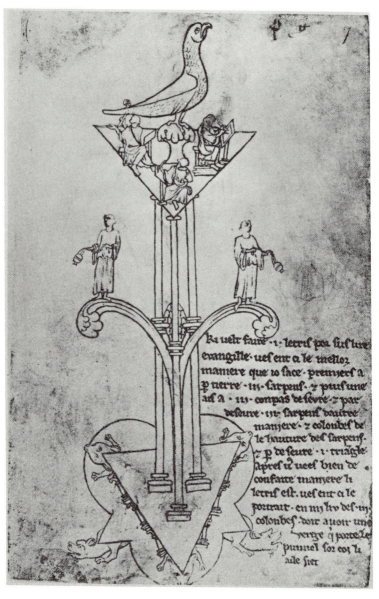

FIG. 6. Villard de Honnecourt, Sketch Book, Plate XIII
"Who desires to make a lectern . . ."

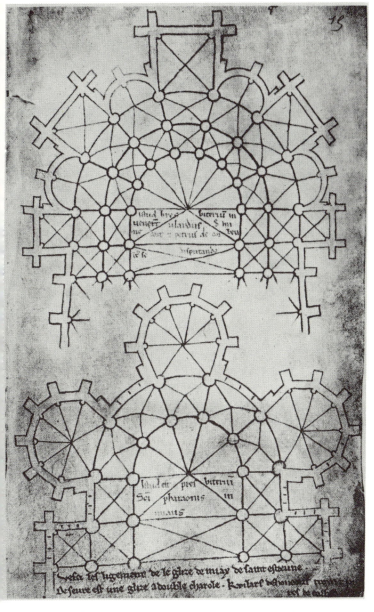

FIG. 7. Villard de Honnecourt, Sketch Book, Plate XXIX
"This choir Villard de Honnecourt and Peter de Corbie
have contrived in collaboration."

FIG. 8. Villard de Honnecourt, Sketch Book, Plate xxxv
"Here begins the instruction in the art of drawing."

FIG. 9. Villard de Honnecourt, Sketch Book, Plate XXXVI
"Here begins the art of the elements of drawing..."

FIG. 10. Villard de Honnecourt, Sketch Book, Plate XLVII
"I will tell you of the training of the lion."

FIG. 11. Matthew Paris. St. Edward, the King, directs
a master-mason, carpenter, and masons to build
Westminster Abbey

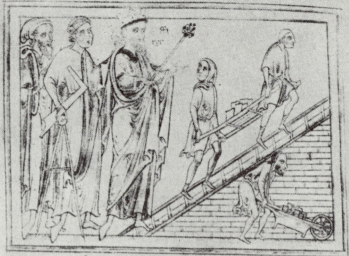

Sell funde hoc une igfule lign minoef crulat et ad...

... ue fue die les fidenntee deuse voutue... pluuiam. Prope lieve... ali.

pete remeautr

Vne congregatio apud uerolam
um epor't optimatum suorum
conalio unanim omnium consensu
et voluntate beato albano amplas
contulit terras + possessiones

quas multiplici libtatum pui
legio roboratas insignut. Mona
chorum ex remotis pabus elan ex
omnibz bene religiosis comibz ad
tubam insic congregaut. Et abbm
eis nomine Willegodum pfece
rat cum ipso monasterio omnia iura
regalia concessit. Ser adiuuaculo
ad matiam redeuntes. ad op condito

ris se retramur. Quin ab
inuentione cepit sacra extem loco
non nulli pfuerut pret
mis tempore quo meroziossim
ter hentur pmus impium reni
it. uenerabilis albert. Ganfridus
poten fric monasterii regularis
impaut. Qui ex illustri reg
gia normanor cenomanensiuq;
psapia trahens originem clemo
sinis + eccl mre bnfuais diuina
q; propiaam studuit materderic.
Vnde contigit ut illo potissimii anni
quo finuet pmatola poa regis de
pasta est populum. tam sect

FIG. 12. School of Matthew Paris. King Offa,
accompanied by his master-mason, views the building
operations of St. Alban's Abbey

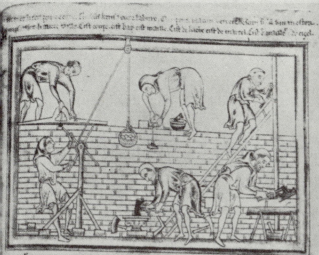

FIG. 13. School of Matthew Paris. Masons constructing
a wall of St. Alban's Abbey

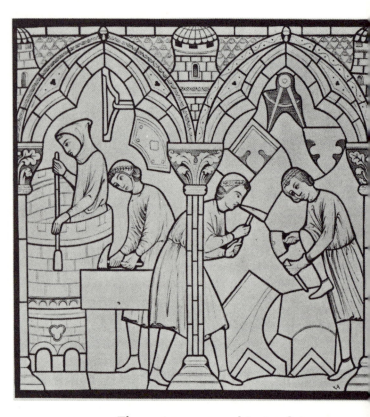

FIG. 14. The master-mason-architect and stone-
cutters depicted in a stained-glass window of
the thirteenth century, Chartres Cathedral
(From Didron, *Annales Archéologiques*,
Paris, 1886; t.11, pp. 242-43)

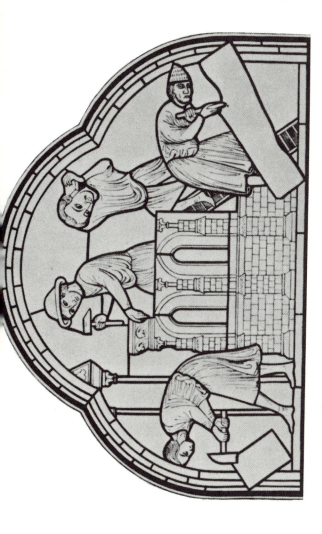

FIG. 15. Construction methods and tools. Thirteenth-century stained-glass window, Chartres Cathedral (From Didron, *Annales Archéologiques*, Paris 1886; t.11, pp. 242-43)

FIG. 16. Ghiberti, Sacrifice of Isaac.
Competitive Panel. Florence, Bargello

FIG. 17. Brunellesco, Sacrifice of Isaac.
Competitive Panel. Florence, Bargello

FIGS. 18 and 19. Pisanello, Alfonso V of Aragon,
and Reverse: Libera Litas Augusta
National Gallery of Art, Washington, D. C.
Samuel H. Kress Collection, Loan

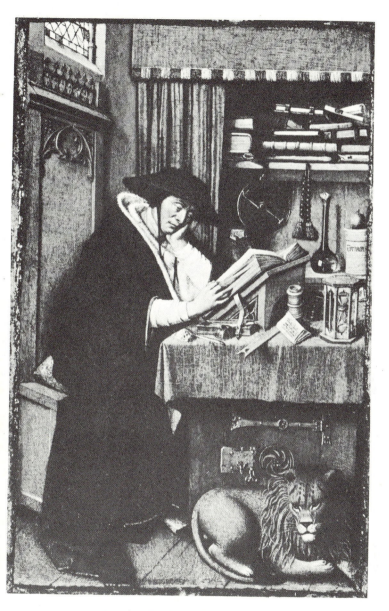

FIG. 20. Jan van Eyck, St. Jerome in His Study
Detroit Institute of Arts

FIG. 21. Jacopo de' Barbari (?), Portrait of Luca Pacioli
Naples Museum (phot. Alinari)

FIG. 22. Disposition of Weight of the Human Figure in Movement. Engraving, after a drawing by Poussin, from L. da Vinci, *Traité de la peinture*, 1561

FIG. 23. Enguerrand Quarton, Coronation of Virgin. Villeneuve-
lès-Avignon, Musée (photo: Archives Photographiques, Paris)

FIG. 24. Dürer, Woodcut from the Fourth Book
of the *Vier Bucher von Menschlicher Proportion*

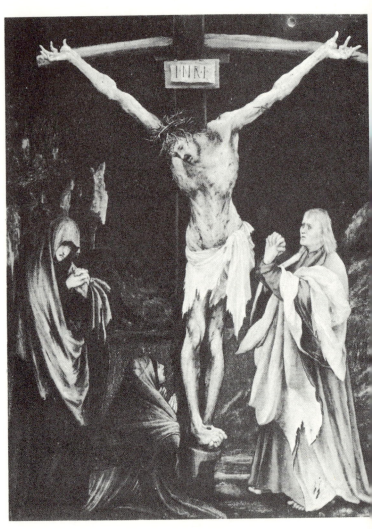

FIG. 25. Mathias Grünewald, The Small Crucifixion
National Gallery of Art, Washington, D. C.
Samuel H. Kress Collection, Loan

tines are sprung from the horse-soldiers of Sylla, but this
view is difficult to justify. Pliny holds that the city must be
of great antiquity, and that the Florentines were called
Fluentini because their city was placed between the
streams of Arno and Mugnone. This is a valid testimony of
its antiquity. Moreover, he cites, by way of further proof,
the shape of the theatre which still exists, the Temple of
Mars, now S. Giovanni, a very ancient building, and cer-
tain aqueducts which are still partially standing; but all
these instances depend only on conjecture, seeing that no
learned scribes have ever put the matter on record. For
this reason Messer Lionardo, in writing his history of
Florence, was put to much trouble through lack of docu-
ments, except for a period of some hundred and fifty years,
and elsewhere he had to base his facts upon such authori-
ties as I have named above.

We find in Florence no writers from the foundation to
the time of Dante, that is for more than a thousand years.
Following Dante came Petrarch and then Boccaccio, but
these tell nothing of the origin of the city because they
found no records. After Dante came two other poets,
Messer Coluccio and Maestro Luigi Marsigli, who was also
a theologian and very learned also in astrology, geometry
and arithmetic. Of the lives of these we have no detailed
record, but they are mentioned occasionally by all writers.
The present age has produced many distinguished men in
all the faculties, as will appear to posterity if a record be
kept of them, as was the practice in old times when learned
writers were plentiful. In this age all the seven liberal arts
have been fruitful in men of distinction, not only in Latin,
but also in Hebrew and Greek; men most learned and
eloquent and equal to the best of any age. In painting,
sculpture and architecture we find art on its highest level,
as we may see from the works which have been wrought
amongst us. An immense number of these great men we
cannot call by name; their fame has perished simply be-
cause no one has written of them. And this loss did not arise
through lack of writers; eloquent and learned men
abounded, but they were loth to undertake the burden of

literature, knowing that in the end they would enjoy neither the repute nor appreciation they deserved.

We may see how numerous men of learning were in the times of Pope Nicolas of happy memory, and of King Alfonso,[3] because they were well rewarded and held in the highest esteem, and how many excellent works they composed or copied through the munificence of princes so liberal as the two I have named, whose fame will last for ever. Moreover, beyond the money they gave, they paid high honour to men of letters and advanced them to high station. In addition to these two princes must be named a worthy successor, the Duke of Urbino, who, having followed their example in honouring and rewarding and promoting men of letters, became their protector in every respect, so that all were wont to fly to him in case of need. Thus, to help them in their labours, he paid them well for their work, so that he gained immortal fame by their writings. But when there was no longer a Duke of Urbino, and when neither the court of Rome nor any of the other courts showed any favour for letters, they perished, and men withdrew to some other calling, seeing that, as I have said, letters no longer led to profit or reward.

As it has chanced that I myself am of this same age, and that from time to time I have met many illustrious men, whom I have come to know well, I have set down a record of these in the form of a short commentary to preserve their memory, though such work is foreign to my calling. I have been moved thereto for two reasons. *First*, that their fame may not perish: *Second*, that if anyone should take the trouble to write their lives in Latin he should find before him a material from which such work could be modelled. And in order that these men of light and leading may be under a worthy chief, whom they may well follow, and because in all cases the spiritual ought to hold the first place, I will assign to Pope Nicolas the leadership of all the rest, and I will tell what I have to say concerning His Holiness with all the brevity possible, considering the praise which is his due. Had this task of mine been undertaken

[3] King Alfonso of Naples.

in ancient times, the Pope must have been portrayed as an illustrious man by anyone who might have done it. It will appear from the life of this excellent Pope how great is the power of virtue, because everyone must see that he could only have attained to his high position by virtuous dealing.

POPE NICOLAS V (1398–1455)

Maestro Tomaso da Serezana, who afterwards became Pope Nicolas V, was born at Pisa of humble parentage. In course of time, through civil strife, his father was banished and withdrew, at his own instance, to Serezana, where he let his son learn grammar as a child. He was an apt scholar, and when he was nine years old his father died leaving two boys, Tomaso, and Filippo who was afterwards Cardinal of Bologna. In the same year Tomaso fell ill, whereupon his widowed mother, perceiving that he was sick and having the highest hope in this son of hers, was in the greatest grief and anxiety. She offered constant prayers to God that He would deliver her son from danger, and while she was thus praying and fearing lest her son should die, she fell asleep about daybreak, but somehow it did not seem to her that she was sleeping, as she was called by her name, "Andreola," by some one who said to her, "Have no fear of your son's recovery." Moreover, in this vision she saw her son clothed in pontifical vestments, and some one told her that he would be Pope, and bade her keep firm hope that all these things which were told her would come to pass. When she was awakened from sleep, she went forthwith to see her son and found him much better, and she told to all the household the vision she had seen.

When the boy had quite recovered his health his mother, firmly sustained by the hope given to her in the vision, urged him to apply himself to his studies; but there was no need for this, seeing that he was by nature most anxious to learn. Thus, by the time he was sixteen, he had an excellent knowledge of grammar, had heard and read much in the Latin tongue: and had begun logic, philosophy and theology. Then he left Serezana for Bologna that he might there prosecute his studies. He made great progress in logic and philosophy, and in a short time he became learned in

all seven of the liberal arts. He remained at Bologna till his eighteenth year, when he was made Master of Arts; but through want of money, he found it necessary to go to Serezana to his mother, who had married again, in order to procure the wherewithal to pay his charges. The mother was poor and the husband not over-rich, moreover, Tomaso was to him not a son but a stepson, so no money was forthcoming. But being determined to continue his studies he went to Florence, at that time the mother of learning and of all merit, and soon after he met Messer Rinaldo degli Albizzi, a prominent citizen, who engaged him at a liberal salary, which he well deserved, as the tutor of his sons. After a year of this engagement Messer Rinaldo left Florence; and, wishing to remain in the city, Messer Tomaso made an advantageous agreement with Messer Palla di Nofri Strozzi to act as tutor. In the house of Messer Palla the greatest honour was paid to his worth in order that the boys might treat him with respect. At the end of another year he had received from these two citizens enough money to allow him to return to his studies at Bologna, although in Florence he had lost no time.

So he quitted Florence and went to Bologna, where he was fain to reside on account of the school of theology: and in a short time, being already learned in philosophy and a Master of Arts, he became a Doctor of Theology in his twenty-second year. Messer Nicolao degli Albergati, Bishop of Bologna, who was of the order of the Carthusian brothers, begged him to come and reside with him; and after he had gone thither the bishop discovered his great merits, and gave over to him the entire ruling of his house. After he had taken up this governorship he did not lose an hour of time, and always attended the disputations in the assemblies. I heard from him that, being a Master in Theology, he overlooked the works of the Master of the Sentences [Peter Lombard], and the works of all those who had written comments thereon, because in these it often happened that one writer would set down what another had omitted. He knew the works both of the modern and the ancient doctors, and there were few Greek and Latin writers whose works he had not studied. He knew the whole Bible

by heart, and his citations thereof were always appropriate. During his pontificate these evidences of scriptural study, in the answers he was called upon to make, added greatly to his fame and honour. When he was twenty-five years old he was ordained priest by the hands of the Bishop of Bologna, and a short time afterwards Pope Martin, having heard of the good repute of the Bishop of Bologna, of his own accord made him cardinal with his title from Santa Croce in Jerusalem, this necessitating his transfer from Bologna to Rome. Messer Tomaso went with him to Rome, which was full of distinguished men, with whom he would hold disputations in theology or in philosophy whenever time permitted. And, not to leave unnoticed his proficiency in universal knowledge, I have heard him remark how he had ascertained from the records of divers authors that Italy had been in the hands of the barbarians, the Goths, the Vandals, the Getae, the Huns, the Lombards and the Heruli, for four hundred and fifty years, and that it was a wonder to him that books or anything of worth should have survived.

While Messer Tomaso was thus settled in Rome, Pope Eugenius considered how peace might be made between the King of France and the King of England and the Duke of Burgundy. Bearing in mind the honesty and good faith of the Cardinal of Santa Croce he [the Pope] resolved to send him as legate to France and England, and to the court of the Duke of Burgundy, where he was held in the highest esteem. Moreover, he designated Maestro Tomaso as a member of this embassy,[4] largely because of the reputation he had acquired during his sojourn at the court. The cardinal, through the good offices and industry of Maestro Tomaso, played a most beneficent part in settling the disputes between France, Burgundy and England. He put an end to divers wars and discords which were rife in these regions, and on his return to Rome, after the conclusion of peace, the Pope, who was greatly pleased at what he had done and confident in his fitness for another mission of the same sort, despatched him to Germany on account of the

[4] See B. Fazio, p. 200, note 11.

frequent quarrels between the princes of that country. Here he remained for a year, and almost all the disputes were brought to an end, partly through the benevolence and good faith of the cardinal himself, and partly through the promptitude and industry of Maestro Tomaso. They suffered privately much pain and weariness from the roughness of these people, who are still barbarians. After his return to Rome the Pope sent the cardinal to Ferrara, where he brought about a peace between Duke Filippo and the Venetians and the Florentines [1433]. Here again the cardinal worked hard for peace, and rested not till they had succeeded in accomplishing this good work. Italy had long been harried by armed bands and by war, and these troubles now ceased. In all these missions the diligence of the cardinal was seconded by that of Maestro Tomaso. The cardinal was troubled with stone and other infirmities, and gave over to the care of Maestro Tomaso the general management of his public and private affairs.

On account of a conspiracy laid against him by the Romans, Pope Eugenius fled from Rome to Florence [1434], and thither went also the Cardinal of Santa Croce and Messer Tomaso. There they found many distinguished men, and many also came with the papal court. For the reason that Lionardo d' Arezzo, Giannozzo Manetti, Poggio, Carlo d' Arezzo, Giovanni Aurispa, Gaspara da Bologna, a very learned man, and many others were accustomed to assemble every evening and every morning at the corner of the palace for discussion and conference on various matters, Maestro Tomaso, as soon as he had gone with the cardinal to the palace, would repair thither and join them. He rode on a mule with two servants on foot, and generally would wear a blue cloak, while the servants would be clad in long coats of *moscavoliere* with priests' caps on their heads. There was no such pomp in the papal court then as we see now. He would constantly be found in the place above named holding discussions, or about the Pope's court, conversing and arguing, for he was a very ardent dialectician. When Pope Eugenius left Florence he went to Bologna, where the cardinal had his bishopric; and, the episcopal residence being in very bad condition, the cardi-

nal, as soon as Maestro Tomaso arrived in the city, began to confer with him as to the rebuilding of it. He gave him a commission to carry out the work, and in a very short time the bishop's home was rebuilt from the foundations.

After the Pope quitted Bologna he went to Ferrara, where he sought to bring the Greeks into communion with the Roman Church, and so arranged things that all the leaders of that people consented to repair to Ferrara [1438]. The Pope agreed, in order to bring them to the true Church, to pay all their charges, their lodging as well as all their necessary wants. The Emperor in person and the Patriarch of the Greeks, the two chiefs of that religion, came together with all the most learned men of Greece. After they had been some time in Ferrara the plague broke out, and it was necessary to leave that city and go to Florence [1439], where they took possession of houses for the lodging of the Greeks, who numbered about five hundred bishops, archbishops and other prelates. Pope Eugenius had assembled in his court all the learned men he could find, friars and priests and seculars, and caused benches to be erected in Santa Maria Novella for the Council, which, by the advice of certain of the learned cardinals, was called the Council of the Greeks. Moreover, the Council of Basel was summoned to appear at Florence, and by this action it was dissolved and its authority annulled. The doings of these learned men in this most momentous occasion are known to everybody; how in this Council every morning, before the Pope and the cardinals and all the court of Rome, the Latins disputed with the Greeks concerning their capital error, which was that the Holy Spirit proceeds from the Father alone, and not from the Son, while the Latins, by the true meaning of the Faith, maintain that it proceeds from the Father and the Son. Amongst those who were present was a certain Nicolo Secondino from Negroponte, who spoke in a fashion which was marvellous to hear, because, when the Greeks spoke and brought forward arguments to prove their opinions, as soon as they had ended Nicolo Secondino explained in Latin *de verbo ad verbum* everything they had said. Then the Latins spoke, making answer to the arguments of the Greeks, which answer

Nicolo translated into Greek. In all these disputations Messer Tomaso found himself on the side of the Latins. He was amongst the leaders and the highest in esteem with both factions, through the universal knowledge he possessed of the Holy Scriptures, and of the doctors, ancient and modern. Pope Eugenius strove unceasingly to abolish heresy all over the world, and amongst those who had come to Florence were certain Ethiopians and Armenians and Jacobites, who are Christians with certain heretical opinions. To all of these they sent some learned man, skilled in the language, and amongst these were some friars of Santo Antonio, true friars, very roughly clad; they were unshod, wore hair cloth and ate neither flesh nor fish that had blood. Pope Eugenius handed over to Maestro Tomaso the duty of disputing with these three nations, the interpreter being a Venetian who was well versed in twenty languages, and twice every day, with the help of this interpreter, Messer Tomaso would hold discussions with them. After these disputations had gone on for some time, these Ethiopians and Armenians and Jacobites were brought into union with the Roman Church by Messer Tomaso's influence, and of this union there is public record in the Palazzo dei Signori, together with that of the Greeks, the greater part of whom also joined the Church. And Maestro Tomaso had much to do in this affair of the Greeks, and of the three other parties as well.

In all matters his merit made itself apparent, and, notwithstanding the high esteem of his position, his carriage towards all those who knew him was most amiable. He was very witty, he had a pleasant word for everyone, and all those who held converse with him were afterwards friendly to him, by reason of his admirable manner and of his marvellous natural gifts. His negotiations with the courts of all the nations of the world gave him an honourable position, and in these he had always met men of worth and worship. He behaved most liberally to all, not regarding what he possessed as really his own. He did not know what avarice was; indeed, if he retained anything of his own, it was simply because no one had asked him for it. He spent money beyond his power, as at that time he maintained a

large number of clerks, the best he could find, and never considered their wage. He had full trust in his own ability, knowing that he would never want, and he used to say that there were two things he would do, if he had the money to spend, that is to say, buy books and build houses. During his pontificate he did both. And although at this time he was poor, he was determined that all the books which were produced for him should be of the finest in every respect. He had books in every branch of learning, and amongst them the works of S. Augustine in twelve fine volumes, all newly edited in the best style: likewise the works of ancient and modern doctors, nearly all of which he had read and annotated with his own hand; for, taking both the ancients and the moderns, he was one of the finest scribes that ever lived, and in these books of his, where he could find no notes, he added some of his own. And to-day in Santo Spirito, in a library called after Boccaccio which forms part of the library of the friars and was built by Nicolao Nicoli, who placed therein certain of Boccaccio's books in order that they might not be lost, there is a book which Maestro Tomaso gave to the friars, the treatise by S. Augustine, *Contra Julianum pelagianistam* and against other heretics, which is throughout annotated by him. Whenever he went with the cardinal out of Italy, he never returned without bringing back some book hitherto unknown, such as the Sermons of Pope Leo, the notes of S. Thomas on S. Matthew, a most excellent work, and many others. There was no Latin or Greek writer in any of the faculties with whom he was not acquainted; and as to the arranging of a library there was no one to equal him, and for this reason Cosimo dei Medici, when he was about to set in order the library of S. Marco, wrote to Maestro Tomaso begging him to send direction as to how a library should be formed. And who is there who has not gone through this trouble before bringing some such a scheme into working order? Maestro Tomaso wrote the instructions with his own hand, and sent them to Cosimo; moreover, he did the same with the libraries of Santo Marco, of the Badia of Fiesole, of the Duke of Urbino and of Signor Alessandro Sforza.

All men of letters are under heavy obligation to Pope Nicolas for the favour he extended to them, and for the high estimation he gained for books and for writers everywhere. It often happened to Maestro Tomaso that he found himself without money, so he had to buy books on credit; and, in order to pay his scribes and miniature painters, he borrowed as much as it seemed he could afterwards repay. . . .

Later on Eugenius sent him, together with Messer Giovanni Carvagialle, a Spaniard, the auditor of the Rota and a very distinguished man, to France and Germany; and on their way they passed through Florence. On his nomination as Bishop of Bologna, Maestro Tomaso had resigned his other two benefices, the subdiaconate and the archidiaconate, and was without income because Bologna then refused obedience to the Church, and held back the revenues of the bishopric. On this account Pope Eugenius made him vice-chamberlain. The first words he said to me when I saw him in Florence were that Pope Eugenius was poor, and he himself of the poorest, for the reason that his only source of income was his bishopric, from which he received nothing; that Pope Eugenius was most liberal, but was without cash and consequently unable to give him such a sum as would allow him to complete his task in France. Then, turning to me, he said, "You must go to Cosimo and beg him to place at my disposal a hundred ducats *per diem* until the date of my return and tell him the reason therefor." I went to Cosimo, who said to me, "I wish to do better even than he demands," and thereupon he sent to him Roberto Martelli, who told him that he had a commission from Cosimo dei Medici to issue a general letter to all the companies and correspondents of the house, who would pay over whatever sums Maestro Tomaso might want. This seemed to him even too great liberality, and he bade Roberto to thank Cosimo on his behalf. Roberto replied in a tone of courtesy, setting forth the good will of Cosimo towards his lordship. . . .

Having quitted Florence the ambassadors travelled to France and Germany. And here I will relate what he told me concerning this embassy. He declared that, because they

were apostolic legates, all the people went down on their knees when they passed along the roads in Germany; and for the same reason the greatest honour was everywhere paid to them. Also that this honourable treatment lasted as far as Padua, where it fell off greatly from what it had been beyond the mountains. These two remarkable men, by their prudence and their uprightness, settled many disputes; and the report of their success reached as far as Rome; so that the Pope, realising the great and praiseworthy work of Maestro Tomaso, determined to reward him therefor. When the two legates had come back to Florence Maestro Tomaso went forthwith to the Signoria, and when he saw me he began to laugh and said, "I have drawn two hundred florins by these general letters of Cosimo, and now I must needs have a hundred more to pay the charges of my journey to Rome. Let us go to Santo Giovanni where the pardon is going on, and afterwards we can go to Cosimo's house." I told him there was no need to do this, and that I would settle the matter. But he went to the pardon, and when he came out of the church he came upon Cosimo in the piazza of Santo Giovanni, and spoke to him about the hundred florins he wanted over and above the two hundred he had already drawn by the general letters. Cosimo answered, "The hundred florins, and as many more as you will, shall be at your disposition." He went on, "Roberto Martelli will wait on you, and will hand over to you whatever sum you may want." Roberto came in due course, authorised to give him what money he required, but he would take no more than a hundred florins.

Having received this money he started the next morning on horseback for Rome, and when he reached Viterbo it appeared that Pope Eugenius, without letting it be known to any of the party, had sent thither two red hats for Tomaso da Serezana and for Giovanni Carvagialle, a Spaniard, who was named Cardinal of Santo Agnolo; moreover, many men of consideration went to meet them, and they were likewise met near Rome by the whole of the College of Cardinals and the ambassadors, entering the city with the stateliest ceremony. Having entered Rome they went to the feet of His Holiness Pope Eugenius, where they explained the

commission given to them, and everything they had done from the day of their departure till now. Afterwards Maestro Tomaso made a most appropriate speech to the Pope and thanked him for the grace he had conferred on him by the gift of the cardinal's hat, testifying his deep gratitude to His Holiness and to the College of Cardinals in the most eloquent words. When this was done the two cardinals quitted His Holiness, attended to their houses by all the cardinals and ambassadors who were there, as well as by those who had accompanied them in their entry into Rome.

It chanced that, in the course of a few months, Pope Eugenius fell sick of a grave distemper and passed away from this life, dying as virtuously as he had lived. The career of Pope Eugenius is an example of obedience to a salutary rule of life, and after his death it became necessary to order the funeral rites within nine days according to custom; and, as on such occasions, a funeral oration was always made over the dead, this charge was now given to Maestro Tomaso. The oration was spoken with great dignity and eloquence, and gave such great satisfaction to all the College, and to the others present that it moved the cardinals to make him Pope, independent of his eminent merits, and in spite of his recent election to the College. I heard from the leaders of the College that the majority had chosen him, and that his reputation was greatly augmented by this noble oration. Everyone knows how great is the power wielded by talents like his. All the cardinals entered the conclave at the Minerva, each one going to his room without intrigue or news from without. At this time the College of Cardinals was a very worthy and holy one.

It happened on the first night of the conclave that a marvellous vision came to Maestro Tomaso as he slept in his chamber, dreaming of the election to the Papacy which lay before the cardinals. Amidst these sleeping fantasies, there appeared to him Pope Eugenius clad in full pontifical habit, and it seemed as if the Pope was minded to dress him in these garments, and that he refused. Maestro Tomaso having asked him why he wanted to put upon him the pontifical vestments, the Pope replied, "Because you will

be my successor; put on all of them except the mitre." As soon as he awoke from sleep he began to laugh and turned to the two companions who were with him in the room, whereupon they asked him why he laughed, and he told them of the vision he had seen, never deeming that aught would come of it, as he was only nine months a cardinal, of low station, not conscious that anyone spoke of him, and never thinking to arrive at such honours. He could claim nought but his integrity and the success of his diplomacy.

Having come to the election of the Pontiff, without any communication from without, they unanimously made him Pope on the second day. After they had taken him and placed him in the chair, according to custom, he remained some time in bewilderment, this thing having come upon him unexpectedly. One might say that it had been brought about by miracle, for in eighteen months he had been made bishop, cardinal and Pope entirely from merit.

In his pontificate he made it plain that he had been elected by divine mercy to pacify Italy, vexed by war and violence for many years. Shortly after his election I, having gone to wait upon His Holiness, went one Friday evening to his weekly public audience. As he came into the audience chamber, about seven in the evening, he spied me at once and called to me in a loud voice that I was most welcome, that I must have patience, and that he wished to see me apart. Not long after, one came and bade me go to His Holiness, whereupon I went and, following usage, I kissed his foot, after which he bade me rise and dismissed all the rest, saying that the audience was at an end. He withdrew to a private apartment close to a doorway which led to a garden balcony. In it were some twenty candles lighted, four of them near to His Holiness. He made a sign that these should be taken away, and when they were removed he began to laugh and cried out to me, to the confusion of his puffed-up attendants, "Vespasiano, would the people of Florence have believed that a priest, fit for nothing better than to ring a bell, should have been made Sovereign Pontiff?" I answered that Florence would believe that he had been chosen by reason of his many virtues, and in order to pacify Italy. To this he replied and said, "I pray God

to give me grace to bring about what I have in my mind, and to do this same thing during my pontificate without using arms other than those which Christ has given me for my defense: that is to say, His Cross. And this will be my course as long as I shall rule."

Then he turned to me and said, "You know what great kindness Cosimo dei Medici has done me in my time of need: however, I am now going to reward him and to-morrow I shall make him my banker. One can never go wrong in liberality towards men of good heart." (There was a time, during the jubilee, when the Medici bank held in its hands more than a hundred thousand florins of the wealth of the Church: this I heard from a trustworthy person in their service.) He then went on, "I wish to pay high honour to the Florentines, and to-morrow I will give them audience in public consistory, as it is given to kings and emperors, to give them this preference and do them this honour." . . . He grieved much that the house of Pope Eugenius had been pillaged, and that the household were forced to put up with borrowed beds: and he told me many things beside which I will leave untold because, as I am writing a commentary on his life, I would not seem to be speaking of myself while I ought to be speaking of Pope Nicolas.

He began his pontificate to the satisfaction of all those who knew him, and the apostolic seat gained great repute throughout the world on account of this happy election. All the learned men of the world flocked to Rome of their own free-will. Some Pope Nicolas sent for because he wished that they should reside at the court of Rome. He made assemble there a vast number of distinguished men, and he began to grant audiences in public consistory. At this time Florentines held all the chief offices in diplomacy and government in Italy; and on the mornings when he gave audience to the Florentines in public consistory many foreigners attended, learned men and men of standing; and many more came attracted by the fame of Messer Giannozzo Manetti, who was one of the six Florentine ambassadors, the others being Messer Agnolo Acciaiuoli, Messer Giannozzo Pitti, Messer Alessandro degli Alessandri, Neri

di Gino and Piero dei Cosimo dei Medici. Giannozzo
Manetti was not then a *cavaliere*. They arrived with a hun-
dred and twenty horses, and made their entry with the
greatest pomp, accompanied from outside by all the court
of Rome and the cardinals. It was wonderful to see the
ambassadors all clad in the same fashion: all six in garments
of the richest crimson cut velvet with open sleeves lined
with miniver, and with them twelve youths with garments
of like fashion of crimson damask, lined with miniver. On
the morning when audience was granted to them the hall
was full of the most illustrious personages, and there was a
gathering of cardinals, all of them men of distinction, and
ambassadors from all parts. Messer Giannozzo made an ex-
cellent speech, lasting an hour and a quarter, in a new style
of oratory which had been but a short time in use. All
listened most attentively and no one moved. The Pope was
deeply absorbed, almost as if he were asleep, and one of
those near him held his arm now and again to support him.
When the oration, which was in two parts, was finished,
it seemed that Pope Nicolas had it by heart, for he re-
capitulated it part by part in a wonderful manner. On this
morning the sanctity of His Holiness waxed greatly as did
the fame of the ambassador. In his reply the Pope won
much approval and everyone departed well content. . . .

A vast amount was sent to the apostolic seat in Peter's
pence, whereupon the Pope began to build, and searched
for Latin and Greek books in all places where they might
be found, never regarding the price. He collected many of
the best scribes and gave them continual employ. He
brought together a number of learned men and set them to
produce new books, and also to translate others not in the
libraries, rewarding them liberally; and when the books
were translated and brought to him he would hand over
ample sums of money in order that the translators might
go to their work with a good will. He spent much in sup-
porting men of letters, and at his death it was found by
inventory that since the time of Ptolemy, there had never
been collected such a store of books. He caused copies to
be made of all, not reckoning the cost; indeed, if he could
not procure a particular work, he would have it copied.

After he had induced a great company of learned men to repair to Rome on liberal payment, he wrote to Messer Giannozzo Manetti at Florence to come also to practise as a writer and translator. Manetti left Florence for Rome, where he was received by the Pope with the highest honour. Nicolas granted to him, besides the office of secretary, six hundred ducats, exhorting him to undertake the translation of the books of the Bible and Aristotle, and to finish the books himself he had already begun, *Contra Judaeos et gentes,* a wonderful work indeed, had it ever been finished; but no more than ten books of it were written. He translated the New Testament and the Psalter, *De Hebraica veritate,* with five books of apologetics in defence of the Psalter aforementioned, showing that in all the Scripture there is not a syllable without a hidden meaning.

It was the design of Pope Nicolas to found a library at S. Peter's for the general use of the Roman court, and this would have been a wonderful work could he have accomplished it; but, forestalled by death, he left it unfinished. For the elucidation of the Holy Scriptures he caused quantities of books to be translated: likewise many pagan writings and certain works of grammar necessary for the study of Latin. The *Ortografia* of Messer Giovanni Tortello, whom His Holiness made his librarian, a valuable and useful book amongst grammarians: the *Iliad* of Homer: *De Situ Orbis* of Strabo were translated for him by Guarino, to whom he gave five hundred florins for each part, Asia, Africa and Europe, making one thousand five hundred florins in all. Herodotus and Thucydides were translated by Messer Lorenzo Valla, whom he paid most generously for his pains: Xenophon and Diodorus by Messer Poggio: Polybius by Nicoli Perotto, to whom, when he was presented to the Pope, Nicolas gave five hundred papal ducats, newly minted, in a purse, and told him that this was not the reward he merited, but that in due time he should receive one which would content him. The works of Philo, a Jew of the greatest merit, unknown in Latin. The *De Plantis* of Theophrastus and the *Problemata Aristotelis* were both translated by Theodore, a Greek of great learning and eloquence. The *Republica* of Plato, together with the *Leges,*

the *Posteriora,* the *Ethica* and *Physica,* the *Magna Moralia,*
the *Metaphysica* and the *Rhetorica* were done by Trabi-
zonda. The *De Animalibus* of Aristotle, a very valuable
work, by Theodore. Amongst sacred writings the works of
Dionisias the Areopagite, a marvellous book, was translated
by Fra Ambrogio, the most of the translations hitherto
made having been very barbarous. I heard Pope Nicolas
say that this translation was excellent, and that he under-
stood it better in this simple text than in the others with
the numberless comments and notes they contained. The
wonderful book, *De preparatione evangelica,* of Eusebius
Panfilus, a work of most profound learning. Many works of
S. Basil, of S. Gregory Nazianzen, about eighty homilies of
Chrysostom on S. Matthew, which had been lost five hun-
dred years and more. Twenty-five of these had been trans-
lated by Orontius more than five hundred years ago, and
this work was much in use, both by ancients and moderns,
for it is on record that when S. Thomas Aquinas was on his
way to Paris, and before he arrived there, he was shown
these homilies, whereupon he exclaimed, "I would rather
have S. John Chrysostom on S. Matthew, than the city of
Paris," so highly did he esteem it. This was now translated
by Trabizonda, as well as Cyril on Genesis and on S. John,
works worthy of all praise. There were many others trans-
lated or written at the request of His Holiness of which I
have no report. I have written only about those known to
me.

Pope Nicolas was the ornament and the light of litera-
ture and of learned men, and if after him there had ap-
peared another Pope following in his footsteps, letters would
have achieved a position worthy of them, but after him they
fell into evil case through want of bounty. . . . Pope
Nicolas did builder's work in several of the Roman
churches, especially to be noted is the wonderful structure
he erected in S. Peter's, which would hold the whole Roman
court, and in all the churches of the country he did marvel-
lous works, concerning which Messer Giannozzo Manetti
has written in his life of the Pope. The building which he
carried out would have sufficed for the activity of one of
those Roman Emperors who ruled the entire world: much

more for that of a pope, and then he beautified the build-
ings with ornaments for Divine worship which cost a for-
tune. It was happiness to him to spend, and he never
counted the cost as many others have done. . . .

BARTOLOMEO FAZIO

[Bartolomeo Fazio (†1457) began his literary career as
a student of one of the revivers of classical learning in Italy,
Guarino da Verona, whose knowledge of Greek qualified
him to serve as an interpreter for the Greeks at the council
of Ferrara and Florence in 1436. Fazio found employment
in the court of Alfonso V of Aragon, at Naples. Alfonso the
Magnanimous, admired both for his prowess as a swords-
man and his knowledge of Latin texts, made his court a
humanistic center for scholars and artists. There, Fazio was
occupied in various capacities and wrote *De Viris Illustribus*
sometime between 1453 and his death. As he utilized the
classical system of assigning illustrious men to different
categories such as heroes, princes, and the like, the artists
appear in this larger framework. Fazio included, therefore,
only those of his contemporaries he considered to be the
greatest, and his choice reflected the broad scope of interest
of the Neapolitan court. The lives of the two northern
painters are the first written sources for the history of the
Netherlands school of painting, which exercised great in-
fluence in Italy at that time. His information has special
value as he described art works he had actually seen.]

ILLUSTRIOUS MEN[1]

GENTILE DA FABRIANO[2]

Gentile da Fabriano was endowed with a talent apt and
suited for every kind of painting. But it is especially in the

[1] Translated from *Bartholomaei Facii, De Viris Illustribus*,
published by L. Mehus, Florence, 1745, pp. 44–49.
[2] An Umbrian painter active 1410–1427, who was Pope
Martin V's court painter.

decoration of buildings that his art and industry are known. His is that famous painting[3] in the church of the Santa Trinita in Florence, in which are seen the Virgin Mary, the infant Christ in her arms, and the three Magi adoring Christ and offering gifts. His is a work at Siena in the public square likewise showing the Mother Mary[4] holding the child Christ in her lap, giving the impression of one who would cover him with a thin cloth; [also] John the Baptist, the Apostles Peter and Paul, and Christopher carrying Christ on his shoulder, all displayed with an art so admirable that he appears to be representing the actual body-motions and gestures. His is a work at Orvieto in the Cathedral—again the Virgin and the infant Christ in her arms smiling, a work to which it seems nothing could be added. He also painted—for a most ample fee—a chapel at Brescia, for Padolfo Malatesta. Again, at Venice, in the Palace, he painted a land battle undertaken and waged by the Venetians against the son of the Emperor Frederick on behalf of the Supreme Pontiff, but this through a defect in the wall has almost entirely perished. In the same city he likewise painted a hurricane uprooting trees and all other like objects, the appearance of which is such as to put dread and horror even into those who view the [picture]. Likewise his is a work at Rome, in the church of St. John Lateran, a scene from the story of John [the Baptist] himself and above this five Prophets so presented as to appear not painted, but wrought from marble; in this work, as if he foresaw his death, he is believed to have surpassed himself. Prevented by death, he left certain parts of this work unfinished and only sketched. Likewise his is a second painting, in which Pope Martin and ten Cardinals are so represented as to seem to equal nature herself and in no way to be dissimilar [to their natural form].

Of this man [Gentile], the story goes that when the renowned painter Roger of Gaul[5] of whom we shall speak

[3] "Adoration of Magi," Uffizi, Florence, painted for Palla Strozzi for the family chapel.

[4] Known as the "Madonna del Notai," it existed until the sixteenth century.

[5] Roger van der Weyden.

later, in the year of the Jubilee[6] had come into the church of John the Baptist and had contemplated Gentile's painting, he was seized with admiration for the work and, upon asking the name of the author, heaped praise upon him and placed him before all the other Italian painters. Also attributed to him are outstanding paintings in various places; of these I have not written, since I had no adequate knowledge concerning them.

JOHN OF GAUL[7]

John of Gaul has been judged the foremost Painter of our time, having no little learning in letters and especially in geometry[8] and in those accomplishments which contribute to the beauty of painting, and he is thought therefore to have found out much concerning the properties of colors, which were reported by the ancients and he had learned from the reading of Pliny and others. His is a remarkable picture in the private rooms of King Alfonso[9] in which appears the Virgin Mary, noteworthy for her charm and modesty, the angel Gabriel announcing that the son of God will be born from her, his locks [of hair] of surpassing beauty, surpassing nature, John the Baptist manifesting an admirable sanctity and austerity of life, Jerome altogether like one alive, a library executed with wonderful art, since, if you move a little away from it, it seems to recede inwards and to display the books in their entirety, while only their main divisions appear to one who draws close.[10] In an outer part of the same picture is painted Baptista Lomellinus,[11]

[6] 1450.

[7] Jan van Eyck (1400?–1441). This text is also given in Panofsky, *Early Netherlandish Painting,* Cambridge, 1953, p. 361.

[8] Meaning: perspective.

[9] Alfonso V of Aragon, King of Naples. (Our *fig.* 18.)

[10] Dr. Ernst Gombrich suggested this reading. The latin text is: "Bibliotheca mirae artis, quippe quae, si paulum ab ea discedas, videatur introrsus recedere, & totos libros pandere, quorum capita modo appropinquanti appareant." See also: E. Panofsky, *op. cit.,* p. 2.

[11] A member of this Genoese family, named Jerome, had been a merchant in Bruges in 1392. This entire triptych has disappeared, but a St. Jerome in His Study by Jan van Eyck has been recently discovered at the Detroit Institute of Art. (Our *fig.* 20.)

—whose property the picture was—, whom you would judge to lack only a voice, and a woman, whom he loved, of remarkable beauty, she too carefully represented just as she was; between them, as if peeping through a crack in the wall a ray of the sun which you would take to be real sunlight. His is a representation of the world in circular form, which he painted for Philip Lord of Belgians, a work which is thought to be surpassed for perfection by none executed in our time. Here you can distinguish not only individual localities and the lie of the land areas but also, by measurement, the distance between localities.

Famous paintings of his are also found in the possession of the distinguished Cardinal Ottaviano,[12]—women of surpassing beauty emerging in a fresh glow, from their bath, the more secret parts of their bodies veiled by a sheer cloth; in the case of one of these women he has shown only the face and the breast, exhibiting the posterior parts of the body with a mirror painted opposite on the wall, so that you see her back just as you can her breast. In the same picture, in the bath chamber, appears a lantern exactly like one that is burning, and an old woman who seems to be sweating, a little dog lapping up water, and likewise horses, people of diminutive size, mountains, groves, villages, and castles worked out with such artistry that you would believe one was fifty miles distant from another. But in the same work almost nothing is more wonderful than a mirror in the same painting, in which whatever is there represented you view as if in an actual mirror. He is said to have executed many other works of which I have been unable to obtain full information.

PISANO OF VERONA[13]

Pisano of Verona in the matter of depicting the forms of

It was probably painted for Cardinal Niccolo Albergati, who, accompanied by Leone Alberti and Tomaso da Serezana, later Nicolas V, was in Flanders to arrange a peace between Philip the Good, Duke of Burgundy, England and France, in 1431.

[12] A member of a Florentine family. The picture has disappeared.

[13] Antonio Pisano, known as Pisanello (1395?–1455), was both a painter and medallionist.

things and of expressing feeling was regarded as being endowed with an almost poetic genius. But in painting horses and other animals, in the opinion of experts, he surpassed all other painters. At Mantua he painted a chapel and certain highly praised pictures. At Venice,[14] in the Palace, he painted Barbarossa the Roman Emperor, and his son as suppliant; also in the same place a great company of court officials showing a German dress and cast of countenance; a priest distorting his face with his fingers, and boys laughing at this with such delight as to excite to merriment those who view the picture. Also, at Rome, in the church of St. John Lateran, he painted what Gentile,[15] in beginning the story of St. John the Baptist, had left unfinished. But this work, as well as I could learn from him, was afterwards largely obliterated through the moisture in the wall. Further examples of his art and genius are a certain number of pictures on panels and on parchments, among which is a Jerome adoring the crucified Christ, venerable for the saint's posture and majesty of countenance, and likewise a desert waste, with many animals of various kinds that you would think were alive.

To painting he added the art of sculpture. Works of his in lead and bronze are an Alfonso,[16] King of Aragon, a Philip, Prince of Milan, and many other Italian princes, to whom he was dear because of the eminence of his art.

ROGER OF GAUL[17]

Roger of Gaul, pupil of John and fellow countryman, produced many singular monuments of his art. His is a very remarkable picture at Genoa, in which there is a woman perspiring in her bath, and near her a little dog, opposite two youths gazing upon her secretly through a crack, remarkable for their smiles. His is a second painting, in the private apartments of the Prince of Ferrara; on one wing of this are Adam and Eve, with nude bodies, having been driven by an angel from the terrestrial paradise, lacking

[14] His only extant frescoes are in Verona.

[15] He was a friend of Gentile.

[16] See our *figs.* 18 and 19.

[17] Roger van der Weyden (1400?–1464). This text is also given in Panofsky, *Early Netherlandish Painting, op. cit.*

nothing of the highest beauty; on the other wing a suppliant Prince, in the center panel Christ taken down from the Cross, Mary, the Mother, Mary Magdalene, Joseph, all with such grief expressed in their tears that you would not suppose they were anything but real. Of the same author are famous paintings on linen in the possession of King Alfonso,—again the Mother of the Lord, now in distress at the capture of her Son, with her tears streaming and yet maintaining her dignity, a work of consummate beauty.[18] Likewise the abuses and punishments that Christ Our Lord suffered at the hands of the Jews, in which you can easily discuss a variety of feelings and emotions matching the variety of the events. At Brussels, which is a city of Gaul, he painted a chapel of most perfect workmanship.

LEON BATTISTA ALBERTI

[Leon Battista Alberti (1404?-1472) was born in Genoa. He was the illegitimate son of one of the most powerful and wealthy families of Florence, the members of which, though banished in 1387, had continued their activities as bankers and wool merchants in Genoa and Venice. In 1414 his father moved to Venice, and Battista attended the school of the famous teacher Barsizza in Padua. In 1421 he was attending lectures in canon law at Bologna, and he received his degree in 1428. Before he had finished his studies his father died, and the estate, which was administered by an uncle, never reached Battista, with the result that he experienced real poverty. He was a precocious scholar and, while still a student, wrote a Latin comedy, *Philodoxeos,* long thought to be an original Latin work, and numerous excellent essays.

Attached to Cardinal Albergati's household as a secretary in 1428, Alberti travelled with him to France and Germany. On his return he spent two years studying natural sciences in Bologna. In 1431 he went to Rome as Cardinal

[18] None of the pictures mentioned exists today.

Molin's secretary and there became an abbreviator in the papal chancery. His sojourn in Rome stimulated his interest in architecture. He accompanied Pope Eugene IV to Florence in 1434 and, in contact with the artists and scholars there, began his work as a creative artist and his study of art theory, the results of which are found in *De pictura* (On Painting) (1435). It presents the theory of the new Florentine art, based on reality controlled by the scientific study of vision. This is a complete break from recipe books like Cennino Cennini's, which provide formulae or techniques for painting that are unrelated to vision. *De statua* (On Sculpture) (1464), which defines the three kinds of sculpture on the basis of technique and gives Alberti's system of proportions, is equally original and acute in its observations. Both are among the most important documents of the early Renaissance. In his writings he refers to his work in painting and sculpture, but there are no known works by him except a medal giving his self-portrait.

During the papacy of Nicholas V, Alberti was again in Rome and wrote his great treatise *De re aedificatoria* (On Architecture), which was finished by 1452 and circulated in manuscript form before being published in 1485. It is modelled after the great work of Vitruvius and, although less original than *De pictura,* shows Alberti's originality in his use of ancient monuments as sources and his keen observations of human needs. Besides his book on architecture and his theoretical treatises on art, Alberti wrote poetry, plays, moral and philosophical essays.

Sigismondo Malatesta called Alberti to Rimini in 1450 to enlarge and enrich the church of S. Francesco, but his plans were carried out only in part. In 1459 he accompanied Pius II to Mantua and was commissioned by Ludovico Gonzaga to furnish the plans for the church of S. Sebastiano. Alberti's plan was in the form of a Greek cross, the first plan of this type in the Italian Renaissance. Alberti was especially active as an architect in Florence, where he designed the Rucellai Palace and Loggia, a chapel in S. Pancrazia, the façade of S. Maria Novella, and, at the request of Ludovico Gonzaga, the plan for the choir of SS.

Annunziata. S. Andrea in Mantua, built from Alberti's plans, is the most perfect expression of his ideas.]

ON PAINTING[1]

To FILIPPO DI SER BRUNELLESCO: I used to be at once amazed and grieved that so many fine and godly arts and sciences, which we know, from their works and the histories, flourished in those most virtuous ancients of old, are now lacking and almost entirely lost: painters, sculptors, architects, musicians, geometricians, rhetoricians, soothsayers, and similar most noble and wonderful minds are very rare and of little account. Hence I believed that it was as many people told me, that nature, the mistress of things, had now indeed grown old and weary, and, just as she no longer brought forth giants, so with talents, which in her younger and more glorious times, so to speak, she brought forth plentifully and wonderfully.

But after I was brought back here to this city of ours,[2] adorned above all others, from the long exile in which we Alberti have grown old, I realized that in many, but especially in you, Filippo, and in our dear friend Donato the sculptor,[3] and in those others, Nencio,[4] Luca,[5] and Masac-

[1] The excerpts from the treatise on painting are translated from the text as given by H. Janitschek, *Leone Battista Alberti's kleinere kunsttheoretische Schriften* (Quellenschriften für Kunstgeschichte, XI), Vienna, 1877, by the editor and Creighton Gilbert. The footnotes are by the translators. An English translation of the entire texts of *De pictura* and *De statua* is appended to Giac. Leoni's *The Architecture of Leon Battista Alberti*, London, 1726.

See also: G. M. Mancini, *Vita di Leone Battista Alberti*, Florence, 1882 (2nd ed., 1911); Kenneth Clark, *Leon Battista Alberti on Painting*, London, 1944; Blunt, *Theory*, pp. 1–22; Olschki, *Geschichte*, pp. 45–87; Schlosser, *Lett. art.*, pp. 105–110, and *Kunstlit.*, pp. 105–112; Venturi, *History*, pp. 86–90; L. B. *Alberti on Painting*, translated by John R. Spencer, New Haven, 1956.

[2] Florence. The Alberti were exiled from 1387 to 1428.

[3] Donatello (1386–1466).

[4] Ghiberti (1378–1455).

[5] Luca della Robbia (1400–1481).

cio,[6] there was talent for every noble thing not to be
ranked below any who was ancient and famous in these
arts. Therefore I perceived that the power to gain praise
consists in our industry and diligence no less than in the
benefit of nature and the times. And I reveal to you, that
if it was less difficult for the ancients, having as they had
so very many to learn from and imitate, to rise to a knowl-
edge of those supreme arts that are so toilsome for us to-
day, then so much the more our fame should be greater if
we, without teachers or any model, find arts and sciences
unheard of and never seen. Who is so stubborn or so envious
that he would not praise Pippo the architect, when he sees
such a big building here, set aloft above the heavens, ample
to cover all the peoples of Tuscany with its shade, made
without any aid from scaffolding or quantity of timber?—
a skillful construction which, if my opinion is right, as in
our times it was unbelievable that it could be done, so
among the ancients it was perhaps not known or known
about.

But there will be another place to tell over your praises
and the gifts of our Donato, and the others whose ways de-
light me. You in the meantime persevere from day to day
in discovering things through which your wonderful talents
will gain endless fame and reputation. And if you happen
to have leisure, it will please me for you to read over this,
my little work on painting, which I have written in Italian
under your name. You will see three books: the first, all
mathematical, makes this pleasant and most noble art rise
up from its sources in nature. The second book puts the
art in the artist's hands, distinguishing its various parts and
explaining everything. The third teaches the artist what
perfect skill and knowledge of all painting he may and
must obtain, and how he may. So may reading me dili-
gently please you, and if you think something needs emend-
ing, correct me. No writer was ever so learned that his eru-
dite friends were not useful to him. I wish to be corrected
first by you in order not to be assaulted by detractors.

[6] Masaccio (1401–1428).

Book I. In writing these very short remarks on painting, to make what I say quite clear I shall first take from mathematicians those things that have to do with my theme, and having become familiar with them, I shall, as far as my faculties permit, discuss painting as it is derived from fundamental principles of nature.

But in all my talking I urge strongly that I may be thought of as writing of these things as a painter, not a mathematician. The latter measure the form of things with the understanding alone, apart from all concrete matter. We, because we wish to make things visible, shall for this purpose use a grosser method, as they say. I shall be very grateful if the reader somehow understands this matter, which is certainly difficult and has never been described by any other writer so far as I know. So I beg that my words be interpreted as those of a painter.

It appears to me obvious that colors vary according to lights, since every color, when placed in shadow, seems not to be the same one that it is in brightness. Shadow makes color dark; light makes color bright where it strikes. The philosophers say that nothing can be seen which is not lighted and colored.

So there is a close relation between colors and lights with respect to seeing. As to how close this is, consider that when light is lacking, colors are lacking; when light returns, colors return. For this reason I shall discuss colors first, then I shall investigate how they vary in light. I speak as a painter.

I say that through the mixture of colors an infinite number of other colors is produced; but just as there are four elements, there are only four true colors from which many many other sub-types of colors are produced. The color of fire is red, of air, blue, of water, green, of earth,[7] grey and ashen. The other colors, such as jasper and porphyry, are mixtures of these. Thus there are four types of colors and these produce their sub-types according as to whether light or dark, white or black, is added, and these are almost numberless. We see green leaves lose greenness from patch to

[7] "Earth," i.e. grey. Alberti means its concrete element; cf. latter part of paragraph.

patch until they become almost white. Similarly, the air is frequently a white vapor around the horizon but little by little it goes on disappearing. In some roses we see much purple, while some are like girls' cheeks, and some like ivory. And in the same way with white or black, the earth produces its sub-types of color. The admixture or addition of white, then, does not alter the types of the colors, but rather produces sub-types. So also the color black has the same power to make almost infinite sub-types of color by being mixed. [Colors appear altered by shadow.][8] The colors may be seen filled with shadow, or when the light is increased the colors become more open and bright. For this reason one may persuade the painter that white and black are not true colors but an alteration of other colors, because the painter finds nothing but white with which to show the final shining of lights, and so only black to show the shades. We may add that you will never find either white or black that is not attached to one of those four colors.[9]

To go on to lights: some come from stars like the sun, the moon, and that other beautiful star, Venus. Other lights come from fires, but between these a great difference can be seen. The light of the stars makes shadows of the same size as the solid, but fire makes them larger. Shadow is left where rays of the lights have been intercepted. Intercepted rays return from where they came or send themselves elsewhere. You see them sent elsewhere when, having reached the surface of water, they strike the beams of a house. Of these reflections, one could say many things about those miracles of painting which many of my friends saw me make a while ago in Rome.[10] Here it is enough that these bent rays carry with them the color they find on the surface. You can see how someone who walks on the meadows in the sunshine looks greenish in the face. . . .

[8] Not in Janitschek text. It is given in A. Bonucci, *Opere volgari di L. B. Alberti*, Florence, 1847, IV, p. 24, line 13.

[9] See Leonardo, p. 281.

[10] Alberti refers to the *camera ottica*, a trick peep-show using the techniques of optics and perspective. Manetti described two executed by Brunellesco (see pp. 171–173). See Samuel V. Hoogstaten, no. 3832, National Gallery, London.

So I ask studious painters not to be ashamed of listening to me. It has never been stupid to learn something useful from whomever it may be. And they should know that they circumscribe the picture planes with its lines, and when they have filled these drawn areas with color, nothing else is wanted but to present the forms of the objects on this surface as if it were of a transparent glass, such that the visual pyramid would pass through it—if there were a certain distance with certain lights and a certain stance in the center—into the air and its other positions.[11] Every painter shows that this is so when, led by nature, he places himself at a distance from what he is painting, almost as though he were looking for the point and angle of the visual pyramid from which the painted objects might best be viewed. But since we see that this is a single surface of wall or panel, on which the painter tries to represent many surfaces included in the visual pyramid, he had best cut across this pyramid somewhere, so that he may express similar outlines and colors. If this is as I have said, then whoever looks at a picture sees a certain cross-section of a visual pyramid. Painting, then, is nothing other than a cross-section of a visual pyramid upon a certain surface, artificially represented with lines and colors at a given distance, with a central stance established and lights arranged. . . .

Ivory and silver are white, which, when placed near swan's down, seem pale. For this reason things seem very bright in painting when there is a good proportion of white and black as there is from lighted to shadowy in the objects themselves; thus all things are known by comparison. Comparison has in itself this power, that it shows immediately in things which are more, which are less, and which of the same size. Therefore one says a thing is large which is larger than this small thing, and very large is that which is larger than this large thing, light is that which is brighter than a dark thing, very light which is brighter than a bright thing. And it is done with very well-known things. [Of all things,

[11] This passage has to be understood from Alberti's system of linear perspective. Dr. Richard Krautheimer suggested the reading of this sentence.

man is best known to us.][12] So perhaps when Protagoras said that man was the mode and measure of all things, he meant that all the qualities of things could be known by comparing them with the qualities of men. This that I am saying has to do with pointing out that, however well small objects are painted in a picture, they will seem large or small only in comparison with the size of whatever man is painted there.

Up to here I have discussed things that were useful and brief and I judge not completely unintelligible. I believe that what follows will be less tedious to the reader. I have told as much as seemed needful about triangles, the visual pyramid, and cross-sections. I am accustomed to explaining these things at some length among my friends with geometrical demonstrations which for the sake of brevity it seemed wise to leave out in these remarks.

Here I have discussed only the first rudiments of art, which I called rudiments because they lay the first foundations for good painting in untaught painters. But they are so made that whoever knows them well, will have as much understanding of talent, as well as knowledge of the definition of painting, as he needs. There is no doubt that he will never be a good painter who does not well comprehend what he is trying to do. The bow is drawn in vain if you have nowhere to point. I wish it to be generally held among us that only he will be a good craftsman who understands the edges of the surfaces and all their qualities. No one will be a good craftsman who is not diligent in learning what we have discussed up to now. Therefore these cross-sections and picture-surfaces are necessary things. It remains to instruct the painter in how to execute with his hand what he has learned with his understanding.

BOOK II. Because it may seem a laborious thing to young people to learn all this, I find it good next to show that painting is not unworthy of occupying all our work and study. Painting has a divine power, being able not only to

[12] This line is not in the text as given by Janitschek. It is given in A. Bonucci, *op. cit.*, p. 31, line 26.

make the absent seem present, as friendship is said to do, but even to make the dead seem almost alive after many centuries, so that they are recognized with great pleasure and great admiration for the craftsman. According to Plutarch, Cassander, one of Alexander's captains, trembled in his whole body at the sight of a portrait of Alexander. Agesilaus, the Lacedemonian, never let anyone paint or carve his portrait. He did not like his physical form and so shrank from being known by those who lived after him. Certainly the face of one already dead lives a long life through painting. Painting has always been a very great gift to mortals, for it makes visible the gods who are worshipped by the people. It greatly aids the piety by which we are joined to the divine, and in keeping our souls full of religion. . . .

Painting is divided into three parts, a division we have taken from nature. Since painting tries to represent seen things, let us observe in what way objects are seen. In the first place, when we see an object we say it is a thing that occupies a place. The painter describing this space will call this marking of the edge with a line *circumscription* or outline. Then, looking it over, we observe that many surfaces in the seen object connect, and here the artist, setting them down in their proper places, will say that he is making the *composition*. Lastly, we determine more clearly the colors and the qualities of the surfaces. Since every difference in representing these arises from light, we may call it precisely the *reception of light* or illumination. Thus painting is composed of *circumscription, composition,* and the *reception of light*. In the following, each will be discussed briefly.

First we shall discuss circumscription or outline. Outline will be that which describes the going around of the edge in painting. They say that Parrhasius, the painter who talks with Socrates in Xenophon, was very expert in this and had studied these lines a great deal. I say this, that in circumscription close attention must be given to its being made with very fine lines, almost such that they escape being seen. In this the painter Apelles would always practice and compete with Protogenes.

Since outline or circumscription is nothing other than the drawing of the edge, which if it is done with too visible a line will not show that there is a surface edge there, but a break, I should wish that nothing be attended to in circumscribing but the going along of the edge. I assure you that in this great care must be exercised. No composition and no illumination deserve praise unless there is a good circumscription in addition. And a good drawing, that is a good circumscription, is often very pleasing on its own account. . . .

Having finished circumscription, that is, the way to draw, it remains to us to speak of compositions. It is necessary to repeat what composition is. Composition is that method in painting by which the parts of the things seen are put together in the picture. A painter's biggest work—a colossus! But let him do narrative pictures, for narrative pictures evoke greater praise for talent than any colossus whatever. The narrative is reducible into bodies, bodies into limbs, limbs into surfaces. Thus the prime divisions of painting are surfaces. There arises from the composition of the surface that grace of bodies which is called beauty.

Therefore in this composition of surfaces the grace and beauty of things is much sought after. To ensure this I think there is no more appropriate and sure way than to follow nature, recalling in what way nature, the marvelous maker of things, has composed the surfaces well in beautiful bodies. To imitate her in this, it is necessary to take great thought and pains about it constantly. . . .

Up to here I have spoken of composition of surfaces; there follows that of limbs. First one must make certain that they go well together. They will do so if they correspond to a single beauty with respect to size and function and kind and color and other such things. For if there were in one painting a very large head and a small breast . . . this composition would surely be ugly to look at. . . .

So therefore take one limb, and let every other limb be accommodated to it in such a way that none of them will not fit the others in length and breadth.

Then let each limb follow its own function in whatever is going on. It is proper for a runner to fling his hands no

less than his feet, but I would have a philosopher while he is talking show modesty much more than the art of fencing. . . . The body is called living when it has a certain movement where it belongs and is called dead when the limbs can no longer carry on the functions of life, that is, movement and feeling. Therefore the painter wishing to express life in things will show every part of them in motion. But in every motion he will maintain charm and grace. Those movements that move upward into the air are very pleasing and lively. . . .

An admirable and praiseworthy narrative picture will present itself so charming and adorned with pleasant features that it will hold anyone who looks at it, taught or untaught, in delight and emotion. The first thing that pleases us in a narrative picture is abundance and variety of objects. As in foods and music, novelty and number please insofar as they differ from old and familiar things. For this reason abundance and variety are pleasing in a painting. I would call that historical picture extremely rich in which there is at the proper places a miscellany of old men, young men, boys, women, girls, children, chickens, cattle, birds, horses, sheep, buildings, views, and all such things. I would praise any richness that belongs to that narrative. And it happens that the painter's richness gains much good will when the spectator lingers to observe all the things there. But I would have this profusion set off by a certain variety, yet moderate, and weighed with dignity and modesty. I rebuke those painters who, when they wish to seem profuse, leave nothing empty and so produce no composition but rather disorderly confusion; whence it does not appear that some worthy thing is being done in the story, but that it is enmeshed in tumult. Perhaps whoever looks for much dignity in his narrative picture will like solitude. Sparseness of words maintains majesty in princes, when they are making their instructions known; so in a picture a suitable number of objects affords not a little dignity.

I dislike sparseness of figures in a narrative picture, but I do not praise profusion which is without dignity. But in every narrative variety is always charming, and a picture

with bodies in very different poses is especially pleasing. Therefore let some stand upright in it, showing the whole face, with hands up and fingers apart, supported on one foot. In others let the face be turned the other way, the arms relaxed, and the feet together. Thus let each have its own action and bending of limbs, some seated, some resting on one knee, and others lying down; and, if it is proper, let some be nude, others partly nude and partly clothed, but always subject to modesty and diffidence. . . .

The narrative will move the mind when the men painted therein exhibit much of their own emotion. It happens according to nature, than which nothing is more able to produce its like, that we weep with the weeping, laugh with the laughing, and sorrow with the sorrowing. But these emotions are to be recognized from motions. So it is best for the painter to know very well all the bodily motions, which are certainly to be learned from nature, though it is hard to imitate many emotions. . . .

It remains to speak of the reception of lights. In the rudiments above I showed sufficiently what power lights have to vary colors, for we taught how a color remains the same and alters its appearance according to the light and shade it receives. And I said that black and white expressed shade and brightness for the painter, and that all other colors were for the painter matter to which he might add more or less shade or light. Therefore, omitting other things, it remains to say here only how the painter should use his black and white. . . . Certainly I assert that the number and variety of colors help much in the charm and praise of a painting. But, as the experts hold, I would have all the highest industry and skill lie in knowing how to use black and white —and it is well to take all pains and care in knowing how to use these two well, for light and shade make things seem to be in relief. . . .

I should hardly ever think of a painter as middling-good who did not know exactly the effect light and shade produce on every surface. I say learned and ignorant alike will praise those faces that seem to issue out from the panel like sculpture, and condemn those faces in which no art

is to be seen except perhaps in the drawing. I would have a good drawing with a good çomposition and well colored. . . .

There are some to be found who use much gold in their narratives, which they consider lends majesty; I do not praise it. And though they were painting that Dido in Virgil, who had a gold quiver, golden hair bound with gold, a purple dress likewise bound with gold, and her horses' reins and everything made of gold, still I should not wish any gold to be used, for in colors imitating the shine of gold there is more admiration and praise for the artist. And we see too in flat panels certain surfaces that shine when they should be dark and seem black when they should be bright. I do say that I should not criticize the other cabinetmakers' ornaments added to the painting, such as columns, sculptured bases, capitals, and cornices, though they were of purest and weighty gold. Rather more, a quite perfect narrative merits ornaments of most precious stones.

Book III. But since there remain still other things useful to a painter so that he may gain full praise, it seems best for me not to omit them in these commentaries. I shall speak of them very briefly indeed.

I would say the business of a painter is this: to draw with lines and dye with colors, on whatever panel or wall is given, the like[nesses of the] visible surfaces of any body, so that viewed from a certain distance and central position, their bodies seem to be in relief and very similar. The end of painting: to acquire favor, good will, and praise for the artist, rather than wealth. And the artists will achieve this when their painting holds the mind and eye of those who look at it; how he can do this, I told above where I treated composition and the reception of light.

But it would please me that the painter, to grasp all these things, should be a good man and versed in literature. Everyone knows how a man's goodness helps more than his industry or skill in acquiring good will from the citizens, and no one doubts that the good will of many people greatly helps the artist to praise as well as earnings. It often happens that the rich, moved more by good will to a person

than by wonder at someone's art, sooner give work to a modest and good person, casting aside that other painter who may be better in art but not so good in his ways. Therefore it is good for the artist to show himself well behaved, and especially polite and good-natured. Thus he will get good will, a firm help against poverty and earn excellent aid toward the mastery of his art.

I like a painter to be as learned as he can be in all the liberal arts, but primarily I desire him to know geometry. I like the saying of Pamphilus, an ancient, most noble painter, with whom the noble youths began to learn of painting. He held that no painter could paint well if he did not know a great deal of geometry. My rudiments, which explain the perfected self-contained art of painting, will be easily understood by a geometrician, but one who is ignorant of geometry will understand neither those nor any other method in painting. So I maintain that a painter has to undertake geometry. And for their mutual delight he will make himself one with poets and orators, for they have many graces in common with the painter and are plenteous in knowledge of many things. So they will greatly assist in the fine composing of narrative pictures, whose whole praise consists in the invention,[13] which often has such an effect, that we see a fine invention is pleasing alone without painting. . . .

It will be helpful to take from all beautiful bodies each part that is praised, and in learning great beauty one must always strain with work and study. Though this may be difficult, because in no one body are all the parts of beauty, but rare and scattered among many bodies, yet one must give all labor to seeking to learn it. It will result that one used to approaching and undertaking great things will easily be able to do the lesser. There is no problem so difficult that study and persistence cannot overcome it.

So as not to waste study and effort, one should avoid the habit of some stupid people who, presuming on their own

[13] "Invention," a technical term meaning the disposition and interpretation of subject matter; e.g. "He made a fine invention of Diana and the Nymphs."

talent, propose to gain praise in painting on their own account without any model from nature for mind or eye to follow. They do not learn to paint well, but grow used to their errors. The untutored lack the idea of those beauties which even the experienced discern with difficulty.

Zeuxis, a most outstanding and experienced painter, did not, in making a picture which he set before the public, in the temple of Lucina Crotona, trust his talent blindly as every painter does today. Because he thought he could not find in a single figure among the Crotonians as many aspects of beauty as he sought, since nature did not give them all to one person, he therefore selected the five most beautiful girls from all the youth of that land, to take from them whatever beauty is praised in women. Wise the man who knows that painters, when they have no example from nature to follow but nevertheless want to acquire praise for beauty by their own talents, will in all likelihood not find the beauty they hunt so laboriously, but will certainly acquire bad habits which later they can never abandon, with all the good intentions in the world. But he who will accustom himself to take from nature whatever he does, will make his hand so practiced that whatever he does will always seem taken from life. How much the painter ought to seek out this can be fathered from the fact that whenever there is the face of a well-known and worthy man in a narrative, this known face will be the first to attract the eyes of all who look at the narrative, even though there are other faces in it more perfected in art and pleasing. Such force, as we see, is contained in what is drawn from nature. Therefore we should always take what we want to paint from nature, and always pick out the most beautiful things.

CONCLUSION. I had these things to say about painting, and if they are of any use or convenience to painters, I ask only this as payment for my labors: that in their stories they paint my face to show that they are thankful and I was studious of the art. If I failed to satisfy their expectations, let them not abuse me, considering that I had the courage to undertake so great a subject. If my talents could not complete what it was a merit to attempt, still the mere

attempting great and difficult deeds is generally a merit. Perhaps after me there will be someone to amend the errors I have written, who will be of more use and help to the painter than I in this most excellent and outstanding art. If there is any such, I beg him again to take up this task with cheerful and ready spirit, and exercise his talents on it to bring this most noble art to a good order. But I hold it a pleasure to have gained this distinction: to have dared to commit this most subtle and noble art to writing. If I have been little able to satisfy the reader's expectations in this very difficult attempt, he has nature to blame as much as me, for nature imposed this law on things: that there is no art but has had its beginning in faulty things. Nothing is born and perfected at once. Whoever follows me, if perhaps he is someone more advanced in learning and talent than I, will, I expect, make painting self-contained and perfect.

ON ARCHITECTURE[14]

THE PREFACE. Our Ancestors have left us many and various Arts tending to the Pleasure and Conveniency of Life, acquired with the greatest industry and diligence: Which Arts, tho' they all pretend, with a kind of emulation, to have in view the great end of being serviceable to Mankind; yet we know that each of them in particular has something in it that seems to promise a distinct and separate Fruit: some Arts we follow for necessity, some we approve for their usefulness, and some we esteem because they lead

[14] The selections from the treatise on architecture have been taken from Giacomo Leoni, *The Architecture of Leon Battista Alberti*, 1st ed., London, 1726. Giacomo Leoni was apparently brought to England by Lord Burlington to prepare a translation of Palladio's writings. Lord Burlington, through his great admiration of Palladio, did much to establish the Palladian style in England. Leoni published his Palladio translation in 1715 and the Alberti translation made from Cosimo Bartoli's Italian translation of the Latin text eleven years later. See also: *Ten Books on Architecture by L. B. Alberti*, edited by Joseph Rykwert, London, 1955. *L'architettuta (De re aedificatoria)*, Latin text and Italian translation, Giov Orlandi, introduction and notes by Paolo Portoghesi, Milan, 1966.

us to the knowledge of things that are delightful. What these Arts are, it is not necessary for me to enumerate; for they are obvious. But if you take a view of the whole circle of Arts, you shall hardly find one but what, despising all others, regards and seeks only its own particular ends: or if you do meet with any such a nature that you can in no wise do without it, and which yet brings along with it Profit at the same time, conjoyn'd with Pleasure and Honour, you will, I believe, be convinced that Architecture is not to be excluded from that number. For it is certain, if you examine the matter carefully, it is inexpressibly delightful, and of the greatest convenience to Mankind in all respects, both publick and private; and in Dignity not inferior to the most excellent. But before I proceed further, it will not be improper to explain what he is that I allow to be an Architect: for it is not a Carpenter or a Joyner that I thus rank with the greatest Masters in other Sciences; the manual Operator being no more than an Instrument to the Architect. Him I call an Architect, who, by a sure and wonderful Art and Method, is able, both with thought and invention, to devise, and, with execution, to compleat all those Works, which, by means of the movement of great Weights, and the conjunction and amassment of Bodies, can, with the greatest Beauty, be adapted to the uses of Mankind: and to be able to do this, he must have a thorough insight into the noblest and most curious Sciences. Such must be the Architect. But to return.

Some have been of opinion that either Water or Fire were the principal occasions of bringing Men together into Societies; but to us, who consider the usefulness and necessity of Coverings and Wall, it seems evident that they were the chief causes of assembling Men together. But the only obligation we have to the Architect is not for his providing us with safe and pleasant places, where we may shelter ourselves from the Heat of the Sun, and from Cold and Tempest, (tho' this is no small Benefit); but for having besides contrived many other things, both of a private and publick nature of the highest use and convenience to the life of Man. How many noble Families, reduced by the calamity of the Times, had been utterly lost, both in our own native City,

and in others, had not their Paternal Habitations preserv'd and cherish'd them, as it were, in the bosom of their Fore-fathers. Daedalus in his times was greatly esteem'd for having made the Selinuntians a Vault, which gather'd so warm and kindly a Vapour, as provoked a plentiful Sweat, and thereby cured their Distempers with great ease and pleasure. Why need I mention others who have contrived many things of the like sort conducive to Health; as Places for Exercise, for Swimming, Baths, and the like? or why should I instance in Vehicles, Mills, Timemeasures, and other such minute things, which nevertheless are of great use in Life? Why should I insist upon the great plenty of Waters brought from the most remote and hidden places, and employ'd to so many different and useful purposes? upon Trophies, Tabernacles, sacred Edifices, Churches and the like, adapted to divine Worship and the Service to Posterity? or lastly, why should I mention the Rocks cut, Mountains bored through, Vallies fill'd up, Lakes confined, Marshes discharged into the Sea, Ships built, Rivers turn'd, their Mouths clear'd, Bridges laid over them, Harbours form'd, not only serving to Men's immediate Conveniencies, but also opening them a way to all Parts of the world; whereby Men have been enabled mutually to furnish one another with Provisions, Spices, Gems, and to communicate their Knowledge, and whatever else is healthful or pleasurable. Add to these the Engines and Machines of War, Fortresses, and the like Inventions, necessary to the defending the Liberty of our Country, maintaining the Honour, and encreasing the Greatness of a City, and to the Acquisition and Establishment of an Empire. I am really persuaded, that if we were to enquire of all the Cities which, within the memory of Man, have fallen by Siege into the Power of new Masters, who it was that subjected and overcame them, they would tell you, the Architect; and that they were strong enough to have despised the Armed Enemy, but not to withstand the Shocks of the Engines, the Violence of the Machines, and the Force of the other Instruments of War, with which the Architect distress'd, demolish'd and ruinated them. And the Besieged, on the contrary, would inform you, that their greatest Defence lay in the Art and

Assistance of the Architect. And if you were to examine into
the Expeditions that have been undertaken, you would go
near to find that most of the Victories were gain'd more by
the Art and Skill of the Architects, than by the Conduct
or Fortune of the Generals; and that the Enemy was oftener
overcome and conquer'd by the Architect's Wit, without the
Captain's Arms, than by the Captain's Arms without the
Architect's Wit: and what is of great Consequence is, that
the Architect conquers with a small number of Men, and
without the loss of Troops. Let this suffice as to the useful-
ness of this Art.

But how much the Study and Subject of Building de-
lights, and how firmly it is rooted in the mind of Man,
appears from several Instances, and particularly from this;
that you shall find no body who has the means but what
has an inclination to be building something: and if a Man
had happen'd to think of any thing new in Architecture,
he is fond of communicating and divulging it for the use
of others, as if constrain'd thereto by Nature. And how often
does it fall out that even when we are employ'd upon other
things, we cannot keep our Thought and Imaginations from
projecting some Edifice? and when we see other Men's
Houses, we immediately set about a careful Examination of
all the Proportions and Dimensions, and, to the best of our
Ability, consider what might be added, retrench'd or
alter'd; and presently give our Opinions how it might be
made more compleat or beautiful. And if a Building be
well laid out, and justly finish'd, who is he that does not
view it with the utmost pleasure and delight? But why need
I mention not only how much benefit and delight, but how
much Glory too Architecture has brought to Nations, which
have cultivated it both at home and abroad? Who that has
built any publick Edifice does not think himself honour'd
by it, when it is reputable to a Man only to have built a
handsome Habitation for himself? Men of publick Spirits
approve and rejoyce when you have raised a fine Wall or
Portico, and adorn'd it with Portals, Columns, and a hand-
some Roof, knowing you have thereby not only served your-
self, but them too, having, by this generous use of your
Wealth, gain'd an addition of great Honour to Yourself,

your Family, your Descendants, and your City. The Sepulchre of Jupiter was the first step to the ennobling the Island of Crete; and Delos was not so much respected for the Oracle of Apollo, as for the beautiful Structure of the City, and the Majesty of the Temple. How much Authority accrued to the Roman Name and Empire from their Buildings, I shall dwell upon no further, than that the Sepulchres and other Remains of the Ancient Magnificence, every where to be found, are a great Inducement and Argument with us for believing many things related by Historians, which might otherwise have seem'd incredible. Thucydides extremely commends the prudence of some Ancients, who had so adorn'd their City with all sorts of fine Structures, that their Power thereby appear'd to be much greater than it really was. And what potent or wise Prince can be named that, among his chief Projects for eternizing his Name and Posterity, did not make use of Architecture. But of this enough. The conclusion is, that for the Service, Security, Honour and Ornament of the Publick, we are exceedingly obliged to the Architect; to whom, in time of Leisure, we are indebted for Tranquility, Pleasure and Health, in time of Business for Assistance and Profit; and in both, for Security and Dignity. Let us not therefore deny that he ought to be praised and esteem'd, and to be allow'd a place, both for the wonderful and ravishing beauty of his Works, and for the necessity, serviceableness, and strength of the things which he has invented, among the chief of those who have deserved Honour and Rewards from Mankind. The consideration of these things induced me, for my Diversion, to look a little further into this Art and its Operations, from what Principles it was derived, and of what Parts it consisted: and finding them of various kinds, in number almost infinite, in their nature marvellous, of use incredible, insomuch that it was doubtful what condition of Men, or what part of the Commonwealth, or what degree in the City, whether publick or private, things sacred or profane, Repose or Labour, the Individual or the whole Humane Species, was most obliged to the Architect, or rather Inventor of all Conveniencies; I resolved, for several Reasons, too tedious here to repeat, to

collect all those things which are contain'd in these ten
Books. In treating which, we shall observe this Method:
We consider that an Edifice is a kind of Body consisting,
like all other Bodies, of Design and of Matter; the first is
produced by the Thought, the other by Nature; so that
the one is to be provided by the Application and Contriv-
ance of the Mind, and the other by due preparation and
choice. And we further reflected, that neither the one nor
the other of itself was sufficient, without the hand of an
experienced Artificer, that knew how to form his Materials
after a just Design. And the use of Edifices being various,
it was necessary to enquire whether one and the same kind
of Design was fit for all sorts of Buildings; upon which ac-
count we have distinguish'd the several kinds of Buildings;
wherein perceiving that the main point was the just com-
position and relation of the Lines among themselves, from
whence arises the height of Beauty, I therefore began to
examine what Beauty really was, and what sort of Beauty
was proper to each Edifice. And as we often meet with
Faults in all these respects, I considered how they might
be alter'd or amended. Every Book therefore has its Title
prefix'd to it, according to the variety of the Subject; The
First treats of Designs; the Second, of Materials; the Third,
of the Work; the Fourth, of Works in general; the Fifth,
of Works in particular; the Sixth, of Ornaments in general;
the Seventh, of the Ornaments proper for Sacred Edifices;
the Eighth, of those for publick and profane ones; the
Ninth, of those for the Houses of private Persons; the Tenth,
of Amendments and Alterations in Buildings: to which is
added, a various History of Waters, and how they are
found, and what use is to be made of the Architect in all
these Works: as also four other Books, three of which treat
of the art of Painting; and the fourth, of Sculpture.

BOOK I. CHAPTER X. *Of the Columns and Walls, and
some Observations relating to the Columns.* We are now
to treat summarily of the Disposition of the Wall. But here
I must not omit what I have observed among the Ancients;
namely, that they constantly avoided drawing any of the
outer Lines of the Platform quite strait, so as to let any

great Length go on without being interrupted by the Concavity of some curve Line, or the Intersection of some Angle; and the Reason why those wise Men did this is plain, that the Wall, having, as it were, Props joined to it to rest against, might be so much the stronger. In treating of the Walling, we should begin with the most noble Parts of it. This Place therefore naturally leads us to speak of the Columns, and of the Things belonging to them; a Row of Columns being indeed nothing else but a Wall open and discontinued in several Places. And having occasion to define a Column, it would not be at all improper to say, that it is a certain strong continued Part of the Wall, carried up perpendicular from the Foundation to the Top, for supporting the Covering. In the whole Compass of the Art of Building, you will find nothing, that either for workmanship, Expence or Beauty, deserves to be preferred before the Columns. But these Columns having some Particulars in which they differ from one another; in this Place we shall speak only of their Agreement; because that regards the Genus of them; but as to their Difference, which relates to their Species, we shall handle it in its proper Place. To begin therefore as we may say from the Root, every Column has its Foundation; this Foundation being brought up to a Level with the Plane of the *Area,* it was usual to raise thereupon a kind of little Wall, which we shall call the Plinth, others perhaps may call it the Dye; upon the Plinth stood the Base, on the Base, the Column; and over the Column the Capital; their Proportion was, that from the middle downwards, they were somewhat bigger, and from thence upwards grew more and more tapered, and that the Foot was something larger than the Top of all. I make no doubt, that at first the Column was invented to support the Covering. Afterwards Men's Thoughts being stirred up to worthy Attempts, they studied, tho' themselves were mortal, to make their Buildings in a Manner immortal and eternal; and for this Reason they made Columns, Architraves, Intablatures, and Coverings all of Marble. And in doing these Things, the ancient Architects always kept so close to Nature, as to seem, if possible, never to have consulted any Thing but mere Convenience in Building, and at the same

Time made it their Care, that their Works should be not only strong and useful, but also pleasant to the Sight. Nature at first certainly gave us Columns made of Wood, and of a round Figure, afterwards by Use they came in some Places to be cut square. Thereupon, if I judge right, seeing in these wooden Columns certain Rings of Circles of Brass or Iron, fasten'd about the Top and Bottom, that the continual Weight, which they are made to bear, might not split them; the Architects too left at the Foot of their Columns of Marble, a little Ring like a sort of Binding; whereby they are defended from any Drops of Rain that may dash up again upon them. And at the Top too they left another little Band, and over that an Astragal or Collar; with which helps they observ'd the Columns of Wood to be fortified. In the Bases of their Columns it was their Rule, that the under Part should consist of strait Lines and right Angles, but that their upper Superficies should terminate circularly to answer to the Round of the Pillar; and they made this Base on every Side broader than high, and wider than the Column by a determinate Part of itself; and the under Superficies of the Base they made broader than the upper; the Plinth too they would have certain Proportion broader than the Base, and the Foundation again a determinate Part wider than the Plinth. And all these Parts thus placed one upon the other, they erected perpendicular from the Center of the Foundation. On the other hand, Capitals all agree in this, that their under Parts imitate their Columns, but their upper End in a Square; and consequently the upper Part of the Capital must always be somewhat broader than the under. This may suffice here as to the Columns. The Wall ought to be raised with the same Proportions as the Columns; so that if it is to be as high as the Column and its Capital, its Thickness ought to be the same with that of the bottom of the Column. And they also observed this Rule, that there shou'd be neither Pillar, nor Base, nor Capital, nor Wall, but what should in all respects correspond with every thing else of the same Order, in Heighth, Thickness, Form and Dimension. But tho' both are Faults, either to make the Wall too thin or too thick, higher or lower than the Rule and Proportion requires; yet of the two

I wou'd chuse to offend on that Side, where we shou'd have occasion to take away rather than to add. And here I think it will not be amiss to take notice of some Errors in Buildings, that we our selves may be the more circumspect: in as much as the chief Praise is to be exempt from Blame. I have observed therefore in St. *Peter's* Church at *Rome* what indeed the thing itself demonstrates, that it was ill advised to draw a very long and thick Wall over so many frequent and continued Apertures, without strength'ning it with any curve Lines or any other Fortification whatsoever. And what more deserves our Notice, all this Wing of Wall, under which are too frequent and continued Apertures, and which is raised to a great Height, is exposed as a Butt to the impetuous Blasts of the North-East: by which means already thro' the continual Violence of the Winds it is swerved from its Direction above two Yards: and I doubt not that in a short time, some little accidental shock will throw it down into Ruins; and if it were not kept in by the Timber Frame of the Roof, it must infallibly have fallen down before now. But the Architect may not be so much in Fault, because consulting only the Necessity of his Situation, he might perhaps imagine that the Neighbourhood of the Mountain, which overlooks the Church, might be a sufficient Shelter against the Winds. Nevertheless it is certain, those Wings ought to have been more strengthened on both Sides.

BOOK V. CHAPTER XIII. . . . *of the three sorts of Prisons, their structures, situations and compartitions.*[15] . . . I observe that the Ancients had three sorts of Prisons. The first was that wherein they kept the disorderly and the ignorant, to the intent that every night they might be doctor'd and instructed by learned and able professors of the best arts, in those points which related to good Manners and an honest life. The second was for the confinement of debtors, and the reformation of such as were got into a licentious way of living. The last was for the most wicked wretched

[15] The analysis of prison treatment and punishment in general one does not encounter until the end of the eighteenth or early nineteenth century when the present system was established.

and horrid profligates, unworthy of the light of the sun or the society of mankind, and soon to be delivered over to capital punishment or perpetual imprisonment and misery. If any man is of opinion that this last sort of Prison ought to be made like some subterraneous Cavern, or frightful Sepulchre, he has certainly a greater regard to the punishment of the Criminal than is agreeable either to the design of the law or to humanity, and tho' wicked men do by their crimes deserve the highest punishment, yet the Prince or Commonwealth ought never to forget Mercy in the midst of Justice. . . .

BOOK VI. CHAPTER I. *Of the reason and difficulty of the Author's undertaking, whereby it appears how much pains, study and application he has employed in writing upon these matters.* In the five preceding Books we have treated of the Designs, of the Materials for the Work, of the Workmen, and of every thing else that appeared necessary to the construction of an Edifice whether publick or private, sacred or profane, so far as related to its being made strong against all injuries of weather, and convenient for its respective use, as to times, places, men and things: with how much care we have treated of all these matters, you may see by the Books themselves, from whence you may judge whether it was possible to do it with much greater. The labour indeed was much more than I cou'd have foreseen at the beginning of this undertaking. Continual difficulties every moment arose either in explaining the matter, or inventing names, or methodizing the subject, which perfectly confounded me, and disheartened me from my undertaking. On the other hand, the same reasons which induced me to begin this work, press'd and encouraged me to proceed. It grieved me that so many great and noble instructions of the ancient Authors shou'd be lost by the injury of Time, so that scarce any but Vitruvius has escaped this general Wreck: a Writer indeed of universal knowledge, but so maimed by age, that in many places there are great chasms, and many things imperfect in others. Besides this, his style is absolutely void of all ornament, and he wrote in such a manner, that to the Latins he seems to write

Greek, and to the Greeks, Latin: but indeed it is plain from
the book itself, that he wrote neither Greek nor Latin, and
he might almost as well have never wrote at all, at least
with regard to us, since we cannot understand him. There
remained many examples of the ancient Works, Temples
and Theatres, from whence, as from the most skilful mas-
ters, a great deal was to be learn'd; but these I saw, and
with tears I saw it, mouldering away daily. I observed too
that those who in these days happened to undertake any
new Structure, generally ran after the whims of the mod-
erns, instead of being delighted and directed by the just-
ness of more noble Works. By this means it was plain that
this part of knowledge, and in a manner of life itself, was
likely in a short time to be wholly lost. In this unhappy
state of things, I cou'd not help having it long, and often,
in my thoughts to write upon this subject myself. At the
same time I considered that in the examination of so many
noble and useful matters, and so necessary to mankind; it
wou'd be a shame to neglect any of those observations
which voluntarily offered themselves to me; and I thought
it the duty of an honest and studious mind, to endeavour
to free this Science, for which the most Learned among the
Ancients had always a very great esteem, from its present
ruine and oppression. Thus I stood doubtful, and knew not
how to resolve, whether I shou'd drop my design, or go
on. At length my love and inclination for these studies pre-
vailed: and what I wanted in capacity, I made up in dili-
gence and application. There was not the least remain of
any ancient Structure, that had any merit in it, but what
I went and examined, to see if any thing was to be learn'd
from it. Thus I was continually searching, considering,
measuring and making draughts of every thing I cou'd hear
of, till such time as I had made myself perfect master of
every contrivance or invention that has been used in those
ancient remains; and thus I alleviated the fatigue of writ-
ing, by the thirst and pleasure of gaining information. And
indeed the collecting together, rehearsing without mean-
ness, reducing into a just method, writing in an accurate
style, and explaining perspicuously so many various mat-
ters, so unequal, so dispersed, and so remote from common

use and knowledge of mankind, certainly required a greater
genius, and more learning than I can pretend to. But still
I shall not repent of my labour, if I have only effected what
I chiefly proposed to myself, namely, to be clear and intel-
ligible to the Reader, rather than eloquent. How difficult
a thing this is, in handling subjects of this nature, is better
known to those who have attempted it, than believed by
those who never tried it. And I flatter myself, it will at least
be allow'd me, that I have wrote according to the rules of
this language, and in no obscure style. We shall endeavour
to do the same in the remaining parts of this work. . . .

BOOK VI. CHAPTER II. *Of Beauty and Ornament, their
effect and difference, that they are owing to art and exact-
ness of proportion; as also of the birth and progress of Arts.*
It is generally allowed that the pleasure and delight which
we feel on the view of any Building, arise from nothing
else but Beauty and Ornament, since there is hardly any
man so melancholy or stupid, so rough or unpolished, but
what is very much pleased with what is beautiful, and pur-
sues those things which are most adorned, and rejects the
unadorned and neglected; and if in any thing that he views
he perceives any ornament is wanting, he declares that there
is something deficient which wou'd make the work more
delightful and noble. We shou'd therefore consult Beauty
as one of the main and principal requisites in any thing
which we have a mind shou'd please others. How neces-
sary our Forefathers, men remarkable for their wisdom,
look'd upon this to be, appears, as indeed from almost every
thing they did, so particularly from their Laws, their Mi-
litia, their Sacred and all other publick Ceremonies; which
it is almost incredible what pains they took to adorn; inso-
much that one wou'd almost imagine they had a mind to
have it thought, that all these things (so absolutely neces-
sary to the life of mankind) if stript of their pomp and
ornament, wou'd be somewhat stupid and insipid. When
we lift up our eyes to Heaven, and view the wonderful
Works of God, we admire him more for the beauties which
we see, than for the conveniences which we feel and derive
from them. But what occasion is there to insist upon this?

when we see, that Nature consults beauty in a manner to excess, in everything she does, even in painting the flowers of the field. If Beauty therefore is necessary in any thing, it is so particularly in Building, which can never be without it, without giving offence both to the skilful and the ignorant. How are we moved by a huge shapeless ill-contrived pile of Stones? the greater it is, the more we blame the folly of the expence, and condemn the builder's inconsiderate lust of heaping up stone upon stone without contrivance. The having satisfied necessity is a very small matter, and having provided for conveniency affords no manner of pleasure, where you are shock'd by the deformity of the work. Add to this, that the very thing we speak of is itself no small help both to conveniency and duration: for who will deny that it is much more convenient to be lodged in a neat handsome Structure, than in a nasty ill-contrived hole? or can any building be made so strong by all the contrivance of art, as to be safe from violence and force? But Beauty will have such an effect even upon an enraged enemy, that it will disarm his anger, and prevent him from offering it any injury: insomuch that I will be bold to say, there can be no greater security to any work against violence and injury, than beauty and dignity. Your whole care, diligence and expence therefore shou'd all tend to this, that whatever you build may be not only useful and convenient, but also handsomely adorned, and by that means delightful to the sight, that whoever views it may own the expence cou'd never have been better bestowed. But what Beauty and Ornament are in themselves, and what difference there is between them, may perhaps be easier for the Reader to conceive in his mind, than for me to explain by words. In order therefore to be as brief as possible, I shall define Beauty to be a harmony of all the parts, in whatsoever subject it appears, fitted together with such proportion and connection, that nothing cou'd be added, diminished or altered, but for the worse. A quality so noble and divine, that the whole force of wit and art has been spent to procure it: and it is but very rarely granted to any one, or even to Nature herself, to produce any thing in every way perfect and compleat. How extraordinary a thing (says the

person introduced in Tully) is a handsome Youth in Athens! This Critick in Beauty found that there was something deficient or superfluous, in the persons he disliked, which was not compatible with the perfection of beauty, which I imagine might have been obtained by means of Ornament, by painting and concealing anything that was deformed, trimming and polishing what was handsome; so that the unsightly parts might have given less offence, and the more lovely, more delight. If this be granted, we may define Ornament to be a kind of an auxiliary brightness and improvement to Beauty. So that then Beauty is somewhat lovely which is proper and innate, and diffused over the whole body, and Ornament somewhat added or fastened on, rather than proper and innate. To return therefore where we left off. Whoever wou'd build so as to have their building commended, which every reasonable man wou'd desire, must build according to a justness or proportion, and this justness of proportion must be owing Art. Who therefore will affirm, that a handsome and just structure can be raised any otherwise than by the means of Art? and consequently this part of building, which relates to beauty and ornament, being the chief of all the rest, must without doubt be directed by some sure rules of art and proportion, which whoever neglects will make himself ridiculous. But there are some who will by no means allow of this, and say that men are guided by a variety of opinions in their judgment of beauty and of buildings; and that the forms of structures must vary according to every man's particular taste and fancy, and not be tied down to any rules of Art. A common thing with the ignorant to despise what they do not understand! It may not therefore be amiss to confute this error: not that I think it necessary to enter into a long discussion about the origin of Arts, from what principles they were deduced, and by what methods improved. I shall only take notice that all Arts were begot by Chance and Observation, nursed by Use and Experience, and improved and perfected by Reason and Study. Thus we are told that Physick was invented in a thousand years, by a thousand men; and so too the Art of Navigation; as indeed, all other Arts have grown up by degrees from the smallest beginnings.

Book VII. Chapter IV. *Of the Parts, Forms and Figures of Temples and their Chapels, and how these latter should be distributed.* The Parts of the Temple are two; the Portico and the Inside: But they differ very much from one another in both these respects; for some Temples are round, some square, and others, lastly, have many Sides. It is manifest that Nature delights principally in round Figures, since we find most Things which are generated, made or directed by Nature, are round. Why need I instance in the Stars, Trees, Animals, the Nests of Birds, or the like Parts of the Creation, which she has chosen to make generally round? We find too that Nature is sometimes delighted with Figures of six Sides; for Bees, Hornets, and all other Kinds of Wasps have learnt no other Figure for building their Cells in their Hives, but the Hexagon. The Area for a round Temple should be marked out exactly circular. The Ancients, in almost all their quadrangular Temples made the Platform half as long again as it was broad. Some made it only a third Part of the Breadth longer; and others would have it full thrice the Breadth long. But in all these quadrangular Platforms the greatest Blemish is for the Corners to be not exactly rectangular. The Polygons used by the Ancients were either of six, eight, or sometimes ten Sides. The Angles of such Platforms should all terminate within a Circle, and indeed from a Circle is the best Way of deducing them; for the Semidiameter of the Circle will make one of the six Sides which can be contained in that Circle. And if from the Center you draw Right-lines to cut each of those six sides exactly in the Middle, you will plainly see what Method you are to take to draw a Platform of twelve Sides, and from that of twelve Sides you may make one of four, or eight,[16] . . . To temples it is usual to joyn Chapels; to some, more; to others fewer. In quadrangular Temples it is very unusual to make above one, and that is placed at the Head, so as to be seen immediately by those that come in at the Door. If you have a Mind to make more Chapels on the Sides, they will not be amiss in those quad-

[16] The description of the method of constructing the geometrical figure is omitted.

rangular Temples which are twice as long as broad; and
there we should not make more than one in each Side:
Though if you do make more, it will be better to make an
odd Number on each Side than an even one. In round Plat-
forms, and also in those of Many Faces (if we may venture
so to call them) we may very conveniently make a greater
Number of Chapels, according to the Number of those
Faces, one to each, or one with and one without alternately,
answering to each other. In round Platforms six Chapels,
or even eight will do extremely well. In Platforms of several
Faces you must be sure to let the Corners be exactly an-
swering and suiting to one another. The Chapels themselves
must be made either Parts of a rectangled Square, or of a
Circle. For the single Chapel at the Head of a Temple, the
semicircular Form is much the handsomest; and next to that
is the rectangular. But if you are to make a good Number
of Chapels, it will certainly be much more pleasing to the
Eye, to make Part of them square and Part round alter-
nately, and answering one to the other. For the Aperture
of these Chapels observe the following Rule. When you
are to make a single Chapel in a quadrangular Temple,
divide the Breadth of the Temple into four Parts, and give
two of those Parts to the Breadth of the Chapel. If you
have a Mind to have it more spacious, divide that Breadth
into six Parts, and give four of them to the Breadth of your
Chapel. And thus the Ornaments and Columns which you
are to add to them, the Windows, and the like, may be
handsomely fitted in their proper Places. If you are to make
a Number of Chapels about a round Platform, you may, if
you please, make them all of the same Size with the princi-
pal one; but to give that the greater Air of Dignity, I should
rather chuse to have it a twelfth Part bigger than the rest.
There is also this other Difference in quadrangular Temples,
that if the principal Chapel is made of equal Lines, that is
to say, in an exact Square, it may not be amiss; but the
other Chapels ought to be twice as broad as they are deep.
The Solid of the Walls, or those Ribs of the Building which
in Temples separate one Chapel from the other, should
never have less Thickness than the fifth Part of the Break
which is left between them, nor more than the third; or, if

you would have them extremely strong, the half. But in round Platforms, if the Chapels are in Number six, let the Solid or Rib which is left between each Chapel, be one half of the Break; and if there be eight of those Chapels, let the solid Wall between them, especially in great Temples, be as thick as the whole Break for the Chapel: But if the Platform consist of a great Number of Angles, let the Solid always be one third of the break. In some Temples, according to the Custom of the ancient *Hetrurians*, it has been usual to adorn the Sides not with Chapels, but with a small Sort of Isles, in the following Manner: They chose a Platform, which was one sixth Part longer than it was broad: Of this Length they assigned two of those six Parts to the Depth of the Portico, which was to serve as a Vestibule to the Temple; the rest they divided into three Parts which they gave to the three Breadths of the side Isles. Again, they divided the Breadth of the Temple into ten Parts, three of which they assigned to the little Isles on the right Hand, and as many to those on the left, and the other four they gave to the Area in the Middle. At the Head of the Temple, and so fronting the Middle of each side Isle, they placed Chapels, and the Walls which separated the several Isles they made in Thickness one fifth Part of the Interspace.

BOOK IX. CHAPTER V. *That the beauty of all edifices arises principally from three things, namely, the number, figure and collocation of the several members.* I now come once more to those points which I before promised to enquire into, namely, wherein it is that beauty and ornament, universally considered, consist, or rather whence they arise. An Enquiry of the utmost difficulty; for what ever that property be which is so gathered and collected from the whole number and nature of the several parts, or to be imparted to each of them according to a certain and regular order, or which must be contrived in such a manner as to joyn and unite a certain number of parts into one body or Whole, but an orderly and sure coherence and agreement of all those parts: which property is what we are here to discover; it is certain such a property must have in itself something of the force and spirit of all the parts with which

it is either united or mixed, otherwise they must jar and disagree with each other, and by such discord destroy the uniformity or beauty of the whole: the discovery of which, as it is far from being easie or obvious in any other case, so it is particularly difficult and uncertain here; the art of Architecture consisting of so many various parts, and each of those parts requiring so many various ornaments as you have already seen. However, as it is necessary in the prosecution of our design, we shall use the utmost of our abilities in clearing this obscure point, not going so far about as to shew how a compleat knowledge of a Whole is to be gained by examining the several parts distinct; but beginning immediately upon which is to our present purpose, by enquiring what that property is which in its nature makes a thing beautiful. The most expert Artists among the Ancients, as we have observed elsewhere, were of opinion that an Edifice was like a Animal, so that in the formation of it we ought to imitate Nature. Let us therefore enquire how it happens that in the bodies produced by Nature herself some are accounted more, others less beautiful, or even deformed. It is manifest that in those which are esteemed beautiful, the parts or members are not constantly all the same, so as not to differ in any respect: but we find that even in those parts wherein they vary most, there is something inherent and implanted which tho' they differ extremely from each other, makes each of them be beautiful. I will make use of an example to illustrate my meaning. Some admire a woman for being extremely slender and fine shaped; the young Gentlemen in *Terence* preferred a girl that was plump and fleshy: You perhaps are for a medium between these two extremes, and wou'd neither have her so thin as to seem wasted with sickness, nor so strong and robust as if she were a Ploughman in disguise, and were fit for boxing: In short, you wou'd like her such a beauty as might be formed by taking from the first what the second might spare. But then because, one of these pleases you more than the other, wou'd you therefore affirm the other to be not at all handsome or graceful? By no means; but there may be some hidden cause why one shou'd please you more than the other, into which I will not now pretend

to enquire. But the judgment which you make that a thing is beautiful, does not proceed from mere opinion, but from a secret argument and discourse implanted in the mind itself; which plainly appears to be so from this, that no man beholds any thing ugly or deformed, without an immediate hatred and abhorrence. Whence this sensation of the mind arises, and how it is formed, wou'd be a question too subtle for this place: however, let us consider and examine it from those things which are most obvious, and make more immediately to the subject in hand: for, without question there is a certain excellence and natural beauty in the figures and forms of buildings, which immediately strike the mind with pleasure and admiration. It is my opinion that beauty, majesty, gracefulness and the like charms, consist in those particulars which if you alter or take away, the whole wou'd be made homely and disagreeable. If we are convinced of this, it can be no very tedious enquiry to consider those things which may be taken away, encreased or altered, especially in figures and forms; for every Body consists of certain peculiar parts, of which if you take away any one, or lessen or enlarge it, or remove it to an improper place; that which before gave the Beauty and Grace to this Body, will at once be lamed and spoylt. From hence we may conclude, to avoid prolixity in this research, that there are three things principally in which the whole of what we are looking into consists: the Number, and that which I have called the Finishing, and the Collocation. But there is still something else besides, which arises from the conjunction and connection of these other parts, and gives the beauty and grace to the whole: which we will call Congruity, which we may consider as the original, of all that is graceful and handsome. The business and office of congruity is to put together members differing from each other in their natures, in such a manner, that they may conspire to form a beautiful Whole: so that wherever such a composition offers itself to the mind either by the conveyance of the sight, hearing, or any of the other senses, we immediately perceive this congruity: for by Nature we desire things perfect, and adhere to them with pleasure when they are offered to us; nor does this Congruity arise so much from

the body in which it is found, or any of its members, as from itself and from Nature, so that its true Seat is in the mind and in reason: and accordingly it has a very large field to exercize itself and flourish in, and runs thro' every part and action of Man's life, and every production of Nature herself, which are all directed by the law of congruity, nor does Nature study anything more than to make all her works absolute and perfect, which they cou'd never be without this congruity, since they wou'd want that consent of parts which is so necessary to perfection. But we need not say more upon this point, and if what we have here laid down appears to be true, we may conclude Beauty to be such a consent and agreement of the parts of a whole in which it is found, as to Number, Finishing, and Collocation, as Congruity, that is to say, the principal Law of Nature, requires. This is what Architecture chiefly aims at, and by this she obtains her beauty, dignity and value. The Ancients knowing from the nature of things that the matter was in fact as I have stated it, and being convinced that if they neglected this main point they shou'd never produce anything great or commendable, did in their works propose to themselves chiefly the imitation of Nature, as the greatest Artist at all manner of compositions; and for this purpose they laboured, as far as the industry of man cou'd reach, to discover the laws upon which she herself acted in the production of her works, in order to transfer them to the business of Architecture. Reflecting therefore upon the practice of Nature as well with relation to an entire Body, as to its several parts, they found from the very first principles of things, that Bodies were not always composed of equal parts or members; whence it happens that of the Bodies produced by Nature, some are smaller, some larger, and some middling: and considering that one Building differed from another, upon account of the end for which it was raised, and the purpose which it was to serve, as we have shewn in the foregoing books, they found it necessary to make them of various kinds. Thus from an imitation of nature they invented three manners of adorning a Building, and gave them names drawn from their first Inventors. One was better contrived for strength and duration: this they

called Doric; another was more tapered and beautiful: this they named Corinthian: another was a kind of medium composed from the other two, and this they called Ionic. Thus much related to the whole Body in general. Then observing that those three things which we have already mentioned, namely, the Number, Finishing and Collocation, were what chiefly conduced to make the whole beautiful, they found how they were to make use of this from a thorough examination of the Works of Nature, and as I imagine, upon the following principles. The first thing they observ'd, as to number, was that it was of two sorts, even and uneven, and they made use of both, but in different occasions: for, from the imitation of Nature, they never made the Ribs of their Structure, that is to say, the Columns, Angles and the like, in uneven numbers; as you shall not find any Animal that stands or moves upon an odd number of feet. On the contrary they made their Apertures always in uneven numbers, as Nature herself has done in some instances, for tho' in Animals she has placed an ear, an eye and a nostril on each side, yet the great Aperture, the Mouth, she has set singly in the middle. But among these Numbers, whether even or uneven, there are some which seem to be greater favourites with Nature than others, and more celebrated among learned men: which Architects have borrowed for the composition of the Members of their Edifices, upon account of their being endued with some qualities which make them more valuable than any others. . . .

Book IX. Chapter X. *What it is that an Architect ought principally to consider, and what sciences he ought to be acquainted with.* But to the intent that the Architect may come off worthily and honourably in preparing, ordering and accomplishing all these things, there are some necessary admonitions, which he shou'd by no means neglect. And first he ought to consider well what weight he is going to take upon his shoulders, what it is that he professes, what manner of man he wou'd be thought, how great a business he undertakes, how much applause, profit, favour and fame among posterity he will gain when he executes

his work as he ought, and on the contrary, if he goes about any thing ignorantly, unadvisedly, or inconsiderately, to how much disgrace, to how much indignation he exposes himself, what a clear, manifest, and everlasting testimony he gives mankind of his folly and indiscretion. Doubtless Architecture is a very noble Science, not fit for every head. He ought to be a man of fine genius, of great application, of the best education, of thorough experience, and especially of strong sense and sound judgement, that presumes to declare himself an Architect. It is the business of Architecture, and indeed its highest praise, to judge rightly what is fit and decent: for tho' building is a matter of necessity, yet convenient building is both of necessity and utility too: but to build in such a manner, that the generous shall commend you, and the frugal not blame you, is the work only of a prudent, wise and learned Architect. To run up anything that is immediately necessary for any particular purpose, and about which there is no doubt of what sort it shou'd be, or of the ability of the owner to afford it, is not so much the business of an Architect, as of a common Workman: but to raise an Edifice which is compleat in every part, and to consider and provide beforehand every thing necessary for such a work, is the business only of that extensive genius which I have described above: for indeed his invention must be owing to his wit, his knowledge, to experience, his choice to judgment, his composition to study, and the completion of his work to his perfection in his art: of all which qualifications I take the foundation to be prudence and mature deliberation. As to the other virtues, humanity, benevolence, modesty, probity; I do not require them more in the Architect, than I do in every other man, let him profess what art he will: for indeed without them I do not think any one worthy to be deemed a man: but above all things he shou'd avoid levity, obstinacy, ostentation, intemperance, and all those other vices which may lose him the good will of his fellow-citizens, and make him odious to the world. Lastly, in the study of his art I wou'd have him follow the example of those that apply themselves to Letters: for no man thinks himself sufficiently learned in any science, unless he has read

and examined all the Authors, as well bad as good that
have wrote in that science which he is pursuing. In the
same manner I wou'd have the Architect diligently con-
sider all the Buildings that have any tolerable reputation;
and not only so, but take them down in lines and numbers,
nay, make designs and models of them, and by means of
those, consider and examine the order, situation, sort and
number of every part which others have employed, espe-
cially such as have done any thing very great and excellent,
whom we may reasonably suppose to have been men of
very great note, when they were intrusted with the direc-
tion of so great an expence. Not that I would have him
admire a Structure merely for being huge, and imagine that
to be a sufficient beauty; but let him principally enquire
in every building what there is particularly artful and ex-
cellent for contrivance or invention, and gain a habit of be-
ing pleased with nothing but what is really elegant and
praiseworthy for the design: and wherever he finds any
thing noble, let him make use of it, or imitate it in his own
performances; and when he sees any thing is well done,
that is capable of being still further improved and made
delicate, let him study to bring it to perfection in his own
works; and when he meets with any design that is only
not absolutely bad, let him try in his own things to work
it if possible into something excellent. Thus by a continued
and nice examination of the best productions, still consid-
ering what improvements might be made in every-thing
that he sees, he may so exercize and sharpen his own in-
vention, as to collect into his own works not only all the
beauties which are dispersed up and down in those of other
men, but even those which lye in a manner concealed in
the most hidden recesses of nature, to his own immortal
reputation. Not satisfyed with this, he shou'd also have an
ambition to produce something admirable, which may be
entirely of his own invention; like him, for instance, who
built a Temple without using one iron tool in it; or him
that brought the *Colossus* to *Rome*, suspended all the way
upright, in which work we may just mention that he em-
ployed no less than four and twenty Elephants; or like an
Artist that in only seemingly working a common Quarry of

Stone, shou'd cut it out into a labyrinth, a temple, or some other useful structure, to the surprize of all mankind. We are told that Nero used to employ miraculous Architects, who never thought of any invention, but what it was almost impossible for the skill of man to reduce to practice. Such geniusses I can by no means approve of; for, indeed, I wou'd have the Architect always appear to have consulted necessity and convenience in the first place, even tho' at the same time his principal care has been ornament. If he can make a handsome mixture of the noble orders of the Ancients, with any of the new inventions of the moderns, he may deserve commendation. In this manner he shou'd be continually improving his genius by use and exercize in such things as may conduce to make him excellent in this science; and indeed, he shou'd think it becomes him to have not only that knowledge, without which he wou'd not really be what he professed himself; but he shou'd also adorn his mind with such a tincture of all the liberal arts, as may be of service to make him more ready and ingenious at his own, and that he may never be at a loss for any helps in it which learning can furnish him with. In short, he ought to be persevering in his study and application, till he finds himself equal to those great men, whose praises are capable of no further addition: nor let him ever be satisfyed with himself, if there is that thing any where that can possibly be of use to him, and that can be obtained either by diligence or thought, which he is not thorowly master of, till he is arrived at the summit of perfection in the art which he professes. The Arts which are useful, and indeed absolutely necessary to the Architect, are Painting and Mathematics. I do not require him to be deeply learned in the rest; for I think it ridiculous, like a certain Author, to expect that an Architect shou'd be a profound Lawyer, in order to know the right of conveying water or placing limits between neighbours, and to avoid falling into controversies and lawsuits as in building is often the case: nor need he be a perfect Astronomer, to know that Libraries ought to be situated to the North, and Stoves to the South; nor a very great Musician, to place the vases of copper or brass in a Theatre for assisting the voice: neither do I re-

quire that he shou'd be an Orator, in order to be able to display to any person that wou'd employ him, the services which he is capable of doing him; for knowledge, experience and perfect mastery in what he is to speak of, will never fail to help him to words to explain his sense sufficiently, which indeed is the first and main end of eloquence. Not that I wou'd have him tongue-tyed, or so deficient in his ears, as to have no taste for harmony: it may suffice if he does not build a private man's house upon the public ground, or upon another man's: if he does not annoy the neighbours, either by his lights, his spouts, his gutters, his drains, or by obstructing their passage contrary to law: if he knows the several winds that blow from the different points of the compass, and their names: in all which sciences there is no harm indeed in his being more expert; but Painting and Mathematics are what he can no more be without, than a Poet can be without the knowledge of feet and syllables; neither do I know whether it be enough for him to be only moderately tinctured with them. This I can say of myself, that I have often started in my mind ideas of buildings, which have given me wonderful delight: wherein when I have come to reduce them into lines, I have found in those very parts which most pleased me, many gross errors that required great correction; and upon a second review of such a draught, and measuring every part by numbers, I have been sensible and ashamed of my own inaccuracy. Lastly, when I have made my draught into a model, and then proceeded to examine the several parts over again, I have sometimes found myself mistaken even in my numbers. Not that I expect my Architect to be a Zeuxis in Painting, nor a Nicomachus at numbers, nor an Archimedes in the knowledge of lines and angles: it may serve his purpose if he is a thorow master of those elements of Painting which I have wrote; and if he is skilled in so much practical Mathematics, and in such a knowledge of mixed lines, angles and numbers, as is necessary for the measuring of weight superficies and solids, which part of Geometry the Greeks call *Podsimata* and *Emboda*. With these arts, joyned to study and application, the Architect

may be sure to obtain favour and riches, and to deliver his name with reputation down to posterity.

BOOK X. CHAPTER VII. *Of the method of conveying Water and accommodating it to the uses of men. . . .* The Searchers into Nature tell us that the Earth is Spherical, tho' in many places it rises into Hills and in many others sinks into Seas: but on so vast a Globe this roughness is not perceptible; as in an Egg, which tho' it is far from being of smooth superficies, yet its little inequalities bearing but an inconsiderable proportion to its whole circumference, they are scarce observed. . . . What the Geometers teach us upon this head is very much to our present purpose. They say that if a strait line touching the globe of the earth at one end were to be drawn on exactly horizontal a mile in length, the space between the other end and the surface of the globe wou'd not be above ten inches. For this reason water will never move on in a Canal, but stands still like a Lake, unless every eight furlongs the trench has a slope of one whole foot from the place where the water was first found and its bed cut; . . .

ANTONIO AVERLINO, IL FILARETE

[Antonio Averlino, il Filarete (1400?–1465?) was born in Florence and may have been among the numerous assistants employed by Ghiberti on his first door for the Baptistry. In 1433 Pope Eugene IV commissioned him to execute in bronze the principal door of St. Peter's. Completed in 1453, it reveals Filarete's study of antiquity as well as his deficiencies as an artist. Through the recommendation of Piero de' Medici, he secured employment as an architect from Francesco Sforza in Milan and was engaged first on the Castello Sforzesco. Previous to this he probably had had no training in architecture. The commission to build the hospital of Milan was given him in 1456. Filarete wrote his curious book on architecture, *Il trattato d'architettura* (Treatise on Architecture), between 1451 and 1464. He

considers architecture in twenty-one books and devotes
three to drawing and painting. His treatise, filled with a
hodgepodge of valuable information, reflects the current be-
liefs, tastes, and practices, and is more closely related to
the fourteenth century and Gothic than to the High Renais-
sance and its classicism of which Alberti is the precursor.
The material is not presented as a practical treatise but as
a novel, much of it in dialogue, in which the author is called
upon by a prince to build an entire city called "Sforzinda."
Because of the death of Filarete's patron, Francesco Sforza,
in 1466, the manuscript was left without a formal ending.
In spite of its close association with the Sforza, Filarete
dedicated it to his former patron, Piero de' Medici, and
added a last book praising the buildings built by the Medici.
In 1465 Filarete resigned of his own accord from his work
on the hospital. The rest of his life and the date of his death
are unknown.]

TREATISE ON ARCHITECTURE[1]

Book VI. *Of the Plan of the Squares and the Streets of
the City.*[2] . . . After the completion of the citadel the
prince had the arrangement of the inner city explained.

At the center, laid out east and west, is the principal
square or piazza, 150 *braccia*[3] wide and 300 *braccia* long.

[1] The excerpts are translated from the text as given by W.
Oettingen, A. A. *Filarete's Tractat über die Baukunst* (Quellen-
schriften für Kunstgeschichte, N.F., III), Vienna, 1890. Footnotes
within brackets are by the translator; others are from Oettingen.
It is pointed out in M. Lazzaroni and A. Muñoz, *Filarete scultore
e architetto del secolo XV*, Rome, 1908, p. 3, note 1, that the text
as given by Oettingen, and used here in the absence of any other,
is full of errors and in need of revision. For this revision see *Trea-
tise on Architecture, being the treatise by Antonio di Piero Aver-
lino, known as Filarete*, translated with introduction and notes by
John R. Spencer, New Haven, 1965. See also Peter Tigler, *Die
Architeckturtheorie des Filarete*, Berlin, 1963.
 See also: Olschki, *Geschichte*, pp. 109–118; Blunt, *Theory*,
p. 43; Schlosser, *Lett. art.*, p. 113, and *Kunstlit.*, p. 112.
 [2] [Oettingen gives no Italian text for this section, only his
German translation.]
 [3] [See p. 155, note 14.]

Each small square of the plan equals one square *stadio*.[4]
At the eastern end of the piazza is the principal church.
Opposite, on the west, is the princely palace. On the north,
the square of the merchants [Piazza de' Mercatanti], 93¾
x 187½ *braccia* (¼ x ½ *stadio*) joins the Piazza. On the
south is the great market, 125 x 250 *braccia* (⅓ x ⅔
stadio), where food will be sold. At the west of this I will
erect the palace of the captain of police. In this way he
will be separated from the royal palace only by a street.
South, are the baths and brothels, west, the inns and tav-
erns; the butchers and shops for fish and fowl will be
planned later. On the west side of the Piazza de' Mercatanti
is the Town Hall [Palazzo della Ragione Comune], and the
prison, and on the north the Palace of the Mayor [Palazzo
del Podestà]. The mint where the money is made and
stored, and the office of the tax collector, [Dogana] are lo-
cated on the west side. The rest will be planned later. The
principal streets will lead to the Piazza from all the eight
gates in the obtuse angles of the city walls and from the
eight round towers in right angles of the city walls. Each
of these sixteen streets will be broken halfway to the Piazza
by a square 80 by 60 *braccia*. In each of the eight squares
on the streets leading from the towers is a parochial church
belonging to a monastic order. The other eight squares
serve as markets in this way: at the two west and east
squares will be sold straw and wood, at the two northern
ones, oil and the like, at the two southern ones, grain and
wine: and in each square there will be placed one or two
butcher shops. Around these squares the workers will settle.

All the streets slope downwards from the Piazza so that
water will run quickly out of the city. The principal streets
are elevated one to two *braccia* above the ground. On each
side are arcades or porticos eight or ten *braccia* wide. The
main streets are forty *braccia* in width, while the other
streets are twenty. We can distribute water everywhere be-
cause of the great abundance provided by the rivers Indo
and Averlo. In order to limit noisy wagon traffic and to pro-
vide greater convenience for the inhabitants, we will sur-

[4] [A *stadio* is about 220 yards.]

round the Piazza and other markets with navigable canals
and make every other principal street a porticoed water
street-canal. Wagons and riders will be restricted to well-
paved streets. A great reservoir will be placed in the Piazza,
from which an overflow will flood and wash all the streets
and squares. Numerous bridges provide convenient com-
munications, those in the Piazza twenty *braccia* wide. . . .

Book VII. *The Plan of the Cathedral.*[5] "Tell me, why
does one lay out most churches in the form of a cross?"
We do it in memory of Christ, who was nailed to a cross.
In antiquity this form was not known. One had round tem-
ples such as the S. Maria Rotonda in Rome, once called
the Pantheon, or octagonal temples such as S. Giovanni [the
Baptistry] in Florence, said to have been formerly dedicated
to Mars, and others in still different forms. According to
Vitruvius, the temples dedicated to Hercules, Mars and
Minerva were what one calls "Doric." These, built of rough-
hewn stones without decoration, were severe and gloomy.
In contrast, Venus, Proserpina and the Goddess Flora or
Ceres had dedicated to them the so-called "Corinthian"
temple, rich and graceful. Less decorated and lower were
the "Ionic" temples for Juno, Diana and Bacchus. Other
gods, I should think, although Vitruvius is silent on the sub-
ject, received a form of sanctuary compatible with their
character. For instance, perhaps Pan and other wood gods
had temples made of brushwood or sticks. We Christians
also build our churches in several forms. The temples of
the ancients were for the most part low-ceilinged, for in
their opinion the praying heart and thought should be hum-
ble before God. Today we build our churches high so that
the person entering feels elevated and his soul can rise to
contemplate God.

Book VIII. *Arches and Doors.* The following day with-
out saying anything else to me the Prince immediately
asked me how one should build an arch, what was its origin
and what form was the most beautiful and best able to sup-
port a great weight. He also asked about doors: which were

[5] [Italian text not given.]

the most beautiful, square or round ones; of what pro-
portion they should be made that would be the most
correct. . . .

Your Lordship asks not a little. I shall tell you what I
have heard. The earliest arch appeared when the first man
to build a dwelling of either straw or some other material
came to make the door. I believe he procured some pliable
wood and bent it. Thus he made, as one says, a half-circle.
This was bound to two wooden uprights which were
planted in the spot he had chosen for the entrance. I be-
lieve the arch was derived from this early method. Then
another made it a little better. He made a circle, cut it
in half, and then placed the half above two wooden uprights
and made a door with an arch above. The square door
was found almost by itself, because there was another man
who fixed two upright logs in the ground just to make an
entrance and bound another log across them. Whether they
were fastened, or tied, or how it was done,—at any rate, it
appears probable that this was the origin of the door;
whether it in this way or that, it makes no difference to us.

Let us consider the reasons of these, and in what style
are they best, how the ancients used them, how they re-
fined and adjusted all these things related to building. And
thus according to their needs, I urge everyone who builds
or has others build to follow them [the ancients' system]
and abandon these styles which are used almost every-
where today.[6] I highly praise those who follow ancient
technique and style. I bless the soul of Filippo di Ser Bru-
nellesco, Florentine citizen, famous and worthy architect
and subtle imitator of Daedalus. He has revived in our city
of Florence this ancient style of building[7] in such a way
that today in churches as in public and private buildings
no other style is used. That this is true, you can see, for
private citizens who have a house or church built all use

[6] [For Filarete the term "modern" refers to the contemporary
style, which was Gothic. See Schlosser, *Lett. art.*, p. 113.]

[7] This part is interesting for the certainty with which Brunel-
lesco was regarded, twenty years after his death, as the real
founder of the new art of building. Beside him Alberti ranked
only as a theoretician. [Cf. above, Manetti, pp. 167 ff.]

that style. Among others, a house newly built in a town district on a street, called la Vigna, has the entire façade composed of dressed stones and all laid in the ancient style.[8] Therefore I urge each one, investigating and trying to apply the ancient manner to building, to use these styles. If it were not the most beautiful and practical it would not be used in Florence as I said above. Neither would the Duke of Mantua, a great connoisseur, use it if it were not what I say. That this statement is true, a house the Duke had built at one of his castles above the Po bears witness.[9] Therefore, I advise everyone to abandon the modern style and not be advised by those masters who use this crude system. May he who found it be cursed! I believe that none other than barbarians brought it into Italy. I shall give this illustration to show the relation of ancient to modern architecture. It is the same as in literature: that is, as the relation of the speech of Cicero or Virgil to that used thirty or forty years ago. Today writing in imitation of the classical style is the best usage, contrary to practice in the past. After several centuries, prose today is enhanced by ornamentation. This has been accomplished only through following the ancient style of Cicero and of other worthy men.[10] The same occurred in architecture. The man who follows the ancient practice in architecture does exactly the same thing as a man of letters who strives to reproduce the classical style of Cicero and Virgil.

I do not wish to say more, but I advise you Milord, that at least in what you have made, not to use it.[11] I am very

[8] The Rucellai Palace is meant. [Why Filarete does not mention Alberti as the architect can be interpreted in various ways: he may have disliked him, or he may have assumed everyone knew of his connection with the palace.]

[9] Which one of the buildings of Lodovico Gonzaga this refers to cannot be determined.

[10] With what justice Filarete sets the beginning of improved diction in 1420–1430 is open to discussion, for if he means either Latin or Italian, both were used in the classical style in the fourteenth century. It is to be supposed that Brunellesco's activity in architecture suggested to him the date for the improvement of speech.

[11] This admonition is skillfully directed at Francesco Sforza who, like all Lombards about the middle of the fifteenth century,

certain that as you understand design a little better you will see this that I say to be true.

"It is true that I do not understand well these differences. Yet I see some things that please me more than others, such as some columns, and also certain arches, doors and vaults."

Which are the columns that please you the most?

"They are some I have seen which appear very old. There are some arches that, like these, are pointed. The ones that are round please me much more than those so pointed. However, I do not know which is better. I have seen some doors which are severely square. There are some that have little arches and such things that break the square; those severely square please me. So tell me which are the ancient ones or which are the best?"

Milord, Your Lordship begins to appreciate and understand. Those you describe, that is, the pointed arches, are modern and in bad style, as are the doors that have any break in the square. You have heard from whence the arch comes, and you also heard the origin of the first square door; now you will understand the reason why round arches are more beautiful, how they should be placed, and in what form they should be made in order to follow the ancients' practice. The reason round arches are more beautiful than pointed ones is plain, for everything that impedes the vision either more or less is not as beautiful as the line that the vision follows and thus the eye has nothing to hinder it. And thus is the round arch, as you see. When you see a semicircular arch your eye is not impeded in any way when you glance at it. Likewise when you see a circle, the eye (or let us say, vision, how you see) immediately encircles it at first glance, for there is not hindrance or obstacle to the progress of the eye. Thus when you look at a semicircle, the eye immediately moves and the vision goes from one end of it to the other without any obstacle or hindrance. Not so with the pointed arch because the eye,

was still building in a completely Gothic style. Filarete had not been able to secure acceptance of his new style either in the building of the castle outside the Porta Giovia or in the construction of the Great Hospital.

or, let us say, vision, fixes itself a moment at that point where the arch is pointed and does not proceed as freely as with a semicircle. Therefore, the pointed arch deviates from perfection. . . .[12] Just because I have taught it to you, I am not advising that you use the pointed arch. I describe it only so you may be on guard, for such arches are neither good nor beautiful.

You might say: these pointed arches are quite strong and substantial. It is true, but if you make an arch that is a semicircular one that has good shoulders, it is also strong. And that is true, for I myself have seen in Rome great round arches that are strong; especially in the Thermae, and in the Antonine Thermae and in many other buildings. Certainly if they [the Romans] had doubted in the least the strength of these arches they would have built two, one above the other. For no reason were any of the pointed arches used. Since they were not used by them, we ought not to use them.

The doors may be square and also they may be half-circles. However, for the most part the ancients used square ones and in the private dwellings one never sees any but square doors. It is true that the city gates, like those in Rome, are all round. . . .

Now you know the measurements of the arches and the doors and the form the ancients used. But this modern crudity is employed in such a way that I do not wish to discuss it. The forms it produces are not beautiful to behold and it would be as unpleasant for you to hear of them as it would be disagreeable and annoying for me to discuss them. When you see arches or doors that are not in the form drawn here, they will be modern. It is true that to one who does not understand design, they appear more beautiful because they are made with more furbelows. But I implore whoever sees them, not to look at them and to turn the mind to these ancient ones. Similarly all the other things [architectural details] should be in the ancient style, as should the other arts related to design as I said above,

[12] [Filarete's instructions for making a pointed arch are omitted.]

painting, stone-carving, and wood-carving. I do not wish to discuss further these differences . . . for you yourself will understand and appreciate the beauty the ancient things have and the crudity there is in the modern.

BOOK XIII. *Of Building Bridges.* . . . When the masonry was finished, the Prince sent word to his father, the Prince, who came immediately to see what we had done. . . . Then the Prince turned to another gentleman, who through interest and good will, and perhaps for other business of theirs, had come with him. He seemed a connoisseur of many things, especially of architecture, which gave him the greatest pleasure. He showed himself to be very expert in these matters of building. Turning to our Prince, he said, "Milord, everything pleases me immensely, but this tower truly is well understood and planned in all details and it has the look of a tower built for strength. In truth, if I had to build a similar structure, I should build it in no other form than this."

Then the Prince replied, "I want you to come and see our recently built city, which I believe will please you."

"So far as I know from what I have already seen it is bound to please me. If one is able to judge from these castles, it is a marvelous thing. Milord, although I have not built similar structures, they give me great pleasure. As I have said, I have a great interest in architecture and I especially enjoy contemplating and viewing these buildings when they are built in the ancient style, for truly they are made differently and with other grace than the modern ones."

The Prince answered, "Milord, they also please me very much, but even the modern structures also please me and appear beautiful to me."

"Your Lordship, they are beautiful, but they are as different from the others as day is from night. I also used to admire modern buildings, but since I began to appreciate the ancient style they have become hateful to me. Also in the beginning, if I built anything, I simply adopted the modern manner because the Prince, my father, followed it."

"But how did you happen to perceive the differences?"

"Milord, the truth is, when I desired to change some details of style and when I also heard that in Florence the antique style of building was in use, I determined to engage one of those architects who are renowned. Conversing with them awakened me in such a way that at present I do not have the slightest thing made that is not in the ancient manner. Do you recall when Your Excellency was in our rooms?"

"I looked at them carefully and I liked them very much."

"Milord, there was one of the courtiers who was very well informed in these matters. For this reason, I kept him with me several days. He executed in wood some models of those small buildings I wish to build for my devotions." . . .

When he had seen and understood everything he said, "Milord, I seem to see in these worthy buildings those that were in Rome in ancient times and those of which one reads in Egypt. I appear to be reborn when I see such fine architecture and they also seem very beautiful to me."

"Would you tell us why in your opinion this science [architecture] declined and why the ancient style, which was so beautiful, was completely neglected?"

I shall explain it, Milord. The cause was this: as learning was lacking in Italy, people became vulgar in speech and ignorant of Latin, and a crude era ensued. It was only fifty or perhaps sixty years ago that men's minds were sharpened and awakened. Speech, as I said, was a crude thing, and so was this art [architecture] because Italy was ruined by the wars of these barbarians who many times conquered and devastated the country. Later, it happened that the customs and observances of the people north of the Alps came into use. For these reasons and because Italy was poor, these great buildings were not erected and men did not have enough experience in such things. The architects, not having an opportunity to practice their skill, had no chance to cultivate their knowledge. Thus the science of these things was lost. And then, when one wished to erect a building in Italy one turned to those who they wished to have build, to goldsmiths, and painters, and masons. Although architecture belonged in part to their trade it was indeed very different. And they have given these styles that

they had known and that are suitable to them in their modern works. The goldsmiths made their structures similar to and in the form of tabernacles and incense burners. They made the buildings in that form because these works appeared beautiful, but it was more suited to their work than to buildings. This custom and style they had acquired, as I said from the people north of the Alps, that is, from the Germans and French. For this reason the ancient styles were lost.

PIERO DELLA FRANCESCA

[Piero della Francesca (1410/20–1492), an Umbrian by birth, began his career as a painter in Domenico Veneziano's studio in Florence. In Florence he came in contact with the scientific studies of Alberti and Brunellesco and the painting of Masaccio.

In 1445, his native town, Borgo San Sepolcro, commissioned him to paint a *Madonna della Misericordia*. Six years later he executed the fresco of *Sigismondo Malatesta before St. Sigismond* at Rimini. After working in Rome for Nicholas V, Piero probably began in 1459 the magnificent frescoes of the *Legend of the Cross* in the choir of S. Francesco at Arezzo. Although he travelled in central Italy and executed work for his patrons, the Duke and Duchess of Urbino, he lived most of his life in Borgo San Sepolcro, where he died in 1492.

His treatise *De prospectiva pingendi* (Of the Perspective of Painting), written sometime between 1480 and 1490 and dedicated to Frederico Montefeltro, Duke of Urbino, is the first to treat the subjects of optics and perspective with a purely scientific method. Basing his work on the geometry of Euclid, he considers his material with mathematical exactness and detail. His work, which represents a great advance over the attempts of Ghiberti and Alberti in the same field, soon became very famous. Although the treatise was not published until the nineteenth century, and the original manuscript is lost, its contents were well known. The

mathematician, Fra Luca Pacioli (our *fig.* 21), Piero's pupil and Leonardo's friend, speaks of it with the highest praise (see Leonardo, p. 279, note 7).

The relationship between the principles of perspective worked out by Piero and contemporary "Production Illustration" has been pointed out by Professor Frederic G. Higbee (Dept. of Engineering Drawing, State University of Iowa) in the following note:

"Current production methods are focusing attention on the contributions made by such pioneers in the geometry of graphical representation as Ghiberti, Alberti, Piero, Viator, Dürer, Leonardo, and their followers. While it may seem far-fetched to credit artists writing as early as the fifteenth century with having an influence on the production of aircraft in the twentieth century, one has but to examine the many 'production illustrations' and 'exploded drawings' in current use to discover that the principles of graphic representation first analyzed and recorded by these artists are playing an important part in modern high speed production.

"The long chain linking the work of these early writers on the geometry of perspective with the production drawing of today has been forged slowly, largely because of necessity, and shockingly enough partly as a by-product of war. The pioneer artists (Ghiberti, Alberti, Piero, Viator, Dürer, and Leonardo) were concerned primarily with the establishment of a geometry of converging visual rays; the graphical mathematics of the proportions a picture should have in relation to the object, and the proportions within that picture due to its varying distances from the artist's eye. As they developed and systematized this graphical science of perspective, even these early geometers were aware that a one-view drawing had its limitations in presenting true conditions, and both Piero and Dürer have left evidence that for some purposes a three-view drawing made by orthogonal projection methods was more useful in conveying exact sizes. Both of these artists used a three-view drawing, complete with top view, front view, and profile view including projection lines, to describe the human head.

"Leonardo was a great engineer as well as a great artist.

This fact is important because it is known from his vast collection of sketches that he used graphical methods to forecast the mechanical development of the years which followed and thus in the century following Alberti and Piero the science whose development they had begun was used for practical purposes. To what extent Leonardo was aware of the limitations of perspective for construction purposes there is scant record, but there is some indication that he used also orthogonal projection.

"It is not so essential to establish the type of representation used by Leonardo as it is to emphasize that during his active life (1475–1516) he practiced and taught a method of graphical description which had for its direct purpose the recording and conveying of ideas on mechanical devices.

"Following the development of the geometry of perspective drawing, the most significant and far-reaching contribution to the science of graphical representation was made by Gaspard Monge (1746–1818). The product of a brilliant and fertile mind, the science of orthogonal projection and of three-dimensional geometry rapidly established itself as the basis for constructional graphics as did the science of perspective earlier as the basis for artistic graphics. So highly was his descriptive geometry regarded, Monge was compelled by the French government to withhold it even from his pupils, and it was not until 1795 that he was permitted to publish his *Geometric Descriptive*.

"Mathematician as he was, Monge early recognized the futility of lengthy computations for certain types of design, and proved not only that his geometric system was adequate for the purposes of design, but also that his methods of representation in design were more useful. Even while Monge was advocating the study of descriptive geometry as a stimulus to manufacturing methods, Thomas Jefferson, then U.S. Minister to France, was reporting a French method of making guns 'so exactly alike that what belongs to any one may be used for every other. . . .'

"Thus in the century following Monge, the need for recording and conveying data about constructive endeavor, the requirements of a rapidly developing industrial age, and

the necessity for a type of graphic language in which actual measurement could take the place of proportional estimates gave impetus to the growth of engineering drawing as the language for constructive undertakings and design. Because of the inadequacy of perspective or one-view drawing, the Mongean geometry and representation by multi-view orthogonal methods became the universal method for developing, recording, and transmitting constructive ideas.

"Even though engineering drawing has been widely proclaimed and universally accepted as the only graphic language suitable for creating, recording, and transmitting ideas of a constructive nature, within the last five years conditions and demands within war industries have demonstrated a reversion to the principles of the fifteenth century geometers is necessary. Again, and in extraordinary fashion, is perspective and other one-view representation being widely used, and used in combination with multi-view drawings. Today, in 1945, there are modern Ghibertis, Albertis, Pieros, Leonardos who again are writing on the geometry of perspective but now under the general title of 'Production Illustration.'—(See George Tharratt, *From Aircraft Production Illustration*, New York, 1944.)"]

OF THE PERSPECTIVE OF PAINTING[1]

BOOK I: POINTS, LINES AND PLANE SURFACES. *Painting consists of three principal parts, which we name drawing, measurement, and coloring.* By drawing we mean profiles and outlines which contain the objects. By measurement we mean the profiles and outlines placed proportionately in

[1] The excerpts and footnotes are translated from *Petrus Pictor Burgensis. De prospectiva pingendi,* ed. C. Winterberg, Strassbourg, 1899. The text, which is in need of verification, permits only a free translation, which was made with the assistance of the German one of Dr. Winterberg.

See also: Philip Hendy, *Piero della Francesca and the early Renaissance,* London, 1968; Piero della Francesca, *De prospectiva pingendi,* ed. G. N. Fasola, Florence, 1942; R. Longhi, *Piero della Francesca,* London, 1930; Schlosser, *Lett. art.,* pp. 121–124, and *Kunstlit.,* pp. 122–124; W. M. Ivins, Jr., *On the Rationalization of Sight* (Metropolitan Museum Papers, no. 8), New York, 1938; Olschki, *Geschichte,* pp. 137–150.

their places. By coloring we mean how colors show them-selves on the objects: light or dark, changing according to the light.

Of these three parts, I intend to consider only measure-ment, which we call perspective, mixing in some parts of drawing,[2] because without this, perspective cannot be em-ployed practically. We shall omit coloring and shall con-sider that which can demonstrate with lines, angles, and proportions, since we speak of points, lines, surfaces and objects. This part consists of five divisions. The first treats vision, namely the eye; the second, the form of objects seen; the third, the distance from the eye to the objects seen; the fourth, the lines that proceed from the outermost edge of the object and go to the eye; the fifth, the plane, between the eye and the object seen, on which one intends to repre-sent the things. The first part, I said, considers the eye of which I intend to treat only as much as is necessary to paint-ing. Therefore I say the eye is the first part because the eye is that in which all the objects seen within different angles are always perceived; namely, when the objects seen are equidistant from the eye, the larger object will be repre-sented within a larger angle than the smaller object. Simi-larly, when the objects are equal in size and are not equidistant from the eye, the nearer is represented within a larger angle than that more distant. By these differences is understood the foreshortening of the objects. The second division considers the form of the object, because without it [form] the intellect would be unable to judge the object or the eye to comprehend it. The third division deals with the distance from the eye to the object, for if there were no distance the object would be even with the eye or touch it, and if the object were larger than the eye, the eye would be incapable of receiving [its image]. The fourth deals with the lines which proceed from the outermost edge of the object and end in the eye, by means of which the eye re-ceives [the image] and discerns the object. The fifth con-siders a plane on which the eye with its visual rays describes the objects proportionately and on which one can judge

[2] Orthogonal projection.

their measurement. If there were no plane, one could not understand how much the objects were foreshortened, and thus they [their image] could not be drawn. Besides this, it is necessary to know how to draw in their true form on a plane all the objects which one intends to depict.

After the above-mentioned things are understood, we proceed with the task, making from this division of perspective three books. In the first we shall speak of points, lines, and planes: in the second of cubes, four-sided pilasters, and round and many-sided columns; in the third of heads and capitals, twisted bases, other bases, and other objects in different position.

A point is that which has no parts and, according to what the geometricians say, is only in the imagination. A line, they say, has length without breadth and because of this is apparent only to the intellect. But I say that in order to discuss perspective with demonstrations, which I wish to be comprehended by the eye, it is necessary to give another definition. Therefore I say, a point is a thing as small as it is possible for the eye to comprehend. A line, I say, is an extension from one point to another whose breadth is of the same quality as the point. Surface, I say, is width and length enclosed by lines. Surfaces are of many kinds, some are triangles, squares, tetragons, pentagons, hexagons, octagons, and some of more and different sides. . . .

Every quantity of size is represented in the eye within an angle. This is self-evident, because no size [dimension] exists in a point, and the power of vision [the eye] is only a point. When a line proceeds from a point to the outermost edge of an object, it necessarily forms an angle. In painting I determined that a point is so small that every other size is larger than it. Consequently, a line proceeding from the outermost edge of the object is so small that it ends in the eye, that is, in a point, and thus forms an angle. Therefore that object is represented within an angle. For example, if A is a point, BC is the size [of the object], and from its outermost edge one draws lines BA and CA terminating in the point A; when one draws BC three angles will be formed. For A is a point and will form an angle and B is a

point and c is a point, and drawing lines from one point to another, the lines not being parallel, will form a triangle. And I say, a is the point from whence the power of vision proceeds, and there is one angle opposite the object bc and it includes bc between the lines ab and ac within the angle a, which is the eye (Diagram 1).

DIAGRAM I

All bases seen within the same angle, even if they are in different positions, appear the same to the eye. For example, a is the eye from which go two lines, ab and ac. Draw between them several bases, bc, ef, gh. I say that each of these will represent itself to the eye as the same, that is, within the angle a, which I say is the eye and from it proceed the straight lines to the bases that are within these lines and touching them, as none extends beyond these lines; for the bases are neither too long nor too short, and so the eye perceives them as equal. Therefore I say that these bases appear as equal to the eye, because ray ac goes

DIAGRAM 2

directly through h and f and none of these planes pass beyond the ray or fail to reach it. The ray ab goes through g and e where it meets their edge in straight lines. Therefore I conclude that all bases contained within the same angle will appear the same to the eye, as the proposition shows (Diagram 2).

260 THE RENAISSANCE

[*The problem is*] *from a given eye* [*point of view*] *to represent on a determined picture plane the designated plane* [*perspectively*] *foreshortened.* The eye A is given: it is above the line DC and perpendicularly above D. DC is divided by point B, which is the fixed point for the picture plane. Above B, I draw FB perpendicularly. BC will be the designated plane which one wants to represent perspectively. Then I draw from point A a line to point C, which is the end point of the designated plane; this line divides BF at point E. Then I say that BE is the foreshortened plane, that is BC, because BE represents to the eye the equal of BC in the determined picture plane. To prove this, draw AB to make a triangle which will be ABC, and the bases thereof, BC and BE, lie opposite the same angle, so that to the eye BC and BE are the same, as was proved in the second proposition of this book. I maintain BE to be the designated plane [perspectively] foreshortened; and because this is the first foreshortening, one should understand it well in order that what follows may be understood more easily. As I have said, by a given eye [point of view] is understood that place in which you will place yourself and from which you will look in order to see the designated plane. By the designated plane is understood that length which you wish to make the plane. The proposed picture plane is that place where the designated plane should be portrayed foreshortened, that is, at the distance from the eye to the wall, or panel, or other surface on which one wants to place the foreshortened object. Place the eye high, low, near, or far according to the requirements of the work. Let us suppose that the designated plane [to be depicted perspectively] is 20 *braccia*[3] [long] and DB, which is the distance from the picture plane to the eye, is 10 *braccia,* and the eye

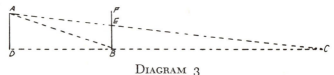

DIAGRAM 3

which I have set at A is 3 *braccia* above D. Then one draws

[3] See p. 155, note 14.

AC, which will divide BF at E, as said above. Then I maintain that C is higher than B in the picture plane to the amount of BE, because A is above BC. The proof is given by the tenth proposition of Euclid, *de aspectuum diversitate*. Thus I say, BE is 2, which is ⅔ of the height, as I have supposed the eye A to be 3 *braccia* above the plane. Two thirds then is 2 *braccia*, because the line which goes out from A divides equidistant lines in the same proportion, so this same proportion exists between DC and 30, BC and 20, which is the same as 20 to 30, or as 2 to 3. Therefore, I maintain BE to be BC, perspectively foreshortened, which I set out to foreshorten [perspectively] (Diagram 3).

Next I must correct the error of those not very skilled in this science. They often say that, when they divided a [perspectively] foreshortened plane into a number of *braccia,* those foreshortened appear larger than those not foreshortened. This occurs because they do not understand the distance that these must be between the eye and the plane on which the objects will be portrayed or how much the eye can extend the [visual] angle with its rays. Thus they are in doubt whether perspective is a true science, judging it falsely from ignorance. Therefore to dispel their doubt, it is necessary to make a demonstration of the true distance and how far the [visual] angle can be enlarged in the eye. Therefore, I shall make a four-sided figure with equal and parallel sides which will be BCDE. Inside this I shall draw FGHI parallel to the four lines: namely, FG parallel to BC, FH parallel to BD, GI parallel to CE, HI parallel to DE. Then I shall draw the diagonals BE and DC, BE passing through F and I, DC through G and H, so that they intersect at point A, which I take as [the center of vision] the eye. Then I shall divide the plane between those two lines into more equal parts. I shall divide BC at points 1, 2, 3, 4, 5, 6, 7, 8, and FG at points 12, 13, 14, 15, 16, 17. BD will be divided at points 21, 22, 23, 24, 25, 26, 27, 28. I shall divide FH at points 32, 33, 34, 35, 36, 37. From these two divisions the rest will be understood. I shall draw F-1, 12-2, 13-3, 14-4, 15-5, 16-6, 17-7, G-8. This is on the first side. On the other side I shall draw 21-F, 22-32, 23-33, 24-34,

25-35, 26-36, 27-37, 28-H. All these are parallel sides of squares and all are represented in point A, which as I said is the eye [center of vision] divided by the diagonals BE and DC into four equal parts. Each of these four parts is understood to be an eye, because in the head the eye is round and one fourth of it shows outside. Therefore I say, point A is four equal eyes. One, I say, is that part opposite line FG; another, I say, is that part opposite line GI; another lies opposite line HI because if four men were there, each facing forward, looking straight out, they would form what I have described as A. This eye, I said, is round and from the intersection of the two nerves that cross comes the power of vision at the center of the crystal fluid.[4] From this the rays proceed and spread straight out, dividing a quarter section of the circle of vision. Since they form at the center one right angle and because the lines going out from the right angle end in point F and point G, I say then that line FG is the greatest quantity which the eye placed opposite can see. If the diagonal would pass by—beyond the designated plane—it would follow that the other eye would be less than a quarter of the circle, which is not possible because the diagonals of a perfect square divide the circle into four equal parts. It follows that FG is the largest picture plane that such an eye can see. So through this it comes that, if the picture plane is exceeded, the perspectively foreshortened object appears larger than the unforeshortened because it enters with the vision into the part of the other eye. Proof: one draws lines from B, 1, 2, 3, 4, 5, 6, 7, 8, C to point A. I say that line B will be the diagonal passing through F of the line FG. Now extend the line BC by the amount which is contained between 1 and B, the continuation being BK, and at 21 add the distance of F to 21, this continuation being 21 to L. Then draw KL. These lines form the square BKL21. If one draws a line from K to point A, it will divide 21 and F at point M. Now I say that KL, which is perspectively foreshortened, seems larger than 21L, the unforeshortened amount, by the amount of 21M,

[4] The same antiquated view which is still encountered in Leonardo (see p. 279).

because KL is represented as equal to LM, which is larger than L21. As I have said, the foreshortened seems larger than the unforeshortened; this cannot be, because the eye is unable to see in that picture plane K, which is a part of the eye opposite line FH. The intellect does not comprehend why the eye sees FG, nor does it distinguish its parts other than as a spot seen from such a distance that one cannot judge whether it is a man or some other creature. Thus F and G are represented in point A, and since objects the parts of which cannot be understood do not allow themselves to be represented perspectively correct except through spots, it is therefore necessary to take a smaller picture plane than the line FG. So that the eye may perceive more easily things opposite it, it is necessary to portray them within a smaller angle than a right angle; which measure, I say, is two thirds of a right angle. For three such angles form together an equilateral triangle in which one angle is as large as

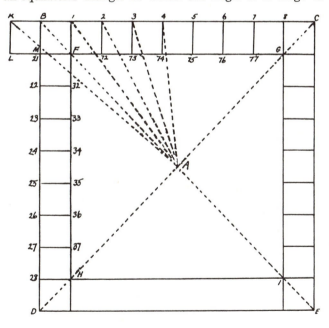

DIAGRAM 4

another. Because this line is expressed by roots, we shall put it into a real number so that this proposition may be more easily understood. I say that, if your work is 7 *braccia* wide, you should stand 6 *braccia* away, not less. If the picture width be more, you should stand proportionately farther away. But when your work be less than 7 *braccia* you may stand 6 or 7 *braccia* away to see it, but you cannot place yourself nearer than the relationship of 6 to 7, as was said, so that the eye in its position to the picture plane can view all your work without turning; for if it had to turn, the boundaries would be false because several eyes would be present. If you employ the given rules, you will recognize that the mistake lies with those [painters] and not with perspective, if the foreshortened object appears to be larger than that which is not foreshortened (Diagram 4).

BOOK II: CUBIC OBJECTS, FOUR-SIDED PILASTERS, AND ROUND AND MANY-SIDED COLUMNS. An object has three dimensions: length, width, and height. Its limits are surfaces. Objects are of different forms. Some are cubic, tetragonal and uneven-sided, some round, some lateral; some are lateral pyramids, and some have many and different sides such as one finds in natural and accidental things. In this second book, I intend to treat these and their foreshortening on the determined picture plane as seen by the eye within composite angles, the bases of which are formed by some surfaces foreshortened according to the first book.

[*The problem is*] *to place above a foreshortened four-sided surface a foreshortened cubic object in the same picture plane and the same distance from the eye as the said foreshortened surface.*

BCDE is the foreshortened surface where I intend to place a cubic form. The surface will be its bases, that is, one side of the cube. This will be easily accomplished if one draws over B a perpendicular the length of BC, which is BF, and another perpendicular over C to the same height, which is CG. Then one draws another perpendicular without a limit over D and another perpendicular over E. Then one draws a line from F to point A and, where it is cut by the perpendicular from D, places the point H. Then one draws a line from G

to point A and, where it is cut by the perpendicular from E, places point I. Then draw FG and HI to form the cube BCDEFGHI. Because BCFG is a rectangle with parallel lines and equal angles, the same proportion exists between HI and FG as between DE and BC, and the same proportion exists between AI and AG as between AE and AC. [Similarly HI is to FG as DE is to BC.][5] [The sides CE, GI are formed by the lines of the surface foreshortened according to the beginning of the first book.] Thus I say the proposition of the proportionally foreshortened cube is completed (Diagram 5).

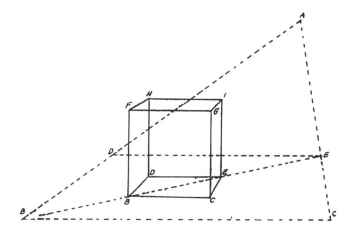

DIAGRAM 5

BOOK III. OF HEADS AND CAPITALS, BASES, IRREGULAR OBJECTS BOUNDED BY SEVERAL BASES AND OTHER OBJECTS IN VARIOUS POSITIONS. Many painters depreciate perspective because they do not understand the significance of the lines and the angles which it produces and by means of which every contour and line can be described in the proper proportion. Therefore I must show how necessary this science is for painting. I say, that the very name of perspective shows that it deals with objects seen from a distance represented within certain given planes proportionately [foreshortened] according to the extent of the distance. Without perspective

[5] Sic.

no object would be foreshortened correctly. Since painting is nothing else than representations of foreshortened or enlarged surfaces and objects placed on an established picture plane as actually the objects seen by the eye within different angles show themselves on the above-mentioned picture plane; and since in every object one part is always nearer the eye than another, and that nearer one always shows itself within a larger angle than the more distant part in the determined plane; and since the mind is incapable alone to judge their measurement, that is, how large is the nearer one and how large the more distant. Therefore, I say perspective is necessary; because as a true science it distinguishes degrees of size in proportional terms, by showing the foreshortening and enlarging of every size [dimension] by means of lines. Observing this [perspective] many ancient painters acquired eternal fame, like Aristomenes of Thasos, Polycles, Appelles Andramides, Nitheusm Zeuxis, and many others. Although many without [having used] perspective are given praise, this has been done with poor judgment by those who have no knowledge of the possibility of art. Therefore, zealous for the glory of art in this age, I have dared presumptuously to write this small part of perspective pertaining to painting, doing it in three books as I said in the first book. In the first I showed the foreshortening in many ways of plane surfaces. In the second I showed the foreshortening of square and many-sided objects placed perpendicularly on planes. But I now intend in this third book to treat the foreshortening of an object comprised of various surfaces and variously placed. . . .

To foreshorten the head proportionately at a given point a certain distance from the picture plane. As I already said at the beginning of this section, it is necessary to know how to draw in their true form those objects which one wishes to draw. Therefore draw a head with one eye, that is from the side, in that profile which you intend to foreshorten, and with this make another drawing from the front with two eyes, of the same size and with all the parts corresponding. First draw a straight line from the top of the head in profile to the top of the head in front view . . . (Diagram 6).

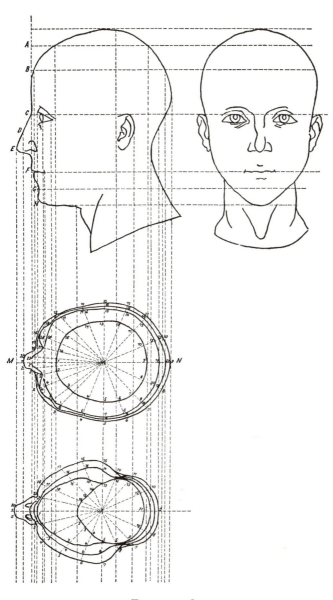

Diagram 6

CONTRACT OF PIETRO PERUGINO WITH THE BENEDICTINE MONKS OF S. PIETRO AT PERUGIA

[This contract for an altarpiece for the main altar of S. Pietro in Perugia sets forth the subject matter for the various parts of the altarpiece, the materials to be used and the terms of payment and forfeits. It is similar in its form and stipulations to most contracts under which an artist of the period undertook to execute a major art work. Such a contract enabled the artist to sue the commissioning party in order to receive payment for his work and to recover the amounts expended. It also enabled the person commissioning the artist either to force him to complete the work within the time limit or to make a financial adjustment such as the heirs of Julius II attempted to exact from Michelangelo for the Pope's tomb. Such contracts were universally used to regulate the negotiations between the artist and the person desiring an art work until the nineteenth century. At that time the position of the artist changed and he undertook the preparation of art works in anticipation of a market.]

THE CONTRACT[1]

In the name of the Lord, amen. In the year of our Lord 1495, in the thirteenth Indiction, at the time of the most Holy Father in Christ, Pope Alexander VI, ruling by Divine Providence, the eighth day of March. Drawn up in Perugia in the monastery of St. Peter in the presence of the following witnesses: Eusebio di Jacopo of Porta Santa Susanna of Perugia, Gianfrancisco Ciambello of Porta Sole of Perugia. The most Reverend Father in Christ, D. Lucianus of Florence, Abbot of the monastery of St. Peter of the Benedictine Order and of the congregation of Santa Giustina at Perugia, and D. Benedetto of Siena, and D. Daniele of

[1] This is a free translation of the text as given in F. Canuti, *Il Perugino*, 2 vols., Siena, 1931, II, pp. 176–177.

Perugia, as the syndics of the order and procurators of the named monastery, with the permission, consent and desire of the above-mentioned Abbot, who is present and consenting, . . . have ordered and commissioned the most honorable man, master Pietro Cristoforo of Castel della Pieve, a most accomplished painter, who is present and has accepted the commission, to paint and ornament the picture for the main altar of the church of St. Peter.[2] The picture must be painted in the following way:

In the rectangular panel, the Ascension of our Lord, Jesus Christ, with the figure of the glorious Virgin Mary, the Twelve Apostles and some angels and other ornaments, as may seem suitable to the painter.[3]

In the semicircle above, supported by two angels, should be painted the figure of God the Almighty Father.[4]

The predella below is to be painted and adorned with stories[5] according to the desire of the present Abbot. The columns, however, and the mouldings and all other ornamentation of the panel should be embellished with fine gold and other fine colors, as will be most fitting, so that the panel will be beautifully and diligently painted, embellished and gilded from top to bottom as stated above and as it befits a good, experienced, honorable, and accomplished master. It will be executed within the space of the coming two and a half years, all at the cost and expense of the said master Pietro himself. The said master Pietro has promised the Reverend Abbot . . . to carry out this agreement in general and in particular under the penalties herein specified. The painter pledges all his goods, real and movable property, present and future.

This the said master Pietro consented to because the Reverend Father, the Abbot, has promised and agreed with

[2] The altarpiece, not begun until 1496, was completed by January, 1500. It remained in S. Pietro until portions were removed on Napoleon's order in 1797.

[3] Napoleon gave the central panel, the *Ascension*, to the cathedral at Lyons, and it is in the museum there.

[4] In St.-Gervais, Paris.

[5] The *Adoration of the Magi*, the *Baptism of Christ*, and the *Resurrection* are now in the museum at Rouen.

him on the pledge of the monastery and his possessions to the said master Pietro, who is present and is executing this contract: namely, to give to him or to his heirs and actually to pay him for his painting, for paints, gold and other things necessary and suitable for the execution of the said painting, as well as for the ornaments of the said panel, 500 gold ducats, payable within four years, counting from the day on which the painting shall be begun, at the rate of one quarter of the sum each year.

In said account, however, the frame which surrounds the panel is not to be included, nor the ornaments placed at the top of said frame, but only the panel itself with its ornaments. . . .[6]

LEONARDO DA VINCI

[Leonardo da Vinci (1452–1519) was the illegitimate son of a notary, but like Alberti he was raised as a legitimate son in his father's household. As a boy Leonardo entered Verrocchio's studio, where he received his first training as an artist. During his years as a student in Florence he became acquainted with two great mathematicians of the period, Benedetto Aritmetico and Pozzo Toscanelli, the adviser of Christopher Columbus, thus acquiring early the scientific and rational attitude that dominated his life and art. The two unfinished paintings, *St. Jerome* and the *Adoration of the Kings,* and the *Annunciation* in the Louvre are of this early period. Where he was between 1481 and 1487 is not exactly known; but from the evidence found in his writings, he may have travelled in the Near East.

In 1493 he applied to Ludovico Sforza, il Moro, for employment, and secured a post at the brilliant court of Milan. With the assistance of his pupils, he executed many portraits of members of the Milan court. The famous *Madonna of the Rocks,* the *Last Supper,* the designs for the decora-

[6] A contract was drawn up November 23, 1496, for the frame, and the price of 60 ducats was fixed. See Canuti, *op. cit.,* i, p. 112; ii, p. 178.

tion of the Sala della Asse in the Castello Sforzesco, and
the sketch for the equestrian statue of il Moro's father, de-
stroyed by the French in 1499, are all of this period. Milan,
like Florence, was a center of learning, and Leonardo had
for friends and associates: Giacomo Andrea da Ferrara, an
architect and commentator of Vitruvius; Fazio Cardano,
a commentator on John Peckham's work on perspective,
who was also interested in law, medicine, and mathematics;
Piero Monte, an engineer and writer on military tactics;
Girolami and Piero Marliani, students of medicine and
geometry; Bramante, the famous architect; and Fra Luca
Pacioli (our *fig.* 21), the great mathematician and geome-
trician.

The invasion of Milan by the French under Louis XII
in 1499 caused Leonardo and Fra Luca Pacioli to go to
Venice and from there Leonardo went to Florence, where
he received several commissions but completed only the
cartoons of *St. Anne.* Dissatisfied with Florence, Leonardo
offered his services to Caesar Borgia, who employed him
as an architect and engineer with instructions to put in order
the fortifications of the Romagna. He soon found himself
without a master, as Caesar Borgia's plans were ended by
Alexander VI's death in 1503. Leonardo returned to Flor-
ence and accepted the commission to paint the *Battle of
Anghiari* in the Palazzo della Signoria. At the same time
Michelangelo received the commission to paint the *Battle
of Cascina* for another wall in the same room. Because of
his experimenting with a new fresco technique, Leonardo's
work was a complete failure, while Michelangelo's work
never advanced beyond the cartoon. After this disappoint-
ment, Leonardo went to Fiesole, a little village above Flor-
ence, and engaged in the study of aeronautics. His most
celebrated portrait, *Mona Lisa,* was painted at this time.

In 1506 Leonardo returned to Milan and was appointed
"Painter to the King" and "painter and engineer" by Louis
XII of France. He painted at this time *The Virgin of the
Bilanca,* the *Madonna Litta, The Holy Family,* and the
Bacchus. He also was busy studying hydraulics and writing
his treatise on anatomy.

The Battle of Ravenna in 1512 ended the domination of

the French in Italy, and Leonardo, without a patron, went
to Rome where Giovanni de' Medici had been made Pope
Leo X. In Rome, Leonardo continued his studies in anat-
omy, acoustics and geology and wrote a book on geometry.
He also made plans and began the project for draining the
swamps of the Campagna; this was finally completed in
1929 by Benito Mussolini. At the invitation of Francis I,
Leonardo left Italy in 1516, and took up his residence in
the Château de Cloux, near Tours, where he died three
years later.

Leonardo's notes, written throughout his life, on his in-
vestigations in every field of science and art, were entered,
often with illustrative drawings, in notebooks which, as
he said in 1508, "will be a collection without order, made
up of many sheets which I have copied here, hoping after-
wards to arrange them in order in their proper places ac-
cording to the subjects of which they treat" (see E. Mac-
Curdy, *The Notebooks of Leonardo da Vinci*, New York,
1939, p. 41). He projected many treatises and some existed
in an almost, or perhaps entirely, completed form. Fra Luca
Pacioli speaks of Leonardo's having finished the book on
painting and human movements. In 1517 Leonardo was
visited by the Cardinal of Aragon, whose secretary wrote:
"This gentleman has written of anatomy with such detail,
showing by illustrations the limbs, muscles, nerves, veins,
ligaments, intestines, and whatever else there is to discuss
in the bodies of men and women, in a way that has never
yet been done by anyone else. . . . He has also written of
the nature of water, of diverse machines and of other mat-
ters, which he has set down in an infinite number of volumes
all in the vulgar tongue, which if they should be published
will be profitable and very enjoyable" (MacCurdy, *op. cit.*,
Introduction). After Leonardo's death in 1519, his heir and
pupil, Melzi, took the manuscripts to Milan where they
were studied and seen by a few artists and scholars, in-
cluding Vasari. After Melzi's death they were dispersed and
many lost.

The principal collections of the notebooks are today in
Milan, Paris, Windsor, and London. A study of them re-
veals that Leonardo, as he himself says, "pre-imagined"—

LEONARDO DA VINCI 273

pre-imagining is the imagining of things that are to be—
many of the scientific discoveries of subsequent centuries.
He foresaw the heliocentric theory, Newton's theory of
gravitation, Harvey's theory of the circulation of blood and
envisaged the use of the airplane, submarine, tanks, and
poison gas. We regard him as one of the most universal
geniuses of all time, but it should be remembered that while
he was looked upon by his contemporaries as an almost
mythical person few of them had any conception of the
scope of his knowledge.]

LETTER TO IL MORO[1]

MOST ILLUSTRIOUS LORD,[2]—Having now sufficiently con-
sidered the specimens of all those who proclaim themselves
skilled contrivers of instruments of war, and that the inven-
tion and operation of the said instruments are nothing dif-
ferent to those in common use: I shall endeavour, without
prejudice to anyone else, to explain myself to your Excel-
lency, showing your Lordship my secrets, and then offering
them to your best pleasure and approbation to work with
effect at opportune moments on all those things which, in
part, shall be briefly noted below.

(1) I have a sort of extremely light and strong bridges,
adapted to be most easily carried, and with them you may
pursue, and at any time flee from the enemy; and others,
secure and indestructible by fire and battle, easy and con-
venient to lift and place. Also method of burning and
destroying those of the enemy.

[1] The excerpts and footnotes are from J. P. and I. A. Richter,
The Literary Works of Leonardo da Vinci, 2 vols., London, Ox-
ford University Press, 1939. Some of the footnotes are conden-
sations of the explanatory text. Miss Richter and the Oxford
University Press generously permitted the inclusion of these
excerpts which give only a suggestion of the genius of Leonardo.
The above-mentioned volume, with the complete text, and excel-
lent reproductions of Leonardo's illustrative drawings and dia-
grams, must be consulted by everyone interested in Leonardo.
See also: Olschki, *Geschichte*, pp. 252–385; Blunt, *Theory*, pp.
23–38; Schlosser, *Lett. art.*, p. 124, and *Kunstlit.*, p. 125.
[2] Richter, *op. cit.*, II, pp. 325–327, no. 1341.

(2) I know how, when a place is besieged, to take water out of the trenches, and make endless variety of bridges, and covered ways and ladders, and other machines pertaining to such expeditions.

(3) *Item.* If, by reason of the height of the banks, or the strength of the place and its position, it is impossible, when besieging a place, to avail oneself of the plan of bombardment, I have methods of destroying every rock or other fortress, even if it were founded on a rock, etc.

(4) Again, I have kinds of mortars; most convenient and easy to carry; and with these I can fling small stones almost resembling a storm; and with the smoke of these cause great terror to the enemy, to his great detriment and confusion.

(9) [8] And if the fight should be at sea I have kinds of many machines most efficient for offence and defence; and vessels which will resist the attack of the largest guns and powder and fumes.

(5) *Item.* I have means by secret and tortuous mines and ways, made without noise to reach a designated [spot], even if it were needed to pass under a trench or a river.

(6) *Item.* I will make covered chariots, safe and unattackable, which, entering among the enemy, with their artillery, there is no body of men so great but they would break them. And behind these, infantry could follow quite unhurt and without any hindrance.

(7) *Item.* In case of need I will make big guns, mortars, and light ordnance of fine and useful forms, out of the common type.

(8) Where the operation of bombardment might fall, I would contrive catapults, mangonels, *trabocchi* and other machines of marvellous efficacy and not in common use. And in short, according to the variety of cases, I can contrive various and endless means of offence and defence.

(10) In time of peace I believe I can give perfect satisfaction and to the equal of any other in architecture and the composition of buildings, public and private; and in guiding water from one place to another.

Item. I can carry out sculpture in marble, bronze, or clay,

and also I can do in painting whatever may be done, as well as any other, be he whom he may.

[32] Again, the bronze horse may be taken in hand, which is to be the immortal glory and eternal honour of the prince your father of happy memory, and of the illustrious house of Sforza.

And if any one of the above-named things seem to anyone to be impossible or not feasible, I am most ready to make the experiment in your park, or in whatever place may please your Excellency, to whom I commend myself with the utmost humility.

"PARAGONE," OR, FIRST PART OF THE BOOK ON PAINTING[3]

PAINTING AND SCIENCE. *Which Science is Mechanical and Which is Not?*[4] (6). They say knowledge born of ex-

[3] There is literary evidence to show that Leonardo composed a treatise on painting. If such a treatise systematically arranged by Leonardo himself ever existed, it is now lost. The oldest manuscript purporting to be a treatise of painting by him is Codex Urbinas 1270, preserved in the Vatican Library. The publication of the treatise was planned in the 17th century in Rome under the patronage of Cardinal Francesco Barberini and Cassiano del Pozzo. Cassiano persuaded his protégé, Poussin, to make new drawings to illustrate the text, and these, together with the manuscript, he turned over to Paul Fréart, Sieur de Chantelou, who was then traveling in Italy. The work was published in Italian in Paris in 1651 and immediately afterwards in French by Rafael Du Fresne, from a translation made by Chantelou's brother, Roland Fréart, Sieur de Chambray. The character of the reproductions of the drawings in Du Fresne's edition (our *fig. 22*) led Poussin to complain in a letter to the engraver, Abraham Bosse, that while he had drawn only the human figures in the original del Pozzo manuscript, all the geometrical drawings and awkward landscape backgrounds in the printed edition had been added without his knowledge. (Richter, *op. cit.*, I, pp. 8–10. For the history of the manuscripts, see *ibid.*, pp. 5–13, and R. Langton Douglas, *Leonardo da Vinci, his Life and Pictures,* Chicago, 1944, chap. IV.)

The heading "Paragone," i.e. comparison, is a modern title first used in *Trattato della pittura di L. da V.*, ed. G. Manzi, Rome, 1817.

[4] The tendency to underline the scientific aspect of painting

perience is mechanical, but that knowledge born and consummated in the mind is scientific, while knowledge born of science and culminating in manual work is semimechanical. But to me it seems that all sciences are vain and full of errors that are not born of experience, mother of all certainty, and that are not tested by experience, that is to say, that do not at their origin, middle, or end pass through any of the five senses. (For if we are doubtful about the certainty of things that pass through the senses, how much more should we question the many things against which these senses rebel, such as the nature of God and the soul and the like, about which there are endless disputes and controversies. And truly it so happens that where reason is not, its place is taken by clamour. This never occurs when things are certain. Therefore, where there are quarrels, there true science is not; because truth can only end one way—wherever it is known, controversy is silenced for all time, and should controversy nevertheless again arise, then our conclusions must have been uncertain and confused and not truth which is reborn.) All true sciences are the result of experience which has passed through our senses, thus silencing the tongues of litigants. Experience does not feed investigators on dreams, but always proceeds from accurately determined first principles, step by step in true sequences, to the end; as can be seen in the elements of mathematics founded on numbers and measures called arithmetic and geometry, which deal with discontinuous and continuous quantities with absolute truth. Here no one argues as to whether twice three is more or less than six or whether the angles of a triangle are less than two right angles. Here all argument is destroyed by eternal silence and these sciences can be enjoyed by their devotees in peace. This the deceptive purely speculative sciences cannot achieve. If you say that these true sciences that are founded on observation must be classed as mechanical because they do not accomplish their end, without manual work, I reply that all

was in accordance with the aims pursued by the leaders of the Renaissance in Florence. See Richter, *op. cit.*, I, pp. 23–30. Cf. also Blunt, *Theory*, chap. IV.

arts that pass through the hands of scribes are in the same position, for they are a kind of drawing which is a branch of painting.

Astronomy and the other sciences also entail manual operations although they have their beginning in the mind, like painting, which arises in the mind of the contemplator but cannot be accomplished without manual operation. The scientific and true principles of painting first determine what is a shaded object, what is direct shadow, what is cast shadow, and what is light, that is to say, darkness, light, colour, body, figure, position, distance, nearness, motion, and rest. These are understood by the mind alone and entail no manual operation; and they constitute the science of painting which remains in the mind of its contemplators; and from it is then born the actual creation, which is far superior in dignity to the contemplation or science which precedes it.

How Painting Embraces all the Surfaces of Bodies and Extends to These. (9). Painting extends only to the surface of bodies; perspective deals with the increase and decrease of bodies and of their colouring, because an object as it recedes from the eye loses in size and colour in proportion to the increase of distance.

Therefore painting is philosophy, because philosophy deals with the increase and decrease through motion as set forth in the above proposition; or we may reverse the statement and say that the object seen by the eye gains in size, importance, and colour as the space interposed between it and the eye which sees it diminishes.

Painting can be shown to be philosophy because it deals with the motion of bodies in the promptitude of their actions, and philosophy too deals with motion.

PAINTING AND POETRY. *The Difference Between Painting and Poetry.*[5] (24). Painting is poetry which is seen and not heard, and poetry is a painting which is heard but not seen. These two arts, you may call them both either poetry or painting, have here interchanged the senses by which they

[5] See Richter, *op. cit.*, I, pp. 31–52; Lee, "Ut Pictura Poesis"; and Blunt, *Theory*, pp. 51–53.

penetrate to the intellect. Whatever is painted must pass by the eye, which is the nobler sense, and whatever is poetry must pass through a less noble sense, namely, the ear, to the understanding. Therefore, let the painting be judged by a man born deaf, and the poem by one born blind. If in the painting the actions of the figures are in every case expressive to the purpose in their minds, the beholder, though born deaf, is sure to understand what is intended, but the listener born blind will never understand the things the poet describes which reflect honour on the poem, including such important parts as the indication of gestures, the compositions of the stories, the description of beautiful and delightful places with limpid waters through which the green bed of the stream can be seen, and the play of the waves rolling through meadows and over pebbles, mingling with blades of grass and with playful fishes, and similar subtle detail which may as well be addressed to a stone as to a man born blind who never in his life has seen what makes the beauty of the world, namely, light, shade, colour, body, figure, position, distance, nearness, motion, and rest—these ten ornaments of nature. But the deaf man who has lost a sense less noble, even though he may thereby be deprived of speech (for never having heard anybody talk he could not learn any language), will understand all the actions of the human body better than one who can speak and hear, and he will therefore be able to understand the works of painters and recognize the actions of their figures.

PAINTING AND MUSIC. *The Painter Measures the Distance of Things as they Recede from the Eye by Degrees just as the Musician Measures the Intervals of the Voices Heard by the Ear.* (34). Although objects observed by the eye touch one another as they recede, I shall nevertheless found my rule on a series of intervals measuring 20 *braccia*[6] each, just as the musician who, though his voices are united and strung together, has created intervals according to the distance from voice to voice, calling them unison, second,

[6] See p. 155, note 14.

third, fourth, and fifth, and so on, until names have been given to the various degrees of pitch proper to the human voice.

If you, oh musician, say that painting is a mechanical art because it is performed with the use of hands, you must admit that music is performed with the mouth which is also a human organ. And the mouth is not working in this case for the sense of taste, just as the hands while painting are not working for the sense of touch!

Words are of less account than performances. But you, oh writer on the sciences, do you not, like the painter, copy by hand that which is in the mind?

If you say that music is composed of proportion, then I have used similar meanings in painting, as I shall show.

SELECTIONS FROM THE ORIGINAL MANUSCRIPTS

PROLEGOMENA AND GENERAL INTRODUCTION TO THE BOOK ON PAINTING. *On the Sections of Painting.* (17). The first thing in painting is that the objects it represents should appear in relief, and that the grounds surrounding them at different distances should appear to extend (three dimensionally) right into the wall on which they are painted, with the help of the three branches of perspective, which are: the diminution of the forms of the objects; the diminution in their magnitude; and the diminution in their colour. And of these three classes of perspective the first results from [the structure of] the eye, while the other two are caused by the atmosphere which intervenes between the eye and the objects seen by it. The second essential in painting is appropriate action and a due variety in the figures, so that the men may not all look like brothers, etc.

LINEAR PERSPECTIVE.[7] (49). The boundaries of bodies

[7] Lorenzo Ghiberti (d. 1455) (p. 151), Leon Battista Alberti (d. 1472) (p. 203), and Piero della Francesca (d. 1492) (p. 253) had written before Leonardo on the subject of optics and perspective. The foundation of an exact science of perspective as applied to painting was laid in the three books entitled *De*

are the least of all things. The proposition is proved to be true, because the boundary of a thing is a surface, which is not part of the body contained within that surface; nor is it part of the air surrounding that body, but is the medium interposed between the air and the body, as is proved in its place. But the lateral boundaries of these bodies is the line forming the boundary of the surface, which line is of invisible thickness. Wherefore, O painter! do not surround your bodies with lines, and above all when representing objects smaller than nature; for not only will their external outlines become indistinct, but their parts will be invisible for distance.

(50). Perspective is a rational demonstration by which experience confirms that every object sends its image to the eye by a pyramid of lines; and bodies of equal size will result in a pyramid of larger or smaller size, according to the difference in their distance, one from the other. By a pyramid of lines I mean those which start from the surface and edges of bodies, and, converging from a distance meet in a single point. A point is said to be that which [having no dimensions] cannot be divided, and this point placed in the eye receives all the points of the cone.

SIX BOOKS ON LIGHT AND SHADE. *Introduction.* (111). [Having already treated of the nature of shadows and the way in which they are cast, I will now consider the places on which they fall; and their curvature, obliquity, flatness, or, in short, any character I may be able to detect in them.]

Shadow is the obstruction of light. Shadows appear to me to be of supreme importance in perspective, because

Prospectiva pingendi by Piero della Francesca, who was a sound mathematician besides being a great painter. Luca Pacioli, Piero's pupil and Leonardo's friend, reports that on hearing of this work Leonardo gave up his plan of preparing a book on this subject. Leon Battista Alberti treats of the "Pyramid of Sight" at some length in his first Book of Painting, but his explanation is not as scientific as Leonardo's. Both may have borrowed the broad lines of their theory from views commonly accepted among painters at the time; but Leonardo certainly worked out its application in a perfectly original manner. (Richter, *op. cit.*, I, p. 125. See also, W. Ivins, *On the Rationalization of Sight* [Metropolitan Museum Papers, no. 8], New York, 1938.)

without them opaque and solid bodies will be ill defined;
that which is contained within their outlines and their
boundaries themselves will be ill understood unless they are
shown against a background of a different tone from them-
selves. And therefore in my first proposition concerning
shadow I state that every opaque body is surrounded and
its whole surface enveloped in shadow and light. And on
this proposition I build up the first Book. Besides this,
shadows have in themselves various degrees of darkness, be-
cause they are caused by the absence of a variable amount
of the luminous rays; and these I call primary shadows be-
cause they are the first, and inseparable from the object to
which they belong. And on this I will found my second
Book. From these primary shadows there result certain
shaded rays which are diffused through the atmosphere,
and these vary in character according to that of the pri-
mary shadows whence they are derived. I shall therefore
call these shadows derived shadows because they are pro-
duced by other shadows; and the third Book will treat of
these. Again, these derived shadows, where they are inter-
cepted by various objects, produce effects as various as the
places where they are cast, and of this I will treat in the
fourth Book. And since all round the derived shadows,
where the derived shadows are intercepted, there is always
a space where the light falls and by reflected dispersion is
thrown back towards its cause, it meets the original shadow
and mingles with it and modifies it somewhat in its nature;
and on this I will compose my fifth Book. Besides this, in
the sixth Book I will investigate the many and various di-
versities of reflections of these rays which will modify the
original [shadow] by [imparting] some of the various
colours from the different objects whence these reflected
rays are derived. Again, the seventh Book will treat of the
various distances that may exist between the spot where
the reflected rays fall and that where they originate, and
the various shades of colour which they will acquire in fall-
ing on opaque bodies.

THEORY OF COLOURS. *Of Painting.* (278). Since white is
not a colour but the neutral recipient of every colour, when

it is seen in the open air and high up, all its shadows are bluish; and this is caused, according to the 4th [prop.], which says: the surface of every opaque body assumes the hue of the surrounding objects. Now this white [body] being deprived of the light of the sun by the interposition of some body between the sun and itself, all that portion of it which is exposed to the sun and atmosphere assumes the colour of the sun and atmosphere; the side on which the sun does not fall remains in shadow and assumes the hue of the atmosphere. And if this white object did not reflect the green of the fields all the way to the horizon nor get the brightness of the horizon itself, it would certainly appear simply of the same hue as the atmosphere.[8]

PERSPECTIVE OF COLOUR AND AERIAL PERSPECTIVE. *Of Aerial Perspective.* (295). There is another kind of perspective which I call Aerial Perspective, because by the atmosphere we are able to distinguish the variations in distance of different buildings, which appear placed on a single line; as, for instance when we see several buildings beyond a wall, all of which, as they appear above the top of the wall, look of the same size, while you wish to represent them in a picture as more remote one than another and to give the effect of a somewhat dense atmosphere. You know that in an atmosphere of equal density the remotest objects seen through it, as mountains, in consequence of the great quantity of atmosphere between your eye and them—appear blue and almost of the same hue as the atmosphere itself when the sun is in the East. Hence you must make the nearest building above the wall of its real colour, but make the more distant ones less defined and bluer. Those you wish to look farther away you must make proportionately bluer; thus, if one is to be five times as distant, make it five times bluer. And by this rule the buildings which above a [given] line appear of the same size will plainly be distinguished as to which are the more remote and which larger than the others.

(296). The medium lying between the eye and the object seen tinges that object with its colour, as the blueness

8 Cf. Alberti, pp. 207 f.

of the atmosphere makes the distant mountains appear blue and red glass makes objects seen beyond it look red. The light shed round them by the stars is obscured by the darkness of the night which lies between the eye and the radiant light of the stars.

(297). Take care that the perspective of colour does not disagree with the size of your objects, that is to say: that the colours diminish from their natural [vividness] in proportion as the objects at various distances diminish from their natural size.

THE PRACTICE OF PAINTING. *The Course of Instruction for an Artist.* (483). The youth should first learn perspective, then the proportions of objects. Then he may copy from some good master, to accustom himself to fine forms. Then from nature, to confirm the rules he has learnt. Then see for a time the works of various masters. Then get the habit of putting his art into practice and work.

A Way of Developing and Arousing the Mind to Various Inventions. (508). I cannot forbear to mention among these precepts a new device for study which, although it may seem but trivial and almost ludicrous, is nevertheless extremely useful in arousing the mind to various inventions. And this is, when you look at a wall spotted with stains, or with a mixture of stones, if you have to devise some scene, you may discover a resemblance to various landscapes, beautified with mountains, rivers, rocks, trees, plains, wide valleys and hills in varied arrangement; or, again, you may see battles and figures in action; or strange faces and costumes and an endless variety of objects, which you could reduce to complete and well-drawn forms. And these appear on such walls confusedly, like the sound of bells in whose jangle you may find any name or word you choose to imagine.

Of Selecting the Light which Gives Most Grace to Faces. (520). If you should have a courtyard that you can at pleasure cover with a linen awning that light will be good. Or when you want to take a portrait, do it in dull weather, or as evening falls, making the sitter stand with his back to

one of the walls of the courtyard. Note in the streets, as evening falls, the faces of the men and women, and when the weather is dull, what softness and delicacy you may perceive in them. Hence, O Painter! have a court arranged with the walls tinted black and a narrow roof projecting within the walls. It should be 10 *braccia* wide and 20 *braccia* long and 10 *braccia* high and covered with a linen awning when the sun is shining; or else paint a work towards evening or when it is cloudy or misty, and this is a perfect light.

How the Mirror is the Master (and Guide) of Painters. (529). When you want to see if your picture corresponds throughout with the objects you have drawn from nature, take a mirror and look in that at the reflection of the real things, and compare the reflected image with your picture, and consider whether the subject of the two images duly corresponds in both, particularly studying the mirror. You should take the mirror for your guide—that is to say a flat mirror—because on its surface the objects appear in many respects as in a painting. Thus you see, a painting done on a flat surface displays objects which appear in relief, and the mirror—on its flat surface—does the same. The picture has one plane surface and the same with the mirror. The picture is intangible, in so far as that which appears round and prominent cannot be grasped in the hands; and it is the same with the mirror. And since you can see that the mirror, by means of outlines, shadows, and lights, makes objects appear in relief, you, who have in your colours far stronger lights and shades than those in the mirror, can certainly, if you understand how to put them together well, make also your picture look like a natural scene reflected in a large mirror.

PHILOSOPHY AND HISTORY OF THE ART OF PAINTING. *He who Despises Painting Loves Neither Philosophy nor Nature.* (652). If you despise painting, which is the sole imitator of all visible works of nature, you will certainly despise a subtle invention which brings philosophy and subtle speculation to the consideration of the nature of all forms—the sky and the land, plants, animals, grass, and flowers—which

are surrounded by shade and light. And truly this is a science and the legitimate issue of nature; for painting is born of nature—or, to speak more correctly, we shall call it the grandchild of nature; for all visible things were brought forth by nature, and these her children have given birth to painting. Hence we may justly call it the grandchild of nature and related to God.

That Sculpture is Less Intellectual than Painting, and Lacks Many Characteristics of Nature.[9] (655). I myself, having exercised myself no less in sculpture than in painting and doing both one and the other in the same degree, it seems to me that I can, without invidiousness, pronounce an opinion as to which of the two is of the greatest skill and difficulty and perfection. In the first place sculpture requires a certain light, that is, from above; a picture carries everywhere with it its own light and shade. Thus light and shade are essential to sculpture, and the sculptor is aided in this by the nature of the relief which produces these of its own accord, while the painter artificially creates them by his art in the places where nature would normally produce them. The sculptor cannot diversify his work by the various natural colours of objects; painting is not defective in any particular. The sculptor when he uses perspective cannot make it in any way appear true; that of the painter can appear like a hundred miles beyond the picture itself. Their works have no aerial perspective whatever, they cannot represent transparent bodies, they cannot represent luminous bodies, nor reflected lights, nor lustrous bodies, as mirrors and the like polished surfaces, nor mists, nor dark skies, nor an infinite number of things which need not be told for fear of tedium. That which it has in advance is that it resists time better, but a picture painted on thick copper covered with white enamel on which it is painted with enamel colours and then put into the fire again and baked, exceeds sculpture in permanence. It may be said that if a mistake is made it is not easy to remedy it. This is but a poor argument to try to prove that a work be the nobler because errors are irremediable; I should rather say that it

[9] See Richter, *op. cit.*, pp. 82–90.

will be more difficult to mend the mind of the master who makes such mistakes than to mend the work he has spoilt.

That Painting Declines and Deteriorates from Age to Age, When Painters have no other Standard than Painting Already Done. (660). Hence the painter will produce pictures of small merit if he takes for his standard the pictures of others, but if he will study from natural objects he will bear good fruit. As was seen in the painters after the Romans who always imitated each other and so their art constantly declined from age to age. After these came Giotto, the Florentine, who—not content with imitating the works of Cimabue, his master—being born in the mountains and in a solitude inhabited only by goats and such beasts, and being guided by nature to his art, began by drawing on the rocks the movements of the goats of which he was keeper. And thus he began to draw all the animals which were to be found in the country, and in such wise that after much study he excelled not only all the masters of his time but all those of many bygone ages. Afterwards this art declined again, because every one imitated the pictures that were already done; thus it went on from century to century until Tomaso, of Florence, nicknamed Masaccio, showed by his perfect works how those who take for their standard any one but nature—the mistress of all masters—weary themselves in vain. And I would say about these mathematical studies that those who only study the authorities and not the works of nature are descendants but not sons of nature, the mistress of all good authors. Oh! how great is the folly of those who blame those who learn from nature, setting aside the authorities who were disciples of nature.

ANATOMY[10]

A GENERAL INTRODUCTION. (796). The mental matters which have not passed through the sense are vain, and they

[10] According to Vasari, Leonardo studied with Marc Antonio della Torre, the learned anatomist who taught at the universities of Padua and of Pavia (1511). The dissection of dead human bodies for purposes of medical research was practiced in Italy

produce no other truth than the injurious one; and as such discourses spring from poverty of genius, such discoursers are always poor, and if they are born rich they shall die poor in their old age; because it seems that nature revenges itself on those who wish to work miracles that they shall possess less than other more quiet men; and those who want to grow rich in a day live for a long time in great poverty, as always happens, and to all eternity will happen, to alchemists, the would-be creators of gold and silver, and to engineers who would have dead water stir itself into life and perpetual motion, and to those supreme fools, the necromancer and the enchanter.

And you, who say that it would be better to watch an anatomist at work than to see these drawings, you would be right, if it were possible to observe all the things which are demonstrated in such drawings in a single figure, in which you, with all your cleverness, will not see nor obtain knowledge of more than some few veins, to obtain a true and perfect knowledge of which I have dissected more than ten human bodies, destroying all the other members, and removing the very minutest particles of the flesh by which these veins are surrounded, without causing them to bleed, excepting the insensible bleeding of the capillary veins; and as one single body would not last so long, since it was necessary to proceed with several bodies by degrees, until I came to an end and had a complete knowledge; this I repeated twice, to learn the differences.

And if you should have a love for such things you might be prevented by loathing, and if that did not prevent you, you might be deterred by the fear of living in the night hours in the company of those corpses, quartered and flayed and horrible to see. And if this did not prevent you, perhaps you might not be able to draw so well as is necessary for such a demonstration; or if you had the skill in drawing, it might not be combined with knowledge of perspective; and if it were so, you might not understand the methods of geometrical demonstration and the method of

from the thirteenth century. The dissection of corpses was permitted by the Church but a brief was required (Richter, *op. cit.*, ii, pp. 83–84).

the calculation of forces and of the strength of the muscles; patience also may be wanting, so that you lack perseverance. As to whether all these things were found in me or not, the hundred and twenty books composed by me will give verdict. Yes or No. In these I have been hindered neither by avarice nor negligence, but simply by want of time. Farewell.

PHILOSOPHICAL MAXIMS

(1133). Thou, O God, dost sell us all good things at the price of labour.

(1140). And you, O Man, who will discern in this work of mine the wonderful works of Nature, if you think it would be a criminal thing to destroy it, reflect how much more criminal it is to take the life of a man; and if this, his external form appears to thee marvellously constructed, remember that it is nothing as compared with the soul that dwells in that structure; for that, indeed, be it what it may, is a thing divine. Leave it then to dwell in its work at its good will and pleasure, and let not your rage or malice destroy a life—for indeed, he who does not value it, does not himself deserve it.

MORALS

(1162). Now you see that the hope and the desire of returning to the first state of chaos is like the moth to the light, and that the man who with constant longing awaits with joy each new springtime, each new summer, each new month and new year—deeming that the things he longs for are ever too late in coming—does not perceive that he is longing for his own destruction. But this desire is the very quintessence, the spirit of the elements, which finding itself imprisoned with the soul is ever longing to return from the human body to its giver. And you must know that this same longing is that quintessence, inseparable from nature, and that man is the image of the world.

A REPORT TO POPE LEO X ON
ANCIENT ROME

[This report to Pope Leo X (1513–1521) on the condition of the Roman monuments and ruins in the Eternal City at the time has been assigned for want of specific evidence of authorship to Bramante, Raphael, Baldassare Castiglione and others. Raphael (1483–1520), prominent among the artists at the papal court of Julius II, became, with the election of Giovanni de' Medici, second son of Lorenzo the Magnificent, to the papacy, the dominant figure at the Vatican court concerned with the varying interests of the Pope. He was in charge of the great fresco series to decorate the palace, executing himself the *Camera della Segnatura,* and succeeded Bramante (†1514) as the architect of St. Peter's. However, his few remaining letters show him to have been inept at expressing himself in writing.

Baldassare Castiglione (1478–1529), the envoy of Guido Montfeltro, Duke of Urbino, at the Vatican, known best as the author of *Il Cortegiano (The Courtier),* describing the qualities possessed by the Italian gentleman of the Renaissance, was a distinguished man of letters. In the Castiglione family library has been found a draft of the report to the Pope in Baldassare's writing, containing personal idiosyncrasies of punctuation and elements of his Mantovan dialect. As Raphael and Baldassare were intimate friends, it is possible Baldassare wrote the report in collaboration with Raphael.]

A REPORT TO THE POPE ON ANCIENT ROME[1]

There are many men, Most Holy Father, who, since they measure with their own feeble judgement the great things written of the Romans—of their arms, their city of Rome with its wonderful art, riches, ornament and the grandeur

[1] Translated from text given in J. Vogel, *Bramante e Raffaello,* Kunstwissenschriftliche Studien IV, Leipzig, 1910, and V. Golzio, *Raffaello, nei documenti e nelle testimonianze dei contemporanei e nella letteratura del suo secolo,* Pontificio Accademia Artistica

of its buildings—believe these things to be more fable than truth.

But to me it has seemed, and does still seem, otherwise.

For, if one considers what may still be seen amid the ruins of Rome, and what divine gifts there dwelt in the hearts of the men of ancient times, it does not seem unreasonable to believe that many things which to us would appear to be impossible were simple for them. Now I have given much study to these ancient edifices: I have taken no small effort to look them over with care and to measure them with diligence. I have read the best authors of that age and compared what they had written with the works which they described, and I can therefore say that I have acquired at least some knowledge of the ancient architecture.

On the one hand, this knowledge of so many excellent things has given me the greatest pleasure: on the other hand the greatest grief. For I behold this noble city, which was the queen of the world, so wretchedly wounded as to be almost a corpse. Therefore I feel, as every man must feel, pity for his kindred and for his country. I feel constrained to use every part of my poor strength to bring to life some likeness, or even a shade of that which once was the true and universal fatherland of all Christians. For Rome was so noble and so powerful that men believed her to be, alone under the heavens, above all fortune and beyond nature, exempt from death and destined to endure forever. It seemed that time, jealous of the glories of men and not wholly trusting to her own powers for their destruction, allied herself with the fortunes of the heathen and iniquitous barbarians who added sword and fire to the sharp file and the poisonous teeth of the chisel. So the famous works which now more than ever should appear in the flower of their beauty, were burned and destroyed by the brutal rage and savage passions of men wicked as the wild beasts. Yet not completely so, for there still remains to us the skeleton of those things, though without their ornament—the bones

dei Virtuosi al Pantheon, Vatican City, 1936. See also V. Cian, "Nel Mondo di Baldassare Castiglioni," *Archivo Storico Lombardo*, Nuova Serie, Milan, 1942.

of the body without the flesh, one might say. And why should we bewail the Goths, the Vandals, and other perfidious enemies of the Latin name, when those who above all others should be fathers and guardians in the defence of the poor relics of Rome, have even given themselves over to the study—long study—of how these might be destroyed and disappear. How many Pontiffs, Holy Father, who held the same office as yourself, though without the same knowledge, the same valour or greatness of soul—how many, I say, of these Pontiffs have permitted the ruin and defacement of the ancient temples, of statues and arches and other edifices that were the glory of their builders? How many allowed the very foundations to be undermined that pozzolana might be dug from them, so that, in but a little time, the buildings fell to the ground? How much lime has been burned from the statues and ornaments of ancient time? I am bold to ask how much of all this new Rome that we see today, however great, however beautiful, however adorned with palaces and churches and other buildings has been built with lime made from ancient marbles? Nor can I remember without grief that during the time I have spent in Rome—not yet twelve years—so many beautiful things have been ruined: as, for example, the Meta that was in the Via Alexandrina; the arch at the entrance to the Baths of Diocletian; the Temple of Ceres on the Sacred Way; a part of the Forum Transitorium burned and destroyed only a few days ago and lime made from its marbles; and the greater part of the Basilica of the Forum, ruined. Besides all these, how many columns have been broken and cracked in two, how many architraves and beautiful friezes shattered? It is the infamy of our time that we have suffered these things, of which it can truly be said that by comparison with what has been done today Hannibal would appear to have been a pious[2] man. Therefore, O Holy Father, let it not be last in the thought of Your Holiness to have a care that the little which remains of the ancient mother of glory and of the Italian name, witness of the divine spirits whose

[2] Or: "that neither Hannibal nor any other did more." N.B. *pio* appears in the dictionary as an old form of *piu.*

memory even today creates and moves us to virtue—spirits still alive among us—should not be altogether wiped out by the depredations of the evil and the ignorant. These, unhappily, do hurt to those souls who of their own blood brought forth so much glory for the world, for our country and for ourselves. May Your Holiness, while keeping the example of the ancient world still alive among us, hasten to equal and to surpass the men of ancient days, as you even now do, by setting up magnificent buildings, by sustaining and encouraging the virtuous, by fostering talent, by rewarding all noble effort—thus sowing the fruitful seeds among the Christian princes. For, as by the calamities of war are brought to birth the destruction and the ruin of the arts and sciences, so from peace and concord are born the happiness of men and that highly-prized serenity of spirit that may imbue us with strength to accomplish work reaching to the heights of achievement. Because of the divine wisdom and authority of Your Holiness this has become the hope of every man of our century. And this is truly to be the merciful Shepherd, yes, the greatest Father of the world.

But to go back to what I have already said: Your Holiness has commanded me to make a drawing of ancient Rome[3] —as much as may be known from what can be seen today— with those buildings showing so much of what remains that, with careful study, you may know exactly what they were. Those that are completely ruined and no longer visible may be understood by the study of those that still stand and can be seen. To this end I have tried to use every skill of mine, so that the mind of Your Holiness and those others who shall profit by our effort shall no longer be left in ignorance, but enjoy the fruits of our work. I have studied in many Latin authors these things that I mean to set forth, but among all these I have chiefly followed P. Victore, since he was one of the latest of them all, and can give more particular information on the works of that time, while not neglecting the older ones. In his writings he identifies the

[3] The literary evidence that Raphael made such a drawing is given by Vincenzo Golzio, *op. cit.*

different regions by means of some of the ancient marbles he also describes.

To some it might seem difficult to distinguish the ancient from the modern buildings, or the most ancient from those of lesser age. To leave no doubt in the minds of those who wish to have such knowledge I would say that with a little effort one may attain to it. For there are only three styles of building to be found in Rome: the first is that of the good antique, which lasted from the first Emperors until the time when Rome was ruined and despoiled by the Goths and other barbarians; the second is what prevailed from that time until the Gothic domination of Rome and for one hundred years afterwards; the third is from that age until our own. The modern buildings are easily known, not only because they are new but also because they are not of such excellent workmanship, nor are they built at such a great cost as that of the ancient edifices that we see and admire. For although in our own day architecture is active and approaches very nearly to the antique style, as may be seen in many beautiful buildings of Bramante, the ornamentation nevertheless is not made of such precious material as that used by the men of ancient times, who spent an immense amount to realize what they had imagined, and by the strength of their will overcame every difficulty. The buildings of the time of the Goths, however, are so wholly without grace or of any style whatsoever that they are unlike both ancient and modern. It is therefore not difficult to recognize the buildings of the period of the Emperors, which are more excellent in style and built more perfectly, at greater expense and with more art than all the others. It is only of the work of this period that I wish to speak. There is no need for any man to question whether the less ancient of this era are lesser in beauty, less well conceived or of a different style. For they were all built in the same manner of beauty. And although many of the buildings were often restored by the men of that age, as we may read that in the same place where the Golden House of Nero had stood the Baths of Titus and his House and the Amphitheatre were built, nevertheless these were constructed in the same style and manner as the other edifices of a time

still older than the time of Nero and contemporary with the Golden House. For although literature, sculpture, painting and almost every art were long in decline and deteriorated until the time of the last Emperors, architecture alone observed and maintained the same principles, and building was carried on in the same manner of greatness and dignity as before. Of all the arts, architecture was the last to decline. This may be learned from many things, and among others from the Arch of Constantine, which is beautiful and well conceived from an architectural point of view. But the sculptures on the same arch are very tasteless, without art or good design, though the fragments from the time of Trajan and of Antoninus Pius are excellent and of the purest style. The same thing may be seen in the Baths of Diocletian, where the sculptures of his own time are mediocre and poorly executed and the remains of painting to be seen there cannot be compared with those of the time of Trajan or Titus. Yet the architecture itself is noble and well-conceived.

In the days when Rome was ruined, burned and destroyed by the barbarians, it seems that by this same fire and tragic ruin of the monuments the art that had known how to erect them was ruined with them. The fortunes of Rome were then so changed that in the place of limitless victories and triumphs came the humiliations and wretchedness of servitude. It appeared unfitting for those who were conquered and in bondage to live in the grand manner that they had known when they were the conquerors of the barbarian. And with the change of fortune came at the same time a change in the manner of living and building, as far distant from what they had known as servitude is from freedom. Men were reduced to a life suited to their misery, without art. They became so ignorant they no longer even knew how to make baked bricks or any other kind of ornament. They stripped the ancient walls to obtain bricks, broke marble into little squares, and with a mixture of these squares and the bricks they built their walls, as we may see today in the tower called the Tower of the Militia. So, for a goodly space of time, they continued in their ignorance, as is shown by all the work of the age. The cruel and

atrocious storm of war and destruction broke not only over
Italy but spread also over Greece, where once the inventors
and perfect masters of all the arts had prevailed, and there
also the worst and most worthless style of painting and
sculpture came into being. Next, in almost every country,
the German style of architecture appeared—a style which
as one can see by its ornament, is far removed from the
good manner of the Romans and the antique. In the Roman
period, aside from the structure of the building itself, there
may be seen the most beautiful cornices, friezes and archi-
traves, columns, capitals and bases, decorations of a perfect
and most pure style. German architecture, which in many
places still persists, often used cramped and poorly con-
structed small figures for ornament, and, worse still, strange
animals, figures and leaves out of all reason, as corbels to
support a beam. Nevertheless, this architecture had a cer-
tain justification: it originated by the taking of branches of
unpruned trees, binding them together and bending them
to construct pointed arches. Although this invention is not
wholly to be despised, it is weak, because the huts de-
scribed by Vitruvius in his account of the origin of the Doric
order, in which tree trunks chained together serve as col-
umns, and with their tops and roofs, can support a far
greater weight than the pointed arch, which has two
thrusts. Moreover, a half circle, whose every line presses
toward a single centre, can, according to mathematical
rules, bear a much greater load. Aside from the weakness
of a pointed arch, it lacks the grace of our style, which is
pleasing to the eye because of the perfection of a circle. It
may be observed that nature herself strives for no other
form. But it is unnecessary to compare Roman architecture
with that of the barbarians, for the difference is well known;
nor is it necessary to speak in detail of the Roman style
since it has been so admirably described by Vitruvius. It
is enough to know that Roman building, down to the time
of the last Emperors, was always constructed in a good
architectural style and therefore harmonized with the older
work. There is no difficulty in distinguishing the Roman
buildings from those of the times of the Goths, or even from
those of later times, because the two are the extreme op-

posite of each other. Nor is it difficult to distinguish them from those of our own modern age, even if it were not for the novelty which makes them noticeable.

I have now spoken enough of the ancient buildings of Rome to show that it was of these that I wished to speak, and also to make plain how easy it is to distinguish them from the others. It remains now for me to teach the method by which we have tried to measure and draw them, so that anyone who himself wishes to devote himself to architecture may learn by this method to execute both processes without error.

It is right to know that in the description of this method we have not been governed by chance, or by experience only, but by following a well thought-out plan. I have never heard or read that the men of ancient times knew of the method used by us of measuring with the magnetic compass, and I therefore believe it to be a modern invention. However, it seems wise to expound it in detail, to one who is not acquainted with it.

A round flat instrument, like an astrolabe,[4] should be constructed, about two hand-spans in diameter, or as much larger or smaller as the user may wish. The circumference of the instrument should be divided into eight equal parts, and in each part should be written the name of one of the eight winds. . . .

. . . If, wishing in every way to obey, I have been fortunate enough to serve Your Holiness, first and Supreme Prince of all Christian lands, I may call myself the most happy of all Your devoted servants. So I pray rightly to value this opportunity of placing my work in the holy hands of Your Holiness, whose most sacred feet I humbly kiss.

[4] A graduated circle, with sights for taking altitudes at sea, is illustrated in our *fig.* 20. It is now superseded by the quadrant and sextant. As the confusion in the description of the instrument and its employment makes it difficult to comprehend its use, it is omitted.

CONTRACT OF ENGUERRAND QUARTON
WITH DOMINUS JEAN DE MONTAGNAC

[This contract between the painter, Enguerrand Quarton, and Jean de Montagnac is for painting an altarpiece to contain the items listed. The resulting picture known as the "Coronation of the Virgin" was ascribed to various artists of the fifteenth century until the discovery of the contract in 1870 documented the date and the artist and also the iconographical stipulations. The contract is unique as it was apparently written jointly by Jean de Montagnac, a priest well versed in theology and the artist who was likewise well informed. Although the subject matter and the iconographical program are defined with meticulous care, the painter is allowed considerable freedom in completing the individual items. He took this liberty also to the benefit of the compositional structure of the painting, as a comparison of the items found in the picture with those listed in the contract shows.

Nothing is known of the donor other than that he was a priest at the Charteuse du Val de Bénédictione at Villeneuve-les-Avignon. He may be the figure in the Carthusian habit kneeling beside the tomb of the Virgin on the right side of the picture.

In the contract, Enguerrand Quarton is named a native of the diocese of Laon, and there are traces of Picardian dialect in the text. He must have been born about 1410. Documents found in the Provence show he was living in Aix in February 1444 and in Arles in February 1446. On the nineteenth of August, 1447, he rented a house on the Place de Saint Pierre in Avignon and remained in that city until 1466.

The painting remained in the church of the Charteuse du Val de Bénédictione until 1835, when it was transferred to the Hospice, now used as a museum.]

CONTRACT FOR PAINTING AN ALTARPIECE FOR DOMINUS JEAN DE MONTAGNAC, PRIEST[1]

On the 25th day of April [1453], Master Enguerrand Quarton, of the diocese of Laon, painter, resident in Avignon, made a contract and agreement with the said Dominus Jean de Montagnac—both contracting parties being present—for painting an altarpiece according to the manner, form, and prescription contained and set forth article by article on a sheet of paper, which they passed over to me, written in French, whose tenor follows and is such:

Here follows the list of items of the altarpiece[2] that Messer Jean de Montagnac has commissioned from Master Enguerrand, painter, to be placed in the church of the Carthusians, Villeneuve-les-Avignon, on the altar of the Holy City.

First: There should be the form of Paradise, and in that Paradise should be the Holy Trinity, and there should not be any difference between the Father and the Son; and the Holy Ghost in the form of a dove; and Our Lady in front as it will seem best to Master Enguerrand; the Holy Trinity will place the crown on the head of Our Lady.[3]

Item: The vestments should be very rich; those of Our Lady should be white-figured damask according to the judgement of said Master Enguerrand; and surrounding the Holy Trinity should be cherubim and seraphim.

Item: At the side of Our Lady should be the Angel Gabriel with a certain number of angels, and on the other side, Saint Michael, also with a certain

[1] The text and footnotes are translated from Charles Sterling, *Le Couronnement del Vierge par Enguerrand Quarton,* Chefs d'Oeuvre des Primitifs Francais, Paris, 1939. (See our *fig. 23.*)

[2] The dimensions of the altarpiece are 1.83 m. x 2.20 m.

[3] This iconographical stipulation is specifically French. The composition has certain relationship to tympanums of the cathedrals. See H. Focillon, *Mediaeval Studies in Memory of Kingsley Porter,* Vol. II, 1939, p. 464.

number of angels, as it will seem best to Master Enguerrand.

Item: On the other side, Saint John the Baptist with other patriarchs and prophets according to the judgement of Master Enguerrand.

Item: On the right[4] side should be Saint Peter and Saint Paul with a certain number of other apostles.

Item: Beside Saint Peter should be a martyr pope over whose head an angel holds a tiara,[5] together with Saint Stephen and Saint Lawerance in the habits of cardinal deacons, also with other martyr saints as arranged by the said Master.

Item: At the side of Saint John the Baptist will be the Confessors. Saint Gregory is to be recognized in the form of a pope as above and two cardinals, one old and one young, and Saint Agricol and Saint Hugh Bishop (Saint Hugh in the habit of a Carthusian), and other saints according to the judgement of said Master Enguerrand.

Item: On the side of Saint Peter should be Saint Catherine with certain other virgins according to the judgement of Master Enguerrand.

Item: The side of Saint John the Baptist, Magdalene, and the two Marys, Jacob and Salome, each of which holds in her hands that which they should hold,[6] together with other widows according to the judgement of said Master Enguerrand.

Item: In paradise below should be all the estates of the world arranged by said Master Enguerrand.

Item: Below the said paradise, there should be the heavens in which will be the sun and the moon according to the judgement of said Master Enguerrand.

Item: After the heavens, the world in which should be shown a part of the city of Rome.

Item: On the side of the setting sun should be the form of the church of Saint Peter of Rome, and, be-

[4] To the right of the spectator, not to the right of the divinity.
[5] The angel placing the tiara is omitted in the picture.
[6] Meaning her attributes.

fore said church at an exit, one cone of pine in copper,[7] and from that one descends a large stairway to a large square leading to the bridge of Sant' Angelo.

Item: At the left side of the above-mentioned, a part of the walls of Rome, and on the other side are houses and shops of all types; at the end of said square is the castle Sant' Angelo and a bridge over the Tiber which goes into the city of Rome.

Item: In said city are many churches, among these is the church of the Holy Cross of Jerusalem where Saint Gregory[8] celebrated mass and there appeared to him Our Lord in the form of Pitie; in which church will be painted the story according to the arrangement of said Master Enguerrand; in that story will be Saint Hugh, the Carthusian, assisting said Saint Gregory with other prelates according to the judgement of said Master Enguerrand.

Item: Outside Rome, the Tiber will be shown entering the sea, and on the sea will be a certain number of galleys and ships.

Item: On the other side of the sea, will be a part of Jerusalem; first, the Mount of Olives where will be the cross of Our Lord, and at the foot of that will be a praying Carthusian, and at a little distance will be the tomb of My Lord and an angel below saying: *He has risen: He is not here: Behold the place where they have laid Him.*

Item: At the foot of said tomb will be two praying figures; on the right side, the valley of Jehoshaphet between the mountains, in that valley, a church where the tomb of Our Lady is, and an angel say-

[7] [For a description of the pine cone in copper, see The Marvels of the City of Rome, p. 72.]

[8] St. Gregory is said to have received the promise that through prayers the suffering of those in purgatory could be shortened or ended. The image of Christ, the Man of Sorrows, was very popular in the fifteenth century as the number of graphic prints of it show.

ing: *Mary has been taken up to a heavenly chamber, in which the King of Kings sits on a star-studded throne;* and at the foot of that tomb a person praying.

Item: On the left side will be a valley in which will be three persons all of one age,[9] from all three will come rays of sun, and there will be Abraham coming forth from his tabernacle and adoring the said three persons saying: *Lord, if I have found favor in thine eyes, pass not thy servant by: Sit, I shall fetch a little water, and your feet will be washed.*[10]

Item: On the second mountain will be Moses with his sheep and a young boy carrying a bag; and there appears to said Moses, Our Lord in the form of fire in the middle of a bush and Our Lord will say: *Moses, Moses,* and Moses will reply: *Here am I.*

Item: On the right part will be Purgatory where the angels lead those joyous on seeing that they will go to Paradise from those the devils lead in great sadness.

Item: On the left side will be Hell, and between Purgatory and Hell will be a mountain, and from the part of Purgatory below the mountain will be an angel comforting the souls of Purgatory; and from the part of Hell will be a very disfigured devil turning his back to the angel and throwing certain souls into Hell, given him by other devils.

Item: In Purgatory and Hell will be all the estates according to the judgement of said Master Enguerrand.

Item: Said altarpiece shall be made in fine oil colors and the blue should be fine blue of Acre,[11] except that which will be put on the frame, that should be fine German blue, and the gold that will be used on the

[9] This whole item is omitted.
[10] The inscription is shortened.
[11] From the city of St. John d'Acre, to signify blue ultramarine.

frame as well as around the altarpiece should be
fine gold and burnished.[12]

Item: Said Master Enguerrand will show all his knowl-
edge and skill in the Holy Trinity and in the
Blessed Virgin Mary, and will be governed by his
conscience.

Item: On the back of the altarpiece will be painted a
cloth of cream damask figures with fleur-de-lis.[13]

A promise was given, I declare, by the same Master
Enguerrand to execute these things faithfully and accord-
ing to the foregoing description, from the next [feast of] St.
Michael, for the next one continuous year, for the price of
one hundred and twenty florins, each at the value of
XXIIII *sous* of the currency at Avignon. Towards the re-
duction of which sum of florins the said painter has ac-
knowledged that he has had from the said Dominus Jean
forty florins current, concerning which the same painter has
expressed his satisfaction, and made the said Dominus Jean
quit of them. . . . The remaining sum the said Dominus
Jean has promised to pay to the same Master Enguerrand
as follows, viz.: twenty florins when the same painter shall
have done a half of the said work; likewise, forty florins ac-
cording to the work he does and in proportion to the work
itself [i.e., the whole work]; and the remaining twenty
florins immediately when the said work shall have been
completed and placed in the said Carthusian church; and
the said Jean has promised that he will arrange with the
prior and community of the Carthusians that they will be
liable to the said Master Enguerrand for the said remainder
in the case of a failure on the part of Jean himself. . . .

Done in the spice shop in the dwelling of Jean de Bria,
spice merchant, citizen of Avignon, in the presence of . . .

[12] The painting is in egg tempera. Probably oil tempera was
used as in Jan van Eyck's painting, a type of glaze difficult to
determine today.

[13] There is no trace of paint on the back of the picture. It
should be thought of as a type of canopy fixed at the top of the
altarpiece.

PHILIP THE GOOD,
DUKE OF BURGUNDY

[Philip the Good (1396–1467), the son of John the Fearless and Margaret of Bavaria, succeeded his father, after the latter's assassination in 1419, as Duke of Burgundy. Through the marriage of his grandfather to Margaret of Flanders, the Courtship of Flanders was joined to that of Burgundy. For the administration of the domains, an audit office was established at Lille and another at Dijon in 1386. These were maintained as the following letters show. Philip the Good, one of the richest and most powerful princes of the Western world in the fifteenth century, was a generous patron of letters and the arts. His interest and liberality encouraged the development of the Netherlands school of painting.]

LETTERS[1]

Jan van Eyck, former painter and equerry of the late Lord John,[2] Duke of Bavaria, was known for his ability and craftsmanship by my said lord[3] who had heard thereof from several of his people and which he knew to be true, being acquainted personally with the said Jan van Eyck. Confident of his loyalty and probity, my lord has retained said Jan as his painter and equerry, with the customary honors, prerogatives, franchises, liberties, rights, profits and usual emoluments[4] pertaining to this position. And to the

[1] Translated from the texts as given by W. H. J. Weale, *Hubert and John van Eyck,* London, 1908, pp. xxx–xxxi, xlii–xliii. See also E. Panofsky, *The Early Netherlandish Painting,* Cambridge, Mass., 1953. Jan van Eyck (1400?–1441), who with his older brother, Hubert, was the founder of the Netherlands school of painting.

[2] John of Bavaria, the Pitiless Prince, unconsecrated Bishop of Liége, Count of Holland and Zeeland, died in 1425. He had employed Jan in the palace at The Hague.

[3] Philip the Good.

[4] Probably room and lodging when at court, exemption from all taxes, and when traveling with the court two horses and one liveried servant.

end that he shall be held to work for him in painting whenever it pleases him, my lord has ordered him to have and to take on his general receipt from Flanders, the sum of 100 parisis[5] in Flemish money in two settlements yearly, half at Christmas and the other half at Saint John's, of which he wishes the first payment to be at Christmas 1425 and the other at Saint John's, and so from year to year and payment to payment, as long as it shall please him. Ordering to the masters of his household and his other officers that all his present honors, rights, prerogatives, profits and emoluments above mentioned they shall make and allow the said Jan to enjoy peaceably without prevention or disturbance; in addition ordering to his said receiver general of Flanders, present and future, that he shall pay, give and deliver every year the said sum of 100 Parisian pounds per year on the above declared terms to the said Jan, his painter and equerry, so all that is said on these matters may appear more plainly in the letters patent of my beforementioned lord, given in his city of Bruges, the 19th day of May in the year 1425. By virtue of that attestation is briefly given here to make payment for the term of Christmas 1425, and that which will follow to make a payment of 50 pounds on his quittance.

For the terms of St. John and Christmas 1426 together is made payment of 100 pounds on his quittance.

To our beloved and faithful keepers of our accounts at Lille.[6]

Very dear and beloved,—we have heard that you do not readily verify certain of our letters granting life pension to our well beloved equerry and painter, Jan van Eyck, whereby he cannot be paid said pension; and for this reason, he will find it necessary to leave our service, which would cause us great displeasure, for we would retain him for certain great works with which we intend henceforth to

[5] 100 £ parisis equals about $300.

[6] Philip granted, in lieu of the salary of 100 £ parisis, a life pension equal to 4,320 £ parisis with no apparent reason for this great increase. His accountants at Lille declined to register the letters patent.

occupy him and we would not find his like more to our taste, one so excellent in his art and science. Therefore, we desire and expressly order that, according to these wishes, you do verify and ratify our said letters of pension and have this pension paid to the said Jan van Eyck, all according to the content of our said letters with no further talk or argument from you nor any omission, change, variation, or difficulty, as much as you would not anger and disobey [us].

For once and for all do so much so that we have no further need to write. This we would only do with great displeasure.

Very dear and well beloved, may the Holy Spirit have you in his Holy care. Written in our city of Dijon, the xii day of March, 1433.

ALBRECHT DÜRER

[Albrecht Dürer (1471–1528), the son of a goldsmith who had immigrated from Hungary, was born in Nürnberg, the great wealth of which, accumulated in the fourteenth and fifteenth centuries, contributed to its rise as an intellectual center of Germany. When Dürer was fifteen his father apprenticed him for three years to Michael Wolgemut, in whose workshop paintings, sculpture and woodcuts for book illustrations were produced.

After completing his apprenticeship in 1490, Dürer went for his *Wanderjahre*. Travelling for a year throughout Germany and possibly visiting Holland, he then went to Colmar to study with the greatest engraver in Europe, Martin Schongauer. As Schongauer had died some months before Dürer arrived, he went on to Basel, a center of book-printing where woodblock cutters for book illustrations were in demand. After a year's work there, he travelled to Strassburg, another publishing center. In 1494 he returned to Nürnberg to be married. The same year he made a short trip to Venice and on his return, in 1495, he established his workshop.

One of the first works to bring him fame was the *Apocalypse,* a series of fifteen woodcuts published in 1498, illustrating the last book of the New Testament. In the same year he finished some woodcuts for the *Large Passion,* depicting scenes from the Passion of Christ. *The Life of the Virgin,* another famous series, was begun somewhat later, but like the *Large Passion,* it was not completed until 1511. In 1511 and 1513 Dürer published two more series portraying the Passion of Christ; one, consisting of smaller woodcuts than the first, is called the *Small Passion,* and, as the other is engraved, it is referred to as the *Engraved Passion.* Dürer's woodcuts and engravings, sold throughout Europe, were exceedingly popular and established Dürer's fame. While the graphic media were most congenial to him and his productivity was greatest in these media, Dürer was also a great painter; and the German Renaissance found its first clear expression in his portraits and altarpieces.

In 1505, Dürer went to Venice again, and while he was there painted the famous *Feast of the Rose Garlands* for the German merchants' Chapel. Although the city of Venice offered to retain him as a city painter, he returned to Nürnberg in 1507, and took his place in a circle of friends who belonged to the leaders of the Renaissance movement in Germany. In 1520, Dürer, accompanied by his wife and her maid, went to Antwerp for a year.

As a result of his second Italian trip and his own studies, Dürer became interested in the field of art theory. Originally (prior to 1512–1513), he planned to write a general treatise on painting, but set down only three programmatic outlines, one more comprehensive than the two others (p. 307). Soon, however, he decided to split it up into more specialized treatises, beginning with one upon the theory of human proportions. This was, he thought, ready for publication as early as 1512–1513, but publication was delayed for internal as well as external reasons. The material assembled went into the First Book of the *Vier Bücher von Menschlicher Proportion* (Four Books on Human Proportion) (see our *fig.* 24) as printed in 1528, after Dürer's death, while the ideas set forth in the Introduction, then planned and preserved in several slightly different drafts

(p. 311) were incorporated in the "aesthetic excursus," now appended to the Third Book of the printed version (p. 318). The contemplated chapter on perspective, on the other hand, developed into a treatise on practical geometry (*Underweysung der Messung . . .* , printed in 1525), likewise divided into four books, with perspective proper treated at the end of the Fourth Book. Like his contemporaries, Leonardo and Michelangelo, Dürer was also interested in fortifications and, a year before his death, he published a book entitled *Zur Befestigung der Städte Schlosser und Flecken* (The Theory of the Fortification of Cities, Castles, and Boroughs).

In the last period of his life, Dürer became increasingly interested in the writings and teachings of Luther. His two last great paintings, *The Four Apostles* (1526), which he presented to the city of Nürnberg, were inscribed with verses from their writings in Luther's translation of the New Testament.]

OUTLINE OF A GENERAL TREATISE ON PAINTING[1] (PLANNED PRIOR TO 1512–1513)[2]

Ihs. Maria

By the grace and help of God I have here set down all that I have learnt in practice, which is likely to be of use in Painting, for the service of all students, who would gladly learn. That, perchance, by my help they may advance still further in the higher understanding of such art, as he who

[1] The excerpts are from William Martin Conway, *Literary Remains of Albrecht Dürer*, Cambridge, Eng., 1889. Dr. Erwin Panofsky has adapted this translation to the text as given by K. Lange and S. Fuhse, *Dürers schriftlicher Nachlass*, Halle a. S., 1893. In our notes L.-F. refers to Lange and Fuhse, C. to Conway, and P. to Panofsky.

See also: E. Panofsky, *Albrecht Dürer*, 2nd ed., Princeton, 1945; H. Wölfflin, *Die Kunst Albrecht Dürers*, Munich, 1926; V. Scherer, *Albrecht Dürer* (Klassiker der Kunst), 4th ed., Stuttgart, 1928; T. Sturge Moore, *Albert Dürer*, New York, 1911.

[2] The following is the first more comprehensive outline for a general work upon the theory and practice of art. It was probably written before 1512. C., pp. 171–173; L.-F., pp. 281, line 14; 285, line 6.

seeks, may well do, if he is inclined thereto; for my reason suffices not to lay the foundations of this great, far-reaching, infinite art of true painting.

Item. In order that you may thoroughly and rightly comprehend what is, or is called, an "artistic painter," I will inform you and recount to you. For the world often goes without an "artistic painter" in that for two or three hundred years none such appears, and this in great part because those who might have become such were prevented from devoting themselves thereto. Observe then the three essential points following, which belong to the true artist in painting. These are the three main points in the whole book.

[I.] The First Division of the book is the Prologue, and it comprises three parts [A, B, and C].

[A.] The first part of the Prologue tells us how the lad should be taught, and how attention should be paid to the quality of his temperament. It falls into six parts:

First, that note should be taken of the birth of the child, in what sign it occurred; with some explanations. (Pray God for a lucky hour!)

Second, that his form and stature should be considered; with some explanations.

Third, how he ought to be nurtured in learning from the first; with some explanations.

Fourth, that the child should be observed, whether he learns best when kindly praised or when chidden; with explanations.

Fifth, that the child be kept eager to learn and not be made disgusted.

Sixth, if the child works too hard, whereby melancholy may superabound in him, that he be drawn away therefrom by merry lute-play to the pleasuring of his blood.

[B.] The second part of the Prologue shows how the lad should be brought up in the fear of God and in reverence, that so he may attain grace, whereby he

may be strengthened in intelligent art and attain to power. It falls into six parts:

First, that the lad be brought up in the fear of God and be taught to pray to God for grace of fine perception (*subtilitet*), and to honor God.

Second, that he be kept moderate in eating and drinking and also in sleeping.

Third, that he dwell in a pleasant house so that he be distracted by no manner of hindrance.

Fourth, that he be kept from women and be not allowed to live in their quarters; that he not see one naked or touch her; and that he guard himself from all impurity. Nothing weakens the understanding more than impurity.

Fifth, that he know how to read and write well, and be also instructed in Latin, so far as to understand some works of writing.

Sixth, that such a one be able to pursue his studies for a long enough time at his own expense, and that his health be attended to with medicines when needful.

[C.] The third part of the Prologue teaches us of the great usefulness, joy, and delight which spring from painting. It falls into six parts:

First, it is a useful art, for it is of godly sort and is employed for holy edification.

Second, it is useful, for if a man devote himself to art, much evil is avoided that would otherwise occur if one were idle.

Third, it is useful, for no one, unless he practices it, believes that it is so rich in joys in itself; it has great joys indeed.

Fourth, it is useful because a man gains great and lasting memory by it if he applies it aright.

Fifth, it is useful because God is thereby honored when it is seen that He has bestowed such genius upon one of His creatures in whom such art dwells. All wise men will hold you dear for the sake of your art.

Sixth, the sixth use is that if you were poor, you might by such art come to great wealth and riches.

[II.] The Second Division of the book treats of Painting itself; it also is threefold.

[A.] The first part speaks of the freedom of Painting: in six ways.

[B.] The second part speaks of the proportions of men and buildings and what is needed for Painting: in six ways.

[C.] The third part speaks of all that which is seen when represented in one view [*scil.*, in perspective]; to do this [is taught] in six ways.

[III.] The Third Division of the book is the Conclusion; it also has three parts.

[A.] The first part tells in what place such an artist should dwell to practice his art: in six ways.

[B.] The second part tells how such a wonderful artist should charge highly for his art, and that no money is too much for it; moreover, it is divine and rightful: in six ways.

[C.] The third part speaks of praise and thanksgiving unto God who has thus bestowed His grace upon him, and unto others for His sake. [?]

ON PAINTING[3]

He that would be a painter must have a natural turn thereto.

Love and delight are better teachers of the Art of Painting than compulsion is.

If a man is to become a really great Painter he must be educated thereto from his very earliest years.

He must copy much of the work of good artists until he attains a free hand.

[3] c., p. 181; l.-f., p. 287, lines 4–20.

What is painting?

To paint is to be able to portray upon a flat surface any one—whichever he chooses of all visible things, howsoever they may be.

It is well for everyone, by way of first instruction, to divide and reduce to measure a human figure, before one learns anything else.

DRAFTS FOR THE INTRODUCTION TO THE BOOK ON HUMAN PROPORTIONS (PLANNED IN 1512–1513)[4]

Salus

The following little book is called "Food for Young Painters."

It is most necessary for a man to be competent in some thing by reason of the usefulness which arises therefrom. Wherefore we should all gladly learn, for the more we know so much the more do we resemble the likeness of God who verily knows all things. You find arts of all kinds; choose then for yourself that which is like to be of greatest service to you. Learn it; let not the difficulty thereof vex you till you have accomplished somewhat wherewith you may be satisfied. Through instruction we would like to be competent in many things, and would not tire thereof, for nature has implanted in us the desire of knowing *all* things, thereby to discern a truth of all things. But our dull wit cannot come unto such perfectness of all art, truth and wisdom. Yet are we not therefore shut out altogether from all arts. If we want to sharpen our reason by learning and to practice ourselves therein, having once found the right path we may, step by step, seek, learn, comprehend, and finally reach and attain unto some of the truth. Wherefore he that understands how to learn something in his leisure time, whereby he finds himself most fitted, in the honor of God, and to the advantage of both himself and others—that man does well. We know that many men who have attained experience in diverse arts have made known the truth discov-

[4] C., pp. 176 f.; L.-F., pp. 310, line 13; 313, line 21.

ered by them, which benefits us now. It is right therefore
for one man to teach another. He that joyfully does so,
upon him shall much be bestowed by God, from whom
we receive all things. May He have the highest praise.
Much learning is not evil to a man, though some be stiffly
set against it, saying that art puffs up. Were that so, then
were none prouder than God Who has created all arts. But
that cannot be, for God is the *Summum Bonum*. The more,
therefore, a man learns, so much the better does he be-
come, and so much the more love does he win for the arts
and for things exalted. Wherefore a man ought not to play
the wanton but should learn in season. One finds some who
know nothing and learn nothing. They despise learning and
say that much evil comes of the arts and that some are
wholly vile. I, on the contrary, hold that no art is evil but
that all are good. A sword is a sword, which may be used
either for murder or justice. Therefore the arts are in them-
selves good. What God has created, that is good, though
many may misuse it. If the artistic man is pious and by
nature good, he eschews the evil and does the good; and
hereunto serve the arts, for they give the discernment of
good and evil. Some may learn something of all the arts,
but that is not given to every man. Nevertheless there is
no rational man so dull but that he may learn the one thing
towards which his fancy draws him most strongly. Hence
no man is excused from learning something.

Now I know that in our German nation, at the present
time, are many painters who stand in need of instruction,
for they lack real art,[5] yet they nevertheless have many
great works to make. Forasmuch then as they are so nu-
merous, it is very needful for them to learn to better their
work. He that works in ignorance works more painfully than
he that works with understanding; therefore let all learn to
understand aright. Willingly will I impart my teaching,
hereafter written, to the man who has little competence
and yet would gladly learn; but I will not care about the
proud who, according to their own estimate of themselves,

[5] Art is used here in the sense of theoretical insight as opposed
to mere practice. P.

know all things, and are the best, and despise all else. By true artists, however, such as can show their meaning with their hand, I humbly desire to be instructed with much thankfulness. Whosoever will, therefore, let him hear and see what I say, do, and teach, for I hope it may be of service and not for a hindrance to the better arts nor lead you to neglect better things.

This art of painting is made for the eyes, for the sight is the noblest sense of man. Some I know will be curious about these matters because they have neither seen nor heard of such things in our land before. Whosoever therefore comes across this thing, let him choose what he will therefrom and seek improvement therein however he please, so only that the truth abide therein. A thing you behold is easier of belief than that you hear; but whatever is both heard and seen we grasp more firmly and lay hold on more securely. I will therefore continue the word with the work [*scil.* text and illustrations] that thus I may be the better understood.

Every form brought before our vision falls upon it as upon a mirror. By nature we regard a form and figure with more pleasure than another, though the thing in itself is not necessarily better or worse. We like to behold beautiful things, for this gives us joy. To pass judgment on beauty is more credible in a skillful painter's speech than in another's. True proportion makes a good figure not only in painting but also in all works, howsoever executed. I shall not labor in vain, if I set down that which may be useful for painting. For the art of painting is employed in the service of the Church and by it the sufferings of Christ and many other profitable examples are set forth. It preserves also the likeness of men after their death. By aid of delineation in painting, the measurements of the earth, the waters, and the stars have come to be understood; and many things will still become known unto men thereby. The attainment of true, artistic, and lovely execution in painting is hard to come unto; it needs long time and a hand most free and practiced. Whosoever, therefore, is not gifted in this manner, let him not undertake it; for it comes by inspiration from above.

The art of painting[6] cannot be truly judged save by such as are themselves good painters; from others verily is it hidden even as a strange tongue. It were a noble occupation for ingenious youths without employment to exercise themselves in this art.

Many centuries ago the great art of painting was held in high honor by mighty kings, and they made the excellent artists rich and held them worthy, accounting such inventiveness a creating power like God's. For a good painter is inwardly full of figures, and were it possible for him to live forever he would always have from his inward "ideas," whereof Plato writes, something new to pour forth by the work of his hand.

Many hundred years ago there were several famous painters, such as those named Phidias, Praxiteles, Apelles, Polycleitus, Parrhasius, Lysippus, Protogenes, and the rest, some of whom wrote about their art and very artfully described it and gave it plainly to the light; but their praiseworthy books are, so far, unknown to us, and perhaps have been altogether lost by war, driving forth of the peoples, and alterations of laws and beliefs—a loss much to be regretted by every wise man. It often came to pass that noble *Ingenia* were destroyed by barbarous oppressors of art; for if they saw figures traced in lines they thought it plain black magic. And [in destroying them] they attempted to honor God by something displeasing to Him; for, to use the language of men, God is angry with all destroyers of the works of great mastership, which is only attained by much toil, labor, and expenditure of time, and is bestowed by God alone. Often do I sorrow because I must be robbed of the aforesaid masters' books of art; but the enemies of art despise these things.[7]

I hear, moreover, of no writer in later times, by whom

[6] C., pp. 177–180; L.-F., pp. 297, line 22; 301, line 24.
[7] A draft connected with the foregoing passage is worth separate translation. "Pliny writes that the old painters and sculptors —such as Apelles, Protogenes, and the rest—told very knowingly in writing how a well-built man's figure might be measured out. Now it may well have come to pass that these noble books were misunderstood and destroyed as idolatrous in the early days of

aught has been written and made known which I might read for my improvement. For though there are some, they hide their art in secrecy, and others write about the things whereof they know nothing. This, then, is all mere noise, for their words are the best [they can do], as he that knows somewhat is swift to discover. I therefore will write down with God's help the little that I have learned. Though many will scorn it, I am not troubled, for I well know that it is easier to cast blame on a thing than to make something better. Moreover, I will expound my meaning as clearly and plainly as I can; and, were it possible, I would gladly give everything I know to the light, for the good of cunning students who prize such art more highly than silver or gold. I further admonish all who have any knowledge in these matters that they write it down. Do it truly and plainly, not toilsomely; and do not lead those who seek and would like to know, over devious paths, to the great honor of God and your own praise.

If I then set something burning and ye all add to it with skillful furthering, a blaze may in time arise therefrom

the Church. For they said Jupiter should have such proportions, Apollo such others; Venus shall be thus, Hercules thus, and so with all the rest. Had it however been my fate to be there at the time, I would have said: 'Oh dear holy Lords and Fathers, do not so lamentably destroy the nobly discovered arts, which have been brought together by great toil and labor, only because of the abuses made of them. For art is very great, hard and good and we might and would use it for the honor and glory of God. For, even as the ancients used the fairest figure of a man to represent their false god Apollo, we will in chastity employ the same for Christ the Lord, who is the fairest of all the earth; and as they figured Venus for the loveliest of women, so will we in like manner set down the same beauteous form for the most pure Virgin Mary, the mother of God; and of Hercules we will make Samson, and thus will we do with all the rest.' Such books we no longer have. Wherefore, as that which is lost arises not again, a man must strive after a new lore, and for these reasons I have been moved to make known my ideas here following, in order that others may ponder the matter further, and may thus gradually come to a new and better way and foundation. And I will undertake my task according to measure, number and weight; he who puts his mind to it will find it thus hereafter." c., p. 178, note 1; L.-F., pp. 315, line 20; 316, line 26.

which shall shine throughout the whole world. *Item.* The sight of a fine human figure is above all things pleasing to us, wherefore I will first construct the right proportions of a man. Thereafter, as God gives me time, I will write of and carry out other matters. I am well assured that the envious will not keep their venom to themselves; but nothing shall in any wise hinder me, for even the great men have had to undergo the like. We see human figures of many kinds arising from the four temperaments; yet if we have to make a figure, and if it is left to our discretion, we ought to make it as beautiful as we can according to the task, as it is fitting. No little art, however, is needed to make many various kinds of figures of men. Deformity will continually of its own accord entwine itself into our work. No single man can be taken as a model for a perfect figure, for no man lives on earth who is endowed with complete beauty; he might still be much more beautiful. There lives also no man upon earth who could give a final judgment upon what the most beautiful shape of a man should be; only God knows that. How beauty is to be judged is a matter of deliberation. One must bring it into every single thing, according to circumstances, for in some things we consider that as beautiful which elsewhere would lack beauty. "Good" and "better" in respect of beauty are not easy to discern, for it would be quite possible to make two different figures, neither of them conforming to the other, one stouter and the other thinner, and yet we scarce might be able to judge which of the two may excel in beauty. What Beauty is I know not, though it adheres to many things. When we wish to bring it into our work we find it very hard. We must gather it together from far and wide, and especially in the case of the human figure throughout all its limbs [seen] from before and behind. One may often search through two or three hundred men without finding amongst them more than one or two points of beauty which can be made use of. You therefore, if you desire to compose a fine figure, must take the head from some and the chest, arm, leg, hand, and foot from others, and, likewise, search through all members of every kind. For from many beautiful things something good may be gathered, even as

honey is gathered from many flowers. There is a right mean between too much and too little; strive to attain this in all your works. In calling something "beautiful," I shall here apply the same standard as is applied to "right." For as what all the world prizes as right we hold to be right, so what all the world esteems beautiful that will we also hold for beautiful and strive to produce.

Item. I do not highly extol the proportions which I here set down, albeit I do not believe them to be the worst. Moreover, I do not lay them down as being just so and not otherwise. You may search out and discover some better method with the aid of these "means," for everyone should look for improvement in his work. Howbeit let him accept this as good until he be truthfully instructed with something better; for one comes nearer the truth than another according as his understanding is stronger, and the models from which he draws excel in beauty. Many follow their taste alone; these are in error. Therefore let each take care that his inclination blind not his judgment. For every mother is well pleased with her own child, and thus also it arises that many painters paint figures resembling themselves. There are many varieties and causes of beauty; he that can prove them is so much the more to be trusted. The more imperfection is excluded so much the more beauty remains in the work.

Let no man[8] put too much confidence in himself, for many see more than one. Though it is possible for one man to comprehend more than a hundred, still that comes but seldom to pass. Usefulness is an important part of beauty; whatever therefore is useless in a man is not beautiful. Guard yourself from superfluity. The harmony of one thing with another is beautiful, therefore limping is not beautiful. [But] there is also a great harmony in diversity. Much will hereafter be written about the problems and artifices of painting. For I am sure that many notable men will arise, all of whom will write and teach both well and better about this art. For I myself hold my art at a very mean value, for I know my shortcomings. Let every man therefore strive

[8] C., p. 180; L.-F., pp. 305, line 1; 306, line 2.

to better my shortcomings according to his powers. Would
to God, if it were possible, that I could see the work and
art of the mighty masters to come, who are yet unborn,
for I know that I might be improved thereby. Ah! how often
in my sleep do I behold great works of art and beautiful
things, the like whereof never appear to me awake; but
so soon as I awake my memory loses hold of it.[9] Let none
be ashamed to learn, for good counsel helps us to a good
work. Nevertheless whosoever takes counsel in the arts let
him take it from one thoroughly versed in these matters
and who can prove this with his hand. Howbeit anyone
may do this, and it is well [to do so]: when you have done
a work pleasing to yourself, show it to crude men of little
judgment that they may give their opinion of it. As a rule
they pick out the most faulty points, though they have no
understanding for the good. If you find that they say some-
thing true, you may better your work. Much remains that
might be written on these matters, but for shortness' sake I
will make an end, and will enter upon the task of construct-
ing the figures of man and woman.

FOUR BOOKS ON HUMAN PROPORTION[10]

Book III. ("*Aesthetic Excursus*"). To him that sets him-
self to draw figures according to this book, not being well
taught beforehand, the matter will at first come hard. Let
him then put a man before him who agrees, as nearly as

[9] The following passage occurs in a letter of March 1522 from
Pirckheimer to Ulrich Varnbühler: "Do you remember what
Dürer told us lately of his dreams? We were standing by the
window in my house beholding the military train pass by. All
the air was filled with the blare of trumpets, the clang of arms,
and the shouts of men. And then he told us how sometimes in
his dreams he seemed to live amongst things so beautiful that if
such only really existed he would be the happiest of men." H.
Grimm, *Über Künstler*, II, p. 150 as quoted in C., p. 180, note 1.

[10] C., pp. 243–250; L.-F., pp. 217, line 11; 231, line 24. There
is no reason to assume with Conway that the aesthetic excursus
was not Dürer's own final version of his ideas, but merely "a
number of miscellaneous notes, culled from Dürer's memoranda
books" by the editors of the Four Books. After all the book ap-
peared no more than about six months after Dürer's death, so

may be, with the proportions he desires; and let him draw him in outline according to his ability and understanding. For this is held to be good: if a man accurately follows life in his imitation so that his work resembles life and is like unto nature, and especially if the thing imitated is beautiful, the work is held to be artistic, and, as it deserves, it is highly praised.

But further, it lies in each man's choice whether, or how far, he shall make use of all the above written "Words of Difference." For a man may, if he choose it, learn to work with art, wherein is the truth, or without art in a freedom by which everything he does is corrupted, and his toil becomes a scorn to look upon to such as understand. For work well done is honoring to God, useful, good, and pleasing unto men. But to labor contemptibly in art is wrong and meet to be condemned, and it is hateful in small works as in great. Wherefore it is needful for everyone that he use discretion in such of his works as shall come to the light. Whence it arises that he who would make anything aright must in no wise retract aught from nature, neither must he lay what is intolerable upon her. Howbeit some will make alterations so slight that they can scarce be perceived. Such are of no account if they cannot be perceived; [to alter] over much also answers not. A right mean is best. But if in this book I have gone to extremes, I have done so in order that it might be better perceived in small things. Let not him, who wishes to proceed to some great thing, imitate this my roughness, but let him make his work smoother, that it be not brutish but artistic to look upon. For the differences are not good to look upon, when they are wrongly and unmasterly employed.

It is not to be wondered at that a skillful master beholds manifold differences of figure, all of which he might make if he had time enough, but which, [for lack of time] he is forced to pass by. For such ideas come very often to artists,

all the copy must have been pretty much in shape, and the editors really did no more than "edit" in the narrower sense (and very little of that—mostly replacing Dürer's expressions for certain parts of the human anatomy by more genteel ones) and proofreading. P.

and their mind is full of images which it were possible for them to make. Wherefore, if to live many hundred years were granted unto a man, who makes skillful use of such art, and were gifted therefor, he would (through the power which God has granted unto men) have wherewith daily to pour forth and make many new figures of men and other creatures, which had not been seen before nor imagined by any other man. God therefore in such and other ways grants great power unto artistic men.

Although there be much talking of differences, still it is well known that all things that a man can do differ of their own nature one from another. Consequently there lives no artist so sure of hand as to be able to make two things exactly alike the one to the other, so that they may not be distinguished. For of all our works none is quite and altogether like another, and this we can in no wise avoid. For we see that if we take two prints from one engraved copperplate, or cast two images in one mould, differences may immediately be found, for many reasons, whereby they may be distinguished one from another. If then it comes thus to pass in things made by processes the least liable to error, much more will it happen in other things which are made by the free hand.

This, however, is not the kind of difference whereof I here treat; for I am speaking of a difference which a man specially intends, and which stands in his will, of which I have spoken once and again. When it comes into a man's mind that he intends to make this or that, he adopts one or the other of the different things—not those aforesaid differences which we cannot keep out of our work but those which make a thing fair or foul, and which may be produced by the "word of difference" dealt with above in this book. If a man produce "different" figures of this kind in his work, it will be judged by every man in his mind according to his own opinion, and these judgments seldom agree one with another. . . . Yet let every man beware that he make nothing impossible and inadmissible in nature, unless indeed he would make some fantasy, in which it is allowed to mingle creatures of all kinds together. . . .

He that desires to make himself seen in his art must dis-

play the best he can, so far as it is suitable for this work.
But here it must be noted that an artist of understanding
and experience can show more of his great power and art
in crude and rustic things, and this in works of small size,
than many another in his great work. Powerful artists alone
will understand that in this strange saying I speak truth.
For this reason a man may often draw something with his
pen on a half-sheet of paper in one day or cut it with his
little iron on a small block of wood, and it shall be fuller of
art and better than another's great work whereon he has
spent a whole year's careful labor, and this gift is wonder-
ful. For God sometimes grants unto one man to learn and
to understand how to make something good; the like of
whom, in his day, no other can be found, and perhaps for
a long time none has been before him and after him another
comes not soon. Of this we behold examples in the days of
the Romans in the time of their splendor. Little is now pro-
duced in our work like unto the works of art which were
made by them and whereof we can still behold the wrecks.

But if we were to ask how we are to make a beautiful
figure, some would give answer: according to the judgment
of men. Others would not agree thereto; neither should I.
For who will give us certainty in this matter without true
knowledge? I believe that no man lives who can grasp the
ultimate in beauty of the meanest living creature, let alone
of man who is an extraordinary creation of God, and unto
whom other creatures are subject. I grant, indeed, that one
man will conceive and make a more beautiful figure than
another and will explain good natural cause thereof so as
to be convincing in his reasoning, but not to such an ex-
tent that there could not be anything more beautiful. For
this enters not the mind of man; God alone knows such,
and he to whom He were to reveal it, he would know it
likewise. Truth only comprehends which might be the most
beautiful form and measurement of a man and none other.

Men deliberate and hold numberless differing opinions
about these things and they seek after them in many dif-
ferent ways, although the ugly is more easily attained than
the beautiful. Being then, as we are, in such a state of error,
I know not how to set down firmly and with finality what

measure approaches absolute beauty. But glad should I be to render such help as I can, to the end that the gross deformities of our work might be and remain pruned away and avoided, unless anyone desires to produce deformities for a special purpose.

But it seems to me impossible for a man to say that he can point out the best proportions for the human figure; for the lie is in our perception, and darkness abides so heavily within us that even our gropings fail. Howbeit if a man can prove his theory by geometry and manifest forth its fundamental truth, him must all the world believe. For then one is compelled, and such an one must be fairly recognized as endowed of God to be a master in such matters; and the demonstrations of his reasons are to be listened to with eagerness and still more gladly are his works to be beheld.

However, because we cannot altogether attain perfection, shall we therefore wholly cease from our learning? This bestial thought we do not accept. For evil and good lie before men wherefore it behooves a rational man to choose the better. Thus to revert to the question as to how a "better" figure may be produced, we must first order the whole figure well and nobly with all its limbs, and we must see next that every limb, regarded in itself, be made aright in all smallest as in greatest things, if so be that thus we may extract a part of the beauty given unto us and come so much the nearer to the true goal. So then, as aforesaid, since a man is one whole, made up of many parts, and since each of these parts has its particular nature, equal care must diligently be given to anything whereby they might be marred, so that this might be avoided and that the true, natural character of each part might be most carefully maintained; nor must we swerve therefrom if we can help it.

Great pains and close attention are needful to make visible that which is praiseworthy. First to consider the head (as it has been described in the foregoing Books): how strangely is it rounded. And so with other parts: what strange lines they require, such as can be laid down by no rule but must be drawn only from point to point. And so must the forehead, cheeks, nose, eyes, mouth, and chin,

with their curvings in and out and their peculiar forms, be carefully drawn, so that not the very smallest thing be passed over, but that all be drawn with well-considered and particular care. Moreover, just as each several part should be drawn fitly and well, so should it harmonize well in respect of the whole. Thus the neck should agree aright with the head, being neither too short nor too long, too thick nor too thin. Then let a man have a care that he put together correctly breast and the back, the belly, and hinder parts, the legs, feet, arms, and hands, with all their details, so that the very smallest points be made correctly and in the best way. These things, moreover, should be wrought out in the [final] work to the clearest and most careful finish, and even the tiniest wrinkles and prominences should not be omitted in so far as it is possible. For it is no good to slur over a thing unless a man has to paint a figure in haste; then he must content himself [with few details]. Howbeit, even so, evidence must be given therein of a true understanding, and —all haste notwithstanding—a just intention must be discoverable and the same quality of form must be retained throughout the whole body. And so in all figures, be they hard or soft, fleshy or thin; one part must not be fat and another bony, as if you were to make fat legs and thin arms, or contrariwise, or a figure fat in front and lean behind, and contrariwise. For all things must agree together in harmony and not be falsely put together. For things that agree in harmony are considered beautiful. Wherefore a uniform age should be indicated in every figure, throughout all the parts of its limbs. The head must not be copied from a youth, the chest from an old man, and hands and feet from one of middle age. Neither must the figure be made youthful before and old behind, or contrariwise; for that unto which nature is opposed is bad. Hence it follows that each figure should be of one kind alone throughout, either young, or old, or middle-aged, lean or fat, soft or hard. For example, you find the grown lad smooth, hairless, and plump, but old age is rugged, bony, wrinkled, and its flesh wasted.

It is well for a man to give account of these things beforehand, before he proceeds to his [final] work; he ought to set down and consider well all this, as he intends it to

be in a line-drawing. Then you shall not be likely afterwards to repent what you have done. It is therefore needful for every artist to learn to draw well, for this is beyond measure serviceable in many arts and much depends thereon. For even if someone had set down a good measurement before, and someone not knowing how to draw were to attempt to follow it, faring with his unskilled hand through the length, thickness, and breadth of the figure, this latter would very soon spoil that which he desires to make. But when a man, who has understanding in drawing, sets a well described figure before him, he can so improve upon it in his [own] drawing as to make it still better.

Further, in order that we may arrive at a good canon whereby to bring somewhat of beauty into our work, thereunto it were best for you, it bethinks me, to take measurements from many living men. Howbeit, seek only such men as are held beautiful, and from such draw with all diligence. For one who has understanding may, from men of many different kinds, gather something good together through all the limbs of the body. For seldom is a man found who has all his limbs good, for every man has some fault. Albeit one ought to gather observations from many kinds of men, yet should one kind of men only be made use of for a single figure. For the sake of harmony, as aforesaid, let a man use, to copy for a youthful figure, young men only,—for an old, old,—for one of middle age, middle-aged men. So likewise with thin, fat, soft, and hard men, strong or weak; let each kind be employed separately for separate figures. And whoso devotes himself to these things, and searches diligently through each part of the body in turn, will find all the matter needful for his work and more than he can accomplish. For the understanding of men can seldom compass the beautiful in creatures rightly to depict it. And, although we cannot speak of the greatest beauty of a living creature, yet we find in the visible creation a beauty so far surpassing our understanding that not one of us can fully bring it into his work.

Item. For different kinds of figures different kinds of men are to be copied. Thus you find two species of mankind, whites and negroes; in these a difference in kind can be

observed as between them and ourselves. Negro faces are
seldom beautiful because of their very flat noses and thick
lips; similarly their shinbones and knees, as well as their
feet, are too bony, not so good to look upon as those of
the whites; and so also is it with their hands. Howbeit I
have seen some amongst them whose whole bodies have
been so well built and handsome otherwise that I never
beheld finer figures, nor can I conceive how they might be
bettered, so excellent were their arms and all their parts.
Thus one finds amongst the species of men types of every
kind, which may be used for figures of diverse sort accord-
ing to the temperament. So the strong are hard in body like
unto lions, whilst the weak are softer and not so rugged
as the strong. Therefore it is not seemly to give a soft char-
acter to a very strong figure, or to a weak figure a hard
character, though as to "thin" and "fat" in figures some al-
lowance must be made. And in sundry differences figures
"soft" and "hard" may be used according to circumstances,
as a man sees fit. Life in nature shows forth the truth in
these things. Wherefore regard it well, take heed thereto
and depart not from nature according to your fancy, im-
agining to find aught better by yourself; else would you be
led astray. For verily "art" is embedded in nature;[11] he who
can extract it, has it. If you acquire it, it will save you from
much error in your work. Moreover, you may demonstrate
much of your work by geometry. But what we cannot dem-
onstrate, that must we leave to good opinion and to the
judgment of men. Still experience avails much in these
matters. The more closely your work abides by life in its
form, so much the better will it appear; and this is true.
Wherefore nevermore imagine that you could or would
make anything better than God has given power His created
nature to produce. For your might is powerless as com-
pared to the creation of God. Hence it follows that no man
shall ever be able to make a beautiful figure out of his own
[private] imagination unless he has well stored his mind by
much copying from life. That is no longer to be called pri-

[11] "Art" here again means insight, *necta ratio faciendorum
operum.* P.

vate but has become "art" acquired and learnt by study which seeds, waxes, and bears fruit after its kind. Thence the gathered, secret treasure of the heart is openly manifested in the work, and the new creature, which a man creates in his heart in the form of a thing.

Hence it arises that a well-practiced artist has no need to copy each particular figure from the life. For he sufficiently pours forth that which he has for a long time gathered within him from without. Such a man has whereof to make good things in his work. Howbeit very few come unto this understanding, though many there be who with great toil produce much that is faulty. For him therefore who, by a right understanding, has attained a good practice it is quite possible to make something good, as far as that is within our power, without any model; yet it will turn out still better if he study from the life. But to make a good thing is impossible for the unpracticed hand, for these things come not by chance. It also happens, though but seldom, that a man becomes so sure of hand by great experience gathered from long and diligent practice, that he out of his own understanding, acquired by great pains, can produce without any model which he might copy, something better than another can do who sets before himself many living men to imitate because he lacks understanding.

Therefore we must take very great care and prevent that deformity and uncouthness introduce themselves into our work. We should therefore avoid bringing useless things into pictures, provided they are to be beautiful, for this is a fault. Take an instance from the blind, lame, withered cripples, and halt. All this is ugly through defect. Superfluity, likewise, must be avoided as if one were to draw a man with three eyes, three hands and feet. The more the ugliness of the aforesaid things is left out and the more things upright, strong, pure, and fitting, which all men commonly love, are made instead thereof, so much the better will the work turn out to be, for such things are held beautiful.

But beauty is so much hidden in men and so uncertain is our judgment about it, that we may perhaps find two men both beautiful and fair to look upon, and yet neither

resembles the other in any single point or part, whether in measure or kind; we do not even understand whether of the two is the more beautiful, so blind is our knowledge. Thus, if we give an opinion on the matter it lacks certainty. Howbeit in some points the one may still surpass the other even though this be imperceptible to us.

Wherefore it follows that no powerful artist should abandon himself to one manner only; but he should be practiced in several styles and in many kinds, and should have understanding therein. Then he will be able to make whatever sort of picture is required of him. Likewise, of the aforesaid instances, a man may know how to make wrathful, kindly, and all other figures, and every figure may be made good in itself. If then someone came to you and would have of you some wicked Saturnine or Martial figure, or one of charming, lovely mien to indicate Venus, you, if you are practiced in the doctrines set forth before, shall easily know what measurements and kind you should employ for each. Thus all sorts of human species can be outwardly indicated by measurement [so as to show] which are of fiery, airy, watery, or earthy nature; for the power of art, as aforesaid, masters every work.

True artists perceive at once which work is a powerful one, and therefrom arises a great love in the mind of him that understands. This they know who have learnt aright and they know what is good practice therein; for knowledge is truthful but opinion betrays oft. Therefore let no one put too much belief in himself, lest he err in his work and fail. It is very needful for one who busies himself about these things to see many good figures and especially such as have been made by the famous good masters, and that he hear them discourse thereof. Howbeit you must ever observe their faults and consider how they might be bettered. Moreover, as aforesaid, permit not yourself to be persuaded to one style alone, that of any one master; for every man tends to make that which pleases him, like unto himself. Howbeit if you consider many of them, choose the best thereof for your imitation; for the error is simply inherent in all opinions. So that, how well soever our work be done, it might still be done better always. Even as it is with men;

how handsome soever a man may be, a still more hand-
some might yet be found.

Let each accept that which is more certain either that he
learn it from some one, or that he search it out from nature
for himself. But let him beware that he learn not from such
as can talk well about the thing, but whose handiwork has
ever been faulty and feeble; of whom I have seen many.
For if you follow them they will lead you astray, as their
work and want of art testify. For there is a great difference
between talking of a thing and making the same. Howbeit
it does not therefore follow that if a man of no understand-
ing tell another a truth he should refuse to believe it; for
it is possible that a peasant might tell you the error of your
work, but he could not set you right therein and teach you
how you should better the same.

A man who has not learnt anything about this art before,
and who desires to make a beginning from this book must
read this with great diligence and learn to understand what
he reads; and, taking a little at a time, he must practice
himself well in the same, until he can do it, and only then
must he go on to do something else. For understanding must
begin to grow side by side with practice, so that the hand
have power to do what the will in the understanding com-
mands. By such means certainty of "art" and practice waxes
with the time; and these two must go together, for the one
is ought without the other. Further, it must be noted how
well a common man knows the better from the worse; yet no
man can more perfectly judge a picture than an under-
standing artist who has often proved this through his work.

Now a man might say: who will devote continual labor
and trouble, with consuming of much time, thus in tedious
wise to measure out a single figure, seeing that it often hap-
pens that he must make, it may be, twenty or thirty differ-
ent figures in a short time? In answer to which, I do not
mean that a man should at all times construct everything
by measurements; but if you have well learnt the theory
of measurements and attained understanding together with
practice, so that you can make a thing with free certainty
of hand, and know how to do each thing aright, then it is
not always needful always to measure everything, for the

art which you have acquired gives you a good eye-measure, and the practiced hand is obedient. And thus the power of art drives away error from your work and restrains you from making falsehoods; for you know art, and by your knowledge you gain confidence and full command of your work so that you make no touch or stroke in vain. And this skill brings it to pass that you have no need long to think, if your head is full stored with art. And thus your work appears artistic, graceful, powerful, free, and good, and will receive manifold praise because rightness is infused into it.

But if you lack a true foundation it is impossible for you to make aught aright and well, although you had the greatest practice of the world as to freedom of hand. For this is rather a slavery when it leads you astray. Wherefore, as there must be no freedom without art, so is art lost without practice. Hence, as aforesaid, the two must go together. It is therefore needful that a man learn to measure most artfully. He that can do so well makes wonderful things. The human figure cannot be outlined with rule or compass, but must be drawn from point to point, as above explained; and without true measurement no one can in any wise accomplish anything good.

It might come to pass that a man, who will transfer these above measurements of figures to some large work, might go wrong through his [own] want of skill, and then might lay the blame upon me, saying that my designs were right for small things but they were misleading for large works. Such however cannot be the case, for the small cannot be right and the large wrong, or the small bad and the large good; therefore the argument cannot be divided in this wise. For a circle, whether small or large, abides round, and so it is with a square. Each proportion therefore remains equal to itself whether the scale be large or small, even as in music a note answers to its octave, the one high the other low, yet both are the same note.

LETTERS

To Willibald Pirckheimer.[12] Venice, Feb. 7, 1506

First, my willing service to you, dear Sir. If things are going well with you I am glad with my whole heart for you as I should be for myself. I recently wrote to you and hope that the letter reached you. In the meantime my mother has written to me, scolding me for not writing to you; and she has given me to understand that you hold me in displeasure because I do not write to you. She said I must apologize to you most seriously and she takes it very much to heart, as her way is.

Now I don't know what excuse to make except that I am lazy about writing, and that you have not been at home. But as soon as I heard that you were either at home or intended to come home, I wrote to you at once; after that I also very specially charged Kastell[13] to convey my service to you. So I humbly pray you to forgive me, for I have no other friend on earth but you. I don't believe, however, that you are angry with me, for I regard you in no other light than as a father.

I wish you were here at Venice! There are so many nice fellows among the Italians who seek my company more and more every day—so that it warms one's heart—wise scholars, good lute-players, pipers, connoisseurs of painting, and many noble minds, true models of virtue; and they show me much honor and friendship. On the other hand there are also amongst them some of the most false, lying, thievish rascals, the like of which I should not have believed lived on earth. If one did not know them, one would think them the nicest men the earth could show. For my part I cannot help laughing at them whenever they talk to me. They know that their knavery is no secret but they don't care.

Amongst the Italians I have many good friends who warn me not to eat and drink with their painters. Many of them are my enemies and they copy my work in the churches

[12] C., pp. 48 f.; L.-F., pp. 21, line 6; 23, line 9.
[13] Castulus Fugger. L.-F., p. 21, note 4.

and wherever they find it; and then they revile it and say that it was not in the *antique* manner and therefore not good. Giovanni Bellini,[14] however, has highly praised me before many nobles. He wanted to have something of mine, and himself came to me and asked me to paint him something and he would pay well for it. And all men tell me what a God-fearing man he is, so that I am well disposed toward him from the outset. He is very old, but still the best in painting. And those works of art[15] which so pleased me eleven years ago please me no longer; if I had not seen it for myself I should not have believed it from anyone else. You must know too that there are many better painters here than Master Jacob[16] abroad, yet Anton Kolb would swear an oath that no better painter lives on earth than Jacob. The others sneer at him, saying: "If he were good he would stay here."

I have only today begun to sketch in my picture,[17] for my hands were so scabby that I could do no work, but I have got it cured.

Now be lenient with me and don't get in a passion so easily. Be gentle like me; you will not learn from me, I don't know why that is. My friend! I should like to know if any one of your mistresses has died—that one close by the water, for instance, or the one

like , or , or the 's girl,[18]

so that you might supply her place with another.

[14] Giovanni Bellini (1430–1516); a leading painter of Venice and teacher of Titian and Giorgione.

[15] The word "Ding" in the original is a general term for works of art. Cf. "Raphael von Urbinos Ding" in the Diary, 3 Sept. (see below, p. 339). P.

[16] Jacopo de' Barbari (1440–1450 to 1515–1516).

[17] *The Feast of the Rose Garlands:* painted for the chapel of the German merchants in Venice, beside their exchange and warehouse—the Fondaco de' Tedeschi—on the Grand Canal. It is now in a very injured state in the Prague Museum. C., pp. 44, 61. Panofsky, *op. cit.*, pp. 107–113.

[18] The rose, duster, and running dog stand for the names of Pirckheimer's mistresses. L.-F., p. 23, note 2.

Given at Venice at the ninth hour[19] of the night, on Saturday after Candlemass in the year 1506.

Give my service to Steffen Paumgartner and to Masters Hans Harstorfer and Folkamer.

ALBRECHT DÜRER

To Jacob Heller.[20] Nürnberg, Aug. 24, 1508

Dear Herr Jacob, I have safely received your letter, that is to say, the last but one, and I gather from it that you wish me to execute your panel well, which is just what I myself have in mind to do. In addition, you shall know how far it has got on; the wings have been painted in stone colors on the outside, but they are not yet varnished; inside they are wholly underpainted, so that [the assistants] can begin to carry them out.[21]

The middle panel I have outlined with the greatest care and at cost of much time; it is also coated with two very good colors upon which I can begin to underpaint it. For I intend, so soon as I hear you approve, to underpaint it some four, five, or six times over,[22] for clearness' and durability's sake, also to use the very best ultramarine for the painting that I can get. And no one shall paint a stroke on it except myself, wherefore I shall spend much time on it. I therefore assume that you will not mind, and have decided to write you my proposed plan of work [but I must add] that I cannot without loss carry out said work [in such elaborate fashion] for the fee of 130 Rhenish florins; for I must spend such money and lose time over it. However, what I have promised you I will honorably perform: if you don't want

[19] About 2:30 a.m., as Dürer began his count of the night hours with darkness. L.-F., p. 23, note 5.

[20] The letter concerns the *Assumption of the Virgin* ordered by Heller for the altar of St. Thomas, in the Dominican Church, Frankfurt a.M. It hung there until Maximilian of Bavaria carried it off to Munich, where it was destroyed by fire in 1729. Panofsky, *op. cit.*, p. 123; c., p. 65; L.-F., pp. 48, line 1; 49, line 23. See also below, p. 356, note 3.

[21] The word "man" in "man darauf anfang auszumalen" implies that the execution was left to the shop, as is indeed the case. P.

[22] Dürer's technique in this picture was similar to a tempera technique. See Cennini, pp. 148 f.

the picture to cost more than the price agreed, I will paint it in such a way that it will still be worth much more than you paid for it. If, however, you will give me 200 florins I will follow out my plan of work. Though if hereafter somebody was to offer me 400 florins I would not paint another, for I shall not gain a penny over it, as a long time is spent on it. So let me know your intention, and when I have heard it I will go to the Imhofs[23] for 50 florins, for I have as yet received no money on the work.

Now I commend myself to you. I want you also to know that in all my days I have never begun any work that pleased me better than this picture of yours which I am painting. Till I finish it I will not do any other work; I am only sorry that the winter will so soon come upon us. The days grow so short that one cannot do much.

I have still one thing to ask you; it is about the Madonna that you saw in my house; if you know of any one near you who wants a picture pray offer it to him. If a proper frame were put to it, it would be a beautiful picture, and you know that it is neatly done. If I had to paint it for someone,[24] I would not take less than 50 florins. I will let you have it cheap. But as it is already done it might be damaged in the house. So I would give you full power to sell it for me cheap for 30 florins, indeed rather than that it should not be sold I would even let it go for 25 florins. I have certainly lost much food over it.

Many good nights. Given at Nürnberg on Bartholomew's day 1508.

<div align="right">ALBRECHT DÜRER</div>

To Jacob Heller. Nürnberg, Aug. 26, 1509[25]

First my willing service to you, dear Herr Jacob Heller. In accordance with your last letter, I am sending the picture well packed and seen to in all needful points. I have handed it over to Hans Imhof and he has paid me another 100 florins. Yet believe me, on my honor, I am still losing

[23] Imhofs: the great banking house of Nürnberg whose agents were found throughout Europe.
[24] Means: "to order." P.
[25] C., pp. 69 f.; L.-F., pp. 56, line 10; 58, line 21.

my own money over it besides losing the time which I have bestowed upon it. Here in Nürnberg they were ready to pay 300 florins for it, which extra 100 florins would have done nicely for me had I not sent [the picture] in order to please and serve you. For I value keeping your friendship at more than 100 florins, I would also rather have this painting at Frankfurt[26] than anywhere else in all Germany.

If you think that I have behaved unfairly in not leaving the payment to your own free will, you must bear in mind that this would not have happened if you had not written by Hans Imhof that I might keep the picture as long as I liked. I should otherwise gladly have left it to you even if thereby I had suffered a greater loss still. But I have confidence in you that, supposing I had promised to make you something for about 10 florins and it cost me 20, you yourself would not wish me to lose by it. So pray be content with the fact that I took 100 florins less from you than I might have got for the picture—for I tell you that they wanted to take it from me, so to speak, by force.

I have painted it with great care, as you will see, using none but the best colors I could get. It is painted with good ultramarine under, and over, and over that again, some five or six times; and then after it was finished I painted it again twice over so that it may last a long time.[27] Since you will keep it clean I know it will remain bright and fresh 500 years, for it is not done as men are wont to paint. So have it kept clean and don't let it be touched or sprinkled with holy water. I feel sure it will not be criticized, or only for the purpose of annoying me; and I believe it will please you well.

No one shall ever compel me to paint a picture again with so much labor. Herr Georg Tausy besought me of his own accord to paint him a Madonna in a landscape with the same care and of the same size as this picture, and he would give me 400 florins for it. That I flatly refused to do, for it would have made a beggar of me. Of ordinary pictures I

[26] Because at Frankfurt one of the largest fairs of Europe was held. Dürer sold his prints at the fair and a picture in one of the churches would serve as an advertisement. c., p. 63.

[27] See above, p. 332 and note 22.

will in a year paint a pile which no one would believe it possible for one man to do in the time. But painstaking drudgery does not get along so speedily. So henceforth I shall stick to my engraving, and had I done so before I should today have been a richer man by 1000 florins.

I may tell you also that, at my own expense, I have had for the middle panel a new frame made which has cost me more than 6 florins. The old one I have broken off, for the joiner had made it crudely; but I have not had it gilded, for you would not have it. It would be a very good thing to have the bands unscrewed so that the picture may not crack.

If the picture is set up, let it be made to hang forward two or three finger breadths, for then it will be well visible, on account of the glare. And when I come over to you, say in one, or two, or three years' time, the picture must be taken down [to see] whether it has dried out, and then I would varnish it over anew with a special varnish, which no one else can make; it will then last another 100 years longer than it would before. But don't let anybody else varnish it, for all other varnishes are yellow, and the picture would be ruined for you. And if a thing, on which I have spent more than a year's work, were ruined it would be grief to me. And when you unpack it, be present yourself lest it be damaged. Deal carefully with it, for you will hear from your own and from foreign painters how it is done.

Give my greeting to your painter Martin Hess. My wife asks you for a *Trinkgeld*,[28] but that is as you please, I screw you no higher. And now I hold myself commended to you. Read by the sense, for I write in haste. Given at Nürnberg on Sunday after Bartholomew's 1509.

ALBRECHT DÜRER

[28] This request for a present was not, according to the custom of the time, presumptuous. L.-F., p. 56, note 6.

THE TRAVEL DIARY ON THE TRIP
TO THE NETHERLANDS[29]

5 AUG. . . . On Sunday,[30] it was St. Oswald's day, the painters invited me to their rooms, with my wife and maid. All their service was of silver, and they had other splendid ornaments and very costly meats. All their wives also were there. And as I was being led to the table the company stood on both sides as if they were leading some great lord. And there were amongst them men of very high position, who all behaved most respectfully towards me with deep bows, and promised to do everything in their power agreeable to me that they knew of. And as I was sitting there in such honor the Syndic,[31] the town councillor of Antwerp came, with two servants, and presented me with four cans of wine in the name of the Town Councillors of Antwerp, and they had bidden him say that they wished thereby to show their respect for me and to assure me of their good will. Wherefore I returned them my humble thanks and offered my humble service. After that came Master Peeter,[32] the town engineer, and presented me with two cans of wine, with the offer of his willing services. So when we had spent a long and merry time together till late in the night, they accompanied us home with lanterns in great honor. And they begged me to be ever assured and confident of their good will, and promised that in whatever I did they would be all helpful to me. So I thanked them and laid me down to sleep.

I have also been in Master Quentin's[33] house and also to their three great shooting places. I had a delicious meal

[29] In July, 1520, Dürer with his wife and her maid left Nürnberg for Antwerp. During the year they were away, Dürer kept a diary in which he wrote his impressions of Antwerp, other cities in Belgium and Holland and jotted down his expenses.

[30] c., pp. 96–98; L.-F., pp. 112, line 6; 115, line 9.

[31] Adrian Horebouts. L.-F., p. 112, note 6.

[32] Peter Frans. L.-F., p. 112, note 7.

[33] Quentin Massys (1466–1530), the famous Antwerp painter. c., p. 97, note 1.

with Lorenz Staiber[34] and another time with the Portuguese Factor[35] whose portrait I drew in charcoal. Of my host, Jobet Plankfelt, I have also made a portrait; he gave me a branch of white coral. Paid 2 st. for butter, 2 st. to the joiner at the Painters' warehouse. [?]

My host took me to the workshop in the Painters' warehouse in Antwerp, where they are making the Triumphal decorations through which King Karl is to make his entry. It is four hundred arches long,[36] and each is 40 feet long. They are to be set up along both sides of the street, handsomely ordered and two storeys high. The plays are to be acted on them. To have this made by the Painters and the Joiners will cost 4000 florins. In addition all this will be fully draped, and the whole work is very splendidly done.

I have dined again with the Portuguese and also once with Alexander Imhof.

Item., Sebald Fischer bought of me at Antwerp 16 small Passions for 4 fl., further 32 of the Large Books[37] for 8 fl., further 6 engraved Passions for 3 fl., further half-sheets,[38] 20 of all kinds mixed together at 1 fl.; of these he took 3 fl. worth. Further quarter-sheets—45 of all kinds at 1 fl.—for 5¼ fl.; and whole-sheets—8 of all kinds taken together for 1 fl.—for 5¼ fl.

I have sold my host a Madonna painted on a small canvas for 2 fl. Rhenish.

I took the portrait of Felix Hungersberg,[39] the luteplayer, for the second time. Paid 1 st. for pears and bread, 2 st. to the barber. I also paid 14 st. for three small panels, besides

[34] A great organist from Nürnberg who was in the service of the Emperor. L.-F., p. 113, note 2.

[35] Factor Brandon might be described as the Portuguese Consul. C., p. 97, note 2.

[36] Probably scaffolds for "tableaux vivants" for the triumphal entry of Charles V. L.-F., p. 113, note 9.

[37] That is, the three large woodcuts: the *Apocalypse*, published first in 1498, reprinted in 1511; the *Life of the Virgin*, 1511; and the *Large Passion* of 1511.

[38] Engravings of whatever kind printed on sheets of those dimensions. C., p. 97, note 3.

[39] Two pen and ink portraits of this man by Dürer are in the Albertina Coll., Vienna. C., p. 97, note 4.

4 st. for laying the white ground and preparing the same.[40] Further I dined with Alexander, the goldsmith, and once more with Felix. Master Joachim[41] has once dined with me, and his apprentice once. I made a drawing in half-colors[42] for the painters. I have taken 1 florin for expenses. I gave the four new little pieces[43] to Peter Wolfgang. Master Joachim's assistant has again dined with me. I gave Master Joachim 1 fl. worth of prints for lending me his assistant and his colors, and I gave his assistant three pounds' worth of prints. . . .

Herr Erasmus[44] has given me a small Spanish "mantilla" and three men's portraits. Tomasin's brother gave me a pair of gloves. I have once more taken the portrait of Tomasin's brother Vincentius, and I gave Master Augustin Lombard the two parts of the "Imagines."[45] I also took a portrait of the crooked-nosed Italian named Opitius. My wife and maid dined one day at Master Tomasin's house; that makes four meals.

The Church of our Lady at Antwerp is so very large that many masses are sung in it at one time without interfering with each other. They have wealthy endowments there, so the best musicians are employed that can be had. The church has many devout services, much stonework, and in particular a beautiful tower. I have also been in the rich Abbey of St.-Michel. There are the most splendid galleries of sculptured stonework I have ever seen; also costly stalls

[40] Wood panels for pictures whose surface is then covered with white ground, usually a mixture of chalk and size called *gesso*. The artist usually laid the ground himself or had his apprentice do so. See Cennini, pp. 148 f.

[41] Joachim de Patinir (1490–1524), the famous painter.

[42] A pen and ink outline, washed with water colors. c., p. 98, note 3.

[43] Four copper engravings of 1519–1520, [three of which were] the *Presentation of the Virgin, St. Anthony,* and *Market Peasants.* L.-F., p. 115, note 5; C., p. 98, note 4.

[44] Erasmus (1466–1536) the famous Humanist, author of *Praise of Folly,* editor and translator of a Greek text of the New Testament.

[45] Celestial maps ordered by Johann Stabius and drawn from plans by the astronomer Conrad Heinfogel. See Scherer, *op. cit.,* p. 431.

in their choir. But at Antwerp they spare no cost on such things, for there is money enough. . . .

27 Aug. Brussels.[46] . . . I also saw the things which have been brought to the King from the new land of gold,[47] a sun all of gold a whole fathom broad, and a moon all of silver of the same size, also two rooms full of armour of the people there, and all manner of wondrous weapons of theirs, harness and darts, wonderful shields, strange clothing, bedspreads and all kinds of wonderful objects of various uses, much more beautiful to behold than prodigies. These things were all so precious that they have been valued at 100,000 florins. All the days of my life I have seen nothing that has gladdened my heart so much as these things, for I saw amongst them wonderful works of art, and I marvelled at the subtle *Ingenia* of men in foreign lands. Indeed I cannot express all that I thought thereby.

3 Sept.[48] . . . Raphael of Urbino's works have all been scattered since his death, but one of his pupils, Tommaso of Bologna by name,[49] a good painter, desired to see me. So he came to me and has given me an antique gold ring with a very well cut stone. It is worth 5 fl. but already I have been offered the double for it. In return I gave him 6 fl. worth of my best prints. I bought a piece of calico for 3 st.; I paid the messenger 1 st.; 3 st. I spent in company. . . .

7 April.[50] . . . When I reached Bruges Jan Prevost took me in to lodge in his house and prepared the same night a costly meal and bade much company to meet me.

8 April.[51] Next day Marx,[52] the goldsmith, invited me

[46] C., pp. 101 f.; L.-F., p. 123, lines 6–21.
[47] Mexico. L.-F., p. 123, note 1.
[48] C., p. 105; L.-F., p. 130, lines 9–18.
[49] Raphael died April 6, 1520. Tommaso was sent to Flanders in 1520 by Leo X to oversee the manufacture of a series of tapestries.
[50] C., pp. 116 f.; L.-F., p. 156, lines 3–6.
[51] C., p. 117; L.-F., p. 156, lines 6–21.
[52] He was later the court goldsmith of Lady Margaret, Governor of the Netherlands, at Mecheln. L.-F., p. 127, note 20.

and gave me a costly meal and asked many to meet me. Afterwards they took me to see the Emperor's house which is large and splendid. I saw the chapel there which Roger[53] painted, and pictures by a great old master; I gave 1 st. to the man who opens up the place. Then I bought 3 ivory combs for 30 st. They took me next to St. Jacob's and showed me the precious pictures by Roger and Hugo,[54] who were both great masters. Then I saw in Our Lady's Church the alabaster Madonna,[55] made by Michelangelo of Rome. After that they took me to many churches and showed me all the good pictures, of which there is an abundance there; and when I had seen Jan's[56] and all the others' works, we came at last to the Painters' chapel, in which there are good things. . . .

9 APRIL.[57] . . . On my arrival at Ghent the Dean of the Painters came to me and brought with him the regents of the painters' guild; they showed me great honor, received me most courteously, offered me their good will and service, and supped with me.

10 APRIL.[58] On Wednesday in the morning they took me to the Beffroi of St. John whence I looked over the great wonderful town, in which I had been taken for something great at once. Then I saw Jan's picture;[59] it is a most precious painting of high understanding, and the Eve, Mary, and God the Father are especially good. Next I saw the lions and drew one with the silver-point.[60] And I saw on

[53] Roger van der Weyden (1400–1464). Perhaps the *Miraflores Altarpiece,* painted in 1445, which is now in Berlin. L.-F., p. 156, note 5.

[54] Hugo van der Goes (d. 1482) whose *Entombment* was in St. Jacob's. C., p. 117, note 2.

[55] White marble. Sculptured between 1501–1506. C., p. 117, note 3.

[56] Jan van Eyck. L.-F., p. 156, note 9.

[57] C., p. 117; L.-F., p. 157, lines 18–22.

[58] C., pp. 117 f.; L.-F., pp. 157, line 22; 158, line 10.

[59] The famous *Ghent Altarpiece* finished in 1432, depicting the "Worship of the Lamb." Jan's older brother, Hubert (1366?–1426) worked on it also.

[60] This drawing from Dürer's sketchbook is in the Court Library, Vienna. C., p. 118, note 1.

the bridge where men are beheaded, the two statues erected[61] as a sign that there a son beheaded his father. Ghent is a fine and wonderful town; four great waters flow through it. I gave the sexton and the lions' keeper 3 st. *trinkgeld*. I saw many wonderful things in Ghent besides, and the painters with their Dean did not leave me alone, but they ate with me morning and evening and paid for everything and were very friendly to me. I gave away 5 st. at the inn for refreshment. . . .

On Friday[62] before Whitsunday in the year 1521, came tidings to me at Antwerp that Martin Luther had been so treacherously taken prisoner;[63] for he was escorted by Emperor Charles' herald with imperial safe-conduct and to him he was entrusted. But as soon as the herald had conveyed him to an unfriendly place near Eisenach he rode away, saying that he no longer needed him. Straightway there appeared ten horsemen and they treacherously carried off the pious man, betrayed into their hand, a man enlightened by the Holy Ghost, a follower of Christ and the true Christian faith. And whether he yet lives, or whether they have put him to death—which I know not—he has suffered this for the sake of Christian truth and because he rebuked the unchristian Papacy, which strives with its heavy load of human laws against the redemption of Christ; and because we are so robbed and stripped of our blood and sweat, and that the same is so shamefully and scandalously eaten up by idle-going folk, while the poor and the sick therefore die of hunger. But this is above all the most grievous to me, that, maybe, God will suffer us to remain still longer under their false, blind doctrine, invented and drawn up by the men alone whom they call Fathers, by which also the precious Word of God is in many places wrongly expounded to us or not taught at all. . . .

May every man[64] who reads Martin Luther's books see

[61] In 1371. L.-F., p. 158, note 1.

[62] C., p. 158; L.-F., pp. 161, line 23; 162, line 22.

[63] In reality he was kidnapped for his own safety on his return to Worms from the Reichstag by his friend, Frederick the Wise. L.-F., p. 161, note 5.

[64] C., p. 159; L.-F., p. 164, lines 11–21.

how clear and transparent is his doctrine, when he sets forth the Holy Gospel. Wherefore his books are to be held in great honor and not to be burnt; unless indeed his adversaries, who ever strive against the truth were cast also into the fire, together with all their opinions which would make gods out of men, provided, however, books of Luther's were printed anew again. Oh God, if Luther be dead, who will henceforth expound to us the Holy Gospel with such clearness? What, of God, might he not still have written for us in ten or twenty years? . . .[65]

CAREL VAN MANDER

[Carel van Mander (1548–1606) was born in West Flanders and died in Amsterdam. He began his career as a pupil of Lucas de Heere of Ghent, who combined the talents of poet and painter. Van Mander journeyed to Rome in 1573 and remained there until 1577, when he went to Austria to execute some frescoes. After a brief sojourn, he returned to his native country and established himself at Haarlem. His few known works as a painter are of inferior quality. His work Het Schilderboeck, "The Painter's Book," the first comprehensive art history produced north of the Alps, was published in 1604. It contains The Principles of the Fine and Liberal Art of Painting, The Lives of the Famous and Illustrious Painters of Ancient and Modern Times, An Explanation of the Metamorphosis of Ovid, known as the "painter's bible," and a chapter summarizing symbolism and mythology. For this book Carel van Mander employs Vasari as a model and a source for the material on Italian artists, and like Vasari he derives some material from Vitruvius, Pliny, and Alberti. He is not an absolute slave to Italian thought and shows originality in appraising his contemporaries and the various schools of painting.]

[65] See Panofsky, op. cit., pp. 198 f.

THE PAINTER'S BOOK[1]

THE LIFE OF THE SKILLFUL AND FAMOUS PAINTER
MARTEN HEEMSKERCK

We often find that our most eminent painters have made their obscure birthplaces renowned and universally celebrated, simple villages though they frequently were. What corner of the world is there in which the village of Heemskerck in Holland is not famous; for here it was that the skillful painter, Marten Heemskerck, was born in the year 1498. His father's name was Jacob Willemsz van Veen, and he was a peasant or farmer.[2] Marten, naturally inclined toward the art of painting from his early youth, received his first artistic training in Haarlem, from a certain Cornelis

[1] The selection is translated from *Het Leven der Doorluchtighe Nederlandtsche en Hooghduytsche Schilders*, Amsterdam, edition of 1617 (1st ed., Alkmaar, 1604), by Prof. Wolfgang Stechow of Oberlin College. The translator is indebted to Miss Ellen Johnson and Mr. Frits Lugt for helpful suggestions. For his notes, the material offered in the French translation by Henri Hymans (Paris, 1884–1885) and the German translation by Hanns Floerke (Munich and Leipzig, 1906) has been used to great advantage. The English translation by Constant van de Wall (New York, 1936) contains many errors in the text (see note 9); the notes add nothing to what was already known in 1906. On van Mander's sources see H. E. Greve, *De Bronnen van Carel van Mander*, The Hague, 1903.

Selected bibliography on Marten van Heemskerck: Leon Preibisz, *Martin van Heemskerck*, Leipzig, 1911; G. J. Hoogewerff, "Heemskerck," in Thieme-Becker, *Künstlerlexikon*, XVI, 1923, pp. 227 ff.; idem, *De Noord-Nederlandsche Schilderkunst*, vol. IV, pp. 290–386; A. B. de Vries, *Het Noord-Nederlandsch Portret in the Tweede Helft van de 16.e Eeuw*, Amsterdam, 1934, pp. 25–29; Max J. Friedländer, *Die Altniederländische Malerei*, XIII, Leiden, 1936, pp. 71–83 and 157–161; Paul Wescher, "Heemskerck und Scorel," *Jahrbuch der preussischen Kunstsammlungen*, LIX, 1938, pp. 218–230; Edward King, "A New Heemskerck," *Journal of the Walters Art Gallery*, VII–VIII, 1944–1945, pp. 61–73.

[2] His portrait by Heemskerck is in the Metropolitan Museum in New York, dated 1532. Preibisz, *op. cit.*, pl. I, and Friedländer, *op. cit.*, pl. XLII.

Willemsz,[3] the father of Lucas and Floris who likewise were rather good painters and had travelled in Italy visiting Rome and other places. Marten's father, who probably thought that there was not much in painting, took him back home and put him to work on the soil of his farm, much to the distress of the boy who was thus prevented from continuing his apprenticeship. It was therefore with great reluctance that he attended to such farmer's work as milking and the like; and one day, returning from his duties with a pail of milk on his head, he—not unintentionally—ran into a branch of a tree and spilled the milk. His father, incensed by the spilling and loss of the good milk, ran after him threatening him with a stick. Marten spent the following night hidden in a haystack. In the morning, his mother provided him with a knapsack and a little money, and on the same day, after having passed through Haarlem, he arrived at Delft where he once more took up his artistic endeavors with a certain Jan Lucas; there, he applied himself to drawing and painting with such industry that he made great strides in his art within a very short period. At this time, Jan Scorel had become very famous because he had imported from Italy an extraordinarily beautiful and novel manner of painting which made a great impression on everyone, and on Marten in particular; wherefore the latter did not rest until he was accepted as a pupil by this master at Haarlem.[4] Here he applied himself to art once more with such diligence that he finally caught up with his prominent master; in fact, to such a degree had he adopted Scorel's style that it was difficult to distinguish their work. His master—or so some people say—became disturbed lest his reputation be impaired, and dismissed his pupil, apparently out of jealousy. Marten then moved to the house of Pieter Jan Fopsen at Haarlem, the same house in which the late Cornelis van Berensteyn used to live; and at this very place

[3] No work of his is known; his name is mentioned in documents between 1481 and 1540.

[4] Scorel had fled to this town in 1527 from Utrecht where a local war had broken out. Heemskerck was thus at least twenty-nine years old when he became a "pupil" of Scorel who was only three years older than he.

he did several paintings, including the life-size figures of *Sol* and *Luna* depicted on the bedstead in a back room. There he also did *Adam* and *Eve*, likewise in natural size, being (it is said) nudes done from life.[5] The wife of the aforementioned Pieter Jan Fopsen who was fond of Marten did not like people to call him just Marten; she said to those who came to visit the painter that he should be called Master Marten since he fully deserved it.[6] From there he went to live in the house of a certain Joos Cornelisz, a goldsmith, also at Haarlem. Among many other works of his was a superbly painted altarpiece of St. Luke which he gave to the painters of Haarlem as a farewell present upon his journey to Rome.[7] This picture shows St. Luke seated and painting from life Mary with the Child on her lap; it is an excellent work, beautifully painted, singularly outstanding and quite unique, though a little too hard in the contours of the lighted parts, in the manner of Scorel. Mary has a graceful and lovely face, her attitude is fine, and the Child is most affable; over her lap hangs a cloth which, after the Indian fashion, is nicely decorated in various colors and with sundry ornaments, most graceful and not to be improved upon. St. Luke, whose face was modelled after that of a baker, is a very fine figure, most effective, and seems to exhibit a great zeal to match his patron. The palette which he holds in his left hand seems to stand out from the panel; the whole work is arranged in such a way as to be viewed from below. Behind St. Luke stands a person who looks like a poet and wears upon his head a wreath of ivy. (This may easily be a self-portrait of Marten as he looked at that time.) However, I could not tell whether by that he wished to indicate that painting and poetry have much in common and that painters should be of a poetic and imaginative mind, or whether he wished to convey the

[5] Probably the panel in the Frans Hals Museum in Haarlem, no. 264, which was formerly attributed to Scorel. Preibisz, *op. cit.*, pl. II.

[6] Obviously, Heemskerck was not yet master in the guild of St. Luke when this happened.

[7] Now in the Frans Hals Museum in Haarlem. Friedländer, *op. cit.*, pl. XXXVIII.

idea that the story of St. Luke was itself a piece of fiction. In the same picture is an angel holding a burning torch, very well painted. I would not know of any other work of Marten's that shows lovelier faces than does this one. The architecture consists mainly of flat walls. From above hangs a cage with a parrot in it.[8] Upon the lower part of the architecture he had painted an ornate scroll which looks as though it had been fastened there with wax and which contains the legend: "This panel has been given in memory of Marten Heemskerck who painted it. In honor of St. Luke he has wrought it, and donated it to his fellow painters. We should thank him by day and by night for his kind gift which is before us; and let us pray, with all our fervor, that God's grace be always with him. Finished[9] on May 23, in the year 1532." Quite deservedly, this panel is still kept by the magistrate of Haarlem in the south room of the Prince's Quarters where it is visited and highly praised by many people. He did it when he was thirty-four years old as is borne out by a comparison of its date with the year of his birth. He then went to the city of Rome to which he had long been attracted, in order to see the works of antiquity and of the great Italian masters. Having arrived there, he stayed in the service of a cardinal to whom he had been given an introduction.[10] He did not sleep away his time nor did he spend it in company of the Netherlanders with drinking and the like, but made drawings of many things, antiques as well as works by Michelangelo, furthermore many ruins, ornaments, and decorative details from antiquity such as are seen in great quantities in that city which is comparable to a painter's academy.[11] Whenever the weather was favorable, he would go on a walk to make drawings. One day when Heemskerck had again gone on one of those study errands, an Italian whom he knew managed to steal into his room, cut two canvases out of their frames, and carry them off, together with drawings

[8] This detail was later cut out of the panel and has not survived.

[9] Van de Wall translates: "He passed away."

[10] Most probably Willem Enckenvoort, Cardinal of Utrecht, who died in 1534.

[11] For his many drawings of this period, see: Christian Hülsen

taken out of their boxes. When Marten came home he was greatly saddened; but since the Italian had made himself suspicious, he went after him and recovered most of his works. However, because he was always very faint hearted, he feared that the Italian might take revenge on him; therefore he did not dare to stay in Rome any longer and undertook to return to the Netherlands. He had spent no more than three years in Rome,[12] but within this short period he had done many good drawings, and also made quite a bit of money which he took home with him. Arriving at Dordrecht with a letter addressed to the father of one of his former young friends in Rome, he was to call at an inn (at the site of the present Brewery of the Little Anchor). In those days, it was a cutthroat den where travelling merchants and other people were being murdered. There he was invited to stay for the night (an art patron, by the name of Pieter Jacobs, was also anxious to put him up); but finding a boat, he departed that same evening, and lucky he was, for in that house was found a whole pit full of corpses when the affair came to light. One of the daughters of that assassin had fled to Venice where she lived in the house of a bachelor, the famous painter Hans von Kalkar. Summoned before the Great Council, she truthfully admitted that she had felt compelled to leave that horrible house because she could not stand witnessing such atrocities, but also that she had considered it immoral to inform against her parents; whereupon she was acquitted. Heemskerck, now having returned to his native country, had changed his former manner of painting in the style of Scorel; but, according to the judgment of the best painters, he had not improved it, save for the fact that he had ceased to give such hard contours to the lighted parts. When one of his pupils told him that people thought he had achieved better results when he painted like Scorel than he did after his return from Rome, he replied: "My son, at that time

and Hermann Egger, *Die römischen Skizzenbücher von Marten van Heemskerck*, 2 vols., Berlin, 1913–1916.

[12] On the duration of Heemskerck's stay in Rome see Hermann Egger in *Mededeelingen van het Nederlandsch Instituut te Rome*, v, 1925, pp. 119 ff.

I knew not what I was doing." However that may be, the difference of style can be studied from the two shutters of the altar of the Clothiers[13] (in the big hall of the afore-mentioned Prince's Quarters) which, on the inside, show the *Nativity* and the *Adoration of the Magi,* two splendidly painted scenes which contain many details, including various portraits of simple folk and also his own.[14] On the outside, one finds the *Annunciation to Mary* in which the heads, painted from life, are very well executed. The angel is clad in a very original and graceful fashion; the lower lappets of his garb are purple, and they were painted by Jacob Rauwaert who at that time lived with Heemskerck as I have heard him tell myself. From this work one can gather how good an architect Heemskerck was and how fond he was of good ornamentation, quite in contrast to the common saying (which he himself was quoting a great deal) that "a painter who wants to do good work should avoid ornaments and architecture." Also, in this work one can make an unusual observation: the angel is reflected on the shiny marble floor as if he were standing on ice, something which actually happens on polished marble. Heemskerck did many large paintings for churches. In the Old Church at Amsterdam, there were two double shutters from his hand, showing on the inside, scenes from the Passion and the Resurrection, on the outside, representations in coppery monochrome; this work received high praise. The central panel was a *Crucifixion* by Scorel.[15] In the Great Church at Alkmaar, the high altar was a work of Marten's;[16] the central panel was a *Crucifixion,* the inside shutters showed the Passion, their outside the Legend of St. Lawrence—a very good work of art. Many of his paintings

[13] Contract dated Jan. 4, 1546. It now belongs to the Royal Gallery in The Hague but is on loan to the Frans Hals Museum in Haarlem. Preibisz, *op. cit.,* pls. v and vi. See also note 31.

[14] The bearded face in the left middle-ground.

[15] Destroyed in 1566.

[16] Documents from 1538 (contract) to 1543 (final payment) exist. Since 1581 it has been in the Cathedral of Linköping, Sweden; see Axel Romdahl, *Oud Holland,* xxi, 1903, pp. 173 ff., and the reproduction in Carl G. Laurin, *Nordisk Konst,* i, Stockholm, 1921, p. 147.

were shipped to Delft where one could see several panels of his, in the Old as well as in the New Church.[17] In St. Agatha's was an altarpiece with the *Adoration of the Kings* which he had arranged in such a way as to make one king appear on the central panel, and one on either of the wings; on the outside was the *Erection of the Brazen Serpent,* painted *en grisaille.*[18] This was a particularly excellent work which netted him an annuity of one hundred guilders for life; he was altogether much bent upon procuring for himself a number of life grants. In the church of the village of Eertswoude in North Holland, he did two double shutters for the high altar whose center part was carved in wood; on the inside he painted the *Life of Christ,* and on the outside the *Life of St. Boniface,* all of it divided into many compartments, and very attractive in painting and coloring.[19] He likewise did the high altar of the church at Medemblik.[20] For the Squire of Assendelft he painted two altar wings, one with the *Resurrection,* the other the *Ascension.*[21] He also did paintings in the chapel of the Assendelft family in the Great Church at The Hague.[22] One could go on indefinitely enumerating all the other altarpieces, easel paintings, epitaphs, and portraits done by him; for he was industrious by nature, worked incessantly, and was skillful in handling his various tasks. Among other excellent easel paintings of his, there was one especially good, full of details and rather large, which represented the Four Last Things: *Death, Last Judgment, Eternal Life,* and *Hell.*[23]

[17] One of these could be the large *Ecce Homo* triptych of 1559–1560, now in the Frans Hals Museum at Haarlem (repr. in *Schlesische Monatshefte,* III, 1926, pp. 526 f.), which comes from Delft, as does a shutter of a triptych in the Rijksmuseum at Amsterdam, dated 1564.

[18] Now in the Frans Hals Museum at Haarlem, dated 1551. Heemskerck's portrait of the rector of the monastery of St. Agatha, Johannes Colmannus, is in the Rijksmuseum at Amsterdam; Preibisz, *op. cit.,* pl. XI.

[19] Not identified.

[20] Not identified.

[21] Not identified.

[22] Not identified.

[23] Now in Hampton Court, dated 1565.

This contained many nudes, and figures in various poses, as well as a multitude of human emotions: pain of death, joy of heaven, sadness and horror of Hell. The picture had been commissioned from him by his aforementioned pupil Jacob Rauwaert, an excellent connoisseur in his time, who paid him in return a whole pile of double ducats, counting them out before the painter until he cried "stop." Furthermore, I saw, first in the house of the art lover Pauwels Kempenaer, and later in that of the excellent connoisseur Melchior Wijntgens, a small oblong painting representing a Bacchanal, or Feast of Bacchus, which was engraved almost identically.[24] This may easily be the best piece of painting he ever did after his return from Rome since it is very *morbido,* i.e. smooth in its nude parts; in it one can observe the frolics characteristic of pagan feasts of that sort, what with drunkenness and similar things taking place. Aernout van Berensteyn owns a very beautiful landscape by his hand, with a St. Christopher and an excellent background.[25] In short, he was universally gifted, well versed in every respect, outstanding in the rendering of nudes. The only thing he might sometimes be blamed for is that dryness or leanness of his figures which is so often found with us Netherlanders, and also an occasional lack of that certain graceful charm in the faces which—as I have pointed out elsewhere—is so great an asset to an artist's work. In composition he was excellent, in fact, his designs have spread practically over the entire world; he was also a good architect as becomes quite evident from all of his works. Indeed, one could go on indefinitely enumerating the prints made from his compositions,[26] and all those nice and in-

[24] The picture is now in the Vienna Gallery. It is based on an engraving by Marcantonio Raimondi after Raphael or Giulio Romano which was copied in the reverse by Cornelis Bos in 1543 (in turn, copied by Jan Theodor de Bry).

[25] Not identified.

[26] For the more than 600 engravings after Heemskerck's drawings, see Th. Kerrich, *A Catalogue of the Prints Which Have Been Engraved after Martin van Heemskerck . . .* , Cambridge, 1829, and Preibisz, *op. cit.,* pp. 53 ff. The main engravers were Philip Galle, Harmen Muller, and Cornelis Cort. For Heemskerck's drawings see Preibisz, *op. cit.,* pp. 82 ff.

genious allegories which were thought up for him by that
spirited philosopher, Dirck Volkertz Coornhert, and pub-
lished by Marten in print. Heemskerck himself was not an
engraver[27] but he did many excellent designs for various
engravers, among others, for the aforementioned Coornhert
whose spirit, mind, and hands were sufficiently able and
skillful to comprehend and to execute anything that a per-
son could possibly understand and accomplish. This man
did several things in etching[28] and engraving,[29] and in par-
ticular, very neat and lovely small scenes from the life of
the emperor, with the exception of the print representing
the capture of the king of France which was done by a
certain Cornelis Bos.[30] Some time after Marten had re-
turned from Rome as a bachelor, he married a beautiful
young girl by the name of Marie, a daughter of Jacob
Coningh. In honor of the wedding, the rhetoricians per-
formed a comedy or farce. This wife of his died in her
childbed eighteen months after. Three or four years later,
he painted the aforementioned shutters which are now
seen in the Prince's Quarters at Haarlem, attached to the
Slaughter of the Innocents by Cornelis Cornelisz.[31] In sec-
ond marriage he took an old maid[32] who was neither beau-
tiful nor clever but wealthy; nonetheless, she cast such
greedy eyes upon other people's property that she bought
many things without paying for them—or, as they say,
found them before they were lost—to the great discomfort
of Marten who entreated everyone not to shame her, and
who, being an honest and upright man, indemnified every-
body. He was a church warden in Haarlem[33] for twenty-

[27] The correctness of this statement is open to some doubt;
see Preibisz, *op. cit.*, p. 54. Heemskerck was also the author
of several woodcuts; *ibid.*, pp. 102 ff.

[28] The earliest date on etchings by Coornhert after Heems-
kerck is 1549.

[29] Dates from 1548 to 1559.

[30] Published by Hieronymus Cock in Antwerp, 1556 and 1558.

[31] See note 13. The picture by Cornelis Cornelisz (1591) now
likewise belongs to the Royal Museum in The Hague and is
on loan to the Frans Hals Museum in Haarlem.

[32] Her name was Marytgen Gerritsdochter (see note 34).

[33] At St. Bavo (the "Great Church").

two years, up to his death. When in 1572, the city of Haar-
lem was besieged by the Spaniards, the Council permitted
him to stay with Jacob Rauwaert in Amsterdam. He was
by nature acquisitive and thrifty, and he was also very faint
hearted, in fact, he was so timid that he would climb on
top of the church spire in order to watch the parade of
the militia because he was afraid of the shooting, thinking
he might not be safe elsewhere. He was forever worried
lest he become poor in his old age; therefore, up to the
day of his death, he used to carry around, hidden away
in his clothes, a goodly number of gold coins. After the fall
of Haarlem, the Spaniards took hold of many of his works
under the pretext that they intended to buy them, and sent
them to Spain; in addition, the fury of image-breaking has
infamously destroyed many other excellent works of his,
with the result that in our time not many of them are found
in this country. Since Marten, a very wealthy man, left no
children, he instituted many fine bequests before he died.
Among others, he ordered the income from a piece of land
to be given every year as a dowry to a young couple who
was to be married upon his grave, an institution which is
still being maintained.[34] In the cemetery at Heemskerck,
he ordered a pyramid, or obelisk, of blue stone, to be
erected on the grave of his father;[35] on its top, one finds
the sculptured portrait of his father, and it also contains
the epitaph in Latin and Dutch, as well as a little boy stand-
ing on burning skeleton bones, leaning upon a torch, and
putting his right foot on a death's head—apparently an em-
blem of immortality. Underneath is written: *Cogita mori.*
At the bottom is his coat-of-arms which shows, in its upper
part on the right, one half of a double eagle, and on the
left, a lion. The lower part contains a bare arm with a quill
or a brush in its hand. The upper part of the arm is winged,

[34] This bequest was drawn up by Heemskerck and his second
wife on April 16, 1558; an additional entry (June 21, 1568)
stipulated that the girls must be married to honest boys who did
not drink. The last marriage of this kind was in 1787.

[35] This was executed in 1570 and is still in existence; repr.
in *Noord hollandsche Oudheden*, II, 1, p. 91, and in *Eigen Haard*,
1901.

and the elbow rests on a turtle, and this seems to me to illustrate the advice of Apelles to the effect that one should neither be too lazy in one's work nor overburden one's mind with too much labor (which was said with respect to Protogenes as I have related elsewhere).[36] Toward the upkeep of this pyramid, Marten set aside the income from another piece of land; in case of its neglect, friends of his were entitled to lay hands on that property. He had a very nice way of drawing with the pen, his hatchings were very neat, his touch loose and fine. At Alkmaar, in the house of his nephew, Jacques van der Neck, one finds his self-portraits in oil from various periods of his life, beautiful pictures, well done and interesting.[37] After Marten had been a shining example of the art of his time, he departed this transitory life in the year of our Lord 1574, on the first day of October, at the age of seventy-six, having lived two years less than his father. His body was buried in the northern chapel of the Great Church at Haarlem.[38] But as he himself brought great light to art, so art in turn will not suffer his name to sink into darkness as long as the art of painting is held in the esteem and respect of man.

JOACHIM VON SANDRART

[Joachim von Sandrart (1606–1688) began his career as an engraver in Nürnberg. After studying painting in Utrecht, he went to Italy in 1627, visiting Venice, Florence, and Rome. In 1635 he left Italy and, after a brief stay in Amsterdam, established himself as an artist in Nürnberg in 1644.

[36] In *Het Leven der oude antijcke Schilders*, edition of 1617, fol. 14b.

[37] A self-portrait by Heemskerck, dated 1553, is now in the Fitzwilliam Museum in Cambridge, England. Preibisz, *op. cit.*, pl. XII. See also note 14.

[38] In accordance with his will, dated May 31, 1572. He appointed the mayors Jan van Suijren and Hendrick van Wamelen executors of his will. For their labors, they should receive two panels, *Christ on the Cross*, and *The Last Judgment*, or if they did not care for them, ten Burgundian dollars each.

He is important principally for his *Academy of the Arts of Architecture, Sculpture and Painting,* published in two volumes in 1675–1679. The first part of this work, a general introduction to the architecture, painting and sculpture, is composed of material taken largely from Vasari, Palladio, Serlio, van Mander, and others. The second part, containing biographies of artists, is likewise derived in part from Vasari and other writers; but there is much original and valuable information about the contemporary artists, many of whom Sandrart had known during his travels and his sojourn in Rome. Of special interest are the lives of the German artists for which he gathered the oral traditions. The third part contains a first notable attempt to give a systematic description of the contents of art collections, a study of iconography, and a translation of the "painters' bible" of Ovid taken from van Mander.]

THE ACADEMY OF THE ARTS OF ARCHITECTURE, SCULPTURE AND PAINTING[1]

LIFE OF MATTHIAS GRÜNEWALD

Matthaeus Grünewald,[2] also known as Matthaeus of Aschaffenburg, is second to none among the greatest of the old German masters in the arts of drawing and painting: on the contrary, he must be regarded as an equal, if not superior, to the very best of them. It is regrettable that

[1] The selection is translated from Joachim von Sandrart, *Teutsche Academie der Edlen Bau-, Bild- und Mahlerey-Künste,* 1675, edited and annotated by A. R. Peltzer, Munich, 1925, by H. W. Janson, Washington University, St. Louis, Mo. The notes based on A. R. Peltzer are by the translator. Although Sandrart wrote in the seventeenth century this selection is placed here because of the context.

See also: Schlosser, *Lett. art.,* p. 415, and *Kunstlit.,* p. 426.

[2] Sandrart may well take pride in his account. It formed the basis for the researches of the last seventy years, which have gradually re-established the historical personality of master "Matthis of Aschaffenburg." Today we know that the artist was born between 1470 and 1483 and that he was active along the Middle Rhine and probably also in the Upper Alsace region from the beginning of the sixteenth century into the 1520's. The

the works of this outstanding man have fallen into oblivion to such a degree that I do not know of a single living person who could offer any information whatsoever, be it written or oral, about the activities of the master. I shall, therefore, compile with special care everything that I know about him, in order that his worth may be brought to light. Otherwise, I believe his memory might be lost completely a few years hence.

Already fifty years have passed since the time when there was in Frankfurt a very old but skillful painter by the name of Philipp Uffenbach who had once been an apprentice to the famous German painter Grimer. This Grimer was a pupil of Matthaeus of Aschaffenburg and had carefully collected everything by him that he could lay his hands on. In particular he had received from his master's widow all manner of wonderful drawings, most of them done in black chalk and in part almost life-size. After the death of Grimer, all of these were acquired by Philipp Uffenbach, who was a famous and thoughtful man. At that time I went to school at Frankfurt not far from Uffenbach's house, and often did him small service; whereupon, if he was in a good mood, he would show me these beautiful drawings of Matthaeus of Aschaffenburg, which had been assembled into a book. He himself was an ardent follower of this master's manner, and would expound to me the particular merits of those designs. After the death of Uffenbach, his widow sold the entire volume for a good deal of money to the famous amateur, Herr Abraham Schelkens of Frankfurt, who placed it in his renowned collection so that the genius of its author

surname Grünewald, which Sandrart was the first to apply to the painter, is spurious; apparently the author confused Matthaeus of Aschaffenburg with Hans Baldung Grün. Recent studies have identified Grünewald with Matthis Gothardt-Nithardt, who appears in early sixteenth century documents as "the painter of the Elector of Mayence." A summary of the master's known life and work in English, as well as an extensive bibliography, may be found in the monograph by Arthur Burkhard, Cambridge, Mass., 1936. More recently a valuable contribution to our knowledge of Grünewald's work has been published by Edgar Wind: "Albrecht of Brandenburg as St. Erasmus," *Journal of the Warburg Institute*, London, I, 1937, pp. 142 ff.

might be remembered for all time to come. There the drawings repose among many other magnificent works of art, such as the best of ancient and modern paintings, rare books, and engravings, which it would take too long to enumerate in detail. I would like to refer the reader to this collection, where every art lover may inspect and enjoy the drawings.

This excellent artist lived in the time of Albrecht Dürer, around the year 1505, a fact that can be inferred from the altar of the *Assumption of the Virgin* in the monastery of the Predicants (Dominicans) at Frankfurt. The altar itself is the work of Albrecht Dürer, but the four outer wings, painted in *grisaille*, were done by Matthaeus of Aschaffenburg. On them are shown St. Lawrence with the grill, St. Elizabeth, St. Stephen, and another subject that escapes me. They can still be seen in their original place at Frankfurt, and are painted with the greatest delicacy.[3] Especially praiseworthy, however, is the *Transfiguration of Christ on Mount Tabor,* painted in water colors; this scene contains an exquisitely beautiful cloud in which appear Moses and Elijah, as well as the disciples kneeling on the ground. The design, the coloring, and every detail of the panel are so excellently handled that there is nothing to equal it anywhere, in fact, its manner and character are entirely beyond compare, so that the picture is a never-ending source of enchantment.[4]

The same distinguished author produced further three altar panels, each having two wings painted on either side, which used to stand in three separate chapels on the left-hand side of the choir of Mayence Cathedral. The first of these showed the Madonna with the Christ Child on a cloud, attended by a large number of saints standing on

[3] The altar was donated by Jakob Heller. Dürer painted the center panel (see p. 332, note 20), the original of which is lost, as are two of the four wings mentioned by Sandrart. The remaining pair, showing St. Lawrence and St. Cyriacus, is preserved in the Staedel Museum at Frankfurt.

[4] This work has disappeared. Two drawings of apostles in the Dresden Museum may have been intended as studies for the picture.

the ground, including St. Katherine, St. Barbara, St. Cecilia, St. Elizabeth, St. Apollonia, and St. Ursula, all of them drawn so nobly, naturally, charmingly, and correctly, and so beautifully colored, that they appeared to be in heaven rather than on earth. The second panel showed a blind hermit walking across the frozen Rhine river with the aid of a boy; he is being killed by two assassins and has fallen on top of the screaming child.[5] This picture was so rich in expression and detail that it seemed to contain a greater wealth of true observations and ideas than its area could hold. The third panel was slightly less perfect than the other two. All three of them were taken away in 1631 or 1632 during the ferocious war that was raging at that time, and dispatched to Sweden by boat, but unfortunately they were lost in a shipwreck, along with many other works of art.[6]

There is said to be an altar panel by the same hand in Eisenach, containing a remarkable figure of St. Anthony; the demons behind the windows are reputed to be especially well done. Furthermore, the late Duke William of Bavaria, an understanding judge and amateur of the fine arts, had in his possession a very fine small *Crucifixion* by the master, which he was very fond of, without knowing the name of the artist. In it are shown the Virgin, St. John, and a Mary Magdalen kneeling on the ground and praying devoutly. Because of the strange figure of Christ on the cross, who conveys the most powerful sensation of hanging since the weight of His body is borne entirely by the feet, this *Crucifixion* is so extraordinarily close to real life that it appears true and natural beyond all others if one contemplates it for some time with patience and understanding. For this reason a copper engraving in half-folio was made after the picture by Raphael Sadeler in 1605 at the behest of the above-mentioned duke, and some time ago I gave

[5] The scene probably represented the martyrdom of St. Lambert.

[6] Grünewald was employed in Mayence by the Cardinal Albrecht of Brandenburg. No copies of the three altar panels in the cathedral have come down to us.

great pleasure to the late Elector Maximilian when I revealed to him the name of the artist.[7]

A series of woodcuts illustrating the Revelation of St. John is supposed to be by the same master, but it is difficult to obtain.[8] In addition, there was in Rome while I was in that city a life-size picture of St. John with his hands clasped and his glance turned upwards as if he were contemplating Christ on the cross. It was extremely moving, done with much devotion and with wonderful grace, and was held in great esteem as a work by Albrecht Dürer. I, however, recognized the true author and demonstrated the difference in style, whereupon I was asked to put the artist's name on the picture in oil paint—I was just then doing the portrait of the Pope in that medium—as follows: Matthaeus Grünwald Aleman facit.[9]

This, then, is everything that I have been able to find out about the works of this excellent German master, apart from the fact that he stayed mostly at Mayence, that he led a secluded and melancholy existence, and that his marriage was far from happy. I do not know where or when he died, but I believe it was around the year 1510.[10] His portrait is shown on plate CC.[11]

[7] The picture was copied several times during the seventeenth century. Max J. Friedländer (*Jahrbuch der preussischen Kunstsammlungen*, XLIII, 1922, pp. 60 ff.) believed that he had rediscovered the original in a panel from a private collection in Essen, Germany. It is now in the Samuel H. Kress Collection, National Gallery of Art, Washington, D.C., (our *fig. 25*).

[8] Sandrart here confuses Grünewald with Matthias Gerung (*ca.* 1500–1568/70), who produced a series of Apocalypse woodcuts.

[9] No trace of this picture seems to have survived.

[10] The painter died in 1528.

[11] The original from which this engraving was taken has disappeared. Several scholars have noted its resemblance to the St. Sebastian from the Isenheim Altar, Grünewald's principal work, which remained unknown to Sandrart. On plate 4 of the second part of his book, Sandrart reproduces another engraved portrait of the artist, taken from a Grünewald drawing that is now in the library of Erlangen University. There are grave doubts, however, as to whether this drawing actually represents a self-portrait; the head seems to bear a distinct similarity to that of the St. Paul in the Isenheim Altar, a fact commented on by various scholars.